THE DRAWINGS OF THOMAS ROWLANDSON
IN THE PAUL MELLON COLLECTION

Corrigenda

Page 9, List of Color Plates, for "Facing page", read
"Facing number"

No. 127, for "Gambo", read "Gambado"

No. 261, for "Australian", read "Austrian"

Nos. 297–303, *The New Bath Guide* . . . , delete 1776

No. 345 (2), for (Anthenea?), read (Athene?)

The Drawings of
THOMAS ROWLANDSON
in the Paul Mellon Collection

CATALOGUE COMPILED BY

John Baskett

AND

Dudley Snelgrove

BARRIE & JENKINS
COMMUNICA–EUROPA

First published in 1977 by Barrie & Jenkins Ltd
24 Highbury Crescent London N5 1RX

ISBN 0 214 20327 1

Designed by John Leath MSTD

Typesetting in Monotype Bell by the University Press, Cambridge, England

Printed by The Meriden Gravure Company, Connecticut, U.S.A.

PREFACE

Rowlandson is rapidly becoming a subject to himself in studies of the British School, most especially in the United States where the major collections of his work are to be found. It is there that research into his work is most active in institutions such as the Boston Public Library, The Huntington Library and Art Gallery, and the University of Princeton.

In view of this widening interest, it was suggested to Paul Mellon that a catalogue of his Rowlandson drawings, amounting to some 400 items with a representative number of illustrations, would be enthusiastically welcomed by both scholars and laymen. Mr Mellon agreed not only to the catalogue being compiled, but that all his drawings should be illustrated; this has been done to the same high standard as other Mellon catalogues by the Meriden Gravure Company.

In a way, the catalogue reflects Paul Mellon's enthusiasm for the English way of life, especially in the eighteenth and early nineteenth centuries, as there is no better graphic witness to the period than Rowlandson. The project is timely too, perhaps, since further studies of Rowlandson are intended at the Yale Center for British Art and British Studies.

The drawings are but one component of the extensive Mellon Collection of British Art, and a brief history of the formation of the collection from its modest inception to its present state of maturity may be given here.

Paul Mellon spent the years 1925 to 1929 at Yale, a time when the University was renowned for its distinguished professors of English literature. Subsequently, he continued his education at Clare College, Cambridge. His sporting activities there, including rowing and riding to hounds, promoted in him an urge to collect books on these subjects, illustrated by fine colour plates. Inevitably, Rowlandson's work as an illustrator was prominent among these. But by far the most important step was the purchase of the colour-plate books from the celebrated library of Major John Abbey. This, and a modest number of paintings of English sport and life which had been accruing by both parental gift and personal purchase, formed the genesis of the collection of today.

Perhaps the most momentous milestone was the relationship that developed between Paul Mellon, a self-confessed 'galloping Anglophile', and the late Basil Taylor, an art historian of strange charm and an extraordinary ability for transmitting his enthusiasm for art. 'It was he who opened my eyes to the beauty and freshness of English drawings and watercolours, their immediacy and sureness of technique . . . their Englishness' Paul Mellon said in his opening speech at the exhibition *Painting in England 1700–1850* at the Virginia Museum of Fine Arts in 1963. As a result of this friendship a policy was formulated, the aim of which was to make the Paul Mellon

Collection unique in that it would house the British School in every media under one roof: paintings, drawings, prints and sculpture with a comprehensive library of source books. Over several years, with constant consultation between Paul Mellon and Basil Taylor, the collection grew in all departments towards this goal and, with this impetus, has been expanding continuously.

The drawings section comprises individual purchases bought on the open market, but the acquisition of six major collections which had already been formed in England comprised the central corpus. Surprisingly, none of the block purchases contained a large number of Rowlandson drawings.

It was not the purpose of the compilers to engage in investigations into Rowlandson's artistic career. Much has been accomplished in this field in recent years, particularly by Dr John Hayes and Dr Robert Wark, whose works have been consulted whenever points arose needing scholarly arbitration. However, a brief résumé may be attempted here and an extensive, if not full, list of earlier biographical studies is to be found in the comprehensive bibliography compiled by Catherine Nicholson. This follows the catalogue and should prove a most valuable source of reference to future researchers.

Rowlandson was born in 1756. As a boy, when his father got into financial difficulties, he and his younger sister were placed in the care of his uncle James Rowlandson, a Spitalfields silk weaver, and his wife Jane. When Thomas was eight years old his uncle died and his aunt, having sold the business, moved to Soho and sent him to Dr Barwis's School in the vicinity. At the age of 16 he was admitted to the Royal Academy Schools where he met Jack Bannister, later to become the famous actor-manager. Some time between 1775 and 1777 he moved from his aunt's house to premises in Wardour Street and in that latter year he received the silver medal of the Academy.

During the course of his student years he spent some time in Paris, possibly staying with friends or relatives of his aunt. On the evidence of Rowlandson's friend, Henry Angelo, he arrived in Paris in 1774. There were several visits to France and a possible one to Italy in the 1780s. In 1784 he made a short tour to the Isle of Wight in the company of his friend Henry Wigstead; an expedition which he recorded in a sketchbook now in the care of the Huntington Library and Art Gallery in California. In the same year he exhibited at the Royal Academy his famous compositions entitled *Vauxhall Gardens* and *The Serpentine River*. The former is known in other versions, but both subjects show the artist at the age of 28 in full possession of his artistic talents.

After he had moved to Poland Street, Rowlandson's aunt died in 1789 leaving him a legacy. He had a number of addresses in the next few years and made several further visits to the Continent, moving finally in 1800 to an attic in James Street, Adelphi, where he lived for the rest of his life.

During the 1790s Rowlandson found a client, Mathew Michell, a banker, who became an incurable collector of his drawings until the latter's death in 1819. They formed a close friendship, Michell being of a genial and generous nature, and Rowlandson was a frequent visitor to his home in London, at Grove House, Enfield, and to

Hengar House, near Bodmin in Cornwall. Michell's only complaint seems to have been founded on the necessity of carrying his stout figure up the many steps to Rowlandson's top floor apartments in Adelphi.

A forceful influence on the second half of Rowlandson's career was exerted by the enterprising and imaginative publisher Rudolph Ackermann. Ackermann employed him on various of his more important colour-plate books between 1798 and 1822. He also worked from 1807 for Thomas Tegg of Cheapside, a hack publisher of no merit. Little is known of the latter part of Rowlandson's career, although some drawings can be roughly dated from watermarks. He made further visits to the Continent – he spoke fluent French – and appears to have been fully active as a draughtsman up to 1824. In 1825 at the age of 68 his health broke down; Hayes suggests a stroke as a possible cause. He died two years later in 1827, and his life-long friends Jack Bannister and Henry Angelo, and his old employer Rudolph Ackermann attended his funeral.

The procedure with the entries has been to describe each drawing, to give details of medium, size, provenance and literature and to append any interesting notes. A chronology of the drawings was not attempted. Rowlandson's dates on drawings are notoriously unreliable and the drawings in this collection were acquired generally for their attractiveness, humour or subject interest rather than to fit into any pattern of evidence to demonstrate his development in style or technique. The catalogue, therefore, is arranged by subjects so ordered that, in most cases, they merge from one to the other without strict frontiers. It will be appreciated that the division between categories has sometimes proved difficult, especially when a drawing has a title unrelated to the subject, or when the composition has more than one theme. The index should however cover these circumstances.

We owe special thanks to Beverly Carter, Administrative Secretary to the Paul Mellon Collection, who has been assiduous over documentation and has supervised the transportation and care of the original drawings; and to Joan Bennet who has helped us with research on the catalogue and has been of great assistance in typing and preparing entries. We are grateful to Judy Egerton for her help with the sporting entries and to many who have given us willing and enthusiastic help, among them John Hayes, Sinclair Hitchings, R. E. Lewis, Ronald Paulson, Philip Pinsof, Morris Saffron, Robert Wark, and members of the staffs in the Print Room of the British Museum, the Boston Public Library, the Metropolitan Museum of Art and Princeton University Library.

SUBJECTS

8

LIST OF COLOUR PLATES

CATALOGUE

———◆———

ABBREVIATIONS

Abbey *Life* or *Scenery*	*Scenery of Great Britain and Ireland in Aquatint and Lithography, 1770–1860 from the Library of J. R. Abbey*, 1952
	Life in England in Aquatint and Lithography, 1770–1860 from the Library of J. R. Abbey, 1953
B. M., L.B.	*Drawings by British Artists in the British Museum*, Vol. III, 1902, by Laurence Binyon
B. M. Satires	*British Museum Catalogue of Political and Personal Satires*, Vols. V–X, 1935–52
Bury, 1949	Adrian Bury, *Rowlandson Drawings*, 1949
Colnaghi and Yale 1964/65	London, Colnaghi 1964/65 and Yale University Art Gallery 1965, *English Drawings and Watercolours from the Collection of Mr and Mrs Paul Mellon*
D. (in provenance)	MS. catalogue of L. G. Duke's collection of English drawings, in the possession of Judy Egerton and Dudley Snelgrove
Falk, 1949	Bernard Falk, *Thomas Rowlandson: His Life and Art*, 1949
Grego I or II	Joseph Grego, *Rowlandson the Caricaturist*, 1880, 2 vols.
Hayes, 1972	John Hayes, *Rowlandson Watercolours and Drawings*, 1972
Lugt	Frits Lugt, *Marques de Collections*, Amsterdam 1921, *Supplément*, The Hague, 1956
N.G. of A., Washington 1962	National Gallery of Art, Washington, *English Drawings and Watercolors from the Collection of Mr and Mrs Paul Mellon*, 1962
Oppé, 1923	A. P. Oppé, *Thomas Rowlandson: His Drawings and Watercolours*, 1923
P.M.L. and R.A. 1972/73	Pierpont Morgan Library, New York and London, Royal Academy, *English Drawings and Watercolours 1550–1850 in the Collection of Mr and Mrs Paul Mellon*, 1972/73
Paulson, 1972	Ronald Paulson, *Rowlandson: A New Interpretation*, 1972
Sitwell, 1929	Osbert Sitwell, *Thomas Rowlandson*, Famous Water-Colour Painters VI, 1929
Tooley	R. V. Tooley, *English Books with Coloured Plates 1790–1860*, 1954
V.M.F.A., Richmond 1963	Virginia Museum of Fine Arts, Richmond, Virginia, *Painting in England 1700–1850; Collection of Mr and Mrs Paul Mellon*, 1963
Victoria, Canada 1971	The Art Gallery of Greater Victoria, Canada, *British Watercolour Drawings in the Collection of Mr and Mrs Paul Mellon*, 1971
Wark, 1975	R. R. Wark, *Drawings by Thomas Rowlandson in the Huntington Collection*, 1975
I. A. Williams, Sheffield 1952, Aberystwyth 1953, Reading 1959	*Early English Watercolours and other drawings selected from the collection of Iolo A. Williams*, Graves Art Gallery Sheffield 1952; National Library of Wales, Aberystwyth, 1953; and Museum and Art Gallery, Reading, 1959

———◆———

Titles in quotation marks are from inscriptions or prints made from the drawings.

Height precedes width in measurements.

Signatures and inscriptions on drawings have been accepted with caution when describing them as in the artist's hand.

ENGRAVED is used generically to cover prints made from drawings with the exception of AQUATINTED which, in the main, refers to illustrations in books.

Left and Right refer to the viewer's standpoint.

1 'A View at Blackwall'

A portly, elderly man is welcomed by two girls on the seashore. He is followed by a sailor carrying a trunk on his head, who has rowed him from an anchored, three-masted ship. Another boat approaches, containing three figures.

Pen and ink and watercolour: $5 \times 7\frac{3}{8}$ in (127×187 mm.)

INSCRIBED as title on the mount in ink.

PROVENANCE William Esdaile (Lugt 2617); L. G. Duke (D.601); Colnaghi 1961.

2 'Bridewell, the Pass Room, House of Correction'

A grim, lofty room with barred windows is occupied by women of all ages, some with babies. Many are lying on plank beds which flank the room. A wardress is ushering in a new and pregnant entrant who is crying at the desolate scene before her. A notice, high on the wall, reads *Whoever Dirts | her Bed will | be punish'd.*

Pen and ink and watercolour: $7\frac{1}{2} \times 11$ in (190×280 mm).

PROVENANCE Charles Sawyer 1965.

AQUATINTED for Ackermann's *Microcosm of London*, 1808–10, I, p. 92.

Bridewell Manor was presented by Edward VI to the City of London in 1553. It became a workhouse and house of correction 'for the strumpet and idle person, for the rioter that consumeth all, and for the vagabond that will abide in no place'. It was demolished in 1863. The Pass Room was used for paupers who were confined for seven days before being sent back to the parish in which they claimed settlement.

Versions are in the Huntington Library, Wark, 1975, no. 200 and the Art Institute of Chicago.

3 Covent Garden Market

Fashionable groups of people stroll unhurriedly between a line of shops on the left and stalls on the right, looking at a display of plants. St Paul's Church is in the centre background.

Pen and red ink and watercolour: $6\frac{1}{4} \times 9\frac{5}{8}$ in (160×245 mm).

PROVENANCE Agnew 1967.

EXHIBITED Yale Center, *Pursuit of Happiness*, 1977, no. 122.

Covent Garden, first recorded as a market place in 1656, flourished as the main London fruit, flower and vegetable market from the early eighteenth century until it moved to Nine Elms, Battersea in 1974.

A slight pencil sketch of this aspect, without figures, is in the Huntington Library, Wark, 1975, no. 391.

4 Dr Graham's Cold Earth and Warm Mud Bathing Establishment at 26 Fleet Street, London

A dilapidated warehouse with raftered ceiling has the left half of the floor covered by banked-up earth. Patients, all looking exceedingly miserable, are in various stages of immersion in earth. The sexes are separated by a loosely hung sheet that is about to collapse. On the left, two men shovel earth on four male patients, one up-ended in a tub, while beyond the sheet, five women are submerged to their necks or waists, but still wearing hats. In the foreground, a naked fat man leaning over a chair, is scrubbed by an old crone while Dr Graham (whose fees included his personal attention) stands by the unhappy man consoling him. On the right, a cadaverous-looking cripple emerges from a sedan chair.

Pen and ink and water colour $10\frac{3}{8} \times 16\frac{3}{8}$ in (267×416 mm).
PROVENANCE L. S. Deglatigny (Lugt 1768*a*); Colnaghi 1968.

James Graham (1745–94), a fashionable quack, travelled in America as a doctor, living in Philadelphia for about two years from 1772. In London he opened his 'Temple of Health' proclaiming his ability to cure most complaints. He demonstrated his 'Earth Bathing' together with a young lady 'stripped to their first suits'. In his pamphlets the doctor 'delicately touched upon the Celestial Beds...for the propagating of Beings rational, and far stronger and more beautiful in mental as well as in bodily endowments than the present puny, feeble and nonsensical race of probationary immortals, which crawl and fret, and politely play at cutting one another's throats for nothing at all, on most parts of this terraqueous globe'. He became obsessed with religious fervour and was ultimately confined as a lunatic in his Edinburgh house.

Colour plate

5 Greenwich

A bustling holiday throng arrives by ferry-boat and ascends the steps which separate the Salutation Inn from a building opposite, both crowded with spectators at their windows. The Seamen's Hospital, now the Royal Naval College, is in the background.
Pen and ink and watercolour: $11\frac{1}{4} \times 18\frac{3}{8}$ in (286×476 mm).
PROVENANCE Agnew 1967.

Another version, inscribed *Landing at Greenwich*, is in the Victoria and Albert Museum, London, and illustrated in Sitwell, 1929, pl. II.

6 Hyde Park Corner

A crowd scene. From the left, two men hoist a fat woman up into a carriage; pedestrians enter by a small gate near the main entrance through which a high carriage, drawn by six horses appears, causing a disturbance. In the foreground stroll two groups of people of fashion, and on the right a rider jumps a rail, tumbling a couple to the ground.
Pen and ink and grey wash: $9 \times 24\frac{1}{4}$ in (230×615 mm).
PROVENANCE Gardner Collection; Colnaghi 1961.

EXHIBITED N.G. of A., Washington 1962, no. 66; V.M.F.A., Richmond 1963, no. 417; Colnaghi and Yale, 1964/65, no. 62.

7 The Arrival of Ferries at London Bridge(?)

At the foot of the wide steps leading up to a bridge, passengers arrive in several crowded ferry-boats. In the prevailing confusion, some women suffer from the attentions of the rascally boatmen. One man is fondling a buxom dame, who protests vehemently, another pours drink into the mouth of a trollop sprawled in the boat and a third pick-a-backs a woman ashore as well as his spindly legs allow.
Verso, pencil sketches of a man and a woman talking, a head of a man, and a soldier blowing a trumpet.
Pen and ink and watercolour: $7\frac{1}{8} \times 9\frac{1}{2}$ in (181×241 mm), all corners cut.
PROVENANCE C. W. Dyson Perrins; L. G. Duke (D.3574); Colnaghi 1961.

Many ferries operated across the Thames and there were some thirty landing-stages between London and Westminster bridges. The Waterman's Company controlled all the passenger boats and the boatmen, taking advantage of their monopoly, were abusive and belligerent, and the river resounded to their constant cries of 'Oars, sculls, sculls, oars, oars'.

8 Rag Fair or Rosemary Lane

Against a background of small shops with garments draped from their eaves, Jewish traders haggle with customers. Prominent among these is a yokel being persuaded to buy a coat. On the right, a woman sells refreshments from a table.

Pen and ink and watercolour: $5\frac{1}{8} \times 7\frac{1}{2}$ in (130×190 mm).

PROVENANCE Leger Galleries 1964.

Rag Fair, now Royal Mint Street, near the Tower of London, is best described by quoting Thomas Pennant: 'The articles of commerce by no means belie the name' (*Some Account of London*, 1791).

This drawing lacks the shops on the right hand side of the versions in the British Museum (L.B.44) ill. Bury, 1949, pl. 19; in Windsor Castle, ill. Falk, 1949, facing p. 60; and in the Boston Public Library.

9 'Richmond Park'

A wooded scene by a pond. On the left, a woman is strolling towards a herdsman and his female companion who sit on the bank watching cattle watering.

Pen and ink and watercolour: $4\frac{1}{2} \times 6\frac{1}{2}$ in (115×165 mm).

INSCRIBED *Richmond Park* lower centre and *T Rowlandson* lower right.

PROVENANCE George, Fifth Duke of Gordon; Elizabeth, Duchess of Gordon; The Brodie of Brodie; Agnew 1962.

LITERATURE Hayes, 1972, p. 43, fig. 38.

10 Viewing at the Royal Academy

In one of the Academy rooms, visitors are surveying the exhibits which are hung to the ceiling. Prominent in the centre stands a connoisseur, whose huge paunch amusingly juxtaposes the convex posteriors of a couple bending low to inspect a picture on the right.

Pen and ink and watercolour: $5\frac{7}{8} \times 9\frac{1}{2}$ in. (150×241 mm).

PROVENANCE F. Meatyard; Thomas Girtin; Tom Girtin; John Baskett 1970.

LITERATURE Randall Davies, *Caricature of Today*, 'The Studio', 1928, pl. 5.

EXHIBITED Spring Gardens, London, *Humorous Art*, 1925; London, Arts Council, *Humorous Art*, 1949–50, no. 1; Sheffield, Graves Art Gallery, *The Collection of Thomas Girtin Jnr.*, 1953, no. 90; London, R.A., *The Girtin Collection*, 1962, no. 102.

11 Soldiers in St James's Park

A squad of soldiers followed by a drummer and with two cavalrymen on its right flank, approaches a gateway to St James's Palace. Fashionable figures parade in the background outside the park wall. To the right of the wall are the stalls with cows where vendors are selling milk. (This was usually done to the cry of 'A can of milk, ladies; a can of red cow's milk, sir!')

Pen and ink and watercolour: $5 \times 7\frac{5}{16}$ in (127×185 mm).

INSCRIBED verso, *Thomas Rowlandson* on old mount.

PROVENANCE Gilbert Davis (Lugt 757a); John Baskett 1970.

12 Vauxhall Gardens

A concert is in progress in the Grove. On the left, musicians accompany a singer in the 'Orchestra', the balconied exterior of the Rotunda used for alfresco promenades in fine weather.

In the alcove below the musicians, a party eats with gusto, while the crowd which spreads across the scene chatters, ogles, drinks and pays scant attention to the performers.

Mrs Weichsel sings to the audience from the front balcony; the orchestra is led by M. Bar-thélemon and includes oboists Messrs Park and Fisher, Mr Sargent a trumpeter, Mr Parkinson a bassoonist and on the kettledrum, Mr Nelson, who died on that spot during a performance in 1785, the year after this was drawn by Rowlandson. In the foreground from the left is a supper party, at one time thought to have been James Boswell, Dr Johnson, Mrs Thrale and Oliver Goldsmith. For a time, Johnson was an enthusiastic frequenter of the Gardens and Boswell records his comment 'I am a great friend to public amusements; for they keep people from vice. You would now have been with a wench had you not been here'. More certainly identifiable is Captain Topham who is spying haughtily through a glass at the Duchess of Devonshire and her sister, Lady Duncannon, who are also being observed from behind a tree by an elderly cleric. (It has been supposed that this is Parson Bate Dudley, the 'Fighting Parson', but as he was only 39 years old at that date and was, to quote Henry Angelo, 'as magnificent a piece of humanity, perhaps, as ever walked arm in arm with fashionable beauty in the illuminated groves of Vauxhall', the supposition seems untenable.) Next to him stands James Perry in Scottish uniform and further along in line, 'Perdita' Robinson flirts with the Prince of Wales while her husband peers suspiciously at them both.

It is feasible that this drawing is a preliminary composition for the larger and more highly finished version exhibited at the Royal Academy in 1784, which is now in the Victoria and Albert Museum. In that drawing, the figure of Admiral Pasley (with his eye-patch and wooden leg) has been inserted on the left of the two titled sisters and on his left, the small boy in the Mellon version has been changed to a small girl. Many changes in detail are noticeable, especially in the size of the crowd and their attitudes. Robert Pollard's engraving, aquatinted by F. Jukes and published in 1785, is faithful in detail and size to the V. & A. drawing.

Pen and ink and watercolour: $13\frac{1}{8} \times 18\frac{3}{4}$ in (333×476 mm).

PROVENANCE L. S. Deglatigny (Lugt 1768a); Sir William Augustus Fraser, Bt.; sold Christie's 3 December 1900 lot 47; Leggatt Bros. 1963.

LITERATURE *Pictures, the Property of Sir W. A. Fraser*, 1887, p. 10; Falk, 1952, p. 78; Martin Hardie, *Watercolour Painting in Britain* 1966, I, p. 212, pl. 213.

EXHIBITED Royal Institute of Painters in Watercolour, *Works of English Humorists in Art*, 1899, no. 32; Victoria, Canada, 1971, no. 32; P.M.L. and R.A. 1972/73 no. 71; Yale Center, *Pursuit of Happiness*, 1977, no. 110.

Vauxhall Gardens originated in 1661 and was then called New Spring Gardens. It was described by John Evelyn as a 'pretty contrived plantation'. From 1732 it flourished under the proprietorship of Jonathan Tyers, who instigated orchestral and vocal concerts. It was patronized by the Prince of Wales and the nobility and gentry who promenaded the woodland groves and pavilions which were lit by more than a thousand lamps. After about 1830 it declined in popularity with the *ton* and became a venue for balloon ascents, firework displays and general amusements. It eventually closed on 25 July 1859 after many vicissitudes in fortune and management.

13 Wapping Old Stairs

People arriving with baskets and bundles by ferry-boat at the foot of the Stairs; to the left, two men are humping sacks down a ramp to a moored barge.

Pen and ink and watercolour: $4\frac{9}{16} \times 6\frac{7}{8}$ in (116×175 mm).

PROVENANCE Edward Marshall, sold Sotheby's 3 May 1961 lot 44; Colnaghi 1961.

EXHIBITED N.G. of A., Washington, 1962, no. 69.

Wapping Old Stairs was notable for the capture in a nearby inn of the brutal Judge Jeffreys of

the Bloody Assizes, who condemned many rebels to be hanged after the Monmouth uprising of 1685.

14 Bodmin, Cornwall: The Arrival of the Stage-Coach

As the passengers alight, the coachman aggressively demands money from an elderly bearded Jew. A drummer-boy, his sword under his arm, looks on with evident enjoyment. The background of locals grouped outside the Sun Inn and adjacent buildings is similar to that of *French Prisoners on Parole* (no. 15).

Pen and ink and watercolour: $9\frac{1}{4} \times 15$ in (235×381 mm).

PROVENANCE Arthur Russell Johnson, sold Christie's 13 July 1965 lot 152(ill.); Colnaghi 1965.

LITERATURE H. L. Douch, *Old Cornish Inns*, 1966, pl. II.

EXHIBITED Yale Center, *Pursuit of Happiness*, 1977, no. 9.

Other versions are in the Royal Library, Windsor; Boston Public Library (Wiggin Collection cat. p. 73) and another exhibited F. T. Sabin, *Thomas Rowlandson*, 1933, pl. II.

15 Bodmin, Cornwall: French Prisoners on Parole

Local inhabitants and French soldiers talk together in a relaxed manner outside the Lion Inn and adjacent shops with stalls. In the centre foreground, a farrier shoes a farm horse. A similar background appears in *The Arrival of the Stage Coach*, no. 14.

Labelled on old mount FRENCH PRISONERS / ON PAROLL / AT BODMIN CORNWALL / 1795

INSCRIBED verso *My dear Rowlandson / I shall be at home and alone, if you will favour me with a call I shall be happy / CN* in ink and *Dear Bess / Am Obliged to dine out shall not be able to call on you / before ten O Clock* in pencil, in the artist's hand.

PROVENANCE Arthur Russell Johnson, sold Christie's 13 July 1965, lot 151 (ill.); Colnaghi 1965.

16 Bodmin Moor

An extensive hilly and wooded landscape. A road winds from a farm on the upper right to the lower right of the composition, where a man, seated in a cart drawn by a donkey and led by a woman, looks back at the view.

Pen and ink and watercolour: $11\frac{1}{4} \times 17$ in (285×432 mm).

INSCRIBED *North Cornwall* lower centre and *Rowlandson* lower right, in ink in the artist's hand.

PROVENANCE H. Reitlinger; A. J. Rowe; Agnew 1969.

17 The Market Place, Brackley, Northamptonshire

Groups of men conversing against a background of the Town Hall and other buildings.

Pen and ink and watercolour: $8\frac{1}{8} \times 10\frac{3}{4}$ in (205×273 mm).

PROVENANCE Mrs J. Maclean; Agnew 1971.

EXHIBITED Cheltenham Festival, 1965, no. 39

18 Bradwell Lodge, Bradwell Quay, Essex

(The buildings are drawn by Thomas Malton Jnr with the landscape figures by Rowlandson.) The fine house stands centrally beyond a wide lawn. On the left, a lady and gentleman converse among trees; a square-towered church behind them. In a group on the right, a gentleman dallies with two ladies sitting on a garden seat while a couple stroll at their side.

Pen and ink and watercolour: $13\frac{3}{4} \times 22\frac{5}{8}$ in (355×578 mm).

PROVENANCE Sotheby's 18 July 1974 lot 92; Baskett & Day 1974.

Engraved by W. Angus for *Seats of the Nobility*, 1793, pl. XXXV.

Originally a Tudor house given by Henry VIII to Anne of Cleves, Bradwell Lodge had additions made to it between 1781 and 1786 by John Johnson, the architect of Chelmsford Shire Hall and other notable Essex buildings. It was the country seat of the Reverend Henry Bate Dudley (the 'Fighting Parson' and editor of the 'Morning Post') who purchased the advowson of Bradwell-juxta-Mare in 1781 for £1,500 and spent £28,000 on rebuilding the church, reclaiming land and other improvements. The house is still in existence.

19 'Alterations in the Ale Cellar at Bullstrode, Buckinghamshire'

A dandified aristocrat quizzes with horror at a sign-writer inscribing disparaging names on a row of vats. A disgruntled servant holds up a candle for the writer who stands on a ladder. A fat steward kneels in supplication and a cleric throws up his hands in anticipation of an angry outburst, while a group of menials await the outcome with relish. In *Dr Syntax Made Free of the Cellar*, no. 311, the scene is the same cellar.

Verso, indecipherable writing.

Pen and ink and watercolour: $5\frac{3}{4} \times 9\frac{1}{4}$ in (145×235 mm).

INSCRIBED as title in ink lower centre and *Board Wages at Bullstrode* lower right in the artist's hand.

PROVENANCE Maas Gallery 1964.

Bulstrode Park and house belonged to the Dukes of Portland and was the home of the Dowager Duchess of Portland, the botanist friend of Mary Delany and Fanny Burney.

20 A Burial at Carisbrooke, Isle of Wight

Mourners follow a heavily shrouded coffin, led by a clergyman, to an open grave in front of a large church. A group of grave-diggers await them having, as a melancholy reminder, dug up two skulls and placed them near the opening. Carisbrooke Castle stands high in the background.

Pen and ink with blue and grey washes: $5\frac{3}{8} \times 17\frac{5}{8}$ in (146×477 mm).

PROVENANCE Desmond Coke; T. E. Lowinsky (Lugt 2420a); Justin Lowinsky 1963.

21 'Church'

Possibly a Church in the West of England (where several hamlets are so named) or Church on the Isle of Wight. A distant hilly landscape forms the background to a group of small buildings on a rise to the right above the road in the foreground. A couple stand talking on the left.

Pen and ink and watercolour: $5\frac{3}{8} \times 8\frac{3}{8}$ in (135×212 mm).

INSCRIBED *Church* in ink lower left.

PROVENANCE Sotheby's 2 May 1962, lot 33; Colnaghi 1966.

22 Mr Drummond's Cottage, East Cowes, Isle of Wight

A panoramic view up the Medina river leading to the estuary. On the extreme right, the cottage, surrounded by trees, has a roof-high balcony supported by tall arched columns. Small boats and groups form the foreground.

Pen and ink and watercolour: $5\frac{3}{8} \times 18\frac{3}{8}$ in (137×467 mm).

INSCRIBED recto, *Mr Drummonds Cottage* upper right and *East Cowes* lower right, in pencil and verso, *East Cowes*.

PROVENANCE Desmond Coke; T. E. Lowinsky (Lugt 2420a); Justin Lowinsky 1963.

23 Admiral Christian and Mr Lyson's (?) Cottages, Cowes, Isle of Wight

An extensive view of a valley with a two-storey house with castellated coping on the extreme left, a church nearby and other houses in the landscape.

Pen and ink and watercolour: $4\frac{3}{4} \times 18\frac{1}{4}$ in (120 × 463 mm).

INSCRIBED recto *Adm Christian & Mr. Lyons (?) | Cottages | Cowes* in pencil top right and verso, *Gate on the road | to Carisbrooke.*

PROVENANCE Agnew 1963.

24 'Dudley Castle', Staffordshire

The low, square ruin of the castle (recorded in the Domesday Survey) is on the right, over-looking an extensive view of a valley and distant hills.

Verso, slight pencil sketch of a man and dog sitting in a doorway.

Pen and ink with blue and grey wash: $5\frac{3}{4} \times 16\frac{7}{8}$ in (146 × 429 mm).

INSCRIBED recto as title in ink lower right and verso, *Dudley Castle* in a later hand.

PROVENANCE Colnaghi 1962.

25 'Dunmow'

A driver with a two-wheeled cart hauls a large timber beam against a background of a stone wall with gates.

Pen and ink and brown wash: $5\frac{3}{4} \times 3\frac{1}{2}$ in (146 × 89 mm), sight size.

INSCRIBED '*DUNMOW, in Essex. Flitch of Bacon – The claiming | of this celebrated reward for connubial bliss & happ[iness] | originated at Dunmow in Essex. Any Person going | thither to claim the flitch of [bacon] were required to kneel | upon 2 Stones placed at the Convent door – | and take upon themselves an Oath swearing that | they had lived together in the greatest harmony | for a given period – T Rowlandson*' in ink at foot of drawing in the artist's hand.

PROVENANCE Herbert L. Carlebach; John Fleming 1966.

It is difficult to understand the connection between the drawing and the Dunmow custom. It is obviously one of a series intended for a publication which never materialised. Other examples are in the Huntington Library and the collection of Major L. M. Dent.

26 The South Gate, Exeter

A rapid sketch of the Gate seen from the street flanked with gabled houses and figures.

Pen and ink and wash: $5 \times 7\frac{1}{2}$ in (122 × 191 mm).

PROVENANCE Colnaghi 1965.

Another version is illustrated in Falk, 1949 facing p. 180, at that time Gilbert Davis Collection ($7 \times 9\frac{3}{4}$ in).

27 View on Exmoor

Two gentlemen and their ladies picnic among flat rocks on a promontory overlooking an estuary and a distant landscape. Their servants and horses remain respectfully a short distance away.

Pencil, pen and red ink and watercolour: $5\frac{5}{8} \times 9\frac{1}{4}$ in (143 × 235 mm).

PROVENANCE Benoni White; J. P. Heseltine; Agnew 1962.

A version of this is in the British Museum.

28 Hengar Wood, St Tudy, Cornwall

A farm bordered by woodland is centrally situated in a valley surrounded by high hills. A shepherd drives his flock along a road to the right.

Pen and ink and watercolour: $6\frac{3}{4} \times 10\frac{1}{4}$ in (172×260 mm).
PROVENANCE Spink 1966.

Mathew Michell, the banker friend of Rowlandson, owned Hengar House, which was six miles north of Bodmin. Michell was a Justice of the Peace and Deputy Lieutenant for Cornwall. Rowlandson frequently stayed in the house and made many drawings around the county.

A version of this is in the Huntington Library, Wark, 1975, no. 172 as *Farm in a hilly landscape*.

29 'The Woolpack at Hungerford, Berks'

A carrier's waggon drawn by six horses approaches in the foreground, passing a couple in a gig whose horse rears up in fright. A group with a donkey rest by the roadside on the right and in the background, mounted travellers are regaled outside the Woolpack Inn. High trees dominate the scene.

Pen and ink and watercolour: $7\frac{7}{8} \times 11$ in (197×280 mm).
INSCRIBED as title lower left and *Rowlandson 1796* lower right in ink.
PROVENANCE Dyson Perrins; R. J. Bailey; Spink 1962.
LITERATURE Oppé, 1923, p. 13, pl. 51.
EXHIBITED London, 39 Grosvenor Square, *British Country Life*, 1937, no. 504; V.M.F.A., Richmond, 1963, no. 427.

Colour plate

30 Valley of Stones, Lynton, Devon

At the foot of high, flat rocks a man harnesses four pack-horses in readiness for loading them with sacks. A steep incline runs diagonally through the rocks from the right.

Pen and ink (some red) and grey wash: $5\frac{5}{8} \times 9\frac{1}{4}$ in (143×236 mm).
INSCRIBED *Rowlandson* lower left and *North Coast Cornwall* lower right, in ink in the artist's hand.
PROVENANCE Sabin Galleries 1962.

Other views of the Valley of Stones are in the British Museum LB. 29–31.

31 Newbury Market Place, Berkshire

A large crowd threatens and jeers at a man locked in a pillory built above the columns of the Old Guildhall (then standing at the centre of the Market Place); on the left, a group stares up from outside the shop of *OBADIAH JENKINS CORN AND COAL DEALER*...; on the right, a potter and his family are unpacking their wares ready for sale.

Pen and ink and watercolour: $10 \times 15\frac{7}{8}$ in (254×403 mm).
INSCRIBED *NEW BERY BERKSHIRE* in ink lower left by the artist.
PROVENANCE Sir John Crompton; H. Jephson; Christie's 28 June 1963 lot 37 (ill.); Colnaghi 1963.

32 'Newport High Street', Isle of Wight

A panoramic view of the High Street on cattle-market day. From the left, soldiers converse outside a building, a horse is being sold among farmers, a man drives a sow and litter, two soldiers link arms with girls and men stand about a pen of sheep; on the extreme right, a drum-major and two drummers indicate the arrival of a military band.

Pen and ink and watercolour: $5\frac{1}{4} \times 18\frac{1}{4}$ in (133×463 mm).
INSCRIBED *Newport High Street* in pencil top left.
PROVENANCE Sir Bruce Ingram, sold Sotheby's 21 October 1964 lot 137; Colnaghi 1964.
LITERATURE Falk, 1949, ill. facing p. 189.

33 Norwich Market Place

A rapid sketch of the south-west aspect of the Market Square with St Peter Mancroft church tower in the upper left corner. Two stalls in the foreground show the small shelters occupied by the traders.

Verso, an interior, with two men by a fireside drinking and smoking long pipes and a woman taking a tray of food through a doorway in the background.

Pen and ink and grey wash (both); $5\frac{3}{8} \times 6\frac{3}{4}$ in (137×170 mm).

INSCRIBED recto, *Norwich* lower right and verso, *Rithes* lower right in ink.

PROVENANCE Walter Schatzki 1962.

34 'Plymouth Dock'

A naval officer and his wife, with porters and luggage, walk towards a crowd assembled for embarkation at the water's edge. The street is flanked by shops and houses alive with people; a woman selling oysters from a stall is prominent in the foreground. Two hulks and a three-masted ship are moored against a background of hills.

Pen and ink and watercolour: $6\frac{7}{8} \times 11\frac{5}{8}$ in (165×295 mm).

INSCRIBED *PLYMOUTH DOCK* lower left and *Rowlandson 1817* lower right by the artist.

PROVENANCE Colnaghi 1961.

35 Richmond Yorkshire

The market square, crowded with shoppers, tents, horses and carts has a background of Holy Trinity church, a stone drinking fountain and the Castle keep.

Pen and ink and watercolour: $8\frac{3}{4} \times 12\frac{5}{8}$ in (222×321 mm).

PROVENANCE Sold Sotheby's 24 November 1965 lot 52; Colnaghi 1965.

A slightly larger version of this was sold at Christie's 22 March 1966 inscribed *Richmond in Yorkshire* and dated 1818.

Holy Trinity church is now deconsecrated and used by the Green Howards for their Regimental Museum.

36 View of the Church and Village of St Cue, Cornwall

In the foreground a farm cart drawn by two horses and two oxen carries farm workers watched by a soldier and his family sitting on the ground to the left.

Pen and ink and watercolour: $6\frac{3}{4} \times 10\frac{1}{4}$ in (172×260 mm).

PROVENANCE Joseph Grego; Baskett & Day 1973.

EXHIBITED F. T. Sabin, *Thomas Rowlandson*, 1933, no. 62, pl. LXII.

Engraved for Ackermann's *Views of Cornwall*, 1812; Grego, II, p. 244 ill.

Another version is in the collection of General Sir John Anderson, Ballyhossett, N. Ireland.

37 'Sandown Fort,' Isle of Wight

The low-built fort facing the sea and surrounded by a dry moat, is armed with cannons and flies the flag. Figures on the shore and a small sailing boat are sketched in lightly and Bembridge headland stands beyond.

Pen and ink and watercolour: $4\frac{3}{4} \times 17\frac{1}{8}$ in (120×435 mm) on two conjoined sheets.

INSCRIBED *Sandown Fort* in pencil upper right.

PROVENANCE W. Littleton; F. T. Sabin 1963.

Sandown Fort, built on the site of an ancient castle, was one of several fortifications on the Isle of Wight ordered by the Commonwealth Parliament as a precaution against the landing of Prince Charles (later Charles II). It was demolished earlier this century.

38 Southampton, The Watergate and Globe Inn

Outside the Globe Inn, which adjoins the archway, three men are trundling barrels while another appears from the doorway. In front of the archway, a timber waggon stands emptied of its load, which rests against the wall.

Verso, a page of a diary reading:

we supd upon a crab which we / brought from Steephill and went to / Bed – / Tuesday. The Angelo family and / ourselves – went out to fish for / whitings – but were unsuccessful / we returned about five to dinner / at our House – owing to the / Cooks negligence we did not get / our dinner till almost seven / I paid for Fowls. 0.3.0. greens etc / 0.1.0 – Shrimps *everyday* 1.8$^{s\ d}$ / the dinner consisted of venison & / a chicken pie from Rogers at /Southampton – after dinner / we walked by moonlight & found it / delightfully pleasant – / Wednesday – / we all set out at nine o clock to / fish at Hurst. poor Mrs. W. and / my dear child were left behind / owing to their fears of the water – / we had a dashing passage. to Hurst / but when we arrived there had / some hauls for fish and were / successful enough to get sufficient / for our dinner and some to bring home / I paid 19s the Bill and 0.10.6 / for the net and mens assistance / we met Captain Terry at Hurst / who invited us to come and see / him – we saluted him on our / return

Pen and ink and grey wash: 5 × 9 in (127 × 229 mm) squared in pencil.
PROVENANCE Iolo A. Williams; Colnaghi 1964.
The drawing must have been done before 1800 as after that date some structural work was attempted on the Tower and Gateway which resulted in the later demolition of the Gateway. The left-hand tower survives in a ruined state.

39 Tintagel Castle, Cornwall

The square tower of the castle ruin, built on a high rugged cliff, is observed from the boulder-strewn shore. The tower, although more faintly drawn than the massive rocks, dominates the composition.
Pencil and watercolour: 9½ × 12 in (241 × 305 mm), on old lined mount.
PROVENANCE Iolo A. Williams; Colnaghi 1964.

40 'The Undercliff, Steephill', Isle of Wight

A stretch of the shore at the Undercliff showing boulders and jagged rocks with the sea on the left.
Verso, Two soldiers in plumed hats, a sailing boat and a seated man, in faint pencil.
Pencil and watercolour: 4¾ × 17⅛ in (120 × 435 mm) on two conjoined sheets.
INSCRIBED *Undercliff Steephill* in pencil top left.
PROVENANCE W. Littleton; F. T. Sabin 1963.

41 'Carnarvon Castle, North Wales'

A detailed panoramic view with the castle high on the left overlooking the lower walls, town and distant sea. In the left corner women are seated in the meadow, busily sewing and knitting.
Pen and ink and watercolour: 5⅝ × 16 in (134 × 406 mm).

INSCRIBED as title in ink lower left in the artist's hand.
PROVENANCE John Mitchell & Son 1962.
AQUATINTED for *A Tour of North and South Wales*, 1800, published by W. Wigstead, facing p. 30.

42 Caernarvon Castle, Entrance to a Tower

A side view of the castle entrance between two crenellated round towers. Steps lead to the shore and a group of figures. Beached fishing craft and distant hills form the background.
Pen and ink and watercolour: $4\frac{5}{8} \times 7\frac{5}{8}$ in (118×190 mm).
PROVENANCE Edward Marshall, sold Sotheby's 3 May, 1961 lot 58; Colnaghi 1961.

A finished version of this is in Leeds Museum & Art Gallery.

43 Falls on the River Conway, North Wales

In a hilly landscape, a farm cart with four horses followed by a horseman progresses up a steep road overlooking the falls on the left. Two women passengers sit on sacks in the cart.
Pen and ink and watercolour $7\frac{3}{4} \times 11\frac{1}{4}$ in (197×290 mm).
PROVENANCE Colnaghi 1964.

44 'Entrance to Festiniog', Wales

A panoramic view of mountains and wooded valleys. Snowdon is high on the left and on the right, a horseman is driving cattle up a steep road towards a farm.
Pen and ink and watercolour: $5\frac{5}{8} \times 16\frac{3}{8}$ in (142×415 mm).
INSCRIBED *Entrance to Festiniog* in ink, lower left, in the artist's hand.
PROVENANCE Dr J. Percy (Lugt 1504, on verso); F. T. Sabin 1964.
Aquatinted for *A Tour in North and South Wales*, published by W. Wigstead, 1800, facing p. 39.
LITERATURE Hayes 1972, p. 159, pl. 94 as *Mountainous Landscape*.

45 'Giant's Causeway', Antrim, Ireland

A view looking down on the columnar basalt rocks and the path through them. Three figures are climbing the section on the left. Beyond is a background of sea, cliffs and small figures.
Pen and ink and watercolour: $5\frac{3}{4} \times 9\frac{1}{4}$ in (146×235 mm).
INSCRIBED *Giants Causeway* in ink, lower right, by the artist.
PROVENANCE Iolo A. Williams; Colnaghi 1964.

46 'The Customs House at Boulogne'

A party arriving at the courtyard of the Customs House. A sign over one doorway advertises *Bureau de France*. A portly man is remonstrating with angry douaniers who are examining the contents of a large trunk. A weary family looks on at the argument and a man-servant sits on the ground, yawning. On the left is a baggage cart with two emaciated horses held by a disconsolate man.
Verso, slight pencil sketch of a coach and a carriage with a background of buildings.
Pen and ink and watercolour: $8 \times 11\frac{1}{2}$ in (203×294 mm).
INSCRIBED recto, as title in ink lower centre and verso, *The Customs House at Boulogne* lower centre and £9.19.6 lower right.
PROVENANCE Baskett & Day 1972.
EXHIBITED Yale Center, *Pursuit of Happiness*, 1977, no. 31.

47 The Ivory Coast, West Africa

Natives are about to launch a boat to carry products out to two sailing ships in the distance. A woman with two children carries a large basket of exotic fruits on her head and a man stands by the boat with a huge tusk on his shoulder. Two coconut trees on the left sway over the scene, and across the bay lies an extensive kraal.

Pen and ink and watercolour: 14¾ × 21 in (375 × 533 mm).

PROVENANCE Dr J. Percy; Randall Davies, sold Sotheby's 12 February 1947 lot 350; Maas Gallery 1964.

EXHIBITED Paris, Musée des Arts Decoratifs, *Caricatures et Moeurs Anglaises 1750–1850*, 1938, no. 88.

48 'View of the Market Place at Juliers in Westphalia'

The three sides of the town square seen here show an array of impressive buildings. The only market activity which seems to be taking place is in the lower right corner. Otherwise, a religious atmosphere prevails with a procession headed by priests walking across the square and a group kneeling before a calvary on the left.

Pen and ink and watercolour: 12¼ × 21 in (311 × 533 mm).

INSCRIBED in ink below drawing in the artist's hand *VIEW OF THE MARKET PLACE AT JULIERS IN WESTPHALIA, | The dutchy [sic] of Juliers is situated between the Maase and the Rhine and bounded by the Prussian Guilderland on the north, | by the electorate of Triers on the south, by the electorate of Cologne on the east, and by the netherlands on the west, being | about 60 Miles long, and 30 broad. This is a very plentiful country, abounding in corn, cattle and fine meadows, and is | plentifully supplied with wood, but is remarkable principally for a fine breed of horses, and wood for drying which is | gathered here in abundance. The Chief Towns are, Juliers, Aix la Chappelle, Durn, Munster, Bedbur, Wasenberg and Lanterns*: and *Rowlandson 1791* in ink lower right.

PROVENANCE Desmond Coke; Harcourt Johnson; J. Leslie Wright, Christie's 22 February 1966 lot 169(ill.); Dr R. E. Hemphill; Colnaghi 1966.

LITERATURE Oppé 1923, p. 14, pl. 33; Desmond Coke, *Confessions of an Incurable Collector* 1928, pl. 26; Hayes, 1972, p. 19.

EXHIBITED Leamington Spa Art Gallery, n.d.

The town of Juliers, now Jülich, is situated some thirty miles west of Cologne. It has at various times been occupied by the Romans, Dutch, and the Spanish, and was in French hands up to 1814. It ranked as a fortress from the seventeenth century until 1860, and was an area of battle between the Americans and Germans in 1945.

Rowlandson's date of 1791, inscribed on the drawing, is unreliable as the French did not occupy the town until 1794, when its name was francized to Juliers.

49 Limbourg, Belgium

In the foreground, a carriage resembling a double sedan is leaving a stone bridge and entering the town through an arch bearing the city arms. Two soldiers by the parapet observe three women on the right, who are pushing a small cart. In the background is a distant coach, church spires and the Town Hall.

Pen and ink and watercolour: 5⅞ × 9½ in (150 × 242 mm).

INSCRIBED verso, *Entrance of St Trons, near Tongres, Limbourg, Flanders* in pencil.

PROVENANCE Lord Radcliffe, sold Christie's 27 April 1965 lot 82; Colnaghi 1965.

50 A Group of Trees

A study of tall trees in full leaf.

Pen and ink and watercolour: $10\frac{3}{4} \times 16$ in (373×406 mm).
PROVENANCE The Earl of Dysart; Gilbert Davis (Lugt 757a); Maas Gallery 1963.

A similar drawing of trees, *Through the Woods*, is in the Boston Museum of Fine Arts.

51 Visitors Inspecting Abbey Ruins

On the right of the composition a gentleman points out features of the ruins to two ladies. A peasant sits against one of the ruined walls and several women and children from the nearby cottages look on.
Pen and ink and watercolour: $5\frac{1}{2} \times 9\frac{7}{8}$ in (140×248 mm).
PROVENANCE Lord Radcliffe, sold Christie's 27 April 1965 lot 68; Colnaghi 1965.

52 Fruit or Nut Picking

In a tree-lined lane, groups of young men and girls are happily plucking from trees and filling baskets, while other couples sit on the ground in romantic postures.
Pen and ink and watercolour: $4\frac{1}{8} \times 6\frac{1}{2}$ in (105×165 mm).
INSCRIBED *Rowlandson* in ink lower left.
PROVENANCE Maas Gallery 1964.

53 The Picnic

A convivial group of soldiers and young women occupy a wooded glade. Foremost is a semi-recumbent soldier drinking with a girl, his musket and drum beside him. On the right, a couple embrace in a light-hearted fashion.
Pen and ink and watercolour: $11 \times 16\frac{1}{2}$ in (280×420 mm).
INSCRIBED *Rowlandson 1798* in ink lower right, in the artist's hand.
PROVENANCE George, Fifth Duke of Gordon; Elizabeth, Duchess of Gordon; The Brodie of Brodie; Agnew 1962.
LITERATURE Paulson, 1972, p. 32, ill. 28.
EXHIBITED V.M.F.A., Richmond, 1963, no. 429; Colnaghi & Yale 1964/65 no. 27 (ill.); P. M. L. and R. A., 1972/73, no. 73.

54 A Summer Idyll

Against the background of a Gothic chapel set in sylvan surroundings, a Watteau-esque party of two damsels and their escorts sit and read from a book. One of the young men is playing a flute and a dog listens in rapt attention. Sheep graze contentedly to the left of the group.
Pen and ink and watercolour: $8\frac{1}{2} \times 11$ in (215×279 mm).
PROVENANCE Mrs Gilbert Miller, sold Sotheby's 19 March 1970, lot 27 (ill.); John Baskett 1970.

55 The Angling Party

By a fast-moving river in a wooded landscape, a young couple stand beneath a tree conversing while they fish. At their feet, a girl reclines on the bank watching her line while her companion reads at her side.
Pen and ink and watercolour: $6\frac{7}{8} \times 10\frac{1}{8}$ in (175×257 mm).
PROVENANCE Christie's 28 June 1963, lot 8; Colnaghi 1963.

Another version is in the Huntington Library, Wark, 1975, no. 186.

56 Bathers in a Landscape

By a river swiftly flowing through a wood four nude women bathers are grouped in classical attitudes on a bank.

Pen and ink (some red) and watercolour: $6 \times 9\frac{5}{8}$ in (152×244 mm).

PROVENANCE Colnaghi 1964.

57 A Rural Scene by a River

A bridge curves round to a road leading to a hostelry (?) on the left of the picture. Groups of rustics talk and a ferryman fixes an oar in preparation for crossing the river, overlooked by a man leaning on the parapet of the bridge.

Pen and ink and watercolour: $5\frac{5}{8} \times 9$ in (143×229 mm).

INSCRIBED *Rowlandson 1818* in ink lower left.

PROVENANCE Herbert L. Carlebach; John Fleming 1966.

58 Figures by a Ferry

A peaceful scene on a winding river with wooded banks. Two women are seated in a punt while a man with a basket is about to step aboard. Other figures, including a man with a wheelbarrow, are nearby.

Pen and ink and watercolour: $4\frac{1}{4} \times 7\frac{5}{16}$ in (115×186 mm).

PROVENANCE Edward Marshall, sold Sotheby's 3 May 1961, lot 43; Colnaghi 1961.

59 River Scene with Small Boats

A high, wooded bank overlooks a house and a narrow river. A traveller asks directions from people in the doorway and two small sailing boats are about to turn the bend in the river.

Pen and ink and watercolour: $5\frac{1}{2} \times 9$ in (140×230 mm).

INSCRIBED verso, *View in Devon* and *A River Party* in pencil in a later hand.

PROVENANCE F. T. Sabin 1964.

60 A High Waterfall

Flanked by rocky banks and trees, the water flows down centrally from the top of the composition to a foreground of boulders.

Verso, colour splashes.

Pen and ink and watercolour: $8\frac{3}{4} \times 12\frac{1}{2}$ in (222×317 mm).

INSCRIBED *Rowlandson 1822* in ink lower right in the artist's hand.

PROVENANCE George, Fifth Duke of Gordon; Elizabeth, Duchess of Gordon; The Brodie of Brodie; Agnew 1962.

61 River Landscape with a Waterfall

A river flows from distant background hills, passing a house on the left, to fall between two clefts in the foreground rocks. Heavy boulders and trees line the banks.

Pen and ink and watercolour: $5\frac{3}{4} \times 8\frac{3}{8}$ in (145×212 mm).

INSCRIBED verso, . . . *Bottom*.

PROVENANCE Desmond Coke; Martin Hardie; Colnaghi 1961.

EXHIBITED V.M.F.A., Richmond, 1963, no. 418 (ill.).

62 A Water-Wheel Driving a Transporter

A large, broad water-wheel drives a primitive transporting system across a swiftly-flowing

river. In the foreground, two men and several donkeys wearing pack-saddles have forded the river. This type of pack-saddle was used to carry slate and culm from Barnstaple and Bideford in Devon.

Verso, a study for *A Sailor's Farewell*: a well-armed young sailor is bidding farewell to his father and his mother, who has her arm about his shoulder. His horse and the figure of a young girl are pencilled in faintly. The family dog looks on at the scene.

Pen and ink and watercolour: $11\frac{1}{4} \times 18\frac{1}{4}$ in (285×464 mm).

PROVENANCE L. G. Duke (D.386); Colnaghi 1961.

EXHIBITED London, 39 Grosvenor Square, *British Country Life*, 1937, no. 514; Midlands Federation of Museums & Galleries, 1951; Art Exhibitions Bureau, 1952.

63 River Scene (The Thames at Eton?)

A building in vague outline on the far bank, a barge in sail loaded with timber (possibly bound for boat-building yards at Reading) and a rowing skiff, all suggest a view near Eton. A woman tends a flock of sheep on the nearside bank to the right.

Pen and red ink and watercolour: $6\frac{1}{4} \times 9\frac{1}{8}$ in (160×232 mm).

PROVENANCE L. G. Duke (D.352); Colnaghi 1961.

64 Pleasure Boats in an Estuary

In the foreground the oarsman of a dinghy rests his oars while he waits for a group of trippers to disembark from a small sailing vessel behind him. Three small craft make way under sail on the right, while in the left background a two-masted vessel lies with sails stowed.

Pen and red ink and watercolour: $4\frac{3}{4} \times 9$ in (120×230 mm).

PROVENANCE Colnaghi 1961.

Another version is in the Metropolitan Museum of Art, New York.

65 Selling Fish on a Beach

Fishermen unload their catch from rowing-boats to sell on the shore, lower right. Several boats sail seawards, skirting an island with a fortress in the centre background.

Verso, colour splashes.

Pen and ink and watercolour: $5\frac{5}{8} \times 9$ in (142×230 mm).

PROVENANCE Max Saffron, Princeton; Agnew 1966.

66 'Mr and Mrs Jolly at their Country House'

The portly Mr Jolly stands smoking a churchwarden and gazing at his chickens while his wife, her son and daughter beside her, rests under a tree. In the background, their house with its shuttered windows stands behind a post and rail fence and a groom un-harnesses a horse from their gig. Pigs, a dog in its kennel and a servant girl complete the scene.

Pen and ink and watercolour: $5\frac{7}{8} \times 9\frac{1}{4}$ in (149×236 mm).

INSCRIBED as title in ink, lower centre in the artist's hand.

PROVENANCE W. Eastland; Agnew 1971.

ENGRAVED with many variations in *The World in Miniature* 1816, pl. 32. Grego II, p. 312.

Similar in subject to *Farmer Gillett of Brize-Norton* in the Huntington Library, Wark, 1975, no. 32.

67 A Village Scene with Peasants Resting

A peasant holding a basket and a sack over his shoulder talks to a group of young women in

front of a cottage door. A cat sits on the projecting roof and a caged bird hangs above the door. On the right a young man consorts with two women and in the street beyond figures are driving cattle.

Pen and ink and watercolour: $8\frac{5}{8} \times 11$ in (218×298 mm).

PROVENANCE Davis Galleries, New York, 1967.

68 A Village Scene Outside a Church

On the left a clergyman addresses a group of young ladies. To his right a man and his wife are mounted on a grey horse, a peasant drives some pigs, and a number of yokels chat with girls. In the background a man stands on scaffolding effecting repairs to a church; houses and an inn are lightly indicated.

Pen and ink and watercolour: $7\frac{3}{8} \times 10\frac{1}{8}$ in (186×256 mm).

PROVENANCE Agnew 1971.

69 A Village Fountain

A stone fountain with a square trough is supplied by water flowing from the head of an ornamental lion. On the right, cattle are watering while two drovers stand by. Villagers, with pitchers filled, are gossiping on the left.

Pen and ink and watercolour: $4\frac{3}{8} \times 7\frac{1}{8}$ in (110×190 mm).

INSCRIBED *T. Rowlandson* in ink lower right.

PROVENANCE Herbert L. Carlebach; John Fleming 1966.

70 Village Street Scene with Girls Spinning

Three girls work at spinning wheels outside a row of houses on the left, and a pedlar holds up a watch temptingly to a man. On the right, a group includes a young man embracing an outraged girl while, from the window above, an angry father remonstrates.

Pen and ink and grey wash: $13\frac{3}{8} \times 19$ in (340×482 mm).

INSCRIBED verso, *A Village Scene in Cornwall Dec E E bt. of Rowlandson* and a sum, in ink.

PROVENANCE G. D. Lockett; Agnew; L. G. Duke (D.1384); Colnaghi 1961.

71 A Village Street Scene with Cattle

A herdsman drives cattle and trails his pack-horse, accompanied by his family, into a village street. On the left, an inn has a sign-board of a running horse; people, horses and a loaded cart are grouped variously.

Pen and ink and watercolour: $3\frac{1}{2} \times 5\frac{3}{4}$ in (90×145 mm), sight size.

INSCRIBED *T. Rowlandson* in ink lower left.

PROVENANCE Herbert L. Carlebach; John Fleming 1966.

72 The Woolpack Inn

Two horsemen are talking and drinking with men grouped around the inn signpost. Above the door, a board advertises the strong ale *STING'O*. On the left a woman loads a donkey behind three routing pigs and on the right is a square church tower and some cottages.

Pen and red ink and grey wash: $4\frac{3}{4} \times 6\frac{1}{8}$ in (120×155 mm).

PROVENANCE Edward Marshall, sold Sotheby's 3 May 1961, lot 52; Colnaghi 1961.

73 Scene Outside an Inn

Travellers on horseback arrive with luggage at an inn on the right while on the left, a man

drives pigs past a woman loading a covered waggon and a group of people converse. A background of trees and houses.

Pen and ink and watercolour: $7\frac{1}{8} \times 10\frac{3}{8}$ in (181×263 mm).

PROVENANCE Geoffrey Philcox; Manning Galleries 1971.

ENGRAVED by the artist for *The World in Miniature*, 1816, pl. 27 with variations; Grego II, p. 312.

74 'The Waggoner's Rest'

A waggoner holding a lantern and whip guides an elderly man, arm in arm with a woman carrying a reticule, towards the lighted doorway of an inn. They are followed by another woman and a soldier with a drum on his back. The waggoner's mate leads four cart-horses into an adjoining stable. The moon shines overhead.

Pen and ink and watercolour: $5\frac{7}{8} \times 9\frac{1}{2}$ in (150×235 mm).

INSCRIBED as title in pencil below drawing.

PROVENANCE Gilbert Davis; John Baskett 1970.

75 Enquiring the Way

A man on horseback sits facing right balancing a basket on his horse's withers while a woman in a mob cap directs him with outstretched arm. On the left a gabled building is sketched in.

Pen and ink and watercolour: $7 \times 7\frac{3}{4}$ in (178×197 mm).

PROVENANCE L. G. Duke; Iolo A. Williams; Colnaghi 1964.

76 A Fair in the Country

Numerous groups of people buying and selling cattle, sheep, pigs, grain etc. are dispersed on a hillside. In the foreground, a girl directs the attention of her seated companion towards a man on the right who stands beside his donkey holding up his wares.

Pen and ink and watercolour: $5\frac{3}{8} \times 9\frac{3}{8}$ in (137×237 mm).

PROVENANCE L. S. Deglatigny (Lugt 1768a), sold Sotheby's 11 May 1938, lot 154; Knoedler 1951.

Another version, then in the collection of Gilbert Davis, is illustrated in Bury, 1949, no. 48.

77 A Road by a Farm

A large farm, with the farmer at the gate talking to a woman and a small boy, is being passed by a mounted drover with cattle and a farm hand.

Verso, pencil sketch of a couple in a phaeton with a figure on the left and a background of trees.

Pen and ink and watercolour: $5\frac{5}{8} \times 9\frac{1}{8}$ in. (142×232 mm).

PROVENANCE Edward Marshall, sold Sotheby's 3 May 1961, lot 49; Colnaghi 1961.

78 Harvesters Setting Out

A party of farm workers in high spirits, with two girls brandishing sickles, are walking away from their cottages, seen on the right. Beyond lies a valley and distant hills.

Pen and ink and watercolour: $9\frac{1}{8} \times 14\frac{7}{8}$ in (232×380 mm).

PROVENANCE Agnew 1972.

Another version, of similar dimensions, is in the Boston Museum of Fine Arts.

79 The Farmyard

Groups of horses, pigs, cows and chickens are gathered in front of thatched stalls and barns.
On the left a man carries a saddle towards a doorway.
Verso, a faint sketch of a man.
Pen and ink and watercolour: $5\frac{5}{8} \times 8\frac{7}{8}$ in (143×226 mm).
PROVENANCE Colnaghi 1965.

80 Ploughing

A man guides the ploughshare towards the right while a woman urges on a team of four horses
with a stick. In the right foreground, a dog barks at a small child holding a cask. A second
ploughing team is seen in the distant background.
Pen and ink and watercolour: $7 \times 5\frac{3}{8}$ in (178×137 mm).
PROVENANCE Colnaghi 1968.

81 'The Hedger and Ditcher'

A labourer wields a shovel in a ditch while above him, a mounted farmer watches his exertions.
Pen and ink and watercolour: $6\frac{3}{4} \times 4\frac{1}{2}$ in (172×115 mm).
INSCRIBED as title lower left by the artist and *T. Rowlandson* lower right by another hand.
PROVENANCE H. S. Reitlinger (Lugt 2274a); L. G. Duke (D.3115); Colnaghi 1961.

82 Labourers at Rest

Four men and a woman are seated at the foot of a tree. Two of the men rest their heads wearily
in their arms and another dozes in an upright position while a dog sleeps at his feet.
Pen and ink and watercolour: $5\frac{3}{8} \times 8\frac{1}{4}$ in (135×210 mm).
PROVENANCE Gilbert Davis (Lugt 757a); Colnaghi 1961.
EXHIBITED N.G. of A., Washington, 1962, no. 67 as *Country Folk Resting*; V.M.F.A., Richmond
1963, no. 416 as *Travellers Resting*.

83 The Woodcutter's Picnic

Grouped on the right, two couples and a child refresh themselves from a basket of food and a
cask of ale. Bundles of faggots are piled nearby and a swift stream flows through the wooded
scene.
Pen and red ink and watercolour: $10\frac{1}{4} \times 14\frac{1}{2}$ in (260×368 mm).
PROVENANCE Maas Gallery 1963.
LITERATURE Falk, 1949, facing p. 204 as *The Faggot Gatherers*.

84 Harvesters Resting in a Cornfield

A convivial party of farm workers, regaling themselves among corn-stooks, overlook a wooded
valley with several houses.
Pen and red ink and watercolour: $8\frac{1}{8} \times 11\frac{1}{4}$ in (206×285 mm).
PROVENANCE C. F. Huth; C. R. Carter, sold Sotheby's 19 November 1970, lot 125 (ill.); John
Baskett 1970.

85 Gypsies Cooking on an Open Fire

Beside a wooden fence two men and four women, one holding a baby, are cooking over a fire.
Pen and ink and watercolour: $6 \times 4\frac{1}{2}$ in (152×121 mm).

PROVENANCE Dr Morris Saffron, sold Christie's 27 April 1965, lot 28; Colnaghi 1965.

This group was used by Rowlandson for a detail in *Bagshot Heath*, illustrated R. H. Wilenski, *English Painting*, 1933, p. 173, pl. 94b.

86 A Potter Returning from Market

A potter with his wife and five children, followed by a donkey laden with crocks, walk through a stream to the left.
Pen and ink and watercolour: $8\frac{3}{4} \times 11\frac{1}{4}$ in (222×285 mm).
PROVENANCE Lord Clwyd; Wakefield-Young; Sawyer 1966.

87 Netting a Salmon Pool in a Wooded River

On the left a fisherman holding a rod directs two others who are dragging the river bottom with a net. On the right bank two young women with baskets look on. The background is densely wooded.
Pen and ink and watercolour: $6\frac{1}{2} \times 10\frac{1}{8}$ in (165×257 mm).
INSCRIBED *T. Rowlandson* in ink lower left.
PROVENANCE Mrs Gilbert Miller, sold Sotheby's 19 March 1970, lot 22 (ill.); John Baskett 1970.
ENGRAVED by the artist for *The World in Miniature*, 1816, pl. 37; Grego II, pp. 312, 405.

88 'Mother Bundle in a Rage or Too Late for the Stage'

A crowded stage-coach, disappearing at speed out of the picture, is chased in vain by a man on behalf of the stranded Mother Bundle. She stands at her gate, loaded with packages and an umbrella, glaring angrily at the departing coach.
Verso, pencil sketch of two figures and sums.
Pen and ink and watercolour: $4\frac{1}{2} \times 7$ in (114×178 mm).
INSCRIBED as title in ink lower centre in the artist's hand.
PROVENANCE Colnaghi 1961.
ENGRAVED as *Mrs Bundle in a rage* etc. published by R. Ackermann, 1 February 1809.

89 A Carrier's Waggon

A four-horse team has just been changed on a heavy waggon with a load of wool sacks. It stands in front of a cottage while travellers climb down a ladder into the road. On the left, a woman and a child draw water from a well under trees.
Pen over pencil and watercolour: 10×15 in. (254×381 mm).
PROVENANCE Gilbert Davis; John Baskett 1970.
LITERATURE Hayes, 1972, p. 171, pl. 107.
EXHIBITED Tokyo, National Museum of Western Art, 1970, and Kyoto, National Museum of Modern Art, *English Landscape Painting of the Eighteenth and Nineteenth Centuries*, 1971, no. 83 (ill.).

90 Loading a Waggon

A waggon harnessed to two draught horses is being loaded with sacks from a wheelbarrow. A man stands astride the load and behind him is a Dutch barn. Two men converse in front of a house on the left.
Pen and red ink: $8\frac{1}{8} \times 12\frac{1}{8}$ in (206×308 mm).
PROVENANCE Manning Galleries 1968.

91 The Baggage Waggon

A covered waggon and team are drawn up outside a cottage. On the right two men stand talking to a third on horseback, watched by a dog. In the background stands a house surrounded by trees.

Pen and ink and watercolour: $3\frac{1}{2} \times 6\frac{1}{8}$ in (90 × 156 mm).

PROVENANCE L. G. Duke (D.695); Colnaghi 1961.

92 Going to Market

Along a country lane, a farmer on horseback follows a two-wheeled haycart carrying farm workers. Other workers walk in the same direction.

Verso, extensive colour splashes and indecipherable writing.

Pen and ink and watercolour: $5\frac{1}{2} \times 8\frac{5}{8}$ in. (140 × 220 mm).

INSCRIBED *T. Rowlandson* in ink lower right.

PROVENANCE L. G. Duke (D.394); Colnaghi 1961.

EXHIBITED London, 39 Grosvenor Square, *British Country Life*, 1937, no. 523; London, South London Art Gallery, *English Landscape*, 1951, no. 52.

93 Loading a Cart for Market

A farmer, loading his cart with vegetables, is helped by his wife bringing him a laden basket. Two children look out from the doorway of a cottage on the left. A river runs close by on the right.

Pen and ink and watercolour: $6\frac{3}{8} \times 9\frac{1}{4}$ in (162 × 235 mm).

INSCRIBED *T. Rowlandson* in ink lower left.

PROVENANCE Herbert L. Carlebach; John Fleming 1966.

94 A Potter Going Out

A man, helped by a woman, adjusts his earthenware pots to rest on straw in a cart. In the background is a row of cottages.

Verso, pencil drawing of a shipwreck by another hand.

Pen and ink and watercolour: $6 \times 9\frac{3}{8}$ in (152 × 240 mm).

PROVENANCE William Esdaile (Lugt 2617), purchased at the artist's sale, 1828 lot 101; Colnaghi 1964.

95 Loading Sacks into a Cart

Outside a cottage with a background of trees, a man standing on the shanks of his cart adjusts sacks being pushed towards him by a woman; a man in the doorway approaches carrying another sack. On the right, outside another cottage, two women and a third at the window watch with interest.

Pen and red ink and brown wash: $6\frac{5}{8} \times 9\frac{3}{4}$ in (169 × 248 mm).

PROVENANCE — Drake; L. G. Duke (D.64); Colnaghi 1961.

96 Loading Sand

Two labourers load sand on to a tumbril while a third rests by his pick and shovel. Three horses stand unharnessed nearby, and trees and a distant landscape form the background.

Pen and ink and watercolour: $10\frac{3}{4} \times 13\frac{1}{2}$ in (273 × 343 mm).

PROVENANCE Lord Radcliffe, sold Christie's 27 April 1965, lot 83; Colnaghi 1965.

97 A Waggonner

A draught horse is harnessed to a waggon loaded with sacks; two unharnessed horses, one a grey, are being led by a carter holding a stick.

Pen and ink and watercolour: $4\frac{3}{4} \times 6\frac{7}{8}$ in (120×175 mm).

PROVENANCE Edward Marshall, sold Sotheby's 3 May 1961, lot 51; Colnaghi 1961.

ENGRAVED by Rowlandson in 1784 and published by E. Jackson in '*The Rhedarium*'; Grego I, p. 101

EXHIBITED N.G. of A., Washington, 1962, no. 63 as '*A Carter*'.

98 A Timber Waggon

Three horses draw a timber waggon towards the right along a wooded path. The drover grasps the bridle of the leading horse and threatens it with a raised stick. His companion is seated astride a load of timber on the waggon, his stick resting on his shoulder.

Pen and ink and grey wash: $4\frac{1}{2} \times 7\frac{1}{4}$ in (115×185 mm).

INSCRIBED *Rowlandson* in ink lower right.

PROVENANCE George, Fifth Duke of Gordon; Elizabeth, Duchess of Gordon; The Brodie of Brodie; Agnew 192.

ENGRAVED in reverse as pl. 5 of the separate *Sheets of Picturesque Etchings*, published 18 June 1790, and included in a volume of 16 plates entitled *Rowlandson's Outlines*, published by Fores in 1792.

LITERATURE Paulson, 1972, p. 30, ill. 26; Hayes, 1972, p. 167, pl. 102.

99 Cottage in a Forest Clearing

In the foreground to the cottage, three farm workers and a child stand by a loaded two-wheeled cart drawn by a tandem of horses.

Pen and ink and watercolour: $4\frac{1}{2} \times 5\frac{1}{2}$ in. (115×140 mm).

PROVENANCE Edward Marshall, sold Sotheby's 3 May 1961, lot 56; Colnaghi 1961.

100 A Village in A Hilly Landscape

Farm workers on a cart drawn by oxen pass a group talking outside a cottage. In the background are distant mountains and a lake.

Pen and ink and watercolour: $9\frac{1}{8} \times 12\frac{1}{2}$ in (232×318 mm).

PROVENANCE L. G. Duke; Iolo A. Williams; Colnaghi 1964.

EXHIBITED I. A. Williams, Sheffield 1952, Aberystwyth 1953, Reading 1959 (no. 102 in each catalogue).

101 A Dead Horse on a Knacker's Cart

On the left, a carter bears away the carcass of a dead horse to the evident consternation of the owner, his wife and two children who stand at the cottage door. The family dog advances to sniff the horse's head which hangs over the side of the cart.

Pen and ink and watercolour: $3\frac{1}{2} \times 6$ in (89×152 mm).

PROVENANCE T. E. Lowinsky (Lugt 2420a); Justin Lowinsky 1963.

LITERATURE M. T. Ritchie, *English Drawings*, 1935, pl. 36.

A slight sketch for this is in the Huntington Library, Wark, 1975. no. 483.

102 'Four O'Clock in the Country'

The hunting enthusiast, yawning and attended by two hounds, pulls on a boot while his

attractive wife, still in her nightgown, pours him a cup of cordial. On the left, beside the bed, a baby sleeps in its cradle. Various accoutrements, including a French horn and several guns, are strewn about the room and a figure departs through the door on the right, bearing a saddle.

Pen and ink and watercolour: $9\frac{3}{8} \times 12\frac{1}{4}$ in (238×312 mm).

PROVENANCE Mrs C. Carr, sold Sotheby's 5 April 1973, lot 158 (ill.); Baskett & Day 1973.

ENGRAVED by the artist and published by S. W. Fores 20 October 1790 as a companion plate to *Four o'clock in the Town*; Grego I, pp. 281/282 (both prints are in the Collection).

Another version, signed and dated 1788, with background variations, is illustrated in Hayes, 1972, p. 123 pl. 59 and Falk, 1949, facing p. 96.

103 Breakfast Before The Hunt

Three men are gathered round a table; one carves a joint watched with interest by two hounds; another, yawning, pulls on a boot while the third drinks thirstily from a tankard. Another man leaves by an open door through which a mounted figure is seen waiting.

Pen and ink with brown and blue wash: 5×8 in (127×202 mm).

PROVENANCE Colnaghi 1963.

LITERATURE Hayes, 1972, p. 97, pl. 33 as *The Hunt Breakfast*.

Another version is in the collection of G. D. Lockett, Esq., The Clonterbrook Trust, Cheshire.

104 Drawing Cover

Three riders, a lady between two gentlemen, wait on the right while two hunt-servants draw cover with hounds on the left.

Pen and ink and watercolour: $3\frac{3}{16} \times 5\frac{9}{16}$ in. (81×141 mm).

INSCRIBED verso, *Rowlandson*.

PROVENANCE Maas Gallery 1964.

105 'How to Twist your Neck'

Two riders and a hound are coming out of a wood, riding towards the left. The woman bends down over the neck of her galloping mount after passing a low branch. Her less fortunate companion is struck under the chin by another low branch and despite the tight reins and forward thrust stirrups, he is about to part company with his horse.

Verso splashes and sums.

Pen and red ink and watercolour: $3\frac{7}{8} \times 5\frac{13}{16}$ in (98×147 mm).

PROVENANCE Maas Gallery 1963.

ENGRAVED with the above title in *Advice to Sportsmen* 1809 facing p. 6; Tooley, 407, 3, p. 6. Another version inscribed *How to become Chop fallen or fell timber on your own estate* is in Princeton University Library.

106 The Enraged Vicar

A stout parson on the left, his church and house in the background, throws up his hands in horror as fox and hounds race through his ornamental flower-beds and the field leaps into his garden in pursuit.

Pen and ink and watercolour: $5\frac{1}{16} \times 7\frac{5}{16}$ in. (128×186 mm).

PROVENANCE Gooden and Fox 1967.

ENGRAVED and published by Rowlandson 1 March 1807 (Grego II, pp. 66/67, ill.; with the field led by a lady, among other variations); also used in *Miseries of Human Life*, 1808 (etching

dated 1805) with a notice-board which reads 'Steel traps, Spring guns set in this garden';
B.M. Satires 10861.

107 The Kill

Hounds turn the fox over while three riders approach from the left, the middle one halloo-ing.
Pen and ink and watercolour: $4\frac{7}{16} \times 7\frac{1}{16}$ in (114 × 180 mm).
PROVENANCE Sabin Galleries 1962.

108 Full Cry

A pack of hounds give chase across a meadow to the right followed by six riders, one a lady, at
full gallop. In the centre of the composition are two trees and in the distance an estuary with
shipping.
Pen and ink and watercolour: $10 \times 13\frac{3}{8}$ in. (254 × 340 mm).
PROVENANCE Gloucester Collection 1956.

109 The Return from the Hunt

Riders and hounds are grouped before the balcony of a country house. On the left a servant helps
a rider to remove his boots and a man helps a lady to dismount. Two grooms are in attendence
while a rider holds up a dead hare to two ladies leaning over the balcony. In the right foreground
two kennel boys attend to the hounds and a mounted figure approaches.
Pen and ink and watercolour: $7\frac{5}{8} \times 11\frac{5}{8}$ in. (194 × 295 mm).
PROVENANCE Alfred E. Pearson, sold Sotheby's 12 July 1967 lot 213; Colnaghi 1967.
EXHIBITED Ellis & Smith, London, 1948, col. pl. on cover.

Another version is in Birmingham City Museum and Art Gallery (J. Leslie Wright Collection)
and is illustrated in Hayes, 1972, pl. 35 (in colour).

110 A Stag Hunt in the West Country

Hounds pursue a stag downhill and across a stream. The leading couples swim close behind the
stag as he gains the bank. On the left, riders follow the pack at full gallop.
Pen and ink and watercolour: $5\frac{1}{4} \times 9$ in (134 × 229 mm).
INSCRIBED *T. Rowlandson* in ink, lower left.
PROVENANCE Mrs Leon Jones, sold Sotheby's 10 March 1965 lot 56; Colnaghi 1965.

111 'Stag at Bay – Scene near Taplow, Berks.'

On the far left the stag turns, lowering his horns at the pursuing hounds as they rush at him across a
small pond within a wood. Eight horsemen, including a lady, approach from the right, several
raising their caps or crops in acclamation.
Pen and ink and watercolour: $16\frac{1}{4} \times 20\frac{5}{8}$ in (413 × 524 mm).
PROVENANCE Gloucester Collection 1956.
ENGRAVED with the title as above and published by R. Ackermann, 1801 in a series of four, the
other three titles being *Going out in the Morning | Scene in Windsor Forest; Fox Chase | Scene
near Maidenhead Thicket* and *Return from the Chase | Scene at Eaton* [sic] (all in the Collection).

112 A Stag Hunt in the Park of a Country House

The field gallops downhill to the left in front of a country house. They follow staghounds in full
cry pursuing a stag towards a river.

Pen and ink and watercolour: $10\frac{7}{8} \times 16\frac{7}{8}$ in. (277×428 mm).
PROVENANCE Miss B. K. Abbot, sold Sotheby's 19 November 1970 lot 168 (ill.); John Baskett 1970.

113 The Hunt Subscription

A laughing hunt secretary, with cap in hand, approaches an unwilling subscriber who rages silently behind a screen. A man and a woman are making stealthy departures in opposite directions.
Pen and ink and watercolour: $8\frac{1}{4} \times 12\frac{1}{2}$ in. (210×317 mm).
PROVENANCE L. G. Duke (D.2555); Colnaghi 1961.

114 The Prize Fight

The two bare-fisted contestants, backed by their seconds, face each other on a raised platform before a huge crowd. Carriages are drawn up on either side and spectators in a jostling throng struggle to see and urge on their fancies.
Pen and ink and watercolours $18\frac{1}{4} \times 27\frac{1}{2}$ in (463×698 mm).
INSCRIBED *T. Rowlandson 1787* in ink lower left by the artist.
PROVENANCE Arthur Reader 1960.
LITERATURE Hayes, 1972, p. 45, pl. 37.
EXHIBITED Bath, Victoria Art Gallery, *Art Treasures*, 1958, no. 283; Yale Center, *Pursuit of Happiness*, 1977, no. 156.

It is possible that this drawing represents the contest staged at Newmarket on 3 May 1786 in which Richard Humphries ('The Gentleman Boxer') defeated Samuel Martin ('The Bath Butcher'). The fight, for which the price of admission was one guinea, was attended by the Prince of Wales, the Duke of York and many members of the English and French aristocracy.

115 Henry Angelo and Madame Cain Fencing

Henry Angelo, wearing cross braces and tight-fitting breeches, thrusts while Madame Cain parries, in front of many spectators who sit or stand around them in a half-circle. A fireplace is partly delineated on the left and a doorway on the right.
Pen and ink and watercolour: $6\frac{3}{8} \times 9\frac{7}{8}$ in (162×250 mm).
INSCRIBED *Rowlandson* in pen lower left and pencil lower right and *Angelo* and *Madame Cain* below the figures.
PROVENANCE J. E. Huxtable; Mrs Pape; Colnaghi 1963.
F. T. Sabin exhibited another fencing composition in 1933 (no. 42 pl. XLII) which was inscribed by the artist *M*ᵐᵉ *Culloni* [sic] and *Mons. Renault Grand Assault, Paris*. In their 1948 exhibition, the same gallery showed a version with the background completed but the combatants were again described as 'M. Renault and *M*ᵐᵉ *Culleoni*' in the catalogue. These two versions have a much more English setting than that of Paris, so the identification of the protagonists as Henry Angelo and Madame Cain would seem more reasonable.

A larger version ($13\frac{1}{2} \times 20\frac{1}{4}$ in) is in the Cecil Higgins Museum, Bedford; another in the Frick Art Gallery is dated 1791 and a third was exhibited by Jocelyn Feilding in 1975.

116 The Annual Sculling Race for Doggett's Coat and Badge

Two competitors are seen in the foreground pulling on their oars while others are sketched in to their right. More than a dozen boats, packed with spectators rowing hard to keep up, accompany

them on the race. On the left, a single-masted vessel lying at anchor is crowded with people waving and shouting encouragement. On the far right is a bridge.

Pen and ink and watercolour: $5\frac{5}{8} \times 9\frac{3}{16}$ in (143 × 233 mm).

PROVENANCE Theodore Cook; Sir Clive Burn; Agnew 1962.

EXHIBITED V.M.F.A., Richmond, 1963, no. 430 (ill.).

The race takes place on 1 August every year between six young watermen, just out of their time (apprenticeship) and it used to start at the White Swan, London Bridge, finishing at the Swan Inn, Chelsea.

Thomas Doggett (d. 1721), actor, enthusiastic Whig and a strong supporter of the Hanoverian cause, gave the Coat (the Whig colour, orange) and the Badge (the white horse of Hanover). The race continues to the present day, the management of the funds left by Doggett being in the disposition of the Fishmongers' Company.

> 'Let your oars like lightning flog it
> Up the Thames as swiftly jog it,
> An' you'd win the prize of Doggett,
> The glory of the river.' (Traditional)

A slight sketch for this is in Princeton University Library, and the finish of the race is shown in a drawing in the British Museum.

117 A French Nobleman out Shooting

The figure, seen from behind in tricorne hat and queue-tailed wig, steps lightly holding his gun in his right hand. With his left he signals to his dog which is sketched in pencil to the left.

Pencil, pen and ink: $5\frac{3}{4} \times 5\frac{1}{2}$ in (147 × 140 mm).

INSCRIBED in pencil along the lower border, *A French Nobleman in his Shooting dress – sketched at Boulogne 1778.*

PROVENANCE Lord Farnham; Dyson Perrins; L. G. Duke (D.3575); Colnaghi 1961.

118 Skating on the Serpentine

On the left, two women with muffs lean forward to assist a man who is falling backwards on to a stout man lying, feet upwards, on the ice. In the centre two men grasping hands are circling on their skates. In the background is a stall for selling refreshments and hiring skates. In the right foreground a woman vendor has fallen on the ice, spilling her wares to the delight of two small boys.

Verso, small pen and ink sketch of ? *The Last Supper* $3\frac{1}{4} \times 2$ in (83 × 51 mm).

Pen and ink and brown wash: $8\frac{7}{8} \times 14\frac{3}{8}$ in (226 × 365 mm).

PROVENANCE L. G. Duke (D.592); Colnaghi 1960.

EXHIBITED V.M.F.A., Richmond 1963, no. 414.

Compositions for this subject are in the Museum of London (dated 1786) and the British Museum.

119 Captain Barclay's Rally Match – the Finish

The captain is walking towards the right in the centre of the composition. He is preceded by a man with a stick and followed by a row of men carrying a bar, while an unruly crowd surges behind them. In the left foreground a fat washerwoman with two companions sits swigging at a bottle and on the right a standing group looks on. A windmill and some booths lie in the background.

Pen and ink and watercolour: $5\frac{5}{8} \times 9\frac{1}{8}$ in (142×232 cm).
PROVENANCE Knoedler 1951.

The match, which took place on Newmarket Heath, is described in W. Thom, *Pedestrianism* published in 1813 at Aberdeen. Robert Barclay Allardice, generally known as Captain Barclay, wagered W. Wedderburn Webster 1,000 guineas that he would walk 1,000 miles in 1,000 successive hours. The rally match started on 1 June and finished at 3.37 p.m. on 12 July 1809, the Captain winning his bet.

Another version, with a companion *The Start* was exhibited at F. T. Sabin in 1933, no. 92 (ill.); a completely different composition of *The Finish* was exhibited at Ellis & Smith, 1948, no. 4 (ill.).

120 A Race on the Knavesmire at York

Five horses race towards the left against a background of spectators. The landscape, featuring the grandstand on the right, stretches to distant church towers on the left and, seen with no. 121 (below), gives a panorama of the whole race-course.
Pen and ink and watercolour: $8\frac{1}{2} \times 14$ in (216×356 mm).
INSCRIBED *Rowlandson* in ink lower right.
PROVENANCE Sir Bruce Ingram; *c.* 1963.

Another version is in the City of York Art Gallery. In *Preview* 108, October 1974 (the Gallery Quarterly) Michael Clarke, *Rowlandson and York Races*, gives an account of the race-course and lists nine scenes there by Rowlandson illustrating nos. 121 and 310.

121 Racing at York

The two-storied grandstand filled with racegoers is on the left at the far side of the course which is lined with temporary stands. Spectators, mounted or in carriages, are grouped behind the rails in front of which a jockey walks his horse up the course to the left.
Pen and ink and watercolour: $9\frac{1}{8} \times 14\frac{1}{2}$ in (230×367 mm).
PROVENANCE Davis Galleries, New York 1970.

Another version is in the Boston Museum of Fine Arts.

122 A Crowded Race Meeting

A clapboard, tile-roofed grandstand packed with people is seen from behind in the centre of the composition. On either side of it carriages line the course. Two mounted jockeys pass the grandstand and in the foreground several groups of racegoers are gathered in conversation.
Pen and ink and watercolour: $5\frac{3}{4} \times 9\frac{1}{2}$ in (146×242 mm).
PROVENANCE Charles Russell; Agnew 1961.
EXHIBITED N.G. of A., Washington, 1962, no. 60.

Another version is in the Museum of Art, Rhode Island School of Design, U.S.A.

123 A Race Meeting: the Finish of a Race

On the right a number of stands line the course all filled with spectators. Half a dozen jockeys race towards the finish while excited racegoers crowd onto the course. On the left a small number of onlookers, some outlined in pencil, are grouped near the rails.
Pencil, pen and brown ink: $7\frac{1}{8} \times 15\frac{5}{8}$ in (181×397 mm).
PROVENANCE Jocelyn Feilding 1973.

124 A Bookmaker and his Client outside the Ram Inn, Newmarket

The bookmaker stands on the left, writing down a bet in a notebook, while his client strikes an attitude to stress his instructions. On the wall above the bookmaker's head is a board inscribed *Ram Inn | Newmarket*.

Pen and ink and watercolour: $9\frac{7}{16} \times 7\frac{9}{16}$ in $(240 \times 192$ mm$)$.

INSCRIBED *Rowlandson* in ink lower left.

PROVENANCE Agnew 1963.

125 A Sporting Cove

A half-length portrait of a brutal-looking character with half-closed eyes and twisted smile. He wears his hat with its uneven brim at a rakish angle and his unbuttoned coat reveals a white neckcloth.

Verso, colour splashes.

Pen and ink and watercolour: $7\frac{3}{4} \times 5\frac{15}{16}$ in $(197 \times 151$ mm$)$.

PROVENANCE — Parsons; Thomas Girtin; Tom Girtin; John Baskett 1970.

EXHIBITED Royal Society of Arts, *Humorous Art*, n.d. no. 4.

The style of this drawing is similar to Rowlandson's portrait of Bob Kennett the forger in the British Museum.

126 The Riding School

The pupils are progressing clockwise around an indoor riding school. A rider in the foreground is having difficulty with his mount which has been upset by a small dog. Behind them the instructor smiles as a man hurries to get out of the way.

Verso, the subject traced in pencil.

Pen and red ink: $5\frac{9}{16} \times 8\frac{3}{8}$ in. $(141 \times 213$ mm$)$.

PROVENANCE L. G. Duke (D.1287); Colnaghi 1961.

Rowlandson copied the composition from Bunbury's *A Riding House*, etched by James Bretherton and published 15 February 1780.

A slight sketch of this subject is in Princeton University Library.

127 Three Illustration for H. W. Bunbury's ('Geoffrey Gambo') *An Academy for Grown Horsemen*

1 'One Way to Stop Your Horse'

A rider heaves on his reins to avoid collision with a passing coach. An alarmed lady passenger exclaims from the window, while the furious coachman brandishes his whip at the rider who raises a cudgel threateningly.

2 'A Bit of Blood'

A rider canters towards the left past a signpost. Mounted on a scraggy grey stallion, he carries a cudgel over his shoulder. In the background, the sea with two ships at anchor.

3 'How to Ride Genteel and Agreeable Downhill'

A rider controls his tired mount with pelham bit and martingale. He grasps the animal's mane to keep himself well back in his seat as he plods to the left down a slight incline, smiling at his success in not sliding forward.

Each pen and ink and watercolour: $2\frac{3}{4} \times 2\frac{3}{4}$ in $(70 \times 70$ mm$)$, on old lined mounts.

INSCRIBED each as title lower centre.

PROVENANCE Maas Gallery 1970.

Bunbury conceived the designs and Rowlandson etched the plates for 'Geoffrey Gambado's' light-hearted travesty on equitation entitled *An Academy for Grown Horsemen*, published in 1787.

128 How to Vault in the Saddle

A clergyman is suspended by his waist from the jib of an ornate crane attached to the wall of the rectory. Two girls standing in the doorway haul on the rope to keep the rector elevated. Beneath him stands his patient old nag held by a laughing groom on the left.

Pen and ink and watercolour: $10\frac{3}{4} \times 8\frac{1}{4}$ in (273 × 210 mm).

INSCRIBED *Rowlandson* lower left and as title lower right in ink.

PROVENANCE Dr Kiczales 1972.

ENGRAVED in reverse by Rowlandson and published with the above title 30 December 1813; Grego II, p. 265.

129 Two Men on Horseback seen from Behind

Two stout parties wearing tricorne hats spur on their horses in a mountainous landscape.

Pen and ink and watercolour: $5\frac{3}{4} \times 4\frac{7}{16}$ in (146 × 113 mm).

PROVENANCE Lady Jane Harriet Pleydell-Bouverie; William Ellice; Martin Hardie; Colnaghi 1963.

EXHIBITED V.M.F.A., Richmond, 1963 no. 421 as *Riders on a mountain*.

Other versions are in Huntington Library, Wark, 1975 no. 141 and Courtauld Institute, Sir Robert Witt Collection.

130 The Ride

A lady, seated side-saddle, canters across a meadow to the right, a dog running beside her. A stout gentleman in a tricorne hat and a groom follow her, both mounted on horses at the trot. Long shadows suggest early morning or evening. The pasture is bordered by trees, and a cottage lies to the right.

Verso, study of trees in pencil.

Pen and brown wash: $9 \times 7\frac{3}{8}$ in (228 × 187 mm).

PROVENANCE L. G. Duke (D.120); Colnaghi 1961.

EXHIBITED London, 39, Grosvenor Square, *British Country Life*, 1937, no. 522; Royal Academy *Old Master Drawings*, 1953, no. 224; N.G. of A., Washington, 1962, no. 61. (ill.); V.M.F.A., Richmond, 1963, no. 426.

Possibly a portion of a larger drawing.

131 Evading the Toll

In the centre, a rider leaps the six-bar gate with whip raised and a dog barking at his feet. On his left, two riders bridle back in surprise while on his right, the angry toll-keeper and his wife gesticulate fiercely. Above the tollhouse is a lamp and a notice inscribed *Toll Gate* showing the charges.

Pen and ink and watercolour: $6\frac{3}{8} \times 9\frac{1}{8}$ in (159 × 231 mm).

INSCRIBED *T. Rowlandson* in ink lower left.

PROVENANCE Colnaghi 1964.

132 Riding and Driving Mishaps

On the left, a mounted man holds the bridle of a horse which is rearing behind him, unseating its female rider; another gallant spurs on his horse while leaning over to support her from behind. In the centre of this frieze of misfortune, a rider holds his horse in check while behind him another struggles to prevent his horse from bolting. A couple in a gig moving in the opposite direction watch him as their horse rears up in between the shafts.

Pen and ink: $5\frac{1}{4} \times 15\frac{5}{8}$ in (134 × 397 mm), on two conjoined sheets.

INSCRIBED verso, *by Bunbury* in an early hand.

PROVENANCE Christie's 6 November 1973 lot 51; Baskett & Day 1973.

133 Horsemen Colliding

On the left an alarmed figure has lost his tricorne hat and is being launched forward by his bucking horse; behind him another rider struggles with his rearing mount while the tail of his wig is grabbed by a third whose horse has collapsed beneath him. On the right a leaping horse threatens to straddle the whole group. In the background a coachman and passengers on the roof of his coach look on.

Pen and ink and brown wash: $11\frac{3}{4} \times 18\frac{3}{4}$ in (298 × 476 mm).

PROVENANCE T. E. Lowinsky (Lugt 2420a); Justin Lowinsky 1963.

134 'The Ages of the Horse':

1 The Foal; 2 The Colt; 3 The Racer; 4 The Hunter; 5 The Post-Horse; 6 Food for the Hounds

Each in pencil: average size $2\frac{3}{4} \times 3\frac{7}{8}$ in (70 × 98 mm).

INSCRIBED as titles in pencil at foot of drawings.

PROVENANCE A gift to Paul Mellon from John and Rosemary Baskett 1964.

This theme, with its melancholy progress, was painted, drawn and engraved repeatedly at this period.

135 Mares and Foals in a Field

In the foreground nine mares and two foals are in various attitudes, grazing, rolling, and bucking. In the distance is a group of four more mares and, to the left, a cottage among trees.

Pen and ink and watercolour: $5\frac{9}{16} \times 9\frac{1}{8}$ in (141 × 232 mm).

PROVENANCE Edward Marshall; Sotheby's 3 May 1961 lot 50; Colnaghi 1961.

EXHIBITED N. G. of A., Washington, 1962, no. 64 as *Horses in a Field*.

136 Interior of a Stable

Four rugged-up horses are tethered in a row of straw-bedded stalls. Two men on the left converse with a groom while a grey turns on one of two dogs at the men's feet.

Pen and ink and watercolour: $5\frac{7}{8} \times 9\frac{3}{8}$ (150 × 237 mm).

PROVENANCE Colnaghi 1962.

The composition has been adapted by Rowlandson from an oil painting by James Seymour which is in the Collection.

137 The Stable of an Inn

Four horses stand at the manger in an old wooden stable. One is still saddled up and another is being rubbed down by an ostler watched by a small group on the right.
Pen and ink and watercolour: $7\frac{7}{8} \times 15\frac{3}{4}$ in (200 × 400 mm) on two conjoined sheets.
PROVENANCE Maas Gallery 1964.

138 Three Horses in Stalls

On the right, a groom mounts a ladder with a bale of hay to replenish the manger.
Pen and ink and brown wash: $4\frac{5}{16} \times 7\frac{1}{4}$ in (110 × 184 mm).
PROVENANCE Colnaghi 1961.

139 A Saddled Cavalry Horse

A three-quarter view of a riderless cantering horse bearing a cavalryman's equipment which includes a fur roll, a leather container and a blanket.
Pen and ink and brown wash: $7 \times 8\frac{1}{2}$ in (178 × 216 mm).
INSCRIBED *Rowlandson* in pencil lower right.
PROVENANCE Maas Gallery 1963.

140 A Horse Sale at Hopkins's Repository, Barbican

An auctioneer standing on his rostrum is about to knock down a grey held before him. On either side of the horse, a group of dealers and sporting types take a critical look at its points. On the left, the following lot is being led out of the stables and an assistant is removing its rug. A thin man converses with a fat one on the right and beyond them, figures stand on the balcony of a colonnaded building.
Pen and ink and watercolour: $10\frac{5}{8} \times 15\frac{3}{4}$ in (270 × 400 mm).
PROVENANCE Gilbert Davis (Lugt 757a); Sir Eldred Hitchcock, sold Sotheby's 24 February 1960, lot 18; Colnaghi 1960.
EXHIBITED N.G. of A., Washington 1962, no. 65; V.M.F.A., Richmond, 1963, no. 428; Victoria, Canada, 1971, no. 33; P.M.L. and R.A. 1972/73 no. 72.

Another version, dated 1785, is illustrated in Falk, 1949, facing p. 132.

141 A Horse Sale at Hopkins's Repository, Barbican

An outline of the frieze of figures from the above drawing, probably intended for an etching.
Pen and ink: $9\frac{1}{4} \times 15\frac{3}{4}$ in (236 × 400 mm).
PROVENANCE Iolo A. Williams; Colnaghi 1964.

142 The Canterbury–Dover Coach Passing Vanbrugh Castle

The coach and four, fully loaded, appears on the right of the composition, moving at speed down the steep hill, its skid-pad noticeably absent. A gig climbs slowly in the opposite direction, the horse led by a man whose wife and baby are sitting in the vehicle. In the distance, the river Thames with ships lying at anchor.
Pen and ink and watercolour: $11\frac{5}{8} \times 18$ in (295 × 457 mm).
INSCRIBED *Rowlandson* in ink lower left.
PROVENANCE Mrs Gilbert Miller, sold Sotheby's 7 July 1965 (lot 49); Colnaghi 1965.

Being in the opposite direction, Vanbrugh Castle (at Greenwich) could not have been on the Dover–Canterbury route.

143 Loading a Stage-Coach

A coach and four are loading up outside the Royal Oak Inn. Several passengers are already settled on the roof and a man is stepping inside. Behind him stands a buxom woman and a burly man kissing a young girl good-bye. Beyond, a tree-lined village street.

Pen and ink and watercolour: $5\frac{1}{2} \times 8\frac{7}{8}$ in (140×225 mm).

PROVENANCE Colnaghi 1966.

144 Scene outside the Half-Moon Inn

On the left a groom rubs down a horse, watched by a benign, corpulent man (?Mr Jolly) whose gig rests on its shafts on the right. Centrally, a young woman with a parasol looks winsomely at a mounted cavalry officer and behind them, the innkeeper's wife hands a tankard to a traveller on horseback. On the extreme right, a soldier and a lady walk gaily away.

Pen and ink and watercolour: $5\frac{3}{4} \times 9\frac{1}{4}$ in (146×235 mm).

PROVENANCE Colnaghi 1965.

ENGRAVED with variations in *The World in Miniature*, August 1 1816 pl. 27; Grego II, pp. 312, 405. The gig faces the other way and the horseman is regaling with groups of people.

145 Two Gigs in Trouble

In the foreground a gig overturns as its wheel strikes a boulder, throwing its occupants, two men and a woman, into alarmed confusion. A short distance ahead on the left, a similar fate is befalling the two travellers in another gig. Ominous clouds and a muddy foreground frame the disasters.

Pen and ink and watercolour: $4\frac{7}{16} \times 7\frac{3}{16}$ in (112×182 mm).

PROVENANCE L. G. Duke (D.412); Colnaghi 1961.

EXHIBITED Paris, Museé des Arts Decoratifs, *Caricatures et Moeurs Anglaises, 1750–1850*, 1938, no. 97; V.M.F.A., Richmond, 1963, no. 423.

146 A Phaeton and Six

A gentleman sitting on the right of a lady is driving six horses with a postilion on the leading pair. The team, curving uphill to the right, is followed by a rider in the lower right of the composition.

Pen and ink and watercolour: $5\frac{1}{4} \times 7\frac{3}{4}$ in (133×197 mm).

PROVENANCE Iolo A. Williams; L. G. Duke (D.619); Colnaghi 1961.

147 'The London Citizen'

Rowdy passengers in a passing coach jeer at a portly man and a woman in a phaeton causing consternation, and alarming their horses which kick and rear.

Pen and ink and watercolour: $5\frac{1}{4} \times 9$ in (134×228 mm).

INSCRIBED as title in ink lower left, and lower right. *T. Rowlandson b. 1756 d. 1827.*

PROVENANCE Edward Basil Jupp; Thomas William Waller; Elizabeth Stauffer Moore; John William Moore Richardson; Elizabeth Richardson Simmons, sold Christie's 12 November 1968, lot 162; Agnew 1969.

Other versions are in the Boston Museum of Fine Arts (with a second gig in place of the coach) and Princeton University Library.

148 'Slender Billy' taking Refreshment

On the right a portly, apron-clad landlord standing under his inn-sign, proffers a cup of cordial

to Billy, who reaches in his pocket to pay for it. Billy's blowsy wife sits behind him in a gig, a whip over her right shoulder. Two dogs are in the left foreground.

Pen and ink and watercolour: $10\frac{7}{8} \times 8\frac{1}{2}$ in (276×216 mm).

PROVENANCE T. Lowinsky (Lugt 2420a); Justin Lowinsky 1963.

149 A Livery Stable

In the foreground of a stable-yard a groom is attending to two horses, rubbing down one with a wisp of straw. On the right in the background, people are gathered in the doorways of a low-roofed building which bears the sign *Post Chaises | Able Horses*.

Pen and ink and watercolour: $5\frac{7}{16} \times 8\frac{9}{16}$ in (138×217 mm).

PROVENANCE Sotheby's 17 January 1962, lot 79; Colnaghi 1962.

150 The Toll-Gate

A couple in a horse-drawn cart pass through the gate as the man pays the dues to the keeper. A small barn adjoins the toll-house on the right.

Pen and ink and watercolour: $4\frac{3}{4} \times 7\frac{1}{4}$ in (121×184 mm).

PROVENANCE George, Fifth Duke of Gordon; Elizabeth, Duchess of Gordon; The Brodie of Brodie; Agnew 1962.

A larger and more finished drawing was exhibited at Fry Gallery 1975, illustrated on the catalogue cover.

151 An English Postilion

The back view of a postilion on the left hand side of a coach shaft raising his whip to the other horse.

Pen and ink and watercolour: $5 \times 7\frac{7}{8}$ in (126×200 mm).

INSCRIBED *Rowlandson Delt* and *English Postilion* in a later hand below drawing.

PROVENANCE John Baskett 1969.

This was a favourite subject with Rowlandson. Versions with variations are in the Courtauld Institute, (Spooner Bequest), the collection of Mrs Dorian Williamson, and in *Tour in a Post Chaise* in the Huntington Library, Wark, 164, pl. 14.

152 The Paris Diligence

The coach, crowded inside and out, enters a town square from an archway by an inn on the left. Groups of people surround a crucifix in the background, approached by a procession of monks.

Pen and brown ink and watercolour: $9 \times 14\frac{1}{4}$ in (228×362 mm).

INSCRIBED *T. Rowlandson* in ink lower right.

PROVENANCE sold Christie's 5 March 1974, lot 134 (ill.); Baskett & Day 1974.

ENGRAVED by Rowlandson, published by T. Tegg (?) 1810; Grego II, p. 189; B.M. Satires, 11624.

Rowlandson used this composition of the diligence, postilion, passengers and beggars repeatedly. It can be seen in no. 153 *Travelling in France*. A similar basket-work coach plied daily between Paris and Versailles.

153 Travelling in France

A long wheel-based French Poste-Diligence moves off from a staging post. A large party is seated inside and more passengers are perched on the roof. On the right, horses are being

changed on a curricle which stands in front of an inn; a panel in the shape of a cartouche on the inn's facade is inscribed *Lion Dargeant | ici on donne bonne | a manger par | J. Maigre Traiteur*. On the extreme left, two figures observe the coach, possibly Henry Wigstead and Rowlandson, one of them sketching.
Verso, colour splashes.
Pen and ink and watercolour: $11\frac{3}{8} \times 17\frac{1}{2}$ in (289 × 445 mm).
PROVENANCE Charles Russell, sold Sotheby's 30 November 1960, lot 84; Colnaghi 1960.
EXHIBITED N.G. of A., Washington, 1962, no. 68.
See note to *The Paris Diligence*, no. 152.
Colour plate

154 Travelling in Holland

An ornate carriage and pair in which a party of ladies and gentlemen converse is preceded by an open coach with an elaborately decorated rear panel and coachman, maid-servant and man-servant inside. Imposing buildings form the background.
Pen and ink and watercolour: $7\frac{3}{4} \times 11\frac{5}{8}$ in (197 × 295 mm).
INSCRIBED *T. Rowlandson* in ink lower left and *14* lower right.
PROVENANCE Herbert L. Carlebach; John Fleming 1966.

A larger version, inscribed with the above title, is illustrated in Oppé 1923, pl. 34, and another closer to the one catalogued was sold Christies 1 March 1977, lot 121 (ill.).

155 Two Greyhounds lying under a Tree

A grey and a white greyhound resting in shade at the base of a tree.
Verso, three men and a woman drinking: pen and pencil $9\frac{5}{8} \times 12\frac{1}{2}$ in (245 × 318 mm) over the whole mount.
Pen and ink and watercolour: $7 \times 9\frac{3}{4}$ in (178 × 248 mm) on old lined mount.
PROVENANCE L. G. Duke (D.831); Colnaghi 1961.
LITERATURE Iolo A. Williams, *Early English Watercolours*, 1952, p. 141, pl. 231.
EXHIBITED London R.A., *British Art*, 1934, no. 698; N.G. of A., Washington, no. 59.

156 A Group of Five Bulls about to Fight

Pen and red ink, and grey wash: $5\frac{11}{16} \times 8\frac{3}{4}$ in (145 × 222 mm).
PROVENANCE L. G. Duke (D.101); Colnaghi 1961.

157 Pigs at a Trough

A rear view of five pigs feeding hungrily from a trough.
Pen and ink and wash: $3\frac{1}{8} \times 6\frac{1}{4}$ in (80 × 157 mm).
PROVENANCE L. G. Duke (D.4144); sold Sotheby's 16 July 1970, lot 155; Spink; Davis & Long, New York, 1975.

158 Study of a Shouting Man

A seated man, wearing a tricorne, is shouting and waving his clenched fists threateningly as he looks back over his right shoulder. On the right, a separate study of a gig with three occupants drawn by three other men in the shafts.

Verso, pen sketch of a man in a broad-brimmed hat.
Pen and ink: 7¾ × 10 in (198 × 254 mm).
INSCRIBED verso, . . . *ton Colsons Dividend Advertised for the 23rd January* in ink.
PROVENANCE T. E. Lowinsky (Lugt 2420a); Justin Lowinsky 1963.
LITERATURE M. Ayrton, *Aspects of British Art*, 1947, p. 36 (ill.).

159 'A Grub Street Poet'

A thin, seedy man with a pinched, hungry expression, walks to the right looking over his shoulder. He is hunched with cold, one hand holding together his coat from the back pocket of which a document protrudes.
Verso, studies for *Leda and the Swan* and inscribed *A Grub Street Poet*, all in pencil.
Pen and ink and watercolour: 10 × 7 in (250 × 178 mm).
INSCRIBED as title lower left and *Rowlandson* lower right in pencil.
PROVENANCE Barlow family 1939; Thomas Churchyard; Iolo A. Williams; Colnaghi 1964.
LITERATURE A. P. Oppé, *Rowlandson the Surprising*, 'The Studio', November 1942 (ill.).
EXHIBITED I. A. Williams, Sheffield 1952, Aberystwyth 1953, Reading 1959, no. 99 in each catalogue.

This figure, in a different attitude, is seen in *The Poor Poet and Rich Carcase Butcher* in the Boston Museum of Fine Arts.

From the early seventeenth century, Grub Street (renamed Milton Street in 1830) London, was home of text-writers (copiers of books when editions were very limited) and later down-at-heel authors of pamphlets, often libellous. They themselves were frequently lampooned by reputable writers such as Marvell and Pope.

160 A Gendarme and Another Man

A rapid sketch of a gendarme facing front, apparently talking, his arms akimbo. Another, in similar faint outline, is in the background to the left.
Verso, slight sketch of Gothic windows.
Pen and ink: 7¼ × 5½ in (184 × 140 mm).
PROVENANCE Lord Farmham; Dyson Perrins; L. G. Duke (D.3576); Colnaghi 1961.

161 An Elderly Buck Walking with a Lady

Back view of a squat man in a short-tailed coat and wide hat, walking stiffly arm in arm with a tall lady wearing a long stole.
Pen and red ink and watercolour: 6¾ × 5¾ in (172 × 145 mm).
PROVENANCE Lady Jane Harriet Pleydell-Bouverie; Martin Hardie; Colnaghi 1961.
EXHIBITED V.M.F.A., Richmond, 1963, no. 422.

162 'A Worn Out Debaucher'

An elderly aristocrat in outdoor dress and wearing a star on his coat, walks with a sprightly gait in the company of a young charmer who carries a muff. She looks attentively at him as he holds forth, his mouth open and his nose in the air.
Pen and ink and watercolour: 11¾ × 7¾ in (299 × 197 mm).
INSCRIBED as title in pencil lower right.
PROVENANCE T. E. Lowinsky (Lugt 2420a); Justin Lowinsky 1963.
EXHIBITED P.M.L. and R.A. 1972 no. 73 (no. 70, colour plate).

163 The Gardener's Offering

In the garden of a mansion, an infatuated gardener kneels to offer flowers to an elegant girl who, ignoring him, bends to pat her begging dog. The scene is watched by a man peering over the wall on the left from the top of a ladder. A large, well-stocked greenhouse is prominent in the background.

Verso, faint pencil sketch of a man and a woman conversing.

Pen and ink and watercolour: $10\frac{7}{8} \times 14\frac{7}{8}$ in (275×378 mm).

PROVENANCE No record.

Another version in the Collection of Brinsley Ford Esq. is reproduced in Oppé, 1923, pl. 61 and Hayes, 1872, pl. 113. The gardener pleading with the girl is also the theme for a drawing in the British Museum, (illustrated in Oppé, pl. 60 and Hayes, pl. 111) entitled *A Scene from 'Love in a Village'*.

164 Outside the Greengrocer's Shop

Two shopkeepers are opening up their small shops in the early morning. On the left, a smiling young buck is provoking the disagreeable woman who stands in the doorway of her shop holding a basket of vegetables. On the right, a baker(?) takes down his shutters.

Pen and ink and watercolour: $10\frac{5}{8} \times 8\frac{1}{4}$ in (270×210 mm).

PROVENANCE F. T. Sabin 1975.

A sketchier version of this is in the Metropolitan Museum of Art, New York.

165 'The Miseries of the Country'

A couple walk away from a house in the distance, preceded by a yawning manservant carrying a lantern. The man, looking disgruntled, holds an umbrella over his wife who is wearing pattens under her shoes.

Pen and ink and watercolour: $3\frac{7}{8} \times 5\frac{3}{4}$ in (95×147 mm).

PROVENANCE L. G. Duke (D.2304); Colnaghi 1961.

ENGRAVED in reverse with the above title in *Miseries of Human Life* (50 plates designed and etched by Rowlandson, 1806) with lines below:

> Losing your way on foot at night
> In a storm of wind and rain
> And this immediately after leaving
> A merry fire-side.

Grego II, pp. 119–124; B.M. Satires, 10840.

EXHIBITED V.M.F.A., Richmond, 1963, no. 424 as *Returning from an evening party*.

166 Three Clerical Scholars

Two bulky figures in mortar-boards and gowns sweep past a third walking in the opposite direction, all parties intent on non-recognition.

Pen and ink and watercolour: 9×11 in. (230×280 mm).

INSCRIBED *Rowlandson 1789* in ink lower right.

PROVENANCE Mrs J. E. Hawkins, sold Christie's 22 June 1962, lot 56; Colnaghi 1962.

167 Three Full-Length Figures of Men Talking

The man on the left, holding his hat under his arm, gesticulates to his two companions, who

appear to be amused by his remarks. The man on the right is removing the lid from a (?) snuff-box.
Pen and red ink: $9\frac{1}{2} \times 7\frac{1}{4}$ in (242 × 184 mm).
PROVENANCE Iolo A. Williams; Colnaghi 1964.

The style of the drawing bears a close resemblance to that of the figure drawings of Pier-Leone Ghezzi (1674–1755), whose caricatures were popular with English travellers.

168 'Bucks of the First Head'

Two undergraduates, wearing gowns and mortar-boards, admire a country girl carrying a basket. One young man chucks her under the chin while his companion leans nonchalantly on his shoulder. In the background, a stout figure with his dog walks away in the direction of the spires of Oxford.
Pen and ink and watercolour: $7\frac{1}{8} \times 8\frac{3}{4}$ in (180 × 222 mm).
PROVENANCE L. G. Duke (D.2169); Colnaghi 1961.
ENGRAVED with variations as *Bucks of the First Head*, 1785.

169 The Elopement

A scantily-clad young lady wearing a feathered hat lowers herself, with the aid of a sheet, from a balcony on to the shoulders of an officer who, while steadying her feet with his hands, peers up her skirt. Above the adjacent door, a board proclaims the house to be a *BOARDING SCHOOL FOR YOUNG LADIES*. On the left, a companion helps to load luggage into a waiting carriage.
Pen and ink and watercolour: $10\frac{7}{8} \times 8$ in (275 × 203 mm).
INSCRIBED *Rowlandson* 1792 in ink lower left, in the artist's hand.
PROVENANCE Agnew 1965.
LITERATURE Hayes, 1972, p. 53, pl. 92.
ENGRAVED in reverse as *Smuggling Out or Starting from Gretna Green*, published 8 August 1810, Grego II, p. 190: G. Schiff, *The Amorous Illustrations of Thomas Rowlandson*, 1969, pl. 45.

170 'Settling a Love Quarrell'

Two young men, stripped to the waist, are squaring up to one another watched with enjoyment by a buxom young woman smoking a clay pipe. Three donkeys graze in the distance.
Pen and ink and pink wash: $7\frac{3}{4} \times 10\frac{5}{8}$ in (197 × 270 mm), top corners rounded.
INSCRIBED as title in ink top centre in the artist's hand.
PROVENANCE L. G. Duke (D.250); Colnaghi 1961.
EXHIBITED London, 39 Grosvenor Square, *British Country Life*, 1937, no. 515.

The man on the left has been adapted from an etched figure in the top right corner of *Six Stages of Marring a Face*, dedicated to the Duke of Hamilton, pub. 29 May 1791 by Fores, Grego I, 307, II, 393; B.M. Satires, 8175.

171 Four Women at a Well in Rome

The right hand figure fills an ewer from a water spout; to her left, another woman is seen from behind, a third crosses her arms over her waist and a fourth, facing left, holds a water container.
Pen and red ink and watercolour: 6 × 9 in (152 × 258 mm).
PROVENANCE Iolo A. Williams; Colnaghi 1964.

Rowlandson was known to have visited Italy but the dates of his journeys are not certain.

172 Parisian Street Figures

On the left, the small figure of a man is seen walking away and a male music grinder is seated beside a woman who plays a hurdy-gurdy. In the centre, a Savoyard porter with a basket on his arm carries baggage on his back. On the right, a water-carrier supports two cans on a yoke.
Pen and ink and grey wash: 6½ × 9½ in (165 × 242 mm).
INSCRIBED *Music Grinders, a Savoyard Porter* and *a Water Carrier* under the individual figures and *Figures Sketch'd from A Window at Paris 1786* – in ink lower centre.
PROVENANCE Lord Farnham; Dyson Perrins; L. G. Duke (D.3577); Colnaghi 1961.

This is a sketch used in two finished drawings: *Parisian Scene*, reproduction in the Witt Library (provenance unrecorded) and *Paris Street Scene*, Courtauld Institute Galleries, (Sir Robert Witt Collection).

173 Feeding the Ducklings

In the wooded grounds of a riverside mansion, a portly invalid in a wheelchair watches a young woman kneeling to feed ducklings enticed from two cages. An elegant lady with a parasol stands behind her and a dog looks on with obvious constraint.
Pen and ink and watercolour: 9 × 11⅝ in (230 × 295 mm).
INSCRIBED *Rowlandson* in ink lower left.
PROVENANCE L. G. Duke (D.399); Colnaghi 1961.
EXHIBITED Eton College 1948, no. 16. [Drawings from the collection of L. G. Duke].

174 'Pidcock, Dealer in Birds and Beasts'

By a wide river stands a thatched hut, the outside walls of which are hung with cages containing livestock. Two young ladies are considering the purchase of a bird and the sharp-featured Mrs Pidcock, scenting a sale, appears at the half-door of the hut. Above the door is a board inscribed *Pidcock | Dealer In | Birds & Beasts*. Other customers inspect the cages, while on the left a man watches from the prow of his boat.
Pen and ink and watercolour: 7 × 10¾ in (177 × 262 mm).
INSCRIBED *T. Rowlandson* in ink lower right.
PROVENANCE Herbert L. Carlebach; John Fleming 1966.
Colour plate

175 'Butterfly Hunting'

Two entomologists, the foremost a Syntax-like figure, trample the flower beds of an ornamental garden in their pursuit with double nets of butterflies. The owner roars at them from an upstairs window, his two daughters protest from the doorway below, while the gardener in the background drops a flower-pot in consternation.
Pen and ink and watercolour: 5¼ × 7¾ in (134 × 197 mm).
PROVENANCE Gooden & Fox 1967.
ENGRAVED by Rowlandson with the title as above and published June 1806, Grego II, 61–2 (ill.); B.M. Satires, 10647.

176 A Man driving a Team of Six Girls

The diminutive driver, standing on the backs of the last two girls, controls all six with reins and whip.
Verso, faint unidentifiable pencil sketch.

Pen and ink and some watercolour: $7\frac{3}{4} \times 9\frac{3}{8}$ in (197×239 mm).
INSCRIBED *J. Gilray* in ink lower left in a later hand.
PROVENANCE Gerald Norman 1968.

In an album in the Huntington Library are three sketches of the same figure by Rowlandson which are known to be early drawings.

177 A Group of Figures

Eight men including a rustic, a clergyman and old soldiers (one wearing an eye patch and another with a wooden leg), converse under the interested gaze of a woman in riding clothes.
Pen and ink and watercolour: $4\frac{3}{8} \times 7\frac{1}{2}$ in (110×190 mm).
PROVENANCE Lady Jane Harriet Pleydell-Bouverie; Martin Hardie; Colnaghi 1961.

178 The Flower Seller

A street vendor at the doorway of a house offers two potted plants to a sharp-featured woman who smells one of them fastidiously. A patient donkey with the cart waits by his master.
Pen and ink and watercolour: $4\frac{1}{8} \times 3$ in (105×75 mm).
INSCRIBED *Rowlandson* in pencil lower left.
PROVENANCE Maas Gallery 1964.
ENGRAVED in reverse by the artist for Rowlandson's *Characteristic Sketches of the Lower Orders*, London, 1820; Tooley, 424, no. 14; not in Grego.
Another version is in the Huntington Library, Wark, 1975, no. 417.

179 'Knives or Scissers to Grind'

The knife-grinder sharpens a small hatchet knife watched by two children and a woman holding a baby.
Pen and ink and watercolour: $4\frac{1}{8} \times 2\frac{3}{4}$ in (105×75 mm).
INSCRIBED as title in ink lower centre by the artist.
PROVENANCE Rev. Thomas Streatfield; Judge Ifor Lloyd, sold Sotheby's 18 December 1963 lot 167; Colnaghi 1963.
ENGRAVED by the artist in the same direction for pl. 51 (un-numbered) of Rowlandson's *Characteristic Sketches of the Lower Orders*, London, 1820; Gre go II, 366; Tooley, 424, no. 9.

Another version in the reverse direction is in the Huntington Library, Wark, 1975, no. 424.

180 'Hot Spice Gingerbread, All Hot' (version A)

A man and a woman stand behind a small, three drawered chest on which are placed four pieces of gingerbread. Two boys, one of them a chimney-sweep, looks on hungrily. This is a version of no. 181 without the buildings in the background.
Pen and ink and watercolour: $5\frac{3}{4} \times 4$ in (142×100 mm).
INSCRIBED as title below drawing in the artist's hand.
PROVENANCE Maas Gallery 1963.

181 'Hot Spice Gingerbread, All Hot' (version B)

This composition is closely related to no. 180 except that there are five pieces of gingerbread on the chest instead of four and some buildings are delineated vaguely in the background.

Pen and ink and watercolour: $4\frac{1}{8} \times 2\frac{5}{8}$ in (102×67 mm).
PROVENANCE Rev. Thomas Streatfield; Judge Ifor Lloyd, sold Sotheby's 18 December 1963 lot 168; Colnaghi 1963.
ENGRAVED by the artist in reverse for pl. 43 (un-numbered) of Rowlandson's *Characteristic Sketches of the Lower Orders*, London, 1820; Grego II, 367; Tooley, 424, no. 31.

182 A Peepshow

A portable street peepshow is surrounded by children and adults, among them a porter with a large pack on his head. The showman has a worried expression as he manipulates the control for the benefit of a boy peering into the front of the box.
Pen and ink and watercolour: $5\frac{1}{2} \times 7\frac{1}{4}$ in (140×183 mm).
PROVENANCE Marcus Read; Tony Straus-Vegbaur; Agnew 1967.
LITERATURE F. J. Mather, *Some Drawings by Thomas Rowlandson*, Print Collector's Quarterly, II, no. 2, 1912, p. 398, (ill.) p. 401.
EXHIBITED Yale Center, *Pursuit of Happiness*, 1977, no. 60.

183 The Arrival of the Fire Engine

A hand-pump fire engine is hauled to a house by five men. A fireman knocks on the street door to warn people looking out of the first floor windows of the encroaching fire, indicated by smoke billowing from behind the building.
Pen and ink and watercolour: $4\frac{1}{2} \times 7\frac{1}{8}$ in (114×180 mm).
PROVENANCE L. G. Duke (D.413); Colnaghi 1961.
EXHIBITED V.M.F.A., Richmond, 1963, no. 425.

184 A Punch and Judy Show

In a town square, a Punch and Judy show is being performed for an amused audience which includes a milkman in smock and yoke and a boy pickpocket. A showman blows a horn to attract girls on a balcony; below them, in a doorway, a corpulent man is standing with two women. On the right, an old roué walks away with a young strumpet.
Pen and ink and watercolour: $5\frac{3}{4} \times 9\frac{3}{8}$ in (146×238 mm).
PROVENANCE Spink 1963.
EXHIBITED Yale Center, *Pursuit of Happiness*, 1977, no. 59.
 Another version, but in the reverse direction, is illustrated in Falk, 1949, facing p. 125.

185 The Town Crier

The stout figure of the Town Crier stands holding his bell and calling out his message to a motley assembly of men, women, children and dogs. Two young girls, laughing at the scene, lean out from an upper window.
Pen and ink and watercolour: $11\frac{3}{4} \times 9\frac{1}{8}$ in (287×230 mm).
INSCRIBED *T. Rowlandson* in ink lower right.
PROVENANCE Herbert L. Carlebach; John Fleming 1966.

186 A Tub Thumper

An orator harangues an audience of uncouth characters who deride, mock or ignore him. He stands in a large tub and gesticulates wildly while behind him, with a bottle protruding from his pocket, stands a man holding an umbrella to protect them both from a deluge of rain.

Pen and ink and watercolour: $12\frac{1}{2} \times 9\frac{1}{4}$ in (318×235 mm).
INSCRIBED *Rowlandson 1811* in ink lower left in the artist's hand.
PROVENANCE Colnaghi 1965.

A weaker version, dated 1812, in the Boston Museum of Fine Arts (J. T. Spaulding collection) is illustrated in Bury, 1949, No. 66 as *The Preacher*.

187 Angry Scene in a Street

Two women quarrel from either side of a street of bawdy houses; the younger woman, bare-breasted with arms akimbo, exchanges abuse with an ageing slattern who shouts accusingly at her. A fat woman spectator holds a basket on her head which is being pilfered from a window above and a buxom trollop makes a coarse gesture. In the background men are being wheedled and robbed and the scene is overhung by a line of fluttering washing strung across the street.
Pen and ink and watercolour: $5\frac{3}{4} \times 9\frac{3}{4}$ in (145×235 mm).
PROVENANCE T. E. Lowinsky (Lugt 2420a); Justin Lowinsky 1963.

188 A Gibbet

Two highwaymen on horses, one holding a pistol, look up with awed expressions at a skeleton suspended in irons from one side of a double gibbet. A coach is faintly outlined in the distant background.
Pen and ink and watercolour: $14 \times 10\frac{3}{4}$ in (350×273 mm).
PROVENANCE T. E. Lowinsky (Lugt 2420a); Justin Lowinsky 1963.

189 Crowd by a Gibbet

Six men and a woman are huddled together on the left of the composition, gazing up towards a gibbet from which four corpses in irons are hanging on separate beams.
Pen and ink and watercolour: $6\frac{1}{2} \times 8\frac{1}{2}$ in (165×215 mm).
PROVENANCE Colnaghi 1961.
EXHIBITED V.M.F.A., Richmond, 1963, no. 420.

A photograph of a version inscribed *Pirates hanging at the Isle of Dogs* is in the Witt Library files.

190 A Funeral Procession

The cortège of an important person winds along a road to a mansion on the bank of a river (probably the Thames, as distant spires and a large dome suggest London and St Paul's). The carriage horses are plumed as is the hearse and a group of people on the right bow respectfully as the procession passes.
Pen and ink and watercolour: $7\frac{7}{8} \times 11$ in (200×280 mm).
PROVENANCE Mrs C. W. Dyson Perrins, sold Sotheby's 20 March 1963, lot 40; Colnaghi 1963.
LITERATURE Oppé, 1923, pl. 57.
EXHIBITED Colnaghi and Yale 1964/65, no. 29.

191 Monks Carousing Outside a Monastery

A monk escorts a veiled woman to the entrance of a chapel in the monastery garden while at a table on the right, a company of jolly friars toast each other with raised goblets.
Pen and red ink and watercolour: $6 \times 8\frac{7}{8}$ in (153×225 mm).
INSCRIBED *Rowlandson* in ink lower left.
PROVENANCE Sotheby's 13 July 1966, lot 43; Colnaghi 1966.

192 A Book Auction

The sale is taking place in a book-lined room with the rostrum on the left overlooking the usual elliptical table. The autioneer, with hammer raised, awaits the final bid for a book being shown to the crowd of buyers surrounding the table. The porter with the book seems to be involved in argument with a prospective purchaser on the right.
Verso, a handsome soldier and other figures, in faint pencil.
Pen and ink and watercolour: 6 × 10 in (152 × 252 mm).
PROVENANCE Colnaghi 1962.
EXHIBITED Yale Center, *Pursuit of Happiness*, 1977, no. 49.

A version of this drawing is at Sotheby's, London, and another illustrated in A. P. Oppé, *Rowlandson the Surprising*, 'The Studio', 1942, p. 156.

193 'Bookseller and Author'

A bookseller, spectacles on forehead and pen behind ear, looks disdainfully at an ingratiating author reading from his manuscript. In the background, a short-sighted cleric reads a book taken from the crowded shelves.
Pen and ink and watercolour: $10\frac{3}{8} \times 12\frac{5}{8}$ in (264 × 321 mm).
PROVENANCE Fry 1969.

An engraving, probably by Rowlandson, is inscribed *H. Wigstead delintt S. Alken fecit*, published September 25 1784; Grego I, 148; B.M. Satires, 6722.
Another version is at Windsor Castle; A. P. Oppé *English Drawings at Windsor Castle* 1950, no. 513, pl. 80.

194 'The Connoisseurs'

Three men in tricorne hats, one seated, scrutinise a large painting of a voluptuous Susannah alarmed by two Elders. The painter, holding his palette, stands on the left of the group awaiting comments.
Pen and ink and watercolour: $9 \times 11\frac{3}{4}$ in (230 × 300 mm).
INSCRIBED as title in ink lower centre.
PROVENANCE L. S. Deglatigny (Lugt 1768a); C. R. Rudolph; Colnaghi 1963.
LITERATURE Paulson, 1972, pp. 83/84, pl. 48.
EXHIBITED Colnaghi and Yale 1964/65 no. 26.

A related drawing, *Connoisseurs in the Studio*, is in the Huntington Library, Wark, 1975, no. 117. In this, the subject on the easel has been changed for a mythological one, and an old woman peers through the door on the left.

195 'The Historian Animating the Mind of the Young Painter'

The artist, turning round from his easel, listens intently to the elderly historian who, sitting below a droll bust of Homer, reads from a paper. The artist's wife dandles a child before the fireplace on the right, behind the easel.
Pencil: $7\frac{3}{8} \times 10\frac{1}{4}$ in (188 × 261 mm).
INSCRIBED *Thompson The Poet Reading His Seasons to Wilson the Painter* in ink in the artist's hand.
PROVENANCE H. S. Reitlinger(L.2274a); L. G. Duke (D.3005); Colnaghi 1961.
EXHIBITED V.M.F.A., Richmond 1963 no. 415.

The subject was etched by Rowlandson in 1784 with the above title, two years after the death of Richard Wilson. Thus, the inscription on the drawing must be an obscure joke alluding

to Rowlandson's old teacher at the R.A. as there is no sure evidence that Wilson was ever married or had offspring. Grego I, 150; B.M. Satires, 6724.

196 An Artist's Studio

A thin coarse-featured, painter is at work on a canvas depicting Homer embracing a buxom maid. An elderly man, with a painting under each arm, looks on. Amid the litter on the floor is a bust of Homer, a cello and a fierce cat. A second cat has climbed to the top of the easel and is hungrily eyeing two hams hanging from the rafters above the smoke of the artist's pipe.
Pen and ink and watercolour: $10\frac{1}{2} \times 8\frac{1}{2}$ in. (266×215 mm).
INSCRIBED *Rowlandson 1814* in ink lower left in the artist's hand.
PROVENANCE Mrs J. E. Hawkins; Christie's 22 June 1962, lot 44; Colnaghi 1962.

197 The Glass-Maker

In a workshop strewn with tools and moulds, the glass-maker, wearing layers of cloth as protection, stirs a bowl in the furnace. Behind him, his assistant looks on, wipes his brow and holds a hook in readiness for extracting the bowl of molten glass.
Pen and ink and watercolour: $5\frac{1}{2} \times 9\frac{1}{8}$ in (140×232 mm).
INSCRIBED *T. Rowlandson* in ink lower left.
PROVENANCE Herbert L. Carlebach; John Fleming 1966.

Rowlandson made several etchings after Teniers and this composition, although not identified as being after him, has an affinity with such interiors of the Dutch School.

198 The Slaughter House

Two butchers at work, each with a knife in his mouth; one cuts at a carcass suspended from the roof, the other bleeds an ox into a tub. Cattle waiting for slaughter are seen in the farmyard through the shed door on the left.
Pen and ink and grey wash: $6 \times 7\frac{1}{2}$ in (152×191 mm).
PROVENANCE Cyril Fry 1966.

An etching by Rowlandson, *A Butcher*, published 1 January 1790, Grego I, 269/70 ill., is similar in character.

199 Diners in a Chop House

The interior of a dining room: on the left, a man stands gazing at himself in a mirror while another sits at a table reading the paper; two others are eating with gusto watched with eager anticipation by two dogs. Behind them a waiter appears carrying a dish.
Verso, some sums.
Pen and ink and watercolour: $4\frac{3}{8} \times 6\frac{5}{8}$ in (112×168 mm).
PROVENANCE Sabin Galleries 1964.

200 A Merchant's Office

Four clerks with ledgers in front of them occupy a double-sided sloped desk. At a separate small table, the elderly merchant, wearing a tam o'shanter and a quill pen behind his ear, checks an account. A rack of account books and papers dealing with exports are on the wall behind.
Pen and ink and watercolour over pencil: 11×13 in (280×330 mm).
INSCRIBED *Rowlandson 1789* in ink lower right, in the artist's hand.
PROVENANCE Somerville & Simpson 1976.

201 A Man Buying Snuff

In a snuff and tobacco shop, a man sniffs a sample from a jar labelled *STRASBOU[RG]* with obvious relish. The shopkeeper, scales in hand, looks at him expectantly while his scowling wife busies herself with a bowl. A man enters the shop puffing clouds of smoke from a long clay pipe. On a bracket, top right, is a model of a cigar-store Indian.
Pen and ink and watercolour: $7\frac{3}{8} \times 5\frac{5}{8}$ in (185 × 142 mm).
PROVENANCE Colnaghi 1962.

202 Register Office for the Hiring of Servants

Business is brisk as on one side of the large office a fat, wealthy woman talks to the younger of two manservants while opposite, an old man quizzes a pretty girl under the stare of a fat domestic. Behind a counter in the background, a fawning clerk takes a fee from a woman applicant while two dogs cavort affectionately at her feet.
Pen and ink and watercolour: $9\frac{1}{4} \times 12\frac{3}{4}$ in (235 × 324 mm).
PROVENANCE L. S. Deglatigny (Lugt 1768a); Colnaghi 1968.

Another version is in the Huntington Library, Wark 1975, no. 135, also illustrated in Bury, 1949, no. 29.
Colour plate

203 Portrait of an Old Man

An old man with a pointed nose and chin is asleep in a chair, his toothless mouth gaping.
Verso, two columns of sums
Pen and ink and water colour: 7×6 in (179 × 152 mm).
PROVENANCE Barlow family 1939; Thomas Churchyard; Iolo A. Williams; Colnaghi 1964.

Another version is in Princeton University Library inscribed *Dotage*.

204 The Love Letter

A young lady wearing a large hat is seated in a chair facing three-quarters right, holding a letter in both hands.
Pen and ink and watercolour: $11 \times 7\frac{1}{2}$ in (280 × 191 mm).
PROVENANCE Lady Jane Harriet Pleydell-Bouverie; Martin Hardie; Colnaghi 1961.
LITERATURE Hayes, 1972, p. 143, pl. 78.

A similar figure reading a letter appears in *The Panting Lover* in the Huntington Library, Wark, 1975, no. 79.

205 A Lady in a White Dress, Wearing a Blue Hat

Full-length study of a plump, smiling lady, one arm on her hip, the other on a coping.
Pencil and watercolour: $13\frac{3}{8} \times 9\frac{1}{2}$ in (340 × 240 mm).
INSCRIBED *Rowlandson* in pencil lower right.
PROVENANCE Henry Oppenheimer; Christie's 22 June 1962, lot 41; Colnaghi 1962.

206 A Young Woman in a Blue Striped Dress

A full-length study of a smiling girl in a mob cap, facing front, her hands behind her.
Pencil, pen and ink and watercolour: $7\frac{5}{8} \times 4\frac{7}{8}$ in (194 × 124 mm).
PROVENANCE Christie's 11 June 1968, lot 55 (ill.): Gooden and Fox 1968.

207 'Mad'elle du The de l'Opera'

A young woman seated three-quarter length, looking to the left, wearing a large be-ribboned hat.

Pen and ink and watercolour: $7\frac{3}{8} \times 5\frac{5}{8}$ in (187 × 143 mm).

PROVENANCE Colnaghi 1967.

ENGRAVED as one of a pair, entitled *English* and *French*, published December 1 1792; Grego I, 317–18, II, 393; Angelo, *Reminiscences* II, 375–8 (ill.), from which the above title is taken.

208 A Mother and Child

A mother wearing a mob cap is seated facing left, looking affectionately at the baby in her arms. The child, in bonnet and long gown, sleeps serenely.

Pen and ink over black chalk: $7\frac{1}{8} \times 5$ in (180 × 127 mm).

PROVENANCE The Hon. Mrs Russell; L. G. Duke (D.1799); Colnaghi 1961.

EXHIBITED V.M.F.A., Richmond, 1963, no. 413 as *Mrs Morland and Child*.

ENGRAVED by Rowlandson as the right hand print of a pair on one plate published December 28 1785, with no titles but depicting, presumably, the single and married state of a young woman.

A photograph of a version inscribed *After Marriage*, once Reitlinger Collection, is in the Witt library files.

209 The Amorous Turk

A Turk, wearing a turban, cummerband and pantaloons, sits on a sofa, a long pipe resting on his knees; his companion, a lady in feathered hat holding a lute, raises her hand in alarm as though at some improper suggestion made by the Turk.

Pen and ink and watercolour: $11\frac{3}{4} \times 11$ in (297 × 280 mm).

PROVENANCE Robert Goldman; Peter Deitsch 1967.

The figure of the Turk with his pipe has associations with Rowlandson's etching of *The Polish Dwarf performing before the Grand Seigneur*, published March 1796, Grego, I, 186–7 (ill.).

210 'Forgiving Lovers'

A stout man on the left stands up on tiptoe to kiss and embrace a buxom woman wearing a mob cap.

Verso, colour splashes.

Pencil: $9\frac{1}{2} \times 6\frac{1}{2}$ in (241 × 165 mm), indented for transfer.

PROVENANCE L. G. Duke (D.2380); Colnaghi 1961.

ENGRAVED as one of a set of twelve prints for *Cupid's Magick Lanthorn*, 1797, with the following verse below:

> 'Tis an Adage most true, without Doubt
> And will ever continue the same,
> When Lovers 'bout nothing fall out,
> It only increases the Flame.
> To Conclude, the wrapt Poet thinks meet,
> To lovers this Maxim he sends,
> Old Grievances never repeat,
> But kiss, and forgive and be Friends.

The series, engraved in reverse and published 15 March 1798, was entitled *Love in Caricature*. Grego I, p. 353.

211 Sleeping Woman Watched by a Man

A recumbent woman is sleeping soundly, unaware that an elderly man, bending over her from behind the couch, is peering into her face.

Pen and ink and watercolour: $5\frac{5}{8} \times 7\frac{3}{4}$ in (143 × 197 mm).

PROVENANCE T. E. Lowinsky (Lugt 2430a); Justin Lowinsky 1963.

212 Two Sleeping Figures

A small girl and her mother curled up asleep on a couch. The woman's face is buried in the cushions.

Pen and red ink and grey wash: $6\frac{3}{4} \times 8\frac{5}{8}$ in (172 × 220 mm).

PROVENANCE Colnaghi 1961.

213 'Cat Like Courtship'

A woman is attempting to repel the advances of an ugly man who is trying to embrace her. One cat grasps his legs and bites the seat of his breeches, while two others climb up his back. A chair lies overturned behind the woman.

Pen and ink and watercolur: $9\frac{5}{8} \times 7\frac{3}{4}$ in (244 × 197 mm).

INSCRIBED as title lower left and *T. Rowlandson* lower right, in ink.

PROVENANCE E. Laffon (Lugt 877a); Wakefield Young 1966.

214 The Gourmand

A pretty servant girl is serving wine to a corpulent gourmand who sits at a table leering at her. With his left hand he grasps a knife in readiness to attack the roasted bird in front of him. A cat, perched on the back of his chair, is casting a hungry glance at the bird.

Pen and ink and watercolour: $9\frac{1}{2} \times 7\frac{3}{8}$ in (240 × 187 mm).

INSCRIBED *T. Rowlandson* in ink lower left and right.

PROVENANCE Davis Galleries, New York 1967.

215 The Drunken Nurse

A sick-room scene. A distraught man lies suffering in a curtained four poster bed while, on the right, a fat, dishevelled woman sprawls in a chair, snoring. A glass is spilling from her hand and she has kicked over a table, the candle from which is about to set fire to the be dclothes.

Pen and ink and watercolour: $5\frac{5}{8} \times 7\frac{1}{2}$ in (143 × 190 mm).

PROVENANCE Lord Westbury; Colnaghi 1962.

The drunken nurse appears in *The Nursery* in the series for *The English Dance of Death* at the Huntington Library, Wark, 1975, no. 296.

216 Reflections or The Music Lesson

A gouty old man rises in his chair as he sees the intimacy of the music teacher and his young female pupil reflected in the looking-glass above the chimney piece.

Verso, colour splashes.

Pen and ink and watercolour: $4\frac{1}{8} \times 6\frac{1}{8}$ in (104 × 156 mm).

INSCRIBED *T. Rowlandson* in ink lower left.

PROVENANCE H. Reitlinger; Colnaghi 1965.

This is a similar composition to *The Music Master*, (no. 305).

217 The Doctor Overcome

A corpulent doctor (or cleric) asleep in an armchair holding a church-warden in one hand and a glass in the other, is oblivious to a woman caressing a man at the other end of the table on the right. The man sprawling in a chair, puffs tobacco smoke into the air, impervious to her advances.

Pen and ink and watercolour: $4\frac{1}{4} \times 5\frac{7}{8}$ in (108 × 146 mm).

PROVENANCE L. G. Duke (D.855); Colnaghi 1961.

218 'A Maiden Aunt smelling Fire'

The bare-breasted, skinny aunt appears from her bedroom, holding a candle, peering up a balu-straded staircase. She glares angrily at a young man and a maid who are fleeing in opposite directions to their respective rooms, he with flying shirt-tail.

Pen and ink and watercolour: $11\frac{3}{8} \times 8\frac{1}{2}$ in (288 × 216 mm).

INSCRIBED *Rowlandson 1804* in ink, lower left.

PROVENANCE H. S. Reitlinger (Lugt 2274a); Davis Galleries 1967.

ENGRAVED by Rowlandson in reverse with the above title and published by him May 1 1806, Grego II, 58.

219 Taunting with Smoke from a Pipe

A grotesque group of three people. An elderly man is shouting in pain from smoke blown into his eye by a coarse young man over whose shoulder a woman laughs at the scene.

Pen and ink and watercolour: $8\frac{5}{8} \times 10\frac{1}{4}$ in. (219 × 261 mm).

INSCRIBED *T. Rowlandson 1823* in ink lower right.

PROVENANCE T. E. Lowinsky (Lugt 2420a); Justin Lowinsky 1963.

Another version entitled *Smoking a Customer* was in the collection of Joseph Grego and is illustrated in Grego II, p. 422.

220 Two Girls Tippling

In a drinking house, two girls sit at a counter with wine glasses and an overturned measure. The foremost girl, overcome with drink, is holding her forehead, her eyes half closed. Her companion seems unaffected. In the background, an uncouth crone is pressing her hands on her ample breasts.

Pen and ink and grey wash: $6\frac{7}{8} \times 6\frac{1}{4}$ in (175 × 155 mm).

INSCRIBED verso, *Ladies in a Tavern*.

PROVENANCE Mrs G. Hopkinson; Agnew 1965.

221 Women Drinking Punch

Three women seated by a table. The one on the left holds the punch-bowl, while the woman in the centre casts a sidelong glance at the tipsy girl on the right.

Pen and ink and grey wash on buff paper: $4\frac{7}{8} \times 7\frac{3}{4}$ in (125 × 197 mm).

PROVENANCE T. E. Lowinsky (Lugt 2420a); Justin Lowinsky 1963.

222 'New Shoes'

A young maid in her kitchen raises her skirt to show her shoes to an undergraduate, who bends low to examine them. A man watches the scene through a latticed window while a cat helps it-self from a bowl on the dresser.

Pen and brown ink and watercolour: $4\frac{3}{4} \times 6\frac{3}{8}$ in (120×162 mm).
PROVENANCE Sir Walter Gilbey; F. Meatyard; T. Girtin; Tom Girtin; John Baskett 1970.
ENGRAVED with the above title by Rowlandson in 1793, in the same direction with some variations, published 1 January; Grego I, pp. 320, 324; B.M. Satires, 8532.

A drawing with the same title but different composition is illustrated in Oppé, 1923, pl. 94.

223 The Undergraduate's Room

A seated undergraduate reads in front of a fire. A maid is making his bed while the housekeeper walks towards the right bearing a tray. Fellow undergraduates are gathered in the doorway.
Pen and ink and watercolour: $4\frac{5}{8} \times 7\frac{5}{8}$ in (117×194 mm).
PROVENANCE Mrs Gilbert Miller, sold Sotheby's 19 March 1970 lot 26 (ill.); John Baskett 1970.

224 The Visitors Being shown the Baby

A standing nursemaid holds a baby forward to be kissed by a woman sitting in a chair. Beside them sits another woman, her hands encased in a muff, and a child stirring a bowl of broth. On the right, the mother is seated by a table with her feet on a footstool.
Pen and ink and watercolour: $4\frac{1}{8} \times 6$ in (105×153 mm).
INSCRIBED *T. Rowlandson* in ink, lower left.
PROVENANCE Colnaghi 1965.
ENGRAVED in reverse in *Miseries of Human Life*, 1808 and copied for *The World in Miniature*, 1816, pl. 1, no. 3 in the same direction as the drawing with variations, titled *A Lying-in Visit*; Grego II, pp. 312 (ill.), 313.

225 Ladies at Tea

Four fashionable ladies, engaged in conversation, are brought a tray of tea by a manservant. Verso, pen and ink, study of a half-seated man, full length, his hand resting against his cheek, (also illustrated.)

Pen and ink and watercolour: $5\frac{7}{8} \times 9\frac{1}{8}$ in (149×232 mm).
INSCRIBED recto, *Would you please to have another Cup of Tea* at foot of drawing by the artist.
PROVENANCE Colnaghi 1965.

226 'Mr Michell's Picture Gallery, Grove House Enfield 1817'

Three visitors, one a portly client, are examining the picture-filled walls in the rooms of Grove House, escorted by a disgruntled housekeeper. In the background, a painter stands before an empty canvas mixing colours on a palette. A quizzical onlooker stands at his elbow.
Pen and ink and watercolour: $5\frac{7}{8} \times 9\frac{3}{8}$ in (150×237 mm).
INSCRIBED as title in ink lower left, by the artist.
PROVENANCE Mrs J. E. HAWKINS, 1936; Christie's 22 June 1962, lot 55 (with *Jealousy, Rage, Disappointment*, no. 228); Colnaghi 1962.
EXHIBITED Yale Center, *Pursuit of Happiness*, 1977, no. 89.

Mathew Michell, the wealthy friend and patron of Rowlandson, kept most of his valuable collection of pictures in Grove House although, until his retirement in 1799, he lived in Beaufort Buildings in London, the site of the present Savoy Hotel. Thereafter, he spent most of his time either at Enfield or at Hengar House, Bodmin (see no. 28), Rowlandson being a constant visitor to both places.

227 A Gentleman's Art Gallery

An attractive salon with glazed toplight has pictures hanging from frieze to floor. The connoisseur, sitting at a large table-case, talks instructively to two women and a child. At each side of the fireplace with its shelf of bronzes sit two ladies. A young couple on the left are looking appreciatively at one of the paintings.

Pen and ink and watercolour: $5\frac{3}{4} \times 9$ in (146×229 mm).

PROVENANCE Baskett & Day 1971.

EXHIBITED Yale Center, *Pursuit of Happiness*, 1977, no. 88.

In the Boston Public Library a drawing inscribed *The British Institution, 1816* shows the same table-case, the statue of Mercury(?) and the paintings of the seated nude, high on the left wall.

228 'Jealousy, Rage, Disappointment . . .'

A young soldier swaggers into a room, ushered in by a brother officer and passing a grinning man-servant. He encounters a mixed reception from the parents of two excited daughters standing behind them; the mother extends her arms in welcome while the father seems to dance with annoyance.

Pen and ink and watercolour: $5\frac{3}{4} \times 9\frac{1}{8}$ in (145×231 mm).

INSCRIBED *Rowlandson 1817* in ink, lower right.

PROVENANCE Mrs J. E. Hawkins 1936; Christie's 22 June 1962, lot 55 (with *Mr Michell's Gallery*, no. 226); Colnaghi 1962.

ENGRAVED by Rowlandson for *Scenes at Brighton, or More Misseries, of Human Life* published by A. Beugo 1807 with the title *Jealousy, Rage, Disappointment, Intrigue, Laughter . . .*; Grego II, p. 71; B.M. Satires, 10882.

A similar composition, which features the enraged father but without the mother, is in Princeton University Library with the title *Jealousy or Introduction* and dated 1806.

229 'The Duchess of Gordon's Rout'

A kilted servant indiscreetly reaches down to retrieve tray of glasses which he has dropped. A group of ladies recoil in horror at his impropriety.

Pen and ink: $4\frac{3}{4} \times 8\frac{7}{8}$ in (120×226 mm).

INSCRIBED *The Ducthess of G——d——ns Rout* in ink, lower left, in the artist's hand.

PROVENANCE Dyson Perrins; L. G. Duke (D.3578); Colnaghi 1961.

230 Elegant Company Dancing

A scene in an assembly-room with a formation dance in progress to the music of a string trio on the right. The majority of the males are military officers.

Pen and red ink and watercolour: $4\frac{1}{2} \times 7\frac{3}{4}$ in (115×197 mm).

PROVENANCE F. T. Sabin 1975.

231 The Vinery

Ladies and gentlemen are standing or sitting under a pergola which supports a vine laden with bunches of grapes. A old gentleman on the right leans on his stick to smell a bloom proffered by a young woman and in the background, various tubs and pots contain a luxuriant growth of plants, shrubs and trees.

Pen and ink and watercolour: $7\frac{5}{8} \times 10\frac{7}{8}$ in (195×276 mm).

PROVENANCE T. E. Lowinsky (Lugt 2420a); Justin Lowinsky 1963.

EXHIBITED Arts Council, *Three Centuries of British Water-colours*, 1951, no. 160, pl. IVa.

232 'Quakers Meeting'

The crowded interior of an austere hall, furnished with uncomfortable wooden pews is occupied by women on the left side and men on the right, all with their backs to the viewer. From a balcony surrounding the hall, men look down on proclaimants standing in the congregation below.

Pen and ink and watercolour: $8\frac{1}{2} \times 11$ in (215×280 mm).

INSCRIBED as title in ink, lower right, on a pew.

PROVENANCE Desmond Coke: Christie's 22 June 1962 lot 39; Colnaghi 1962.

AQUATINTED in Ackermann's *Microcosm of London*, 1808–10, facing p. 236.

Another version is in the Art Institute of Chicago.

233 A Legal Wrangle

A scene in a crowded chamber with a legal action in progress. Lawyers and interested parties listen to a jaunty witness who answers a questioning barrister defiantly. One of the figures at the top of the table resembles Charles James Fox. The case is obviously one of public importance.

Pen and ink and watercolour: $6\frac{3}{8} \times 12\frac{1}{4}$ in (162×311 mm).

PROVENANCE T. E. Lowinsky (Lugt 2420a); Justin Lowinsky 1963.

234 Checkmate

An army officer stares confidently across the chess-board at his civilian adversary who, deep in concentration, fingers a piece on the board. A fashionable couple stand behind them, the pretty girl looking admiringly at the officer while her companion directs an approving glance at her.

Pen and ink and watercolour: $5\frac{3}{8} \times 7\frac{3}{8}$ in (137×188 mm).

PROVENANCE James Christie; Agnew 1965.

EXHIBITED Yale Center, *Pursuit of Happiness*, 1977, no. 117.

Another version, more freely drawn, is in the Vassar College Art Gallery, New York.

235 Chess Players

In the foreground two players, one in a high hat, concentrate on their game. Behind them, spectators and, perhaps, another game in progress.

Pen and ink and brown wash: $4\frac{3}{8} \times 7$ in (111×178 mm).

PROVENANCE T. E. Lowinsky (Lugt 2420a); Justin Lowinsky 1963.

LITERATURE M. T. Ritchie, *English Drawings* 1935 pl. 37.

Probably a counterproof.

236 'A Black Leg Detected Secreting Cards' (A Study)

A standing man holding a stick in his left hand makes to strike a reeling figure on his left, whose nose he is grasping with his right hand. Two figures look on from the right hand side of the composition.

Pen and ink: $3\frac{1}{2} \times 5\frac{1}{2}$ in (89×140 mm).

PROVENANCE Dyson Perrins; L. G. Duke (D.3579); Colnaghi 1961.

This rapid sketch is a preliminary study for no. 237.

237 'A Black Leg Detected Secreting Cards'

The central figures appear as in no. 236, playing cards strewn at their feet. On the left, two

figures seated at a table examine more cards. One of them, a gouty man, waves his crutch in vexation. Four other men in attitudes of violent gesticulation complete the scene.

Pen and ink and watercolour: 5 × 7⅞ in (127 × 200 mm).

PROVENANCE G. Norman 1965.

ENGRAVED by Rowlandson for *Scenes at Brighton, or More Misseries of Human Life* published by A. Beugo 1808, pl. 3, *A Black Leg detected secreting cards* . . . ; Grego II, p. 84; B.M. Satires, 11108.

238 The Billiard Room

Men crowd around a billiard table watching a young man about to strike a ball with a mace (the precursor of the cue). On the left a man acts as marker on a score-board with two circular dials. Above the portal of the door is printed *BILLIARD ROOM*.

Pen and ink and watercolour: 4¾ × 7¾ in (121 × 197 mm).

PROVENANCE W. Eastland; John Baskett 1970.

ENGRAVED in reverse in *The Dance of Life* published 1 August 1817, pl. 13, facing p. 230 with the couplet:

> By gambling link'd in Folly's Noose
> Play ill or well, you're sure to loose.

Grego II, p. 360. Abbey, *Life*, 264, 15; Tooley, 410, 15, p. 230.

EXHIBITED Yale Center, *Pursuit of Happiness*, 1977, no. 118.

239 The Gaming Table

An assemblage of low-life gamblers sitting and standing around an oval table. Attention is focused on a young buck with his hand over a dicebox who is smiling tantalisingly at the anxiety of the elderly man next to him.

Pen and ink and watercolour: 5⅞ × 9½ in (150 × 240 mm).

INSCRIBED *Rowlandson 1801* lower left in ink.

PROVENANCE Colnaghi 1963.

EXHIBITED Yale Center, *Pursuit of Happiness*, 1977, no. 119.

240 'The Club Room'

A late evening scene with three men in front of a fire; two are asleep and the third, a disillusioned officer, contemplates the fire, his face in his hands; a yawning servant topples a glass from a tray behind him. In the background, a table surrounded by a crowd of shouting men playing dice. (This may be the gaming room of the Thatched House Tavern, St James's.)

Verso slight pencil sketches of figures.

Pen and ink and watercolour: 4⅞ × 8¾ in (125 × 222 mm).

INSCRIBED as title lower centre and *T. Rowlandson* lower right, in ink.

PROVENANCE Colnaghi 1963.

241 Serving Punch

A grotesque assemblage of drinkers crowd in a pyramid behind an oval table. In the forefront, the belligerent host stirs the punch while glaring at his fawning neighbour. Wens and warts figure prominently on the distorted faces in this macabre scene.

Pen and ink and watercolour: 9½ × 13⅞ in (244 × 352 mm).

PROVENANCE Mickelson's Inc. 1962.

A version, entitled *The Ugly Club*, is in the Huntington Library, Wark, 1975, no. 375 and illustrated in Paulson, 1972, pl. 9; a photograph of another is in the Witt Library files.

242 An Audience Watching a Play at Drury Lane Theatre

A fashionable section of an audience is seated in what would now be called the Grand Circle. Some observe the play through quizzing-glasses; others talk together, while three young beaux gaze up at two beauties who are chaperoned by their mother. In the background, left, are tiers of boxes fully occupied.
Pen and ink and watercolour: $9\frac{1}{2} \times 14\frac{3}{8}$ in (241 × 365 mm).
PROVENANCE Baskett & Day 1976.
Colour plate

243 An Audience at Drury Lane Theatre

A study of expressions varying from rapture to boredom on the faces of a theatre audience.
Pen and ink and watercolour: $8\frac{1}{2} \times 17\frac{1}{2}$ (216 × 460 mm).
INSCRIBED *Rowlandson f.* in ink, lower right.
PROVENANCE Almina, Countess of Caernarvon, 1925; Christie's 22 June 1962, lot 37 (ill.); Colnaghi 1962.

244 Female Dancer with a Tambourin, Performing on a Stage

The dancer, bedecked with plumes and jewellery, sings while she dances. Below her, a row of elderly men peer up appreciatively at her legs and swirling skirts.
Pen and ink and watercolour: $11\frac{5}{8} \times 8\frac{5}{8}$ in (295 × 220 mm).
PROVENANCE L.S. Deglatigny (Lugt 1768a); T. E. Lowinsky (Lugt 2420a); Justin Lowinsky 1963.
LITERATURE Paulson, 1972, p. 81, pl. 45.
EXHIBITED Aldeburgh 1964, no. 38; Colnaghi and Yale 1964–65, no. 28.

The dancer resembles Mme Theodore in the etching *The Prospect before us no. 2* published 13 January 1791, which is dedicated to the singers, dancers etc. at the King's Theatre and at the Pantheon; Grego I, p. 286 (ill); B.M. Satires, 8008.

245 'Modern Grace... or the Operatical Finale of the Ballet of Alonzo e Cara'

Five figures perform the dance. The three principals in the centre foreground are Charles-Louis Didelot (1767–1837), his wife Mme Rose on his right, and Mlle Parisot at his left. The women, including the two in the background, are bare-breasted and the ballet seems to be reaching a happy climax.
Pen and ink and watercolour: $6\frac{7}{8} \times 9\frac{1}{8}$ in (175 × 235 mm).
INSCRIBED as title in ink below drawing in the artist's hand.
PROVENANCE L.G. Duke (D.659); Colnaghi 1961.

This motif was used by Rowlandson for *Opera House* in Ackermann's *Microcosm of London*, II, facing p. 213.

Interest in opera was flagging when this ballet by Oranati was first interpolated as a finale to a performance of 'Alonzo e Cora' in 1796. The scanty apparel of the women dancers, however,

61

prompted an immediate controversy. This focused in the main on Mlle Parisot whose 'attitudes' (especially on one leg) caused hands to be raised in disapproval, as well as some eyes lifted in appreciation. Several caricatures appeared on the issue and this drawing by Rowlandson is based on a print by Gillray (B.M. Satires, 8891).

Rowlandson's title is a mis-spelling of Gillray's 'Alonzo e Caro' which in turn was Gillray's play on the real title 'Alonzo e Cora'. In copious correspondence between Leonard Duke and V. C. Clinton-Baddeley (see photocopy of Duke catalogue, B.M. Print Room), they surmised that Gillray's change of 'Cora' to 'Caro' (flesh) was intentional to meet the public opinion mentioned above.

246 'Actresses Dressing Room at Drury Lane'

In an atmosphere of urgency, three actresses prepare for the next scene. A dresser helps one, who is bare-breasted and buxom, out of her dress. In the background, the other two are likewise rushing through intimate necessities.

Pen and ink and watercolour: $7\frac{3}{8} \times 6$ in (187 × 152 mm).

INSCRIBED as title at foot of drawing in ink, by the artist.

PROVENANCE L. G. Duke (D.52); Colnaghi 1961.

Colour plate

247 The Opera Singers

Two women rehearse a duet. The foremost, a plumed and bejewelled prima donna, clasps her hands and looks upwards soulfully while reaching a top note. Her more modest companion harmonises from the score in front of them.

Pen and ink and watercolour: $5\frac{1}{2} \times 4\frac{3}{4}$ in (140 × 120 mm).

PROVENANCE—Parsons; S. Girtin; Tom Girtin; John Baskett 1970.

EXHIBITED Cambridge, Fitzwilliam Museum, *Drawings by the Early English Watercolourists*, 1920, no. 46; London, Arts Council, *Humorous Art*, 1949–50, no. 3; Sheffield, Graves Art Gallery, *Early Watercolours from the Collection of Thomas Girtin, Jnr.*, 1953, no. 91; London, Royal Academy, *The Girtin Collection*, 1962, no. 101; Yale Center, *Pursuit of Happiness*, 1977, no. 71.

248 The Ballad Singers

Two young women are singing from a ballad sheet; the one on the left rests her left arm on the shoulder of her companion.

Pen and ink and watercolour: $5\frac{3}{8} \times 4\frac{3}{8}$ in (136 × 111 mm).

PROVENANCE—Parsons; S. Girtin 1921; Tom Girtin; John Baskett 1970.

EXHIBITED Cambridge, Fitzwilliam Museum, *Drawings by the Early English Watercolourists*, 1920, no. 45; Sheffield, Graves Art Gallery, *Early Watercolours from the Collection of Thomas Girtin Jnr*, 1953, no. 92; London, Royal Academy, *The Girtin Collection*, 1962 no. 109.

Another version was sold at Sotheby's 18 November 1976, lot 76 (ill.).

249 'A Consultation'

Three doctors with grotesque faces stand outside a sick-room in deep discussion. Through the door, an ailing man in bed is offered a cup of nourishment by a woman in a mob cap.

Pen and ink and watercolour: $10\frac{3}{4} \times 8\frac{3}{4}$ in (272 × 222 mm).

INSCRIBED as title, lower centre and *Rowlandson* lower right, in ink, by the artist.

PROVENANCE Herbert L. Carlebach; John Fleming 1966.

A larger drawing of the three doctors, without the background, is in the Huntington Library, Wark, 1975, no. 459.

250 A Death-Bed Scene

A young woman lies dead in bed with a grief-stricken woman lamenting at her side. In front, on the right, an old nurse harangues an elderly man (probably the doctor) who is withdrawing from the room, glancing backwards towards the dead figure.
Pen and ink and brown wash: $6\frac{3}{4} \times 9$ in (171×229 mm).
PROVENANCE T. E. Lowinsky (Lugt 2420a); Justin Lowinsky 1963.

251 The Maniac

A man with a look of extreme madness attempts to get out of his bed. His wife, her arms around him, tries to restrain him, while his two children grieving at the bedside complete the distressing tableau.
Pen and ink and grey wash: $6\frac{7}{8} \times 7\frac{3}{4}$ in (174×197 mm).
INSCRIBED *Rowlandson 1787* (or 9) in ink, lower left.
PROVENANCE Duleep Singh 1909; S. Girtin; Tom Girtin; John Baskett 1970.

252 The Preacher

In the nave of a large church, a clergyman preaches from a pulpit to an attentive congregation. The wooden pulpit is reached by winding steps with a balustrade. The church's high walls and columns are hung with hatchments and memorial plaques.
Pen and ink and watercolour: $5\frac{7}{8} \times 9\frac{1}{4}$ in (150×184 mm).
PROVENANCE Lady Jane Harriet Pleydell-Bouverie; Martin Hardie; Colnaghi 1961.
ENGRAVED in reverse in *The World in Miniature*, 1816, pl. 38; Grego II, p. 312.

253 The Cloisters of a Monastery

The vaulted passage in a cloister leads up to open doors and archways, giving an impression of infinite recession; the floor is paved with inscribed tombstones. A monk is going through a small doorway on the left and, on the right, another is seated on a stone bench reading.
Verso, colour splashes.
Pen and red ink with blue and grey wash: $4\frac{7}{8} \times 8$ in (123×203 mm).
PROVENANCE Christie's 22 June 1962 lot 58; Colnaghi 1962.

254 Scene in a Monastery

The entrance to, or gallery of, a monastery with archways leading to the cloisters. On the left, a monk enters a doorway and a veiled woman follows while, on the right, a corpulent monk talking to an elderly man points to a monument high up on the wall.
Pen and ink and watercolour: $5\frac{1}{4} \times 7\frac{1}{2}$ in (133×191 mm).
INSCRIBED *T. Rowlandson* in ink, lower right.
PROVENANCE Achenbach Foundation for Graphic Art, San Francisco, sold Sotheby's 24 November 1965, lot 17 (ill.); Colnaghi 1965.

255 A Tour in a Cathedral

A man and a woman question a guide in a gown who points with his stick to a full-length effigy on a railed-in tomb. Set on the wall in front of the couple is a marble memorial bust with an ornamental surround.

Pen and ink with blue and grey wash: $4\frac{1}{2} \times 7$ in (119×178 mm).
INSCRIBED *Rowlandson* in ink, lower left.
PROVENANCE Sabin Galleries 1964.

Similar subjects are illustrated in Hayes, 1972, pl. 117 (dated c. 1800–5) and Wark, 1975, no. 460.

256 Mrs Abington, Reclining on a Couch

Pencil, wash and watercolour: $7\frac{3}{4} \times 11\frac{3}{4}$ in (197×299 mm).
PROVENANCE Colnaghi 1964.

Frances Abington, née Barton (1737–1815), whose origins are obscure, started working life precariously by selling flowers, street-singing and reciting at tavern doors. At the age of 22, she contracted an unhappy marriage with her music master, which resulted in separation. Turning to acting, her progress was slow but eventually she established herself and enjoyed a successful career. Although admiring and being admired by Garrick, she had a difficult and sour relationship with him. After retiring from the stage in about 1790, she made a brief re-appearance seven years later, when it was said that 'Her person had become full and her elegance somewhat unfashionable'.

257 Jack Bannister in his Dressing Room at Drury Lane

The actor is seated in profile facing left while a dresser arranges his hair.
Pencil, pen and ink and brown wash: $6\frac{3}{4} \times 4\frac{1}{2}$ in (172×115 mm).
INSCRIBED at base of drawing *Sketch'd from Mr Bannister Junr. in his dressing | Room at Drury Lane – Decr 23–83–* and above on border *From Old Jack Bannister 55 Gower St. to his Young Friend Wm. Henderson* in ink in the artist's hand.
PROVENANCE T. E. Lowinsky (Lugt 2420a); Justin Lowinsky 1963.
LITERATURE M. T. Ritchie *English Drawings*, 1935, p. 35 ill.; Hayes, 1972, p. 73, pl. 9.

'Jack' Bannister (1760–1836) was a fellow student with Rowlandson at the Royal Academy during the keepership of Moser, see no. 265. According to Nollekens, Bannister's high-spirited antics were the despair of George Moser and subsequently led him to seek Garrick's advice about a stage career for Bannister. He specialised in comic parts and his active career continued to be highly successful until 1815. At the date of this drawing he was aged 23 and just married. The allusion by 'Old' Jack Bannister to his 'Young Friend' William Henderson is presumably humorous, as Henderson was an older actor with an established reputation at this time.

258 Interior of a Dressing-Room with Jack Bannister the Actor

An actress is seated with her back to the spectator, having her hair arranged by a figure drawn in outline. She is engaged in conversation with Bannister who is seated opposite her on a dressing table. On the right, a seamstress makes some alteration to a gown.
Pencil, pen and ink and watercolour: $5 \times 8\frac{1}{4}$ in (127×210 mm).
PROVENANCE Manning Galleries 1969.
LITERATURE Bury, 1949, no. 11.

259 Portrait of Francesco Bartolozzi

Head and shoulders, looking to right. This is one of the very few portraits by Rowlandson.
Pen and ink and watercolour: $10\frac{1}{4} \times 8\frac{1}{4}$ in (260×210 mm).

INSCRIBED *Francesco Bartolozzi* in ink, lower left.

PROVENANCE T. E. Lowinsky (Lugt 2420a); sold Sotheby's 26 March 1975, lot 277 (ill.); Baskett & Day 1975.

Francesco Bartolozzi (1727–1815), the most productive and skilful of all eighteenth-century engravers, was brought to England from Italy in 1764 by Richard Dalton, Librarian to George III. His genius was immediately recognised and he was appointed Engraver to the King, and was a founder member of the Royal Academy. At 75 years old, still engraving with skill and celerity, he was persuaded by the Prince Regent of Portugal to found a School of Engraving at Lisbon. It was a success and Bartolozzi was knighted by the Prince.

260 The Duchess of Devonshire, her Sister the Countess of Bessborough and a Musician

The sisters are seated on a couch with a music score on their laps. Behind them to the right, a man sings to his own accompaniment on a guitar.

Pen and ink and watercolour: 19⅝ × 16⅞ in (499 × 429 mm).

INSCRIBED *Rowlandson 1790* in ink, lower left.

PROVENANCE George, Fifth Duke of Gordon; Elizabeth, Duchess of Gordon; The Brodie Brodie; Agnew 1963.

LITERATURE Hayes, 1972, p. 138, pl. 75.

EXHIBITED Yale Center, *Pursuit of Happiness*, 1977, no. 66.

The Duchess of Devonshire (1757–1806), like her sister, was an active socialite and created a stir when she canvassed vigorously on behalf of Charles James Fox during the Westminster Election of 1784. Her favours of kisses and bribes in exchange for votes were 'coarsely received by some worse than tars', according to the caustic Walpole (Letters VIII, 469). Apart from this notoriety, she was renowned for her high intelligence and talent for composing poetry. The posture and likeness of the Duchess is very similar to the Gainsborough painting in the National Gallery of Art, Washington.

Another version, without the musician and entitled *The Syrens*, is illustrated in Falk, 1949, facing p. 85.

261 Studies of George III and Statesmen

In three rows: top, Edmund Burke and Lord North; middle, Kaunitz, George III and Lord Thurlow; bottom, William Pitt and Charles James Fox.

Pen and ink: 8 × 6⅛ in (202 × 155 mm).

INSCRIBED names printed in ink and stuck separately below each portrait.

PROVENANCE J. E. Huxtable; Mrs Pape; Colnaghi 1963.

The King is surrounded by the most prominent statesmen of his reign and Prince von Kaunizt-Reitburg, the Australian Chancellor and diplomat.

262 Lord Harrington and Lord Petersham

Lord Petersham stands facing the spectator holding his hat in his right hand and resting his left hand on his hip while clasping his sword. A head of receding curly hair and bush sidewhiskers protrude from the high collar of a cutaway military topcoat. His father, Lord Harrington is seen on his left from behind. Like his son, he is booted and spurred, but he is wearing his hat and a sheathed cutlass hangs from his side.

Pen and ink and watercolour: 8½ × 6½ in (216 × 165 mm).

INSCRIBED *Lord Harrington* and *Lord Petersham* below each figure, in ink in the artist's hand.
PROVENANCE Iolo A. Williams; Colnaghi 1964.
ENGRAVED in reverse by Rowlandson, the figure of Lord Petersham was published January 10 1812; Grego II, 225; B.M. Satires, 11925. A print by Gillray of an almost identical figure of Lord Harrington, with the title *Patern-Staff* was published November 3 1797; Grego, *James Gillray* 1873, p. 231; B.M. Satires, 9070.

Charles Stanhope, third Earl of Harrington (1753–1829), was present at the action on the Heights of Abraham. He was appointed aide-de-camp to General John Burgoyne in the disastrous campaign which ended with Saratoga. In 1792 he was appointed Colonel of the 1st Life Guards. He was succeeded by his eldest son, Lord Petersham.

263 Henderson in the Character of Falstaff

The actor stands, facing three-quarters left, patting his expansive paunch and smiling. He wears a feathered hat, ruff, jerkin, cloak, breeches and hose.
Pencil: $12 \times 10\frac{1}{2}$ in (305×267 mm).
INSCRIBED as title in ink, lower centre in the artist's hand
PROVENANCE L.G. Duke (D.2539); Colnaghi 1961.

John Henderson (1747–1785) was known as the 'Bath Roscius'. He played at Bath for many years before he could get a foothold on the London stage. His mimicry of influential people, sometimes to their faces, gave offence, but ultimately he was acclaimed by Garrick. Mrs Siddons described him as 'a fine actor, with no great personal advantages'. As a young man he won a premium for a drawing exhibited at the Society of Artists in 1767. He is buried in Westminster Abbey.

264 George Morland

Standing, full length, facing left, striking an attitude with right arm outstretched and left hand tucked in his waistcoat.
Pencil and watercolour: $10 \times 6\frac{1}{8}$ in (254×156 mm).
PROVENANCE L. G. Duke (D.1349); Colnaghi 1961.
George Morland (1763–1804) is the best known English painter of rural and rustic scenes of the eighteenth century. His life is typical of the sad, romantic legend attached to artists with great talent but no resistance to temptation. His character, unreliable and quarrelsome, ruined his marriage, antagonised all but his dissolute companions and caused him to be constantly hounded for debt. He was, however, endowed with the energy needed to meet all vicissitudes and his output in painting, usually of high competence and charm, was prodigious.

In the British Museum there is a full length watercolour of George Morland and three associated pencil drawings by Rowlandson.

265 Portrait of George Moser

The subject is seen, head and shoulders, facing left, wearing cap and smock.
Pen and brown ink: $6 \times 5\frac{3}{4}$ in (152×147 mm).
INSCRIBED lower left *R. Moser RA Keeper of the Royal Academy*.
PROVENANCE G. W. Girtin; T. Girtin; Tom Girtin; John Baskett 1970.
George Michael Moser (1706–1783) was a gold chaser, medallist and enameller. He was a founder member of the Royal Academy and its first Keeper. He had known Hogarth and Roubiliac and was a friend of Dr Johnson and Oliver Goldsmith. Moser would have been in his late

sixties when Rowlandson was a young student at the Royal Academy Schools and the older man's German-Swiss accent and slow manner would have been a perfect butt for Rowlandson's boisterous humour.

Another version is in the British Museum, dated by John Hayes as *c.* 1780.

266 Dr O'Meara Preaching

The seated divine, his hands on a book, smiles unctuously as he looks up to left.
Pen and ink and watercolour: $4\frac{1}{8} \times 2\frac{7}{8}$ in (105 × 73 mm).
INSCRIBED *Doctor O'Meary wishing to be made | a Bishop applied to M^rs. Clarke...in | hopes her influence with the Duke of York | to obtain leave to preach before Royalty | his Sermon was well | received – but unfortunately | for him his Name beginning | with the Letter O... | stopt his preferment* – in ink above subject and *1809 March,* lower left in the artist's hand.
PROVENANCE T. E. Lowinsky (Lugt 2420a); Justin Lowinsky 1963.
ENGRAVED by Hopwood, in the same direction, as a plate to *Trial of the Duke of York* published J. Stratford 1809; Grego II, p. 178; B.M. Engraved Portraits III, p. 371.

The Reverend Doctor was a subject of much comment and caricature; some nine prints were made by Rowlandson. O'Meara approached Mrs (Mary Anne) Clarke, mistress of the Duke of York and notorious for procuring favours for considerations, to secure a bishopric for him. His coy plea that 'he wished to preach before Royalty' was passed to the Duke, and the Doctor duly delivered a sermon at Weymouth. This obviously made no impression and the preferment was withheld. Subsequently, Mrs Clarke was deposed from royal favour and later imprisoned for libel, but she lived well for the rest of her life, admired for her beauty, courage and fund of scandals wittily recounted.

267 'Rogero' Playing his Guitar

Pen and ink and watercolour: $11\frac{1}{4} \times 8$ in (286 × 204 mm).
PROVENANCE L. G. Duke (D.2758); Colnaghi 1961.

'Rogero', a character in the *Rovers*, a parody on German sentimental drama by George Canning and John Hookham Frere, was usually represented as singing a then well-known song, the 'U-niversity of Gottingen'.

268 The Return of the Fleet to Great Yarmouth after the defeat of the Dutch in 1797

In the centre, a naval officer, arm in sling, steps from a boat into the arms of his rejoicing family. On the right, wounded sailors are brought ashore by their loved ones. To the left, wigs, hats and feathers are blown about in a stiff breeze and a lecherous peasant with a wheelbarrow stares at a woman whose dress is lifted by the wind. A flag flies, and on the end of Yarmouth jetty a small crowd assists in landing provisions with the aid of a crane. Out at sea the ships of the line are seen in full sail with their captured Dutchmen.
Pen and ink and watercolour: $10\frac{3}{4} \times 17$ in (273 × 410 mm).
INSCRIBED *Rowlandson Del* in ink, lower right, in the artist's hand.
PROVENANCE Edward VII (an old label on a backboard stated that the Prince of Wales presented the drawing to a Mme Granier); John Baskett 1968.
EXHIBITED National Museum of Western Art, Tokyo, 1970 *English Landscape Painting of the Eighteenth and Nineteenth Centuries*; Kyoto National Museum of Modern Art, Kyoto, 1970–1971, no. 82 (ill.).

The drawing is a romanticised version of a subject engraved 22 October 1797 under the title *Glorious defeat of the Dutch Navy 10th Oct. 1797 by Admirals Lord Duncan and Sir Richard Onslow with a view drawn on the spot of the Six Dutch line of battleships captured and brought into Yarmouth*, Viz. 'Vryheid', 'Gelykeid', 'Wasseneer', 'Delft', 'Hercules' and 'Alkmaar'.
Colour plate

269 The Launching of H.M.S. 'Hibernia' at Devonport 1804

The ship is seen on the right, still upon the stocks. Three traditional flags have been hoisted to celebrate her launching and a large crowd is gathered in small boats, on the jetty, in the shed where the ceremony is taking place and up a gang plank leading to the ship. On the left lie three other Men o'War.
Pen and ink and watercolour: $9\frac{3}{4} \times 15\frac{1}{4}$ in (248 × 387 mm).
PROVENANCE Desmond Coke; Sir Bruce Ingram; Sotheby's October 21 1964, lot 142 (ill.); Colnaghi 1964.
LITERATURE Falk, 1949, facing p. 172, where it was incorrectly described as 'The Launching of H.M.S. Nelson 1805'.

H.M.S. *Hibernia*, 120 guns, was built at Devonport in 1804 and launched under the direction of Joseph Tucker on 15 November of that year. She was the flagship to Admiral Lord Gardner in the blockade of Brest in 1805 and was commanded by Capt. C. M. Schomberg in the blockade of the Tagus in 1807. During her career, she flew the flags of Earl St Vincent, Sir Sydney Smith and Sir William Parker.

270 'The Sailor's Return'

A sailor is seated on the left of a table, holding a bowl in his right hand. He passes some coins to the young harlot seated opposite him. A smiling procuress stands in the doorway on the left, chalking up a board.
Pen and ink and watercolour: $8\frac{5}{8} \times 6\frac{7}{8}$ in (220 × 175 mm).
INSCRIBED as title in ink, lower left, in the artist's hand.
PROVENANCE Dr R. E. Hemphill, sold Christie's 22 Feb. 1966 lot 172; Colnaghi 1966.
ENGRAVED and published 10 October 1799 by R. Ackermann in reverse with the title *The Sailor's Return*. The print is a companion to *The Soldier's Departure*.

271 Naval Officers and a Bowl of Punch

Between decks three officers are seated at a table. The central figure pours two bottles into a punchbowl. Behind him a laughing servant mops his brow. On the left, the second officer proposes a toast while a third drinks from a bottle.
Verso, tracing of the subject.
Pen and ink and watercolour: $5\frac{3}{4} \times 6$ in (146 × 153 mm).
PROVENANCE L. G. Duke (D.2288); Colnaghi 1961.

This is the left hand portion of an engraving by Rowlandson *Song by Commodore Curtis*, *Tune Cease Rude Boreas* published by Thos. Tegg 1809; the verses below the print parody *The Storm* by G. A. Stevens; Grego II, p. 163; B.M. Satires, 11362.

272 A Dutch Packet in a Rising Breeze

The vessel's deck is occupied with various figures. The helmsman holds the rudder and a sailor is sitting nonchalantly on the right. The background of a choppy sea and wind-tossed ships

explains the attitudes of the passengers, some of whom look decidedly unwell.

Pen and grey ink and watercolour: $7\frac{3}{4} \times 10\frac{3}{4}$ in (197×273 mm).

INSCRIBED *Rowlandson 1791* lower left and *Dutch Packet*, lower centre, in ink in the artist's hand.

PROVENANCE Sir Bruce Ingram; C. A. Hunter, sold Christie's 11 March 1969, lot 97; John Baskett 1969.

LITERATURE Hayes, 1972, p. 41, fig. 33.

273 A Pier at Amsterdam

Version A. A single-masted sail boat containing men, women and a small child lies alongside the end of a jetty to the right. Steps lead up to a platform on which a number of men are unloading packages. A boat with two figures in it is moored on the right and a rowing boat and several sailing vessels are in the left background.

Pen and ink and watercolour: $8\frac{1}{2} \times 11\frac{1}{8}$ in (216×283 mm).

PROVENANCE Lord Radcliffe; Wakefield Young 1965.

This drawing, which is not inscribed, is a version of no. 274. Another version, closer to this drawing than no. 274 and inscribed verso *Drawn at Amsterdam 1792*, is in Birmingham City Art Gallery and illustrated in Hayes, 1972, pl. 89.

274 A Pier at Amsterdam

Version B. This composition relates directly to no. 273 with variations: the boat on the right contains five people, one grasping the steps and in the background there are only two sailing vessels.

Pen and ink and watercolour: $10 \times 11\frac{1}{2}$ in (254×292 mm).

INSCRIBED *Rowlandson 1801* in ink, lower left.

PROVENANCE Colnaghi 1961.

EXHIBITED V.M.F.A., Richmond, 1963, no. 431 (ill.) as *Embarking for the Fleet*.

If the inscription is correct, this version was executed nine years after the example at the Birmingham City Art Gallery.

275 'Distress'

A ship-wrecked crew, in various attitudes of distress and despair, are huddled together in a small single-masted craft with an unwisely hoisted sail in gale-force wind and a heavy sea. An apparently dead man is being cast overboard. Another, standing in the stern with raised hand, attempts to steer, while an oarsman has given up and rests his head on his arm.

Pen and ink and watercolour: $12\frac{1}{4} \times 17\frac{1}{8}$ in (311×434 mm).

PROVENANCE Dr T. C. Girtin; G. W. Girtin; Tom Girtin; John Baskett 1970.

EXHIBITED Cambridge, Fitzwilliam Museum, *Drawings by the Early English Watercolourists*, 1920, no. 46.

ENGRAVED by Rowlandson, published Thomas Palser 1799 (?); Grego I, pp. 372–73 ill.; Oppé, 1923, p. 18, pl. 45.

276 Two Shipwrecked Sailors

A wretched sailor stands shivering in a cove surrounded by steep cliffs, his companion dead at his feet. A barrel and some wreckage have been washed up on the shore.

Pen and ink and watercolour: $10\frac{1}{4} \times 8$ in (261×203 mm).

INSCRIBED *T. Rowlandson* in ink, lower right.

PROVENANCE Herbert L. Carlebach; John Fleming 1966.

277 Shipwrecked Sailors

Two sailors standing on rocks are flying an improvised distress signal to attract the attention of two ships out at sea. Behind them, two other men watch hopefully. In the background, at the foot of steep cliffs, a makeshift shelter has been erected to protect a fifth sailor who lies on his back apparently dying.

Pen and ink and watercolour: $6\frac{1}{2} \times 9\frac{1}{8}$ in. (165×235 mm).

PROVENANCE T. E. Lowinsky (Lugt 2420a); Justin Lowinsky 1963.

278 The Dying Sailor

A half-clothed sailor lies dying in a rocky cove, mourned by another sailor who kneels by his side, hat in hand. A third sailor is given a chair lift by two companions towards a ship's boat which has put ashore to effect the rescue. Further out to sea a ship lies at anchor.

Pen and ink and watercolour: $12\frac{3}{4} \times 10\frac{7}{8}$ in (325×276 mm) oval.

PROVENANCE T. E. Lowinsky (Lugt 2420a); Justin Lowinsky 1963.

279 Study of a Hulk

A former Man o'War, now reduced to a hulk is shored up and grounded on a beach, her decks covered with huts and shacks. Two small sailing vessels lie beached in front of her.

Pencil: 8×14 in (204×351 mm).

INSCRIBED *One of the Old men of War made a Brakewater and fitted for Shipwrights at Sherness.*

PROVENANCE Lord Farnham; Appleby 1967.

Another version is illustrated in F. G. Roe, *Connoisseur*, 1946, Vol. CVXIII, p. 88.

280 The Recruiting Sergeant

A pot-bellied uniformed sergeant stands with a sword under his left arm, holding a bowl. He playfully tosses the King's Shilling which a country bumpkin, a potential recruit, attempts to grasp. A third man stands between them with arms folded, laughing at the scene.

Pen and ink and watercolour: $11\frac{7}{8} \times 8\frac{1}{4}$ in (303×210 mm).

PROVENANCE Desmond Coke; T. E. Lowinsky (Lugt 2420a); Justin Lowinsky; Agnew 1964.

281 An Officer and his Servant

A slim, erect officer walks towards the right, a cane under his right arm. His bearing, well-cut clothes, shapely legs and snugly-fitting spatterdashes contrast with the appearance of his servant who follows him.

Verso, pencil sketch of three labourers digging against a background of trees and houses.

Pen and ink and watercolour: $6\frac{1}{8} \times 3\frac{7}{8}$ in (155×100 mm).

INSCRIBED *T. Rowlandson* in ink, lower left.

PROVENANCE Colnaghi 1962.

282 The Arrival of a Company of Soldiers at an Inn

In the centre three soldiers are unloading provisions and assisting a female passenger from a baggage cart. On the right, in the forecourt of the tavern, a group of soldiers and civilians rest. On the left, an officer directs a soldier who is pushing a wheelbarrow loaded with packages.

Pen and ink and watercolour: $5\frac{7}{8} \times 9\frac{5}{8}$ in (150×244 mm).

PROVENANCE Agnew 1971.

283 'A Review on Blackheath, May 1785'

Spectators on horseback and in carriages fill the foreground of the X-shaped composition. Beyond, towards the right, the cavalry pass in review order. In the far distance on the left is a single windmill.

Pen and ink and watercolour: $7\frac{3}{4} \times 13$ in (196×330 mm).

INSCRIBED as title in ink, lower right, in the artist's hand.

PROVENANCE Agnew 1963.

284 A Review of the Northampton Militia at Brackley, Northamptonshire

In the market place a group of spectators, seen from behind, watch a line of soldiers on parade. Between the troops and the onlookers a small military band is playing.

Verso, colour splashes.

Pen and ink and watercolour: $7\frac{3}{4} \times 10\frac{1}{4}$ in (197×260 mm).

PROVENANCE Colnaghi 1964.

The colonnaded building on the right is the Town Hall, built in 1705 by the Duke of Bridgewater whose family had estates in the area; it can also be identified in *The Market Place, Brackley, Northamptonshire*, no. 17.

A larger version entitled *Brackley, Northampton* is illustrated in Bury, 1949, no. 46.

285 Review of Light Horse Volunteers on Wimbledon Common

In the foreground, a man and a woman are seated in a gig harnessed to a horse which is shying. To their left a rider is drawing in his rearing horse. On the left and right, there are numerous spectators mounted or in carriages. In the far centre, lines of mounted cavalry and limbered artillery pass in review.

Pen and ink and watercolour wash: $9\frac{7}{8} \times 16\frac{1}{2}$ in (250×420 mm).

INSCRIBED *Rowlandson* in ink, lower left.

PROVENANCE Desmond Coke; L. G. Duke (D.2682); Colnaghi 1961.

LITERATURE B. S. Long, *More Rowlandson drawings in the Coke Collection, Connoisseur* 1928, vol. 80, p. 72 (ill.). Hayes; 1972, pp. 36–7, fig. 26.

ENGRAVED by Rowlandson with the title, *The Light Horse Volunteers of London and Westminster / commanded by Col. Herries / Reviewed by His Majesty on Wimbledon Common 5 July 1798* and published July 18 1798 by H. Angelo; Grego II, 394; B.M. Satires, 9238.

This is a preliminary drawing for the composition; the finished watercolour is in the Boston Public Library (Wiggin Collection).

286 A Review in a Market Place

A Falstaffian drill sergeant addresses a line of raw recruits. On the left a mounted farmer drinks from a tankard while his companion speaks to the standing women; on the right several groups of marketgoers converse. Houses line the two sides of the market square behind the figures.

Pen and ink and watercolour: $11\frac{3}{8} \times 17\frac{1}{2}$ (287×445 mm).

INSCRIBED *Review in the Market Place Winchester* lower centre and *T. Rowlandson* lower right, in later hand on the old mount.

PROVENANCE Gilbert Davis (Lugt 757a); Colnaghi 1961.

LITERATURE Hayes, 1972, p. 143, pl. 79.

EXHIBITED N.G. of A., Washington, 1962, no. 62; V.M.F.A., Richmond, 1963, no. 432 (ill.); P.M.L. and R.A. 1972–73, no. 69.

287 'Soldiers on a March'

A group of soldiers with their womenfolk march to the left through a river. Two soldiers carry women on their backs and some of the women have babies in knapsacks while, at the back of the column, an officer is being carried on the back of a young wench.

Verso, traced and indented for etching.

Pen and ink and watercolour; $9 \times 15\frac{1}{4}$ in (228×388 mm).

INSCRIBED recto, as title lower left, *Rowlandson 1805* in ink lower right in the artist's hand and verso, *Soldiers and their baggage fording a river then they pack up their tatters and follow the drum* along the lower edge in pencil.

PROVENANCE F. Meatyard 1966.

ENGRAVED by Rowlandson and published April 1 1808; Grego II, p. 85; B.M. Satires, 11104 (impression in the collection).

A version of this drawing is in Auckland City Art Gallery.

288 Embarkation at Southampton on June 20th after Lord Howe's Action

Version A

A line of infantryman marches down between two cottages and is embarking on dinghies and a longboat. A baggage waggon is drawn up at the waterfront and supplies are being handed into the longboat.

Pen and ink and grey wash: $8\frac{1}{2} \times 11$ in (216×280 mm).

INSCRIBED recto, *June 20th after Ld Hows Action* top right and *Embarcation at Southampton* lower right in pencil; verso, as title in another hand.

PROVENANCE L. S. Deglatigny (Lugt 1768a); Iolo A. Williams; Colnaghi 1964.

During May and early June, 1794 a rather complicated battle took place off the coast of Brittany between the English fleet under the command of Admiral Earl Howe and a French fleet under Rear-Admiral Villaret Joyeuse. The French had put to sea to protect a convoy of provision ships coming to Brest from America, and the British to intercept them. After much manœuvring and a number of engagements, Howe and his command gained the day and six prizes were towed into Spithead on 13 June.

According to Henry Angelo, Rowlandson joined him at Portsmouth to witness the landing of the French prisoners of war, and afterwards went to Southampton where he made a number of sketches of the troops under Lord Moira embarking for La Vendée. This drawing and no. 289 may be two of these sketches.

289 Embarkation at Southampton on June 20th after Lord Howe's Action

Version B

A more detailed and extended version of no. 288. Small craft are shown being rowed out to a group of Men o' War moored on the right of the composition.

Pen and ink and watercolour: $4\frac{3}{4} \times 11\frac{5}{8}$ in (120×295 mm).

PROVENANCE Brigadier C. Huxley; Agnew 1962.

290 Soldiers Embarking

A scene on the sea-shore with soldiers embarking in small boats. In the foreground a group of soldiers and their womenfolk.

Pen and ink and watercolour: $3\frac{1}{4} \times 5\frac{5}{8}$ in (83×142 mm).

PROVENANCE Herbert L. Carlebach; John Fleming 1966.

291 Soldiers Playing Cards while Quartered in a Church

A group of cavalrymen is seated at a table on the right playing cards, drinking and smoking by the light of an oil lamp suspended from the ceiling. The building, with Gothic arches supported by heavy columns, has been converted into a temporary stable and horses feed at a hay rack and manger on the left, observed by a mounted cavalryman.
Pen and ink and watercolour: $7\frac{1}{4} \times 11\frac{3}{4}$ in (185×287 mm).
INSCRIBED *T. Rowlandson* in ink, lower right.
PROVENANCE Herbert L. Carlebach; John Fleming 1966.

292 A Cavalry Barracks

An interior scene in which cavalrymen disport themselves with young women. In the foreground are two boys, one playing the flute and on the right, horses in stalls.
Pen and ink and watercolour: $5\frac{3}{4} \times 9\frac{3}{8}$ in (146×238 mm).
PROVENANCE Dr R. E. Hemphill; Spink 1966.

Another version inscribed *Light Horse Barracks* is illustrated in R. H. Wilenski *English Painting*, 1933, pl. 93.

293 Mounted Cavalry Charging a Crowd

A line of cavalrymen gallops towards the right with raised sabres charging a crowd which is retiring in disorder and confusion. In the background stands a factory chimney.
Pen and ink and watercolour: $3\frac{1}{4} \times 5\frac{7}{8}$ in (82×150 mm).
PROVENANCE Herbert L. Carlebach; John Fleming 1966.

It is possible that this composition may illustrate the 'Peterloo Massacre'. This took place at St Peter's Field, Manchester on 16 August 1819, when a large crowd assembled to petition Parliament for representational reform. Orders were given for a contingent of yeomanry (said afterwards to have been in a drunken state) to charge the crowd. This resulted in the killing of several and the wounding of many. The magistrates were thanked by the Prince Regent but the event aroused enormous resentment and indignation.

294 A Military Escapade

Soldiers, who have just landed by moonlight from a small boat on to a rock, form themselves into a pyramid to assist the escape of a young prisoner who has lowered himself by a sheet from the improbably narrow window of a castle tower. On the right a raised drawbridge is partly visible.
Verso, extensive colour splashes.
Pen and ink and watercolour: $15\frac{1}{4} \times 10\frac{7}{8}$ in (387×276 mm).
INSCRIBED verso *Escape from Prison Walls / by Rowlandson / drawn about 1800* in a later hand.
PROVENANCE Charles Sawyer 1965.
LITERATURE Hayes, 1972, p. 164, pl. 100.

295 Two studies of a (?) French Cavalryman

A grinning cavalryman is seated on his mount facing left in both sketches.
Verso, a fat friar (?) talking to a thin one.
Pen and ink: $4\frac{1}{4} \times 5\frac{3}{4}$ in (108×146 mm).
PROVENANCE Cyril Fry 1966.

296 'Hungarian and Highland Broadsword Exercise'

A cavalryman canters towards the right where he meets two others coming from the opposite direction. He makes to strike with his sabre while one attempts to defend himself and the other discharges his pistol.

Verso, the subject traced in pencil.

Pen and ink and watercolour: $8\frac{1}{4} \times 10\frac{3}{4}$ in (210×272 mm).

INSCRIBED *Cut two and Horses off side protect New Guard* lower centre left, in ink in the artist's hand.

PROVENANCE John Fleming 1966.

AQUATINTED by the artist 1 September 1798 for no. 16 of *Hungarian and Highland Broadsword*, London 1799; Grego I, p. 374; Tooley, 414, no. 4.

A monochrome drawing by Rowlandson of this is in the Victoria & Albert Museum.

297 The Comforts of Bath: 'The Concert'

In an oval room, an orchestra behind a balustrade on the right accompanies a female singer who faces the audience holding the music score before her. In the foreground, men sprawled in easy chairs set a relaxed tone to the scene.

Pen and ink and watercolour: $4\frac{5}{8} \times 7\frac{3}{8}$ in (118×188 mm).

PROVENANCE Bernard Penrose, sold Christie's 14 March 1967, lot 111 (ill.); Colnaghi 1967.

LITERATURE M. C. Salaman, *British Book Illustrations Yesterday and Today*, 1923, p. 13, pl. 45.

AQUATINTED by Rowlandson and published by S. W. Fores, 1798; as pl. 2 of Christopher Anstey's *The New Bath Guide or The Memoirs of the Blunderhead Family*, 1766, Abbey, *Scenery*, 40, p. 33; Tooley, 408.

298 The Comforts of Bath: 'The Pump Room'

Through three tall doors on the left of a high room, cripples are arriving in chairs or sedans. On the right, the well-water is being served in glasses from a counter while in the background two rows of people observe the scene.

Pen and ink and watercolour: $4\frac{5}{8} \times 7\frac{3}{8}$ in (118×188 mm).

PROVENANCE Bernard Penrose, sold Christie's 14 March 1967 lot 113; Colnaghi 1967.

LITERATURE Oppé, 1923, p. 16. pl. 47; F. J. Mather, *Some Drawings by Thomas Rowlandson*, Print Collectors' Quarterly, no. 2, 1912, p. 395 (ill.).

AQUATINTED by Rowlandson and published by S. W. Fores, 1798; as pl. 3 of Christopher Anstey's *The New Bath Guide or The Memoirs of the Blunderhead Family*, 1766, Abbey, *Scenery*, 40, p. 33; Tooley, 408.

299 The Comforts of Bath: 'The Bath'

In surroundings of pillared architecture, groups of men and women, fully clothed even to their hats, walk about up to their armpits in the warm mineral waters. The drawing could have been composed to illustrate Walpole's barbed comment that 'one would think that the English were ducks; they are forever waddling to the waters'.

Pen and ink and watercolour: $4\frac{1}{8} \times 7\frac{1}{8}$ in (108×181 mm).

PROVENANCE Maas Gallery 1964.

EXHIBITED Yale Center, *Pursuit of Happiness*, 1977, no. 14.

AQUATINTED by Rowlandson and published by S. W. Fores, 1798; as pl. 7 of Christopher Anstey's *The New Bath Guide or The Memoirs of the Blunderhead Family*, 1766, Abbey, *Scenery*, 40, p. 33; Tooley, 408.

300 The Comforts of Bath: 'Gouty Gourmands at Dinner'

Two obese men occupy a table loaded with rich victuals supplied by a stream of waiters. The man on the left, his wheelchair pushed by an attendant, points indignantly at the other who, stretching up on his crutches is, licking gravy from a dish held to his mouth.
Pen and ink and watercolour: $5 \times 7\frac{7}{8}$ in (127×200 mm).
PROVENANCE Sir Bruce Ingram (Lugt 1405A); Charles Sawyer 1965.
AQUATINTED by Rowlandson and published by S. W. Fores, 1798; as pl. 9 of Christopher Anstey's *The New Bath Guide or The Memoirs of the Blunderhead Family, 1766*, Abbey, *Scenery*, 40, p. 33; Tooley, 408.

The verse which accompanies the print in the New Bath Guide is a song composed to Mr Gill, a celebrated cook in Bath.

301 The Comforts of Bath: 'The Ball'

In an impressive hall with a pillared balcony surround, the orchestra, grouped in front of the organ, plays to a crowd performing a set dance with onlookers on both sides.
Pen and ink and watercolour: $4\frac{7}{8} \times 7\frac{3}{8}$ in (124×188 mm).
PROVENANCE Bernard Penrose, sold Christie's 14 March 1967 lot 117 (ill.); Colnaghi 1967.
AQUATINTED by Rowlandson and published by S. W. Fores, 1798; as pl. 10 of Christopher Anstey's *The New Bath Guide or The Memoirs of the Blunderhead Family, 1766*, Abbey, *Scenery*, 40, p. 33; Tooley, 408.

302 The Comforts of Bath: 'The Breakfast'

A communal meal is in progress at a long table. The majordomo, hat in hand, is escorting an important-looking woman and her daughter towards the vacant places at the table. In the background, pictures in ornate frames hang between the high windows.
Pen and ink and watercolour: $4\frac{3}{4} \times 7\frac{1}{4}$ in (121×191 mm).
PROVENANCE Bernard Penrose, sold Christie's 14 March 1967 lot 118 (ill.); Colnaghi 1967.
AQUATINTED by Rowlandson and published by S. W. Fores, 1798; as pl. 11 of Christopher Anstey's *The New Bath Guide or The Memoirs of the Blunderhead Family, 1766*, Abbey, *Scenery*, 40, p. 33; Tooley, 408.

303 The Comforts of Bath: 'Gouty Persons Fall on Steep Hill'

Calamities befalling invalids on Circus Hill; a portly man with a crutch is tipped out of his chair in the foreground while on the right, a woman falls backwards out of a sedan chair.
Pen and ink and watercolour: $4\frac{7}{8} \times 7\frac{1}{4}$ in (121×185 mm).
PROVENANCE Bernard Penrose, sold Christie's 14 March 1967, lot 119 (ill.); Colnaghi 1967.
AQUATINTED by Rowlandson and published by S. W. Fores, 1798; as pl. 12 of Christopher Anstey's *The New Bath Guide or The Memoirs of the Blunderhead Family, 1766*, Abbey, *Scenery*, 40, p. 33; Tooley, 408.

304 The Comforts of Bath: Coaches Arriving

A street band, comprising two violins, a clarinet, horn and tambourin, plays while coaches arrive. On the left, a woman at a coach window gives money to a collector for the musicians.
Pen and ink and watercolour: $4\frac{5}{8} \times 7\frac{1}{4}$ in (118×188 mm).
PROVENANCE Bernard Penrose, sold Christie's 14 March 1967, lot 112 (ill.); Colnaghi 1967.
Unpublished study.

305 The Comforts of Bath: The Music Master

While a portly, gouty man sleeps in front of a fire on the right his daughter (or his young wife) is embraced by the young master at the pianoforte behind him.

Pen and ink and watercolour: $4\frac{3}{4} \times 7\frac{3}{8}$ in (121 × 188 mm).

PROVENANCE Bernard Penrose, sold Christie's 14 March 1967, lot 111 (ill.); Colnaghi 1967.
LITERATURE Hayes, 1972, p. 57 fig. 60.

See no. 216 for a similar composition. Other versions are in the collections of N. M. Fleishman, Vancouver and John Baskett, London.

Unpublished study.

306 The Comforts of Bath: Private Practice Previous to the Ball

A corpulent man and his skinny wife practise steps to the time set by the instructor playing his kit. A man appears at the door, laughing derisively.

Pen and ink and watercolour: $4\frac{7}{8} \times 7\frac{3}{8}$ in (124 × 188 mm).

PROVENANCE Bernard Penrose, sold Christie's 14 March 1967 lot 116 (ill.); Colnaghi 1967.

Unpublished study.

307 'Dr Syntax Bound to a Tree by Highwaymen'

The Doctor, deprived of wig, breeches and hose, is bound to a tree on the right. Two girls on panniered horses approach in surprise while their dog barks suspiciously.

Pen and ink and watercolour: $5\frac{1}{4} \times 7\frac{1}{4}$ in (133 × 184 mm).

PROVENANCE Hamill and Barker 1959.
ENGRAVED by the artist in the same direction with variations for William Combe's *The Tour of Doctor Syntax in Search of the Picturesque*, first published in the *Poetical Magazine*, 1809; Grego II, p. 176; B.M. Satires, 11510; Abbey, *Life*, 214, Part 2, no. 5; and in book form, 1812; Grego II, p. 247; Tooley, 427, 4, p. 12.

308 'Dr Syntax Meditating on the Tombstones'

The Doctor stands, hands behind back and feet astride, on a tombstone inscribed *SACRED TO THE MEMORY* while he converses with the sexton who rests on his shovel. Behind him an aged man waits, hat in hand, and two children play at his feet. Beyond them to the right, the Doctor's horse, Grizzle, grazes among the tombstones.

Pen and ink and watercolour: $4\frac{3}{4} \times 7\frac{1}{2}$ in (110 × 190 mm).

INSCRIBED *T. Rowlandson* in ink, lower left.
PROVENANCE John Fleming 1966.
ENGRAVED by the artist in reverse for William Combe's *The Tour of Doctor Syntax in Search of the Picturesque*, first published in the *Poetical Magazine*, 1809; Grego II, p. 177; B.M. Satires, 11516; Abbey, *Life*, 214, Part 8, no. 17; and in book form, 1812; Grego II, p. 247; Tooley, 427, 11, p. 56.

309 'Dr Syntax Copying the Wit of the Window'

The Doctor stands, with his sketching book in his hands, copying lines which have been etched or finger-drawn on some of the window panes. Meanwhile a dog leaps from a chair to steal his breakfast off the table. A maid, seized in an embrace by an ardent swain, accidentally pours hot water from a kettle onto the Doctor's coat-tail.

Verso, tracing of subject and money sums.

Pen and ink and watercolour: $5\frac{3}{8} \times 8\frac{1}{4}$ in (135 × 210 mm).

INSCRIBED *Amuses himself at an Inn with reading the Poetry on the Windows* in ink by the artist at foot of drawing.
PROVENANCE John Fleming 1966.
ENGRAVED by the artist in the same direction for William Combe's *The Tour of Doctor Syntax in Search of the Picturesque*, first published in the *Poetical Magazine*, 1809; Grego II, p. 177; B.M. Satires, 11512; Abbey, *Life*, 214, Part 5, no. 10; and in book form, 1812; Grego II, p. 247; Tooley, 427, 7, p. 32.

310 'Doctor Syntax Loses his Money on the Race Ground at York'

Four horses race to the right past the winning post in front of the grandstand. A small group in the foreground includes Dr Syntax, waving tricorne hat and crop in disappointment at the result. To the left of the grandstand, three windmills are prominent on the skyline.
Pen and ink and watercolour: $4\frac{1}{4} \times 6\frac{1}{4}$ in (108 × 172 mm).
INSCRIBED in ink lower right (incorrectly) *Newmarket*.
PROVENANCE W. Eastland; Agnew 1970.
ENGRAVED by the artist in the same direction for William Combe's *The Tour of Doctor in Search of the Picturesque*, first published in the *Poetical Magazine*, 1810; Grego II, p. 177; B.M. Satires, 11673; Abbey, *Life*, 214, Part 10, no. 21; and in book form, 1812; Grego II, p. 247; Tooley, 427, 13, p. 80.

Another version is in the City of York Gallery (see note to no. 120).

311 'Dr Syntax Made Free of the Cellar'

In the centre, the Doctor carouses with three other jovial figures. A crouching servant on the left draws more liquor from one of the heavy butts under the cellar vaults and on the right, a semi-recumbent man vomits into his hat. Beyond, figures peer down from the top of a staircase.
Pen and ink and watercolour: $5\frac{1}{4} \times 8\frac{3}{8}$ in (132 × 212 mm).
INSCRIBED verso, *Bolton Castle near Malton / Lord Carlisle's* in pencil.
PROVENANCE R. L. Mills 1964.
ENGRAVED by the artist in reverse with variations for William Combe's *The Tour of Doctor Syntax in Search of the Picturesque*, first published in the *Poetical Magazine*, 1810; Grego II, p. 177; B.M. Satires, 11676; Abbey, *Life*, 214, Part 12, no. 26; and in book form, 1812; Grego II, p. 247; Tooley, 427, 16, p. 102.

This drawing bears a certain similarity to no. 19.

312 'Dr Syntax Sketching the Lake'

Preparatory sketch for no. 313. A pencil outline study with ruled margins in the upper left part of the sheet.
Pencil: $6\frac{1}{2} \times 9\frac{5}{16}$ in (165 × 239 mm).
INSCRIBED in the lower margin:

> *But Grizzle, in her haste to pass,*
> *lured by a tempting tuft of grass,*
> *a luckless slip now chanced to take,*
> *And sous'd the doctor in the Lake*

and in the right margin:

> *Slow Brute he cry'd your noisy glee*
> *I do not want to hear — but see: —*
> *Tho' by the Picturesquish Laws*
> *You're better too with open Jaws*

in ink.

PROVENANCE Manning Gallery 1968.

While Ackermann was employing William Combe to write verse for the *Poetical Magazine*, each month he sent an etching or a drawing by Rowlandson to Combe's apartment in the King's Bench. Combe then composed lines to describe the illustration and filled out the work to provide continuity. The result was that after three years he had completed the verse which was published as *The Tour of Doctor Syntax in Search of the Picturesque*. The lines in the lower margin were incorporated on page 11 of the *Tour*, but those on the right were rejected.

313 'Dr Syntax Sketching the Lake'

The Doctor, sheltered by an umbrella, is seated in the saddle sketching while his horse, Grizzle, drinks from the water. Behind him, a rustic with rod and basket approaches the lakeside, a dog at his feet. Beyond the Doctor to the left, four figures sit in a boat on the water, three huddled under umbrellas. Mountainous scenery frames the far side of the lake.

Pen and ink and watercolours: $5 \times 7\frac{1}{2}$ in (127×185 mm).

INSCRIBED in pencil lower right *The Doctor arrives at the Lake | in Foggy Weather*.

PROVENANCE Agnew 1962.

EXHIBITED V.M.F.A. Richmond, 1963 no. 419.

ENGRAVED by the artist for William Combe's *The Tour of Doctor Syntax in Search of the Picturesque*, first published in the *Poetical Magazine*, 1810; Grego II, p. 177; B.M. Satires1 1677; Abbey, *Life*, 214, Part 13, no. 28; and in book form, 1812; Grego II, p. 247; Tooley, 427, 17, p. 110.

314 'Dr Syntax and the Dairymaid'

The Doctor is seated, hands on knees, by the side of the demure dairymaid who holds a bowl of cream in her lap. On the left of the room a milk churn stands beside a shelf on which a cat is drinking from a dish. On the right, near a press, a woman looks through the door.

Pen and ink and watercolour: $5\frac{1}{4} \times 7\frac{7}{8}$ in (133×200 mm).

INSCRIBED under the mount *N* (sic) *35 The Doctor makes strong Love over a Bowl of Cream, and endeavours | to enforce his old friend Madam's Doctrine on the Plurality of Wives*.

PROVENANCE Hamill and Barker 1959.

ENGRAVED in reverse by the artist for William Combe's *The Tour of Doctor Syntax in Search of the Picturesque* first published in the *Poetical Magazine*, 1810; Grego II, p. 177; B.M. Satires, 11682; Abbey, *Life*, 214, part 18, no. 38; and in book form, 1812; Grego II, p. 247; Tooley, 427, 22, p. 156.

The inscription does not relate to Combe's text in the published work and may have been connected with an alternative, but discarded theme, for which no. 320 *Kitty Overcome* and no. 319 *Dr Syntax and Kitty Cowslip* were studies.

315 'Dr Syntax Visits a Boarding School for Young Ladies' Version A

The Doctor is seated beneath a tree on a bench with the Principal of the school. With right arm raised, he addresses the young ladies who are gathered round him. In the distance, on the left, is a temple among trees.

Pen and ink and watercolour: $5\frac{1}{4} \times 8\frac{1}{8}$ in (132×207 mm).

PROVENANCE Hamill and Barker 1959.

ENGRAVED by the artist in the same direction for William Combe's *The Second Tour of Doctor Syntax Search of Consolation*, 1819; Grego II, p. 250; Abbey, *Life*, 266, part 2, no. 6; Tooley, 428, 17, p. 225.

316 'Dr Syntax Visits a Boarding School for Young Ladies' Version B

Version in reverse of no. 315.
Pen and ink and watercolour: $5\frac{1}{8} \times 8\frac{1}{4}$ in (130 × 210 mm).
INSCRIBED *T. Rowlandson* in ink, lower right.
PROVENANCE Walter Schatzki 1962.

317 'Dr Syntax Painting a Portrait'

The Doctor, standing in front of a large canvas by the window of an ornate room, paints a large seated woman while her son, daughter and grandchild look on. A servant bearing refreshment enters through a door on the left.
ETCHED OUTLINE and watercolour: $4\frac{1}{2} \times 7\frac{1}{2}$ in (115 × 191 mm).
INSCRIBED *Rowlandson* in ink, lower left.
PROVENANCE John Fleming 1966.
ENGRAVED by the artist for William Combe's *The Second Tour of Dr Syntax in Search of Consolation*, 1820; Grego II, 250; Abbey, *Life*, part 5, no. 13; Tooley, 428, 19 p. 242.

318 'Dr Syntax Soliloquising'

Doctor Syntax has risen from his studies and looks out from a porch at a distant crowd of figures at a fair; he stands in a declamatory attitude with his hands behind his back. Two small dogs are at his right foot and his elderly housekeeper works at a spinning wheel under a birdcage suspended from one of the columns on the right.
Verso, subject traced in pencil.
Pen and ink and watercolour: $4\frac{3}{4} \times 7\frac{3}{4}$ in (120 × 197 mm).
PROVENANCE John Fleming 1966.
ENGRAVED by the artist in the same direction for William Combe's *The Third Tour of Doctor Syntax in Search of a Wife*, 1820; Grego II, p. 251; Abbey, *Life*, 267, part 1, no. 3; Tooley, 429, 2, p. 10.

319 Dr Syntax with Kitty Cowslip

The Doctor bends to kiss the hand of Kitty Cowslip who stands with another maiden and a shepherd in front of fairground tents. On the right women are selling pottery and behind them is a small group making merry in front of a cottage.
Pen and red ink and watercolour: $5\frac{1}{8} \times 8\frac{3}{4}$ in (130 × 215 mm).
INSCRIBED ...*mouth Fair and* | ...*with Kitty Cowslip* in pencil, lower left.
PROVENANCE Colnaghi 1964.

This drawing was not published in the Syntax series but may relate in theme to *Dr Syntax and the Dairymaid*, no. 314 and *Kitty Overcome*, no. 320.

320 Kitty Overcome

The Doctor lifts the bare-breasted Kitty off her feet, and while struggling she snatches off his wig with her right hand. Three figures and a dog rush through the door on the left and on the right, a milk churn lies overturned and a cat with his dish of milk falls from a shelf.
Pen and red ink and watercolour over pencil: $5\frac{1}{2} \times 7\frac{7}{8}$ in (140 × 174 mm).
INSCRIBED recto, under the mount, *N[o]36. Kitty not to be overcome by the Doctors elocution | he suffers his passion | to overcome his Reason and is caught in the act of taking unwarrantable liberties*

and verso, in red ink by the artist *The Doctors Passions overcomes his Reason and attempts unwarrantable | liberties with Kitty.*
PROVENANCE Hamill and Barker 1959.

Dr Syntax and the Dairymaid, no. 314 which was published in the *Picturesque* is marked N[0]36 on the old mount although it appeared as no. 38, pl. 11, Vol. 3 in the *Poetical Magazine*. In the poem as published, Syntax did not indulge in any impropriety, but was accused of doing so by the mother through a misunderstanding which was quickly cleared up. The numbering of the above drawing, together with the introduction of the milk churn and cat, gives us to understand that the author originally intended to place Syntax in a more compromising situation, but changed his mind. This drawing was unpublished.

321 Dr Syntax Alarmed by a Whale

The Doctor, riding along the beach on his horse Grizzle, is surprised by a huge whale which, with head upraised and mouth open, appears from the shallows on the right. Doctor Syntax throws up his arms and legs in horror and his hat and wig fly through the air. To the left, two figures and a horse flee under an escarpment above which is a village.
Pen and red ink and watercolour: $5\frac{3}{4} \times 9$ in (145×227 mm).
INSCRIBED as title in red ink, lower right.
PROVENANCE Walter T. Spencer 1966.

This subject was not published in the Syntax series; for others see Martin Hardie, *Connoisseur*, 1907, Vol. XVIII, pp. 214–219.

Other versions are in the Huntington Library, Wark, 1975, no. 400; in the Victoria and Albert Museum and the Boston Public Library (Wiggin Collection).

322 Dr Syntax Attends the Execution

Three condemned men are seated behind a coffin on a tumbril which approaches an archway. Several mounted figures including the sheriff and Dr Syntax follow behind and the procession is encircled by a crowd of spectators while more onlookers peer from the windows of surrounding houses.
Pen and red ink and watercolour: $5\frac{3}{8} \times 8\frac{1}{2}$ in (138×215 mm).
INSCRIBED in pencil lower right *Attends the Execution.*
PROVENANCE Sotheby's 20 November 1963, lot 49; Colnaghi 1963.

This subject was not published in the Syntax series.

323 Dr Syntax outside the Halfway House

Below the sign-board the innkeeper brings a tankard of ale to a couple in a gig. On the right, two men converse with the Doctor at a table.
Pen and ink and watercolour: $4\frac{1}{8} \times 6\frac{3}{4}$ in (105×170 mm).
PROVENANCE Edward Marshall, sold Sotheby's 3 May 1961 lot 45; Colnaghi 1961.
ENGRAVED by the artist in *The World in Miniature* 1816, pl. 12 (top) in the reverse direction with the inn-sign of *Half Moon Inn*; Grego II, p. 312.

This drawing was not used in the Syntax series. Another version with the sign-board of the *Half Moon* is in the Boston Museum of Fine Arts.

324 'The Doctor is so Severely Bruised that Cupping is Judged Necessary'

The unfortunate Doctor, revealed in all his skinniness lying on a tester bed, is having heated

glass cups applied to his shoulders and buttocks by a doctor. Three old nurses in attendance bring pots and warming pans to the bedside, behind which a portly man wrings his hands, as indeed does Syntax, at the pain having to be endured.

Pen and ink and watercolour: $5\frac{1}{2} \times 8\frac{3}{8}$ in (142 × 213 mm).

INSCRIBED as title in pencil above drawing.

PROVENANCE W. Eastland, sold Sotheby's 20 November 1969, lot 126 (ill.); John Baskett 1969.

This drawing was not published in the Syntax series.

325 'Time and Death and Goody Barton'

Time is seated on a cart drawn by a skeletal horse and filled with corpses. Behind the cart, Death throws in a protesting figure and Goody Barton emerges from her cottage door, urging her aged husband along as a candidate for Death's attention. Over her shoulder, her soldier lover leans against the cottage porch.

Pen and red ink and wash: $5\frac{1}{8} \times 8\frac{3}{8}$ in (130 × 212 mm).

PROVENANCE Hamill and Barker 1958.

ENGRAVED by the artist in the same direction for William Combe's *The English Dance of Death*, 1814–16, I, pl. 22 with the couplet:

> On with your Dead; and I'll contrive,
> To bury this old Fool alive,

Grego II, p. 332; B.M. Satires, 12432; Abbey, *Life*, 263, Vol. I, 24; Tooley, 411, Vol. I. 22, p. 181.

Another version with Death driving the cart and Goody Barton flinging the unwilling figure into it, is in the Huntington Library, Wark, 1975, no. 277.

326 'Death turned Pilot'

A ship's boat pulls away from two vessels foundering in a storm. The crew wrestle unavailingly with the oars while other figures are thrown about in attitudes of distress. On the heaving stern of the boat, Death grasps the helm with one hand while holding up an hour-glass with the other.

Pen and red ink and watercolour: $5\frac{7}{8} \times 9\frac{3}{8}$ in (150 × 237 mm).

PROVENANCE Alan G. Thomas 1959.

ENGRAVED by the artist for William Combe's *The English Dance of Death*, 1814–16 II, pl. 9 with the couplet:

> The fatal Pilot graps[sic] the Helm
> And Steers the Crew to Pluto's Realm.

Grego II, p. 344; B.M. Satires, 12673; Abbey, *Life*, 263 Vol. II, 47; Tooley, 411, Vol. II, 45, p. 79. Other known versions of this subject; Huntington Library, Wark, 1975, no. 302; New York Public Library (Spencer Collection) and formerly Fitz Eugene Dixon, sold American Art Association, 6 January 1937, lot 139

327 'The Family of Children'

On the right, Jemmy Guest sits at breakfast with 14 of his 16 children; another is on the nurse's knee beside the fireplace while Mrs Guest suckles the latest arrival in the bedroom glimpsed through an open door. A housemaid dries clothing in front of the fire while Death approaches through the door on the left bearing his barbed arrow.

Pen and ink and watercolour: $4\frac{1}{4} \times 7\frac{1}{4}$ in (107 × 185 mm).

INSCRIBED in red ink lower left *ANY COMMANDS TODAY* or *Death paying a charitable Visit* verso, money sums.

PROVENANCE Hamill and Barker 1958.

ENGRAVED by the artist in the same direction for William Combe's *The English Dance of Death*, 1814–16, II pl. II, with the couplet:

> 'Twere well to spare me two or three,
> Out of your num'rous Family.

Grego II, p. 344; B.M. Satires, 12675; Abbey, *Life*, 263, Vol. II, 49; Tooley 411, Vol. II, 47, p. 95.

Another version with variations, among them the introduction of a painting on the right hand wall, is in the Huntington Library, Wark, 1975, no. 304

328 'The Mausoleum'

Melissa's aged father Sir Gabriel Giltspur, bent on his crutch, is aided through the mausoleum door on the left by Death, while her suitor, young Lord Edward, moves to caress her. The lovers turn towards a waiting carriage, a small dog barking at their feet.

Pen and ink and watercolour: 5 × 8¾ in (126 × 222 mm).

INSCRIBED recto, *Rowlandson* in ink lower right, and verso, *The Mausoleum | Your Crabbed Dad is just gone home | and now we look for Joys to come*, in ink in the artist's hand.

PROVENANCE Appleby 1963.

ENGRAVED by the artist in the same direction for William Combe's *The English Dance of Death*, 1814–16, II, pl. 20 with the above couplet; Grego II, p. 347; B.M. Satires, 12684; Abbey, *Life*, 263 Vol. II, 58; Tooley 411, Vol. II, 56, p. 167.

According to Robert Wark, the drawing in the Huntington Library (Wark, 1975, no. 314), began as a counterproof pulled from the above drawing.

A reproduction in the Witt Library inscribed *Your Crabbed wife is just gone home | and now we look for joys to come* shows a couple seated beside a coffin.

329 Death and the Debauchée

A coarse-looking man in a half-tester bed grips the bed clothes in terror while Death enters through the door on the right bearing dart and hour-glass. At the foot of the bed, a woman crouches imploringly before the figure of Death. On the left of the attic room is a dressing-table and some clothes strewn on the floor.

Pen and red ink and wash: 5⅜ × 8½ in (135 × 215 mm).

INSCRIBED as title in ink, lower centre.

PROVENANCE Hamill and Barker 1958.

This subject was not published in *The English Dance of Death*.

330 An Old Man Taunted by Death

Death grasps a tottering old man by the beard while behind him, his young wife looks back over her shoulder at another figure.

Pencil: 8⅝ × 7⅝ in (219 × 194 mm).

PROVENANCE Mrs Mavis Strange 1967.

331 'The Military Adventures of Johnny Newcome'

Dash'd with his suite for Santarem that night. The hero, made an aide-de-camp, with hand on hip and wearing a cocked hat, sits astride a good mettled grey. Behind him, a long-coated figure holds two baggage mules on leading reins and two others, their horses laden with provisions, follow beneath a tree. The outlines of a castle are in the distance.

Pen and ink and watercolour: $4\frac{1}{4} \times 7$ in (108 × 178 mm).

PROVENANCE George: Fifth Duke of Gordon; Elizabeth, Duchess of Gordon; The Brodie of Brodie; Agnew 1962.

ENGRAVED by Rowlandson in the above work, published by Patrick Martin 1815, pl. 12 facing p. 116; Grego II, p. 299; B.M. Satires, 12496; Abbey, *Life*, 378 no. 13; Tooley, 417, 13, p. 116.

332 'The Grand Master or the Adventures of Qui Hi? in Hindostan'

Strange Figures near the cave of Elephanta 1814 Bombay.

A sheet with three tablets of figures resembling portions of a classical frieze, but drawn in caricature of Europeans, some wearing masks with horns and pointed ears.

Pen and red ink and pink wash: 5 × 8 in (127 × 200 mm).

INSCRIBED recto, *AUSPICIO – REGIS. ET SENATUS ANGLIA* above drawing and as title below drawing in ink, and verso, *plate at p. 252 of Adventures of Quiffe Smith* (?) in pencil.

PROVENANCE Iolo A. Williams; Colnaghi 1964.

ENGRAVED in the same direction in *The Grand Master*, text by William Combe, published T. Tegg November 1815; Grego II, pp. 299–301, B.M. Satires, 12745; Tooley, 412, 28, p. 252.

Grego writes 'The intention of this work seems an attempt to hold up the Governor-General (the Marquis of Hastings) to opprobrium, but whether deserved or not, Europeans have small chance of judging.'

'Qui-hi', from the Urdu 'Koi hai' meaning 'Is anyone there?', a call used in India to summon a servant, is a nick-name for an Anglo-Indian (*The Oxford Companion to English Literature*).

333 The Vicar of Wakefield:

Fourteen of the twenty-four illustrations designed by Rowlandson for Oliver Goldsmith's work, Ackermann 1817.

Front.	*The Vicar of Wakefield*
Pl. 3	*The Departure from Wakefield*
Pl. 5	*The Welcome*
Pl. 6	*The Esquire's Intrusion*
Pl. 8	*The Dance*
Pl. 9	*Fortune – telling*
Pl. 10	*The Vicar's Family on the Road to Church*
Pl. 13	*The Vicar Selling his Horse*
Pl. 14	*The Family Picture*
Pl. 16	*The Surprise*
P.. 18	*Attendance on a Nobleman*
Pl. 20	*The Scold, with News of Olivia*
Pl. 21	*The Fair Penitent*
Pl. 23	*The Vicar Preaching to the Prisoners*

Pen and ink and watercolour: average size $4\frac{1}{2} \times 7\frac{1}{2}$ in (113 × 191 mm).

INSCRIBED *T. Rowlandson* in ink below drawings, variously left and right.

PROVENANCE Marquess of Sligo; Bransom Winthrop, sold Parke Bernet 12–13 March 1945; Selima Nahas.
ENGRAVED by Rowlandson and aquatinted; Grego II, pp. 236–7; Tooley, 436 (the book is in the Collection).

334 'The Test'

A mob of dissenters with picks and axes is attacking a church and molesting defenders. Charles James Fox is seen right, blowing a horn on a balcony while men holding money bags enter the door below a sign *Places under Government | to be disposed of | WALK IN WALK IN*.
Pen and ink and grey wash: $11\frac{1}{4} \times 16$ in (289×406 mm).
PROVENANCE L. G. Duke (D.2560); Colnaghi 1961.
ENGRAVED Rowlandson (?) with variations published by S. W. Fores 20 February 1790; Grego I, p. 270 (ill.); B.M. Satires, 7629.

INSCRIBED *The Test* at foot and *Flame of Liberty or the Torch | love of our country or the book* above.
The subject is connected with Fox's motion for the repeal of the Test and Corporation Acts, March 1970.

335 Drury Lane. 'The School for Scandal'

From one of the arches of Drury Lane Theatre, Richard Brinsley Sheridan appears thrusting John Kemble's head on a lance towards a scared and retreating crowd, shouting 'Booo-oo-oo'. A link-boy with torch has fallen to the ground at Sheridan's feet.
Verso, money sums.
Pen and ink and watercolour: $10\frac{1}{2} \times 15$ in (267×381 mm).
INSCRIBED recto, *Thalia's frolick or the Drury Lane Bug'a'boo!* in ink at foot of drawing and verso, *Mr Henry Wigstead Radhishes*.
PROVENANCE L. G. Duke (D.1984); Colnaghi 1961.

This cartoon may allude to the production of 'The School for Scandal' in 1791 when Kemble played the part of Charles Surface but was not a success.

336 'The Prospect Before Us'

Mrs. Schwellenberg, Keeper of the Robes to the Queen, is seen as a fat, coarse creature carrying the bag of the Great Seal and shouldering a mace. She talks over her shoulder to Queen Charlotte, a slight figure with a weak face, who seems completely dominated by the German. William Pitt trails after them, hanging on to the sash of the Queen's dress. Following the group is a small figure representing Warren Hastings. Each figure has a balloon containing rather obscure sentiments.
Pen and ink and brown wash: $8\frac{3}{4} \times 12$ in (223×305 mm).
PROVENANCE Zeitlin and Ver Brugge 1966.
ENGRAVED, possibly by Rowlandson, with the above title, published 20 December 1788; Grego I, p. 230; B.M. Satires, 7383.

The cartoon implies the Prime Minister, William Pitt's ambition to act as Regent during the mental illness of George III in 1789, and is one of the many satires on the subject.

337 'Concerto a la Catalani'

Half a dozen cats are seated on a round table singing from a book of music propped up in the middle, an owl perched behind it. Two monkeys clad in fancy dress stand on the left, one playing

a wind instrument. Lutes and bagpipes are seen on the right and the head of an irate woman appears at a window to complain of the noise.

Pen and grey ink and watercolour: $5\frac{7}{8} \times 8\frac{1}{4}$ in (138×210 mm).

INSCRIBED as title in ink lower left of centre, in the artist's hand.

PROVENANCE Dr Rigull; Christie's 4 June 1974 lot 109 (ill.); Baskett and Day 1974.

Angelina Catalani came to England at the age of 26 in 1806 and stayed for seven years. Because of the enormous fees she was able to command ($£200$ for a single performance of 'God save the King' and 'Rule Britannia') she strained the financial resources of the King's Theatre, where she mainly performed, until they were not able to afford the engagement of other singers competent in operatic roles, so she eventually became the only singer of eminence. With the help of her equally greedy husband Valabrègue, she managed to dissipate her large earnings in fast living and gambling.

Rowlandson's scorn for her is portrayed in other caricatures in which she is variously referred to as 'The Cat' and 'Madame Catsqualani' (the latter is reproduced in Oppé, 1923, pl. 72).

Another version of this, uninscribed, entitled *The Musical Cats*, is in the Huntington Library, Wark, 1975, no. 346 and illustrated in Paulson, 1972, p. 35, pl. 39 and others in the Princeton Art Museum and the Collection of Sir John Witt.

338 The Heralds

Two men, one mounted on a grey and holding a stick, the other riding a chestnut and blowing a trumpet, move towards the right.

Pen and ink and watercolour: $6\frac{1}{4} \times 7\frac{1}{2}$ in (159×191 mm).

PROVENANCE Iolo A. Williams; Colnaghi 1964.

EXHIBITED I. A. Williams Collection, Sheffield 1952, Aberystwyth 1953, Reading 1959, (no. 100 in each catalogue).

The riders' costumes and the horses' accoutrements date from a period over one hundred years earlier and may have been inspired by the work of such an artist as Stefano della Bella.

339 A Bearded Man

Probably a figure from a classical frieze. Half-length study of an old man with long curling hair and beard, pointing with his right hand over to his left arm.

Watercolour: $11\frac{1}{4} \times 8\frac{1}{8}$ in (285×205 mm).

INSCRIBED *T. Rowlandson* lower left.

PROVENANCE Herbert L. Carlebach; John Fleming 1966.

340 Venus Crowned by Cupid

Venus reclining and being crowned with a garland by one of the four cupids. She holds an arrow taken from a quiver at her side; in the background, a chariot surmounted with doves.

Pen and red ink and watercolour: $5\frac{5}{8} \times 8\frac{3}{4}$ in (143×222 mm).

PROVENANCE Charles Slatkin Inc. Galleries, New York 1971.

Copied from an engraving after Boucher; the original drawing, sold at Sotheby's 10 June 1959, lot 2 was in the reverse direction.

341 Nymphs at a Roman Bath

Four curvaceous, naked maidens disport themselves in and around a bath while a fifth, clothed

and with a feather in her hat, looks on. In the background the columns of a rotunda.
Pen and ink and watercolour: $8\frac{3}{4} \times 7\frac{3}{8}$ in (222×187 mm).
INSCRIBED *T. Rowlandson* in pen, lower left, and *1788* in pencil, lower right.
PROVENANCE Achenbach Foundation for Graphic Arts, San Francisco (Lugt 3a on verso);
Davis Galleries, New York 1967.

342 Spanish Inquisition

A torture room with barred windows contains prisoners, mostly manacled at neck or limbs or
with their feet in blocks of wood; one is suspended from the ceiling while another's head and
hands only appear through a trapdoor on the floor. Most of the men look Homeric and elderly.
Pen and ink and watercolour: $5\frac{1}{2} \times 8\frac{1}{2}$ in (140×216 mm).
INSCRIBED as title in ink, lower right, in a later hand.
PROVENANCE Abbott and Holder 1967.
Another version is in Princeton University Library inscribed *Punishment of Nero*.

343 Study of a Vase

The design portrays *putto* about to cut a bunch of grapes from a vine. The vineleaf design covers
the entire vase and a horned beast and another *putto* form decoration on the waist.
Pen and brown ink: $12\frac{1}{2} \times 9\frac{3}{8}$ in (319×238 mm).
PROVENANCE Abbott and Holder 1974.
Rowlandson made copies from the antique, possibly in the Louvre, in 1814. Several examples
are in the collection of G.D. Lockett Esq., the Clonterbrook Trust, Cheshire, and albums of
similar drawings are in the British Museum.

344 'An Old Coquette outstood her Market'

An elderly spinster, pathetically thin and decrepit, is seen half-length facing left. She wears a
bridal head-dress adorned with flowers, her be-ringed right hand holds back her veil while her
left is encased in a muff.
Verso, colour splashes and a pencil drawing of a similar figure.
Pen and ink and watercolour: $6\frac{11}{16} \times 5\frac{3}{16}$ in (170×131 mm).
INSCRIBED as title, in ink, on the old mount lower left, in the artist's hand.
PROVENANCE Sir Bruce Ingram (Lugt 1405a); Hazlitt, Gooden & Fox 1976.

345 Drawings from the Antique

Thirty-five drawings in an album.
1 Greek warrior with the visor of his helmet drawn over his face $7\frac{3}{8} \times 4\frac{1}{2}$ in (187×114 mm)
2 A Greek woman wearing a helmet (Anthenea?) $7\frac{3}{16} \times 4\frac{1}{2}$ in (183×114 mm)
3 Ceres $7\frac{7}{16} \times 4\frac{1}{2}$ in (189×114 mm)
4 Antinous $7\frac{7}{16} \times 4\frac{1}{2}$ in (189×114 mm)
5 Melpomene $7\frac{5}{16} \times 4\frac{3}{8}$ in (186×111 mm)
6 Mars $7\frac{3}{8} \times 4\frac{1}{2}$ in (187×114 mm)
7 Venus $7\frac{1}{2} \times 4\frac{1}{2}$ in (191×114 mm)
8 Antinous $7\frac{1}{2} \times 4\frac{1}{2}$ in (191×114 mm)
9 Antique Seat of White marble / from the Original at Rome $7\frac{1}{4} \times 4\frac{1}{2}$ in (185×114 mm)
10 Two thrones with claw legs $9\frac{1}{16} \times 5\frac{9}{16}$ in (231×141 mm)
11 Candelabre $7\frac{1}{2} \times 4\frac{1}{2}$ in (191×114 mm)
12 Trepied d'Apollon $7\frac{3}{8} \times 4\frac{1}{2}$ in (187×114 mm)
13 Venus $7\frac{3}{8} \times 4\frac{1}{2}$ in (187×114 mm)

14 Libation $7\frac{1}{2} \times 4\frac{1}{2}$ in (191×114 mm)
15 Monument de deux femmes $7\frac{3}{8} \times 4\frac{1}{2}$ in (187×114 mm)
16 Greek philosopher $7\frac{1}{4} \times 4\frac{1}{2}$ in (185×114 mm)
17 A Greek warrior $7\frac{1}{4} \times 4\frac{3}{8}$ in (185×111 mm)
18 A Greek woman holding a ball $7\frac{1}{4} \times 4\frac{1}{2}$ in (185×114 mm)
19 Chœurs Musicaux $7\frac{1}{2} \times 4\frac{1}{2}$ in (191×114 mm)
20 Greek Lady $7\frac{1}{4} \times 4\frac{1}{2}$ in (185×114 mm)
21 Biga/in the Vatican $7\frac{1}{4} \times 4\frac{3}{8}$ in (185×111 mm)
22 Claudia Italia $7\frac{3}{8} \times 4\frac{1}{2}$ in (187×114 mm)
23 Siège $7\frac{3}{16} \times 4\frac{1}{2}$ in (183×114 mm)
24 Roman General / from the arch of Constantine at Rome $7\frac{1}{4} \times 4\frac{1}{2}$ in (185×114 mm)
25 Libation Heroique $7\frac{1}{4} \times 4\frac{1}{2}$ in (185×114 mm)
26 A mummy, front and back views $5\frac{1}{16} \times 3\frac{5}{8}$ in (129×93 mm)
27 Three Grecian urns $3\frac{5}{8} \times 6$ in (93×152 mm)
28 Jeune fille Romaine $7\frac{3}{8} \times 4\frac{1}{2}$ in (187×114 mm)
29 Grand antique bathing vase of red oriental Granite / from the collection in the Museum of the Vatican $7\frac{5}{16} \times 4\frac{1}{2}$ in (186×114 mm)
30 Autel de Mars $7\frac{1}{2} \times 4\frac{1}{2}$ in (191×114 mm)
31 Greek girl with drapery $7\frac{1}{4} \times 4\frac{1}{2}$ in (185×114 mm)
32 Mariage grec $7\frac{3}{8} \times 4\frac{3}{8}$ in (187×111 mm)
33 Man sitting on a throne $5\frac{3}{4} \times 4\frac{1}{4}$ in (146×109 mm)
34 Greek warrior $7\frac{1}{4} \times 4\frac{3}{8}$ in (185×111 mm)
35 Woman at a well $4\frac{3}{8} \times 6\frac{1}{2}$ in (111×165 mm)
All pen and red ink: average size $7\frac{1}{4} \times 4\frac{1}{4}$ in (184×114 mm)

INSCRIBED *T. Rowlandson* nos. 7, 10, 13, 16, 31, 34, and *T.R.* 2, 3, 6, 8, 9, 11, 12, 17, 28, 32, and 33.

PROVENANCE H. D. Lyon 1970.

Other drawings of antiquities are in the British Museum, the Victoria and Albert Museum and the Huntington Library, Wark, 1975, nos. 467–474.

THE DRAWINGS OF THOMAS ROWLANDSON
IN THE PAUL MELLON COLLECTION

ILLUSTRATIONS

All plates are numbered in accordance with the
catalogue, although, for reasons of size and
subject, they are not always in strict order.

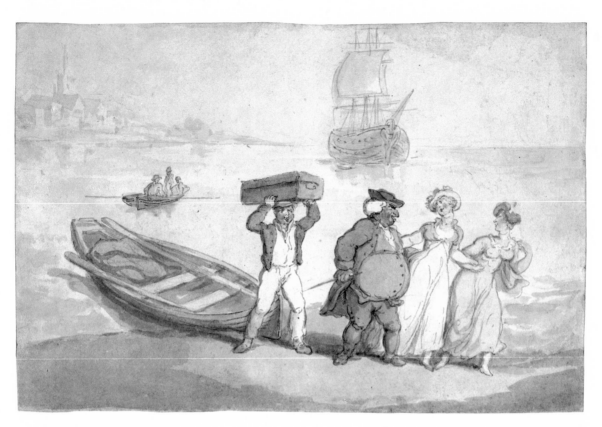

1 'A view at Blackwall' $5 \times 7\frac{3}{8}$ in $(127 \times 187$ mm$)$

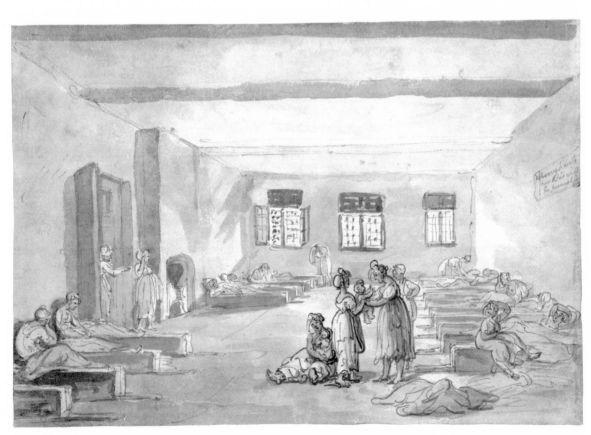

2 'Bridewell, the Pass Room, House of Correction' $7\frac{1}{2} \times 11$ in $(190 \times 280$ mm$)$

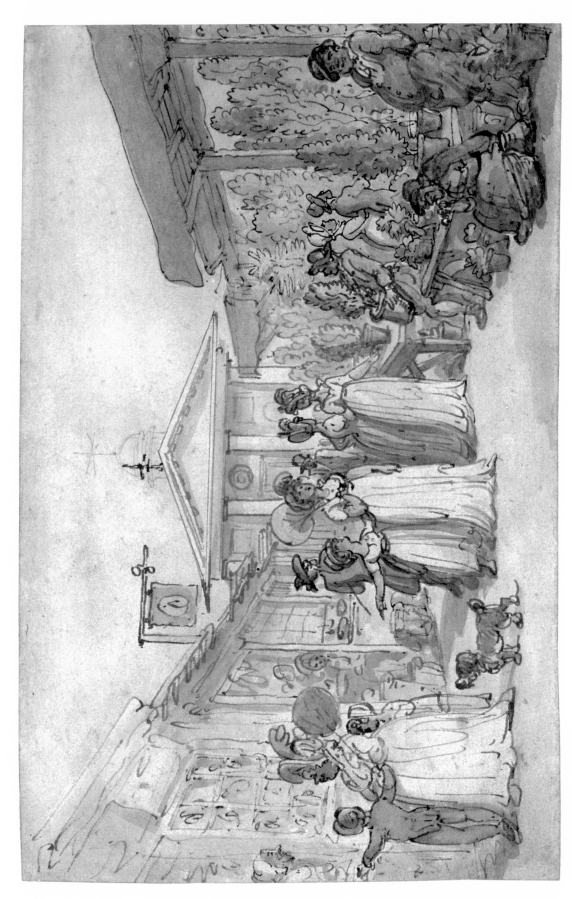

3 Covent Garden Market

$6\frac{1}{4} \times 9\frac{5}{8}$ in (160 × 245 mm)

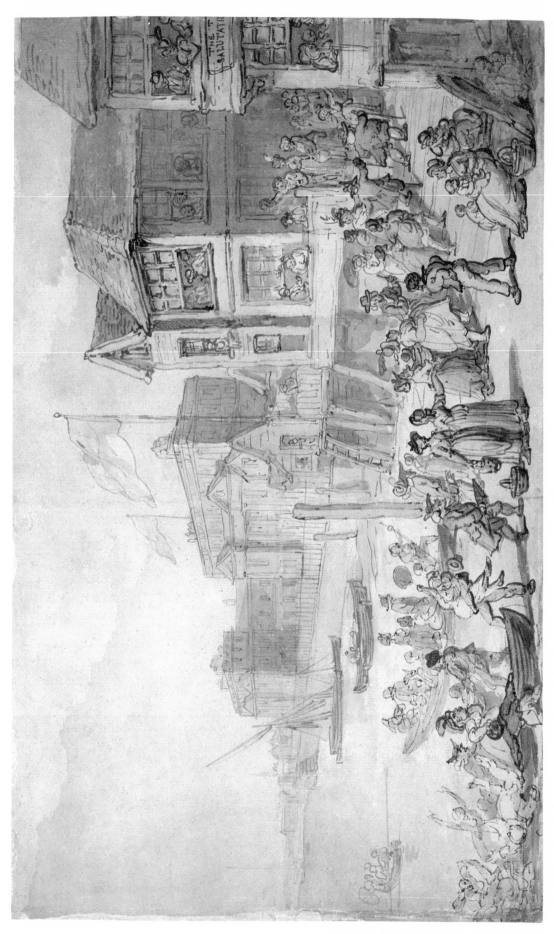

5 Greenwich

$11\frac{1}{4} \times 18\frac{3}{8}$ in (286×476 mm)

6 Hyde Park Corner

$9 \times 24\frac{1}{4}$ in $(230 \times 615$ mm$)$

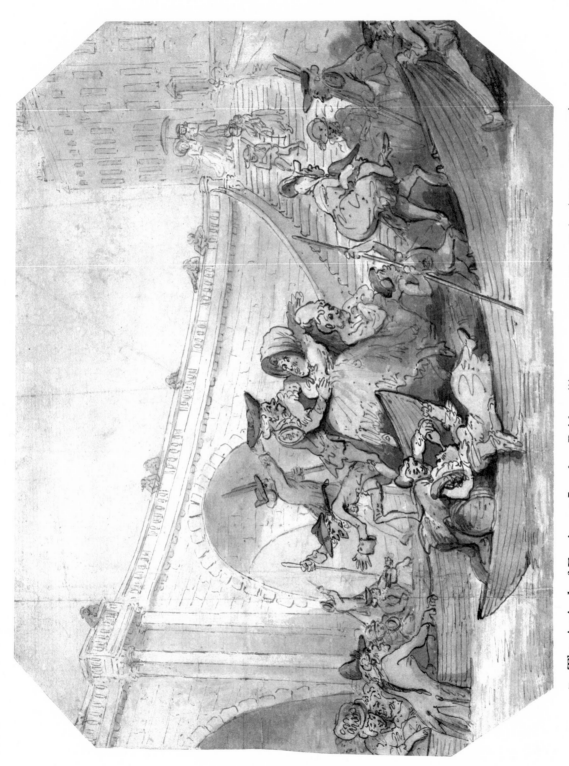

7 The Arrival of Ferries at London Bridge (?) $7\frac{1}{8} \times 9\frac{1}{2}$ in (181×241 mm)

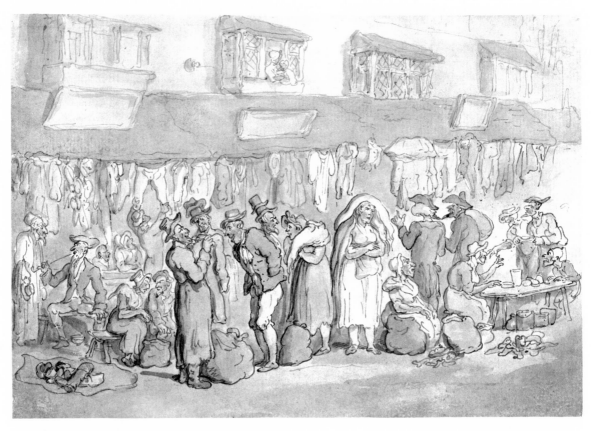

8 Rag Fair or Rosemary Lane 5⅛ × 7½ in (130 × 190 mm)

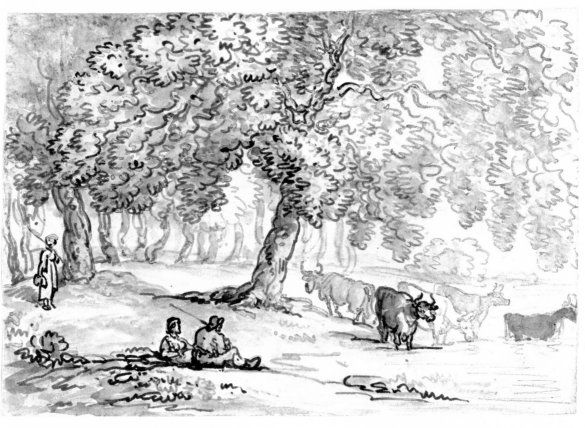

9 'Richmond Park' 4½ × 6½ in (115 × 165 mm)

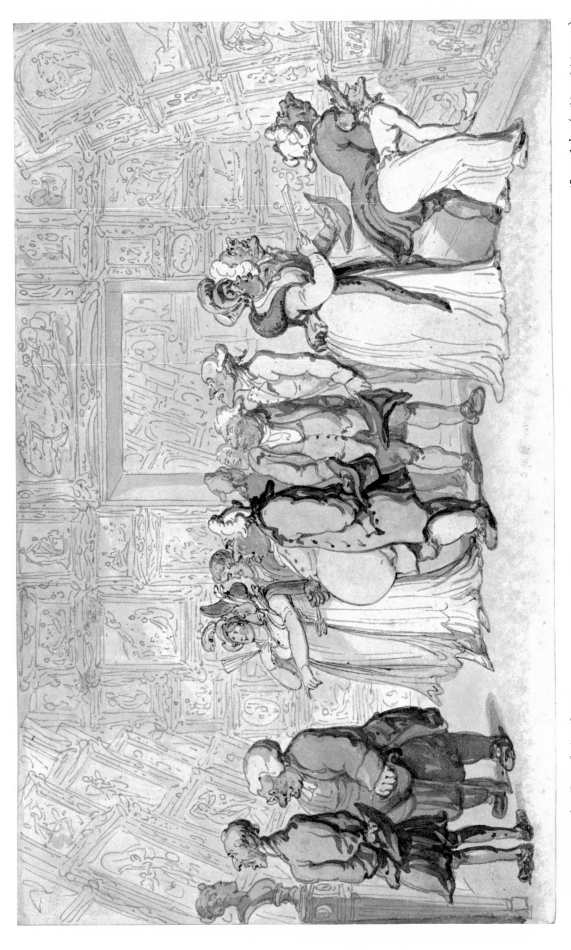

10 Viewing at the Royal Academy

$5\frac{7}{8} \times 9\frac{1}{2}$ in (150×241 mm)

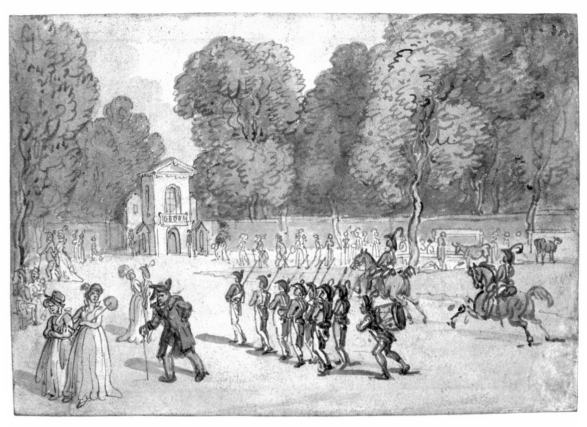

11 Soldiers in St James's Park $5 \times 7\frac{5}{16}$ in $(127 \times 185$ mm$)$

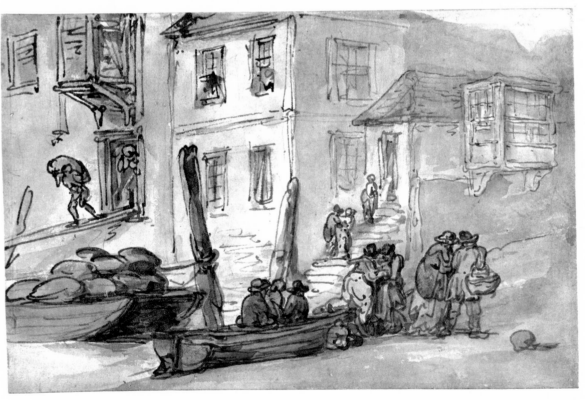

13 Wapping Old Stairs $4\frac{9}{16} \times 6\frac{7}{8}$ in $(116 \times 175$ mm$)$

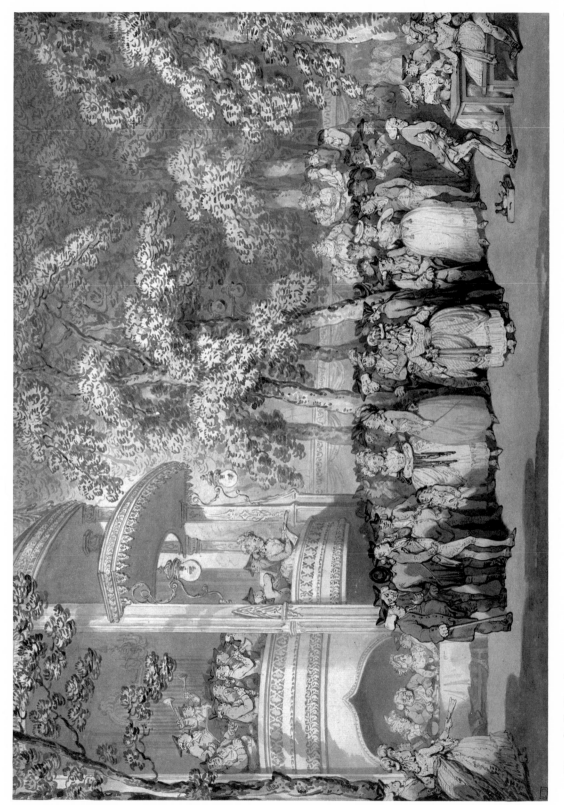

12 Vauxhall Gardens $13 \times 18\frac{3}{4}$ in $(330 \times 476$ mm$)$

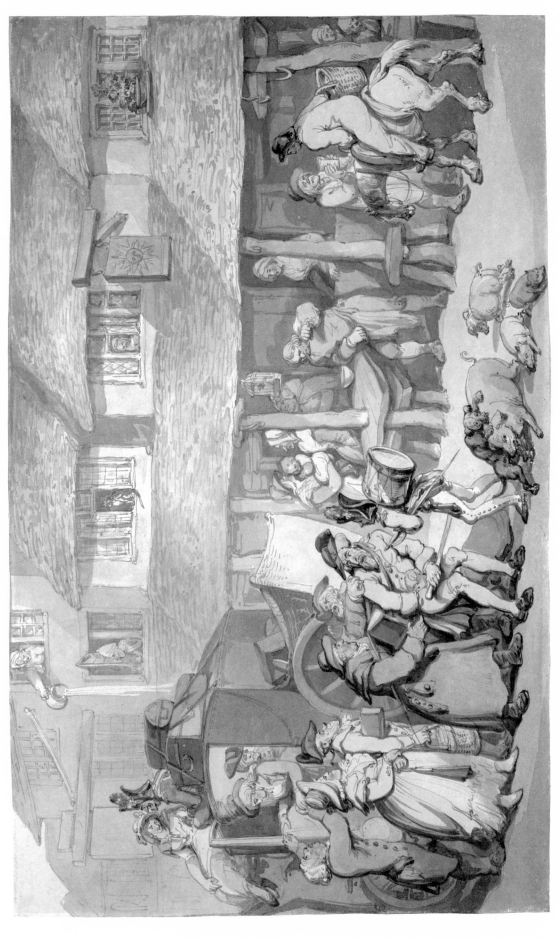

14 Bodmin Cornwall: The Arrival of the Stage-Coach 9¼ × 15 in (235 × 381mm)

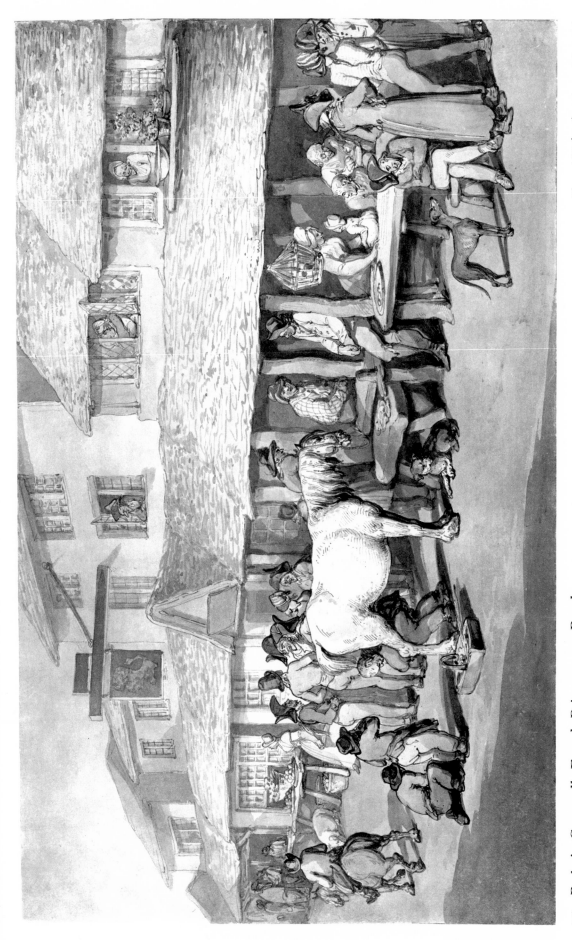

15 Bodmin Cornwall: French Prisoners on Parole $9\frac{1}{4} \times 15\frac{1}{8}$ in $(235 \times 385$ mm$)$

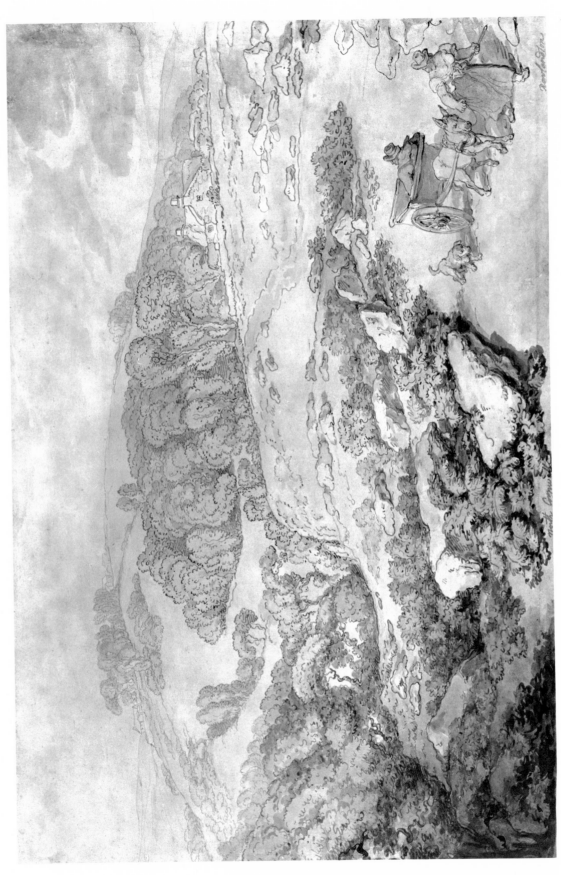

16 Bodmin Moor

$11\frac{1}{4} \times 17$ in $(285 \times 432$ mm$)$

17 The Market Place, Brackley, Northamptonshire

$8\frac{1}{8} \times 10\frac{3}{4}$ in $(205 \times 273 \text{mm})$

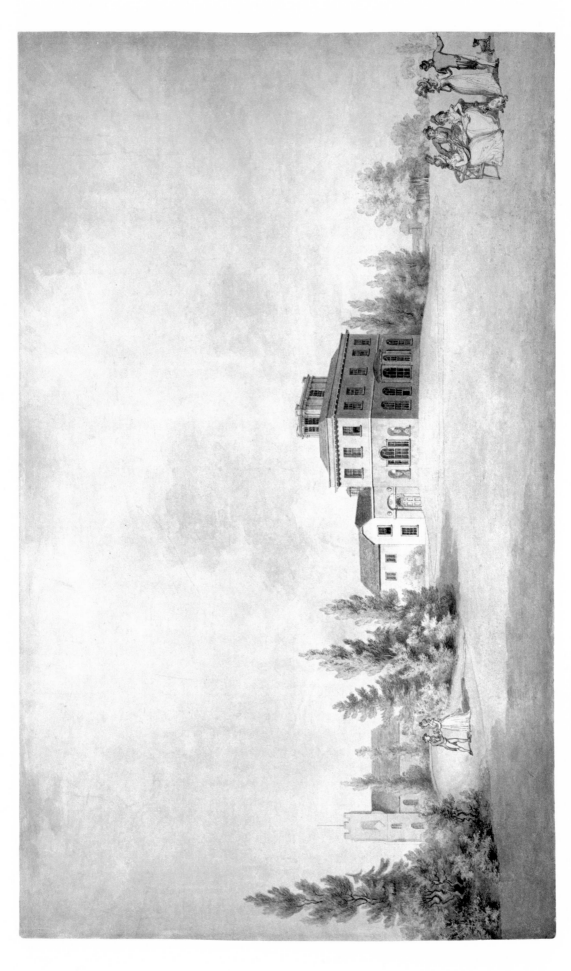

18 Bradwell Lodge, Bradwell Quay, Essex

$13\frac{3}{4} \times 22\frac{5}{8}$ in $(355 \times 578$ mm$)$

Labels visible within the drawing: BRIBERY TAP, SMALL BEER, AQUA POMPAGINA, VINEGAR, HOG WASH, EMPTY BUTT, EMPTY, DREGS, GUIPPS

Alterations in the Ale Cellar at Bullstrode

$5\frac{3}{4} \times 9\frac{1}{4}$ in $(145 \times 235 \text{ mm})$

19 'Alterations in the Ale Cellar at Bullstrode'

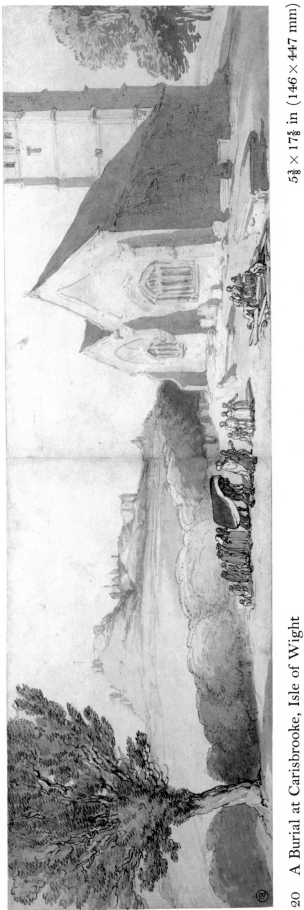

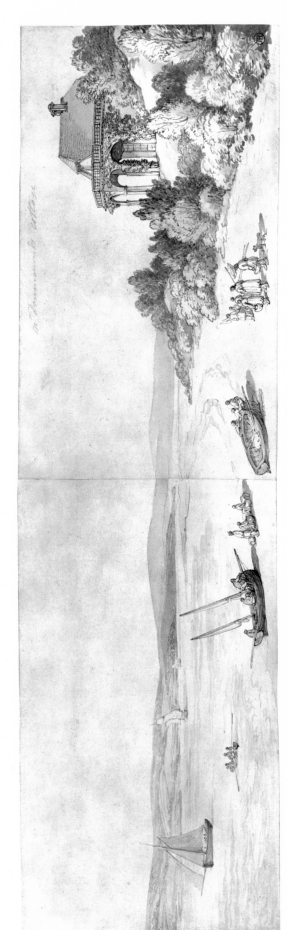

20 A Burial at Carisbrooke, Isle of Wight

$5\frac{3}{8} \times 17\frac{5}{8}$ in $(146 \times 447$ mm$)$

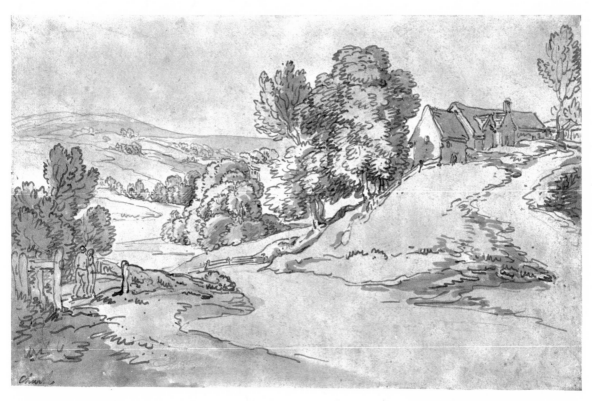

21　'Church'　　　　　　　　　　　　　　　　　　$5\frac{3}{8} \times 8\frac{3}{8}$ in $(135 \times 212$ mm$)$

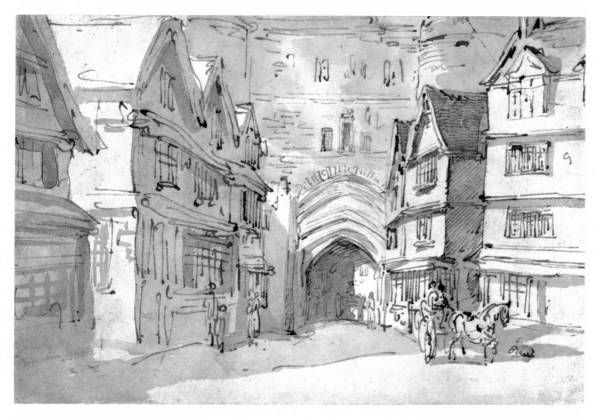

26　The South Gate, Exeter　　　　　　　　　　　$5 \times 7\frac{1}{2}$ in $(122 \times 191$ mm$)$

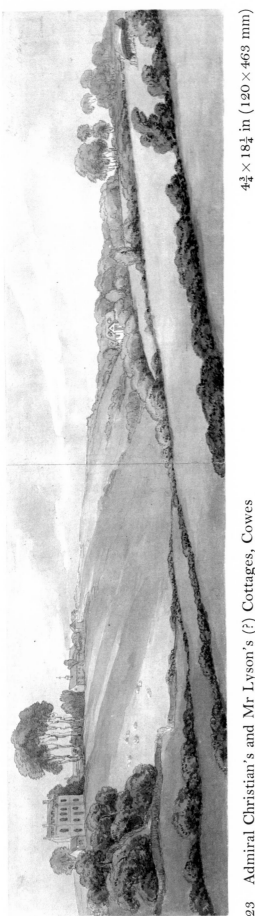

23 Admiral Christian's and Mr Lyson's (?) Cottages, Cowes

$4\frac{3}{4} \times 18\frac{1}{4}$ in (120×463 mm)

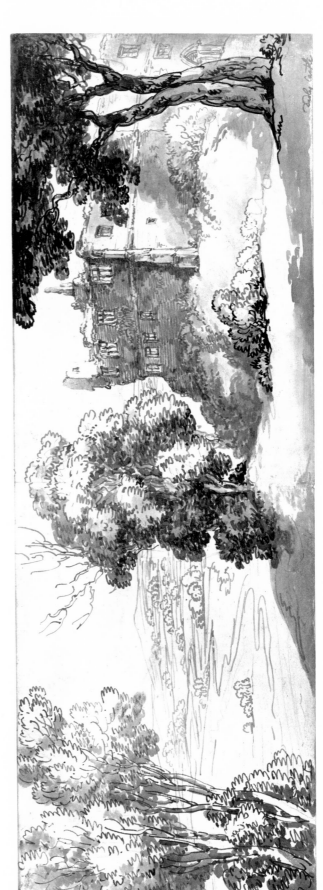

24 'Dudley Castle'

$5\frac{3}{4} \times 16\frac{7}{8}$ in (146×429 mm)

25 'Dunmow'

$5\frac{3}{4} \times 3\frac{1}{2}$ in $(146 \times 89$ mm$)$

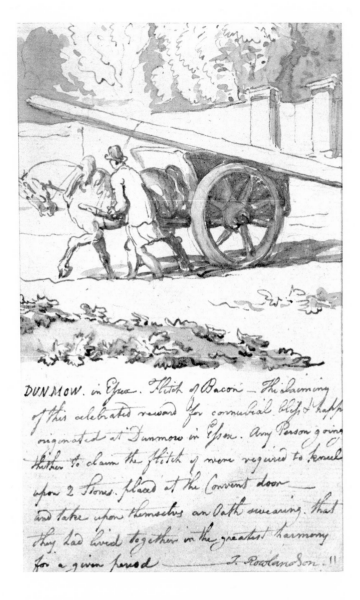

DUNMOW. in Essex. Flitch of Bacon — The claiming of this celebrated reward for connubial bliss & happiness originated at Dunmow in Essex. Any Person going thither to claim the flitch of were required to kneel upon 2 Stones. placed at the Convent door — and take upon themselves an Oath swearing. that they had lived together in the greatest harmony for a given period ——— T. Rowlandson. 11

38 Southampton, the Watergate
and Globe Inn

5×9 in $(127 \times 229$ mm$)$

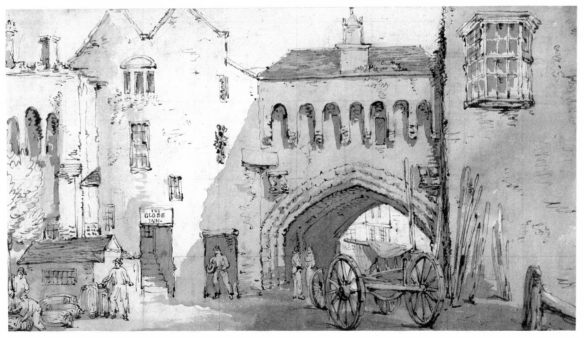

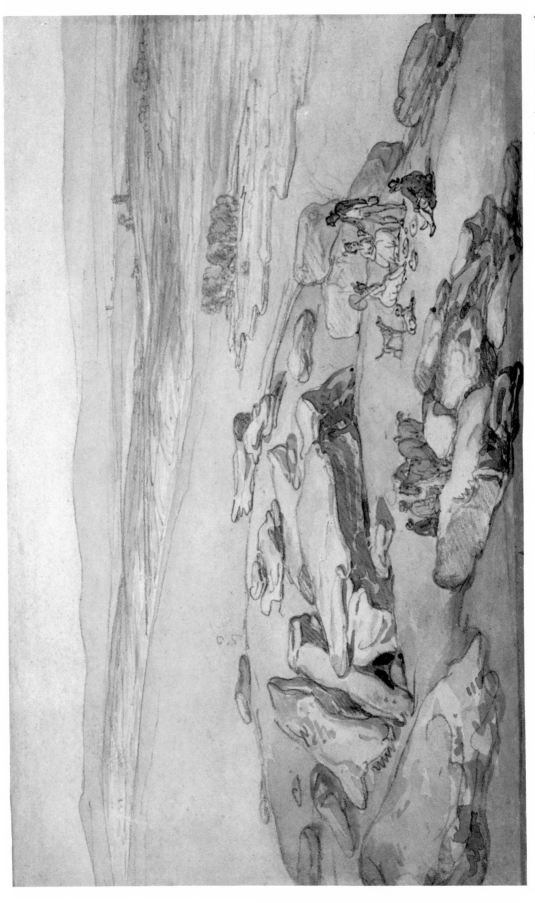

27 View on Exmoor

$5\frac{5}{8} \times 9\frac{1}{4}$ in $(143 \times 235$ mm$)$

28 Hengar Wood, St Tudy, Cornwall

$6\frac{3}{4} \times 10\frac{1}{4}$ in $(172 \times 260$ mm$)$

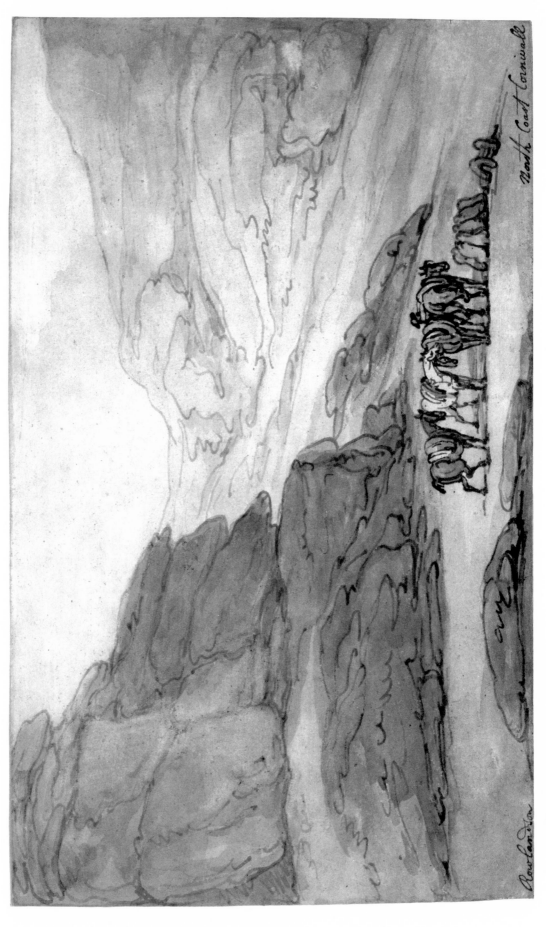

30 Valley of Stones, Lynton, Devon

$5\frac{5}{8} \times 9\frac{1}{4}$ in $(143 \times 236$ mm$)$

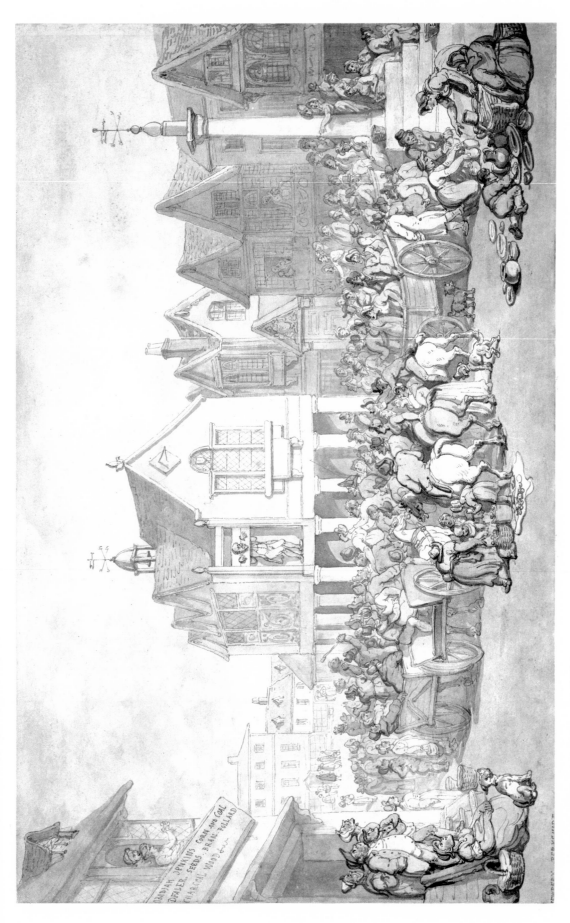

31 Newbury Market Place, Berkshire

$10 \times 15\frac{7}{8}$ in $(254 \times 403$ mm$)$

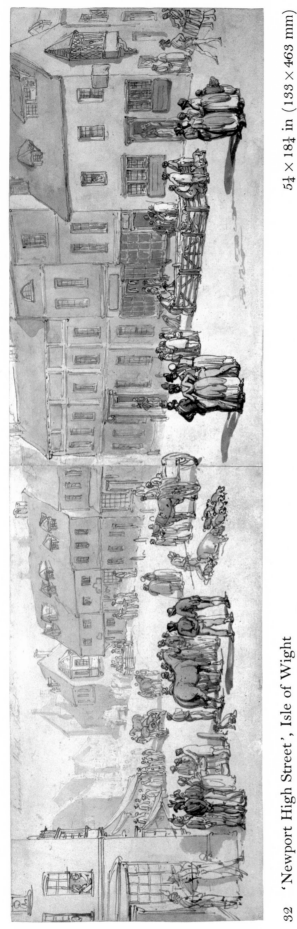

32 'Newport High Street', Isle of Wight $5\frac{1}{4} \times 18\frac{1}{4}$ in $(133 \times 463$ mm$)$

37 'Sandown Fort' $4\frac{3}{4} \times 17\frac{1}{8}$ in $(120 \times 435$ mm$)$

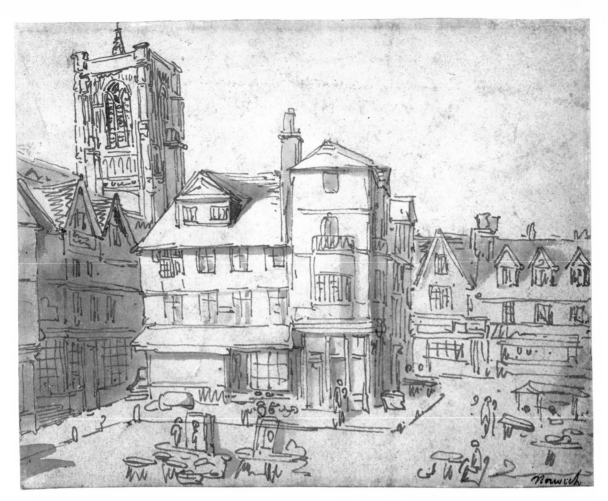

33 (recto) Norwich Market Place $5\frac{3}{8} \times 6\frac{3}{4}$ in $(137 \times 170$ mm$)$

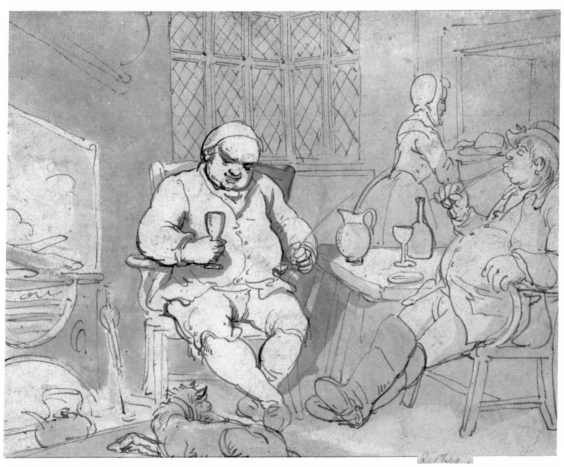

33 (verso) Two Men Drinking by a Fireside $5\frac{3}{8} \times 6\frac{3}{4}$ in $(137 \times 170$ mm$)$

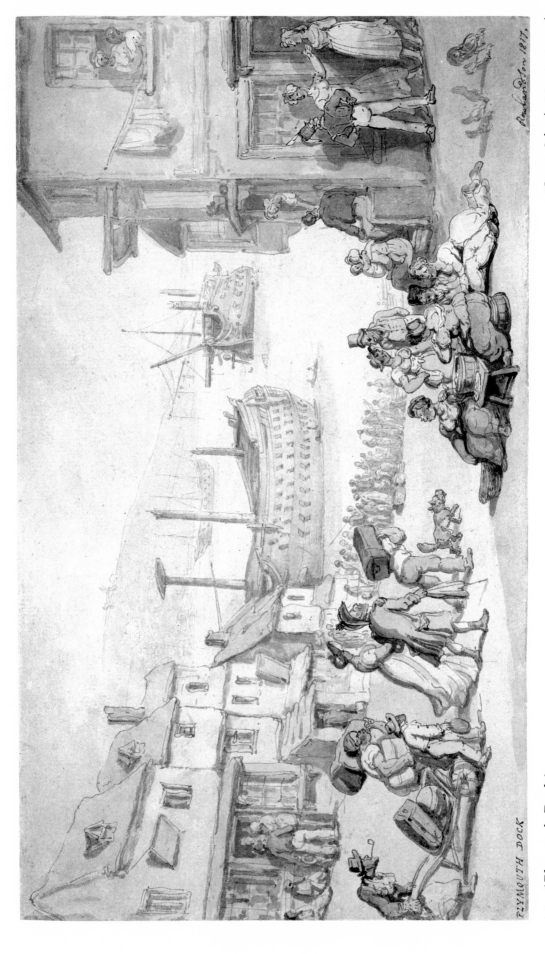

34 'Plymouth Dock'

$6\frac{7}{8} \times 11\frac{5}{8}$ in $(165 \times 295$ mm$)$

35 Richmond, Yorkshire

$8\frac{3}{4} \times 12\frac{5}{8}$ in $(222 \times 321$ mm$)$

36 View of the Church and Village of St Cue, Cornwall

$6\frac{3}{4} \times 10\frac{1}{4}$ in (172×260 mm)

39　Tintagel Castle　　　　　　　　　　　　　　$9\frac{1}{2} \times 12$ in $(241 \times 305$ mm$)$

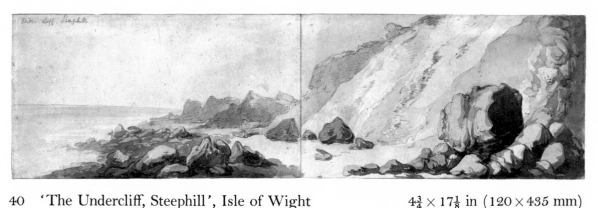

40　'The Undercliff, Steephill', Isle of Wight　　　　$4\frac{3}{4} \times 17\frac{1}{8}$ in $(120 \times 435$ mm$)$

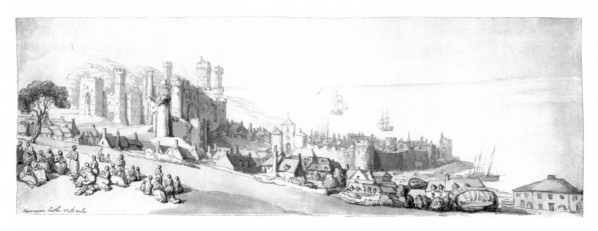

41 'Carnarvon Castle, North Wales' $5\frac{5}{8} \times 16$ in $(134 \times 406$ mm$)$

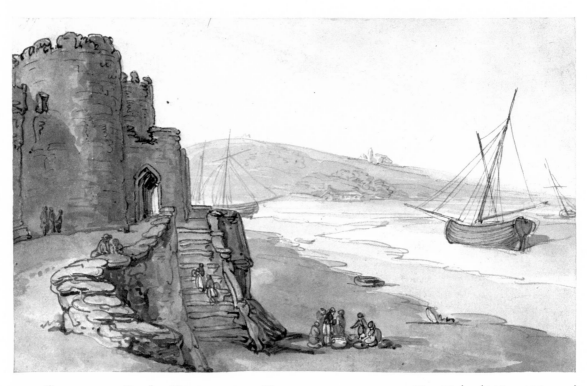

42 Caernarvon Castle, Entrance to a Tower $4\frac{5}{8} \times 7\frac{5}{8}$ in $(118 \times 190$ mm$)$

43 Falls on the River Conway, North Wales $7\frac{3}{4} \times 11\frac{1}{4}$ in (197 × 290 mm)

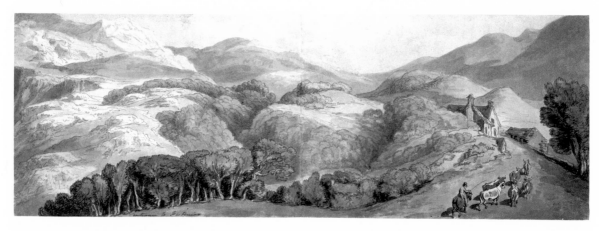

44 'Entrance to Festiniog', Wales $5\frac{5}{8} \times 16\frac{3}{8}$ in $(142 \times 415$ mm$)$

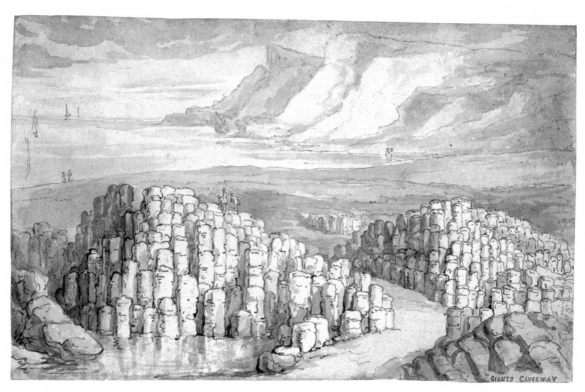

45 'Giant's Causeway', Antrim, Ireland $5\frac{3}{4} \times 9\frac{1}{4}$ in $(146 \times 235$ mm$)$

46 'Customs House at Boulogne' $8 \times 11\frac{1}{2}$ in $(203 \times 294 \text{ mm})$

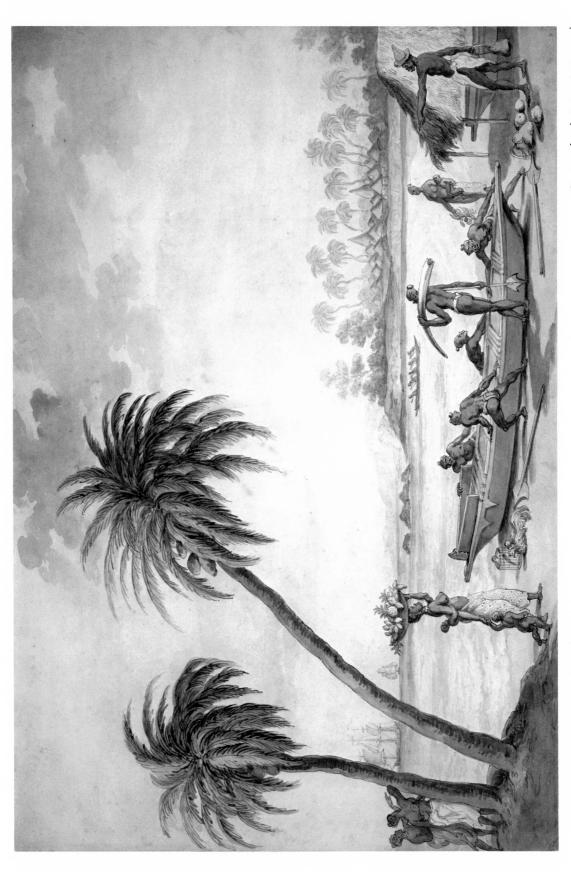

47 The Ivory Coast, West Africa

$14\frac{3}{4} \times 21$ in (375×533 mm)

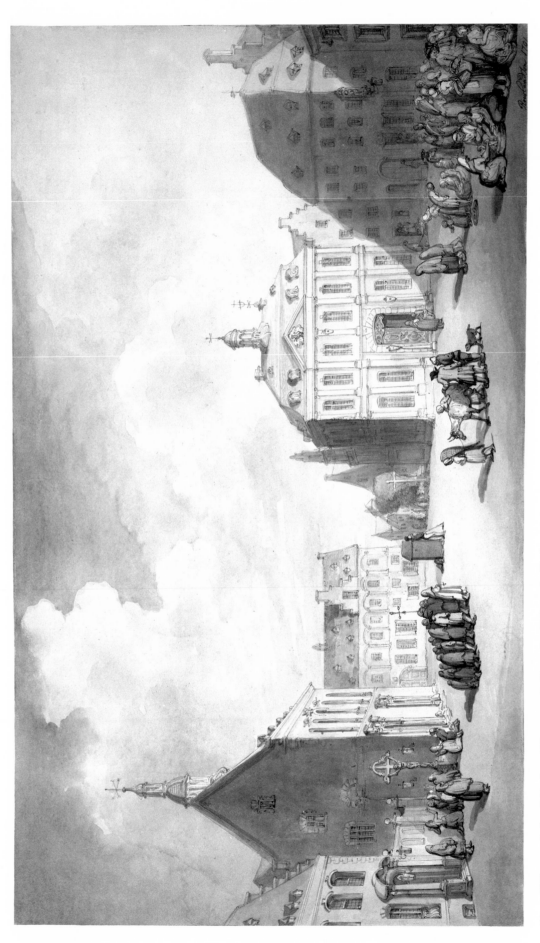

48 'View of the Market Place at Juliers in Westphalia'

$12\frac{1}{4} \times 21$ in $(311 \times 533$ mm$)$

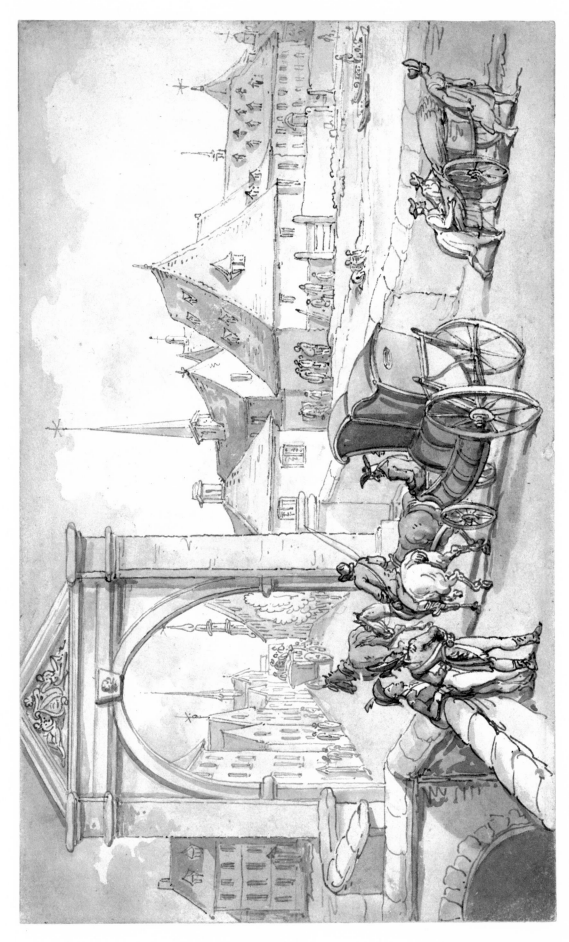

49 Limbourg, Belgium

$5\frac{7}{8} \times 9\frac{1}{2}$ in $(150 \times 242$ mm$)$

50　A Group of Trees　　　　　　　　$10\frac{3}{4} \times 16$ in $(273 \times 406$ mm$)$

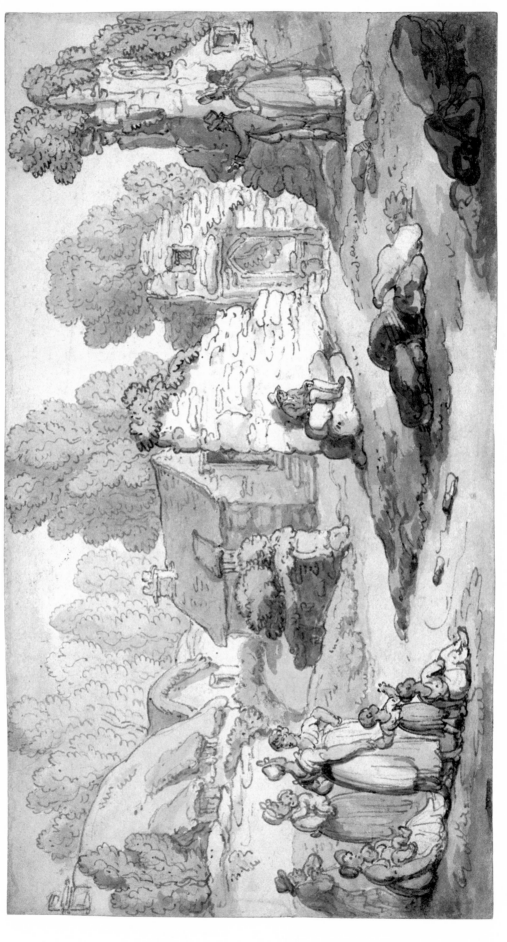

51 Visitors Inspecting Abbey Ruins $5\frac{1}{2} \times 9\frac{7}{8}$ in (140×248 mm)

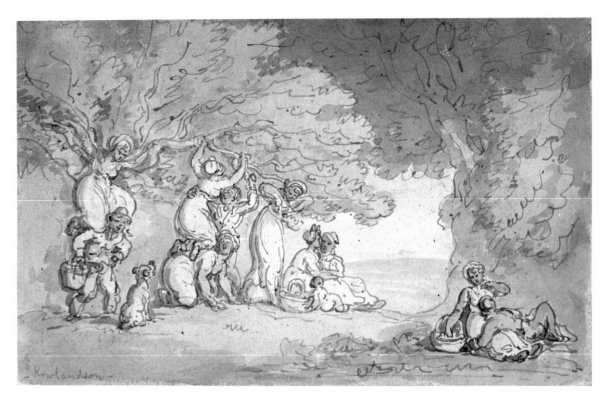

52 Fruit or Nut Picking $4\frac{1}{8} \times 6\frac{1}{2}$ in $(105 \times 165$ mm$)$

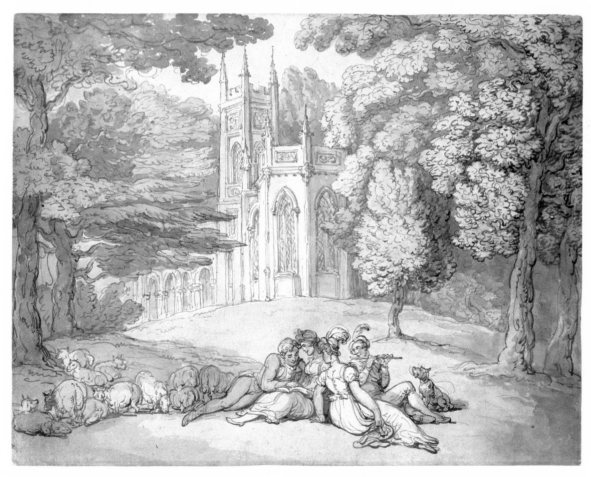

54 A Summer Idyll $8\frac{1}{2} \times 11$ in $(215 \times 279$ mm$)$

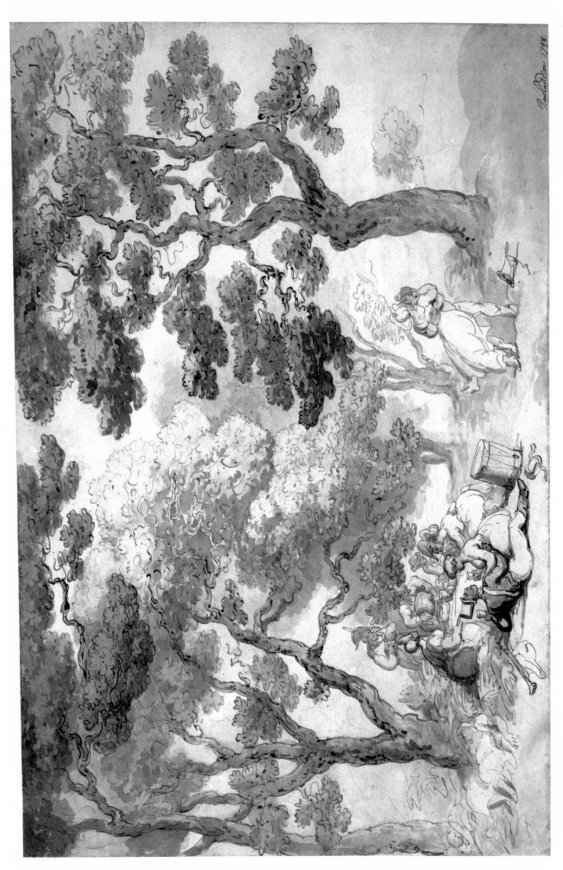

53 The Picnic $11 \times 16\frac{1}{2}$ in $(280 \times 420$ mm$)$

55　The Angling Party　$6\frac{7}{8} \times 10\frac{1}{8}$ in $(175 \times 257$ mm$)$

56 Bathers in a Landscape

$6 \times 9\frac{5}{8}$ in $(152 \times 244 \text{ mm})$

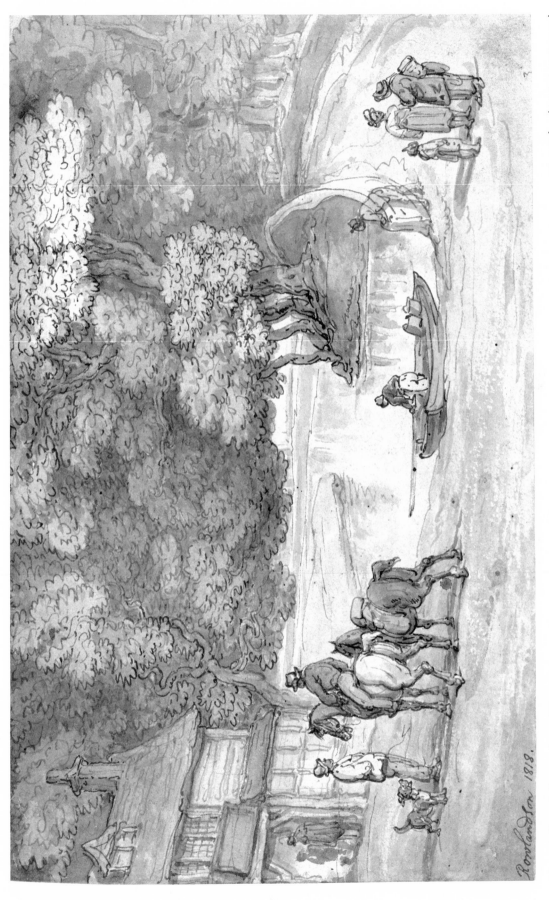

Rowlandson 1818.

57 A Rural Scene by a River

$5\frac{5}{8} \times 9$ in (143 × 229 mm)

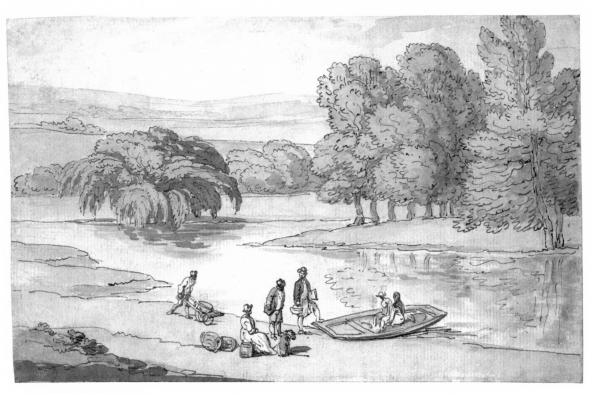

58 Figures by a Ferry $4\frac{1}{2} \times 7\frac{5}{16}$ in $(115 \times 186$ mm$)$

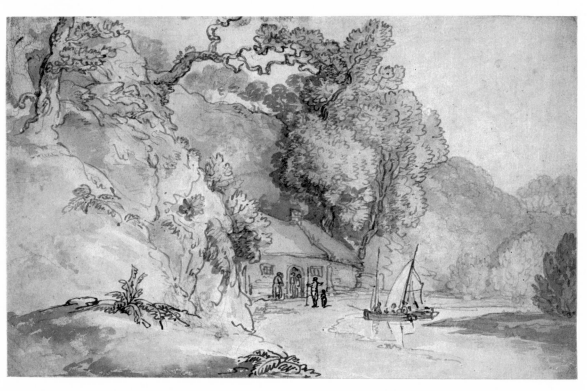

59 River Scene with Small Boats $5\frac{1}{2} \times 9$ in $(140 \times 230$ mm$)$

60 A High Waterfall $8\frac{3}{4} \times 12\frac{1}{2}$ in (222×317 mm)

61 River Landscape with a Waterfall 5¾ × 8⅜ in (145 × 212 mm)

62 A Water-Wheel Driving a Transporter

$11\frac{1}{4} \times 18\frac{1}{4}$ in $(285 \times 464$ mm$)$

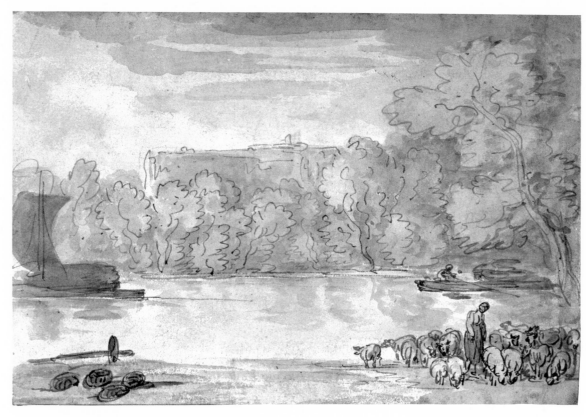

63 River Scene (The Thames at Eton?) $6\frac{1}{4} \times 9\frac{1}{8}$ in (160×232 mm)

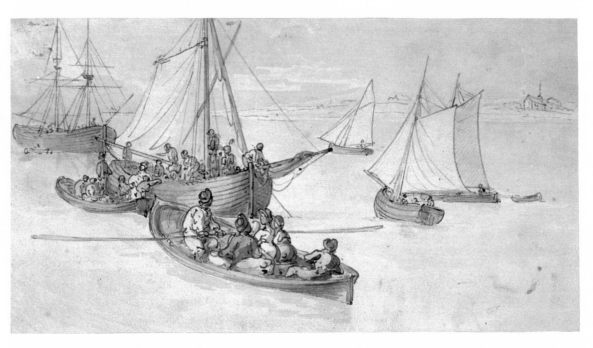

64 Pleasure Boats in an Estuary $4\frac{3}{4} \times 9$ in (120×230 mm)

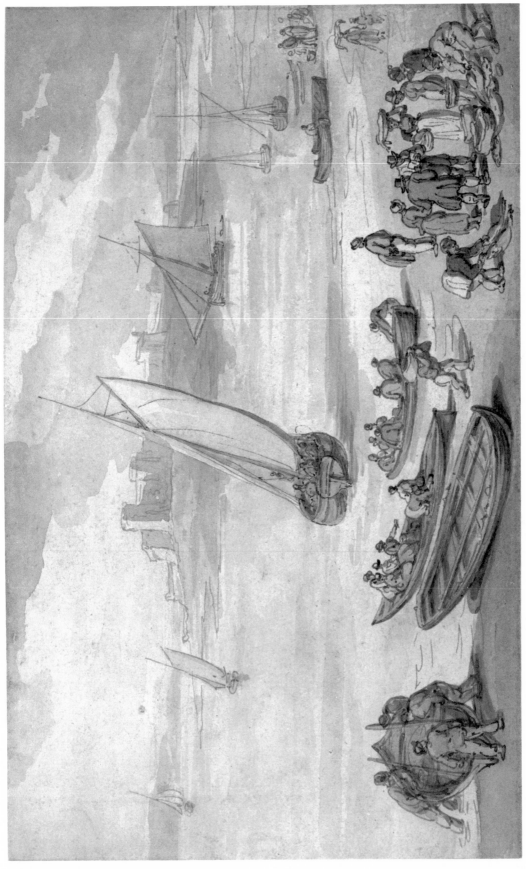

65 Selling Fish on a Beach $5\frac{5}{8} \times 9$ in (142×230 mm)

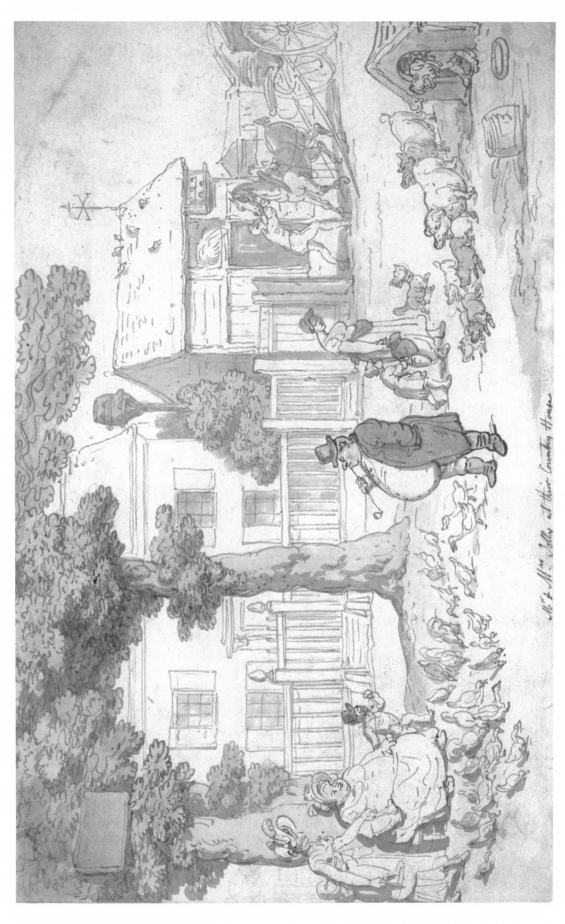

66 'Mr and Mrs Jolly at their Country House'

$5\frac{7}{8} \times 9\frac{1}{4}$ in $(149 \times 236$ mm$)$

67 A Village Scene with Peasants Resting

$8\frac{5}{8} \times 11\frac{3}{4}$ in $(218 \times 298$ mm$)$

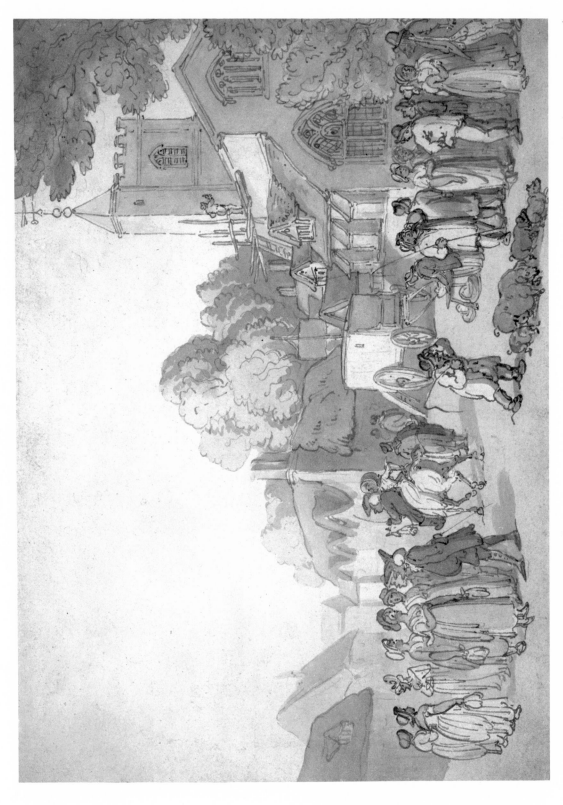

68 A Village Scene outside a Church $7\frac{3}{8} \times 10\frac{1}{8}$ in $(186 \times 256$ mm$)$

70 Village Street Scene with Girls Spinning $13\frac{3}{8} \times 19$ in (340×492 mm)

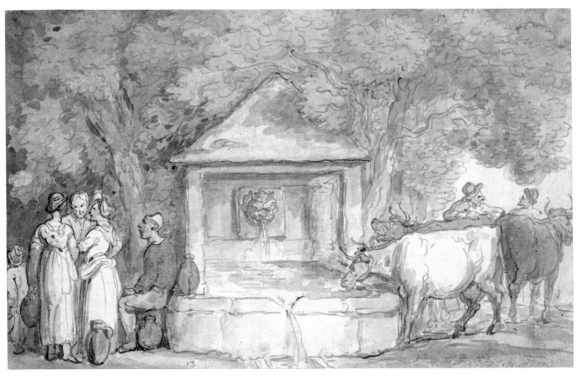

69 A Village Fountain $4\frac{3}{8} \times 7\frac{1}{8}$ in $(110 \times 190$ mm$)$

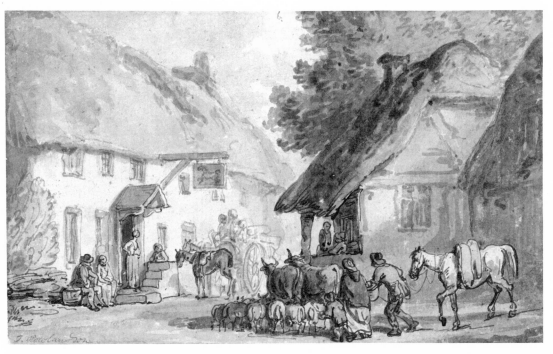

71 A Village Street Scene with Cattle $3\frac{1}{2} \times 5\frac{3}{4}$ in $(90 \times 145$ mm$)$

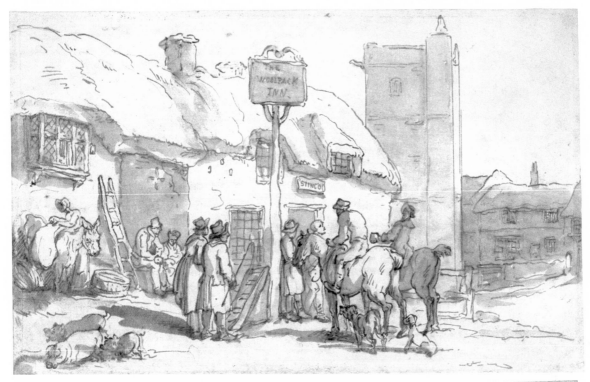

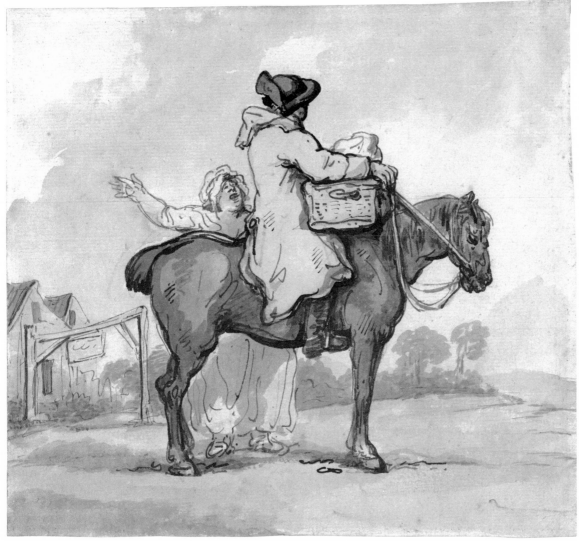

75 Enquiring the Way $7 \times 7\frac{3}{4}$ in $(178 \times 197$ mm$)$

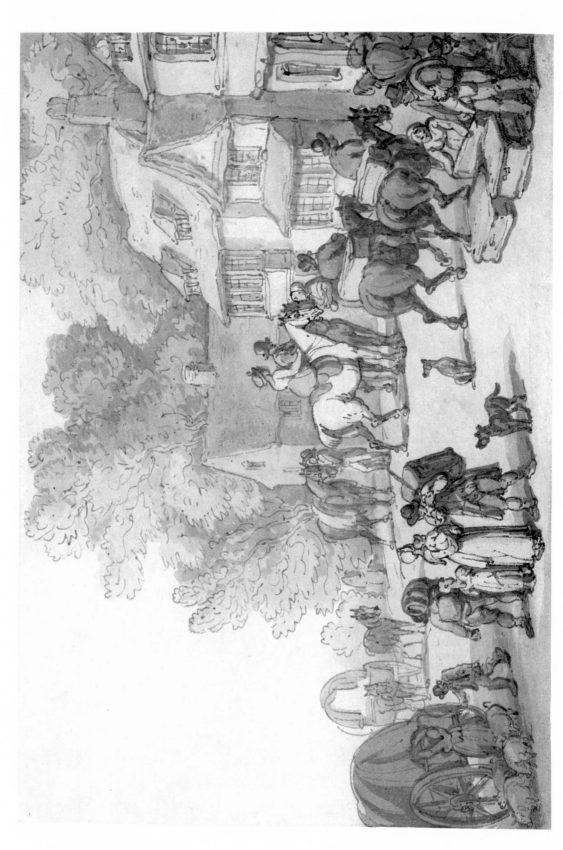

73 Scene outside an Inn $7\frac{1}{8} \times 10\frac{3}{8}$ in $(181 \times 263$ mm$)$

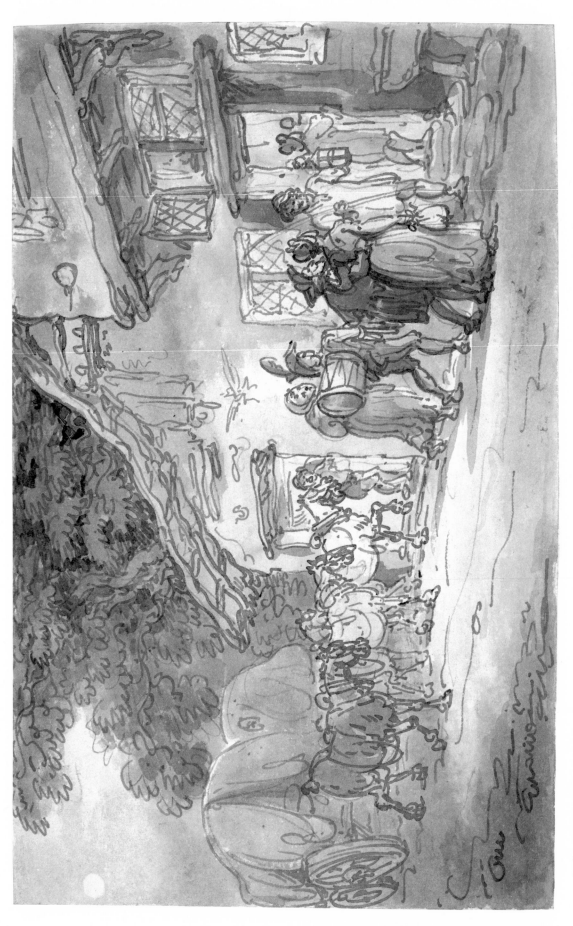

74 'The Waggonner's Rest' $5\frac{7}{8} \times 9\frac{1}{4}$ in $(150 \times 235 \text{ mm})$

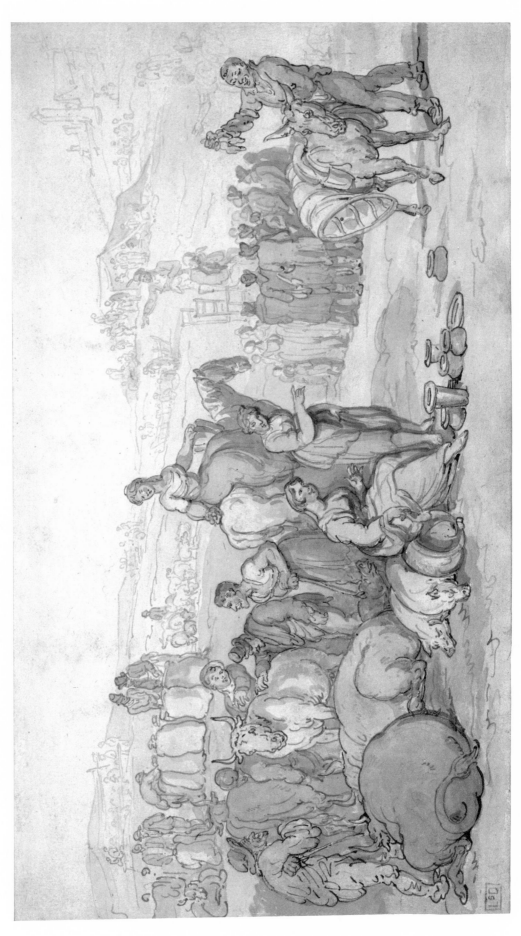

76 A Fair in the Country

$5\frac{3}{8} \times 9\frac{3}{8}$ in $(135 \times 237$ mm$)$

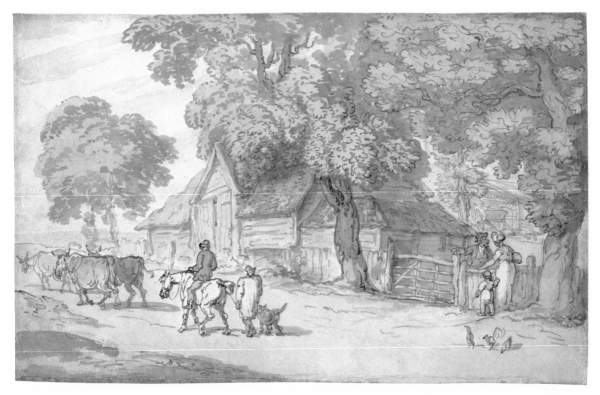

77 A Road by a Farm $5\frac{5}{8} \times 9\frac{1}{8}$ in (142×232 mm)

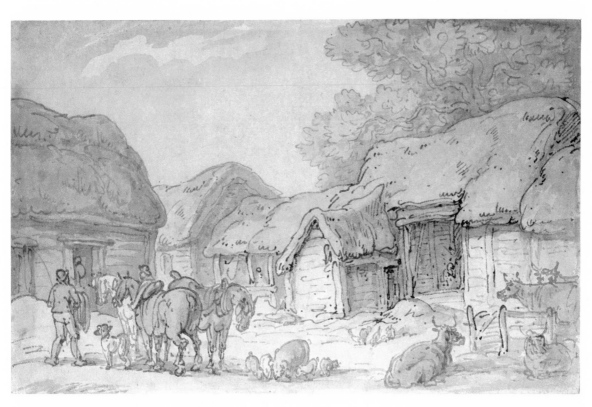

79 The Farmyard $5\frac{5}{8} \times 8\frac{7}{8}$ in (143×226 mm)

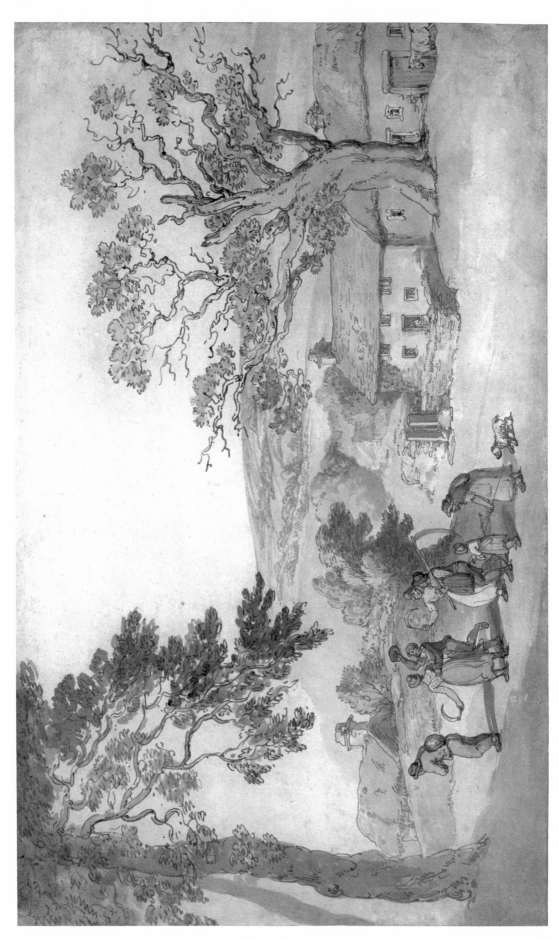

78 Harvesters Setting Out

$9\frac{1}{8} \times 14\frac{7}{8}$ in $(232 \times 380$ mm$)$

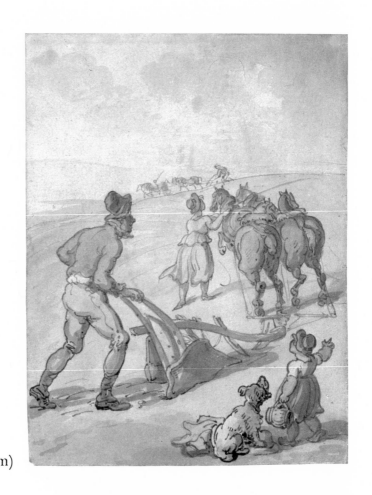

80　Ploughing

$7 \times 5\frac{3}{8}$ in $(178 \times 137$ mm$)$

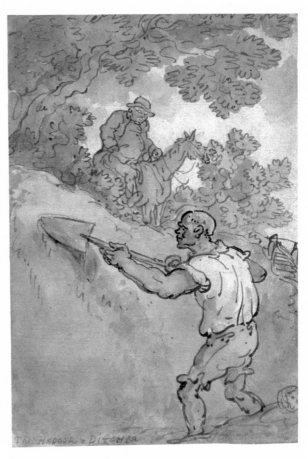

81　'The Hedger and Ditcher'

$6\frac{3}{4} \times 4\frac{1}{2}$ in $(172 \times 115$ mm$)$

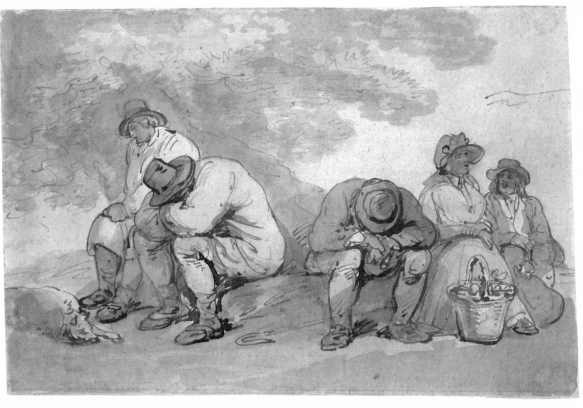

82 Labourers at Rest 5⅜ × 8¼ in (135 × 210 mm)

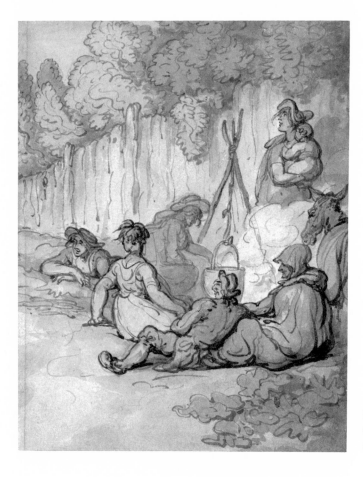

85
Gypsies Cooking on an Open Fire
6 × 4½ in (152 × 121 mm)

83 The Woodcutter's Picnic $10\frac{1}{4} \times 14\frac{1}{2}$ in (260×368 mm)

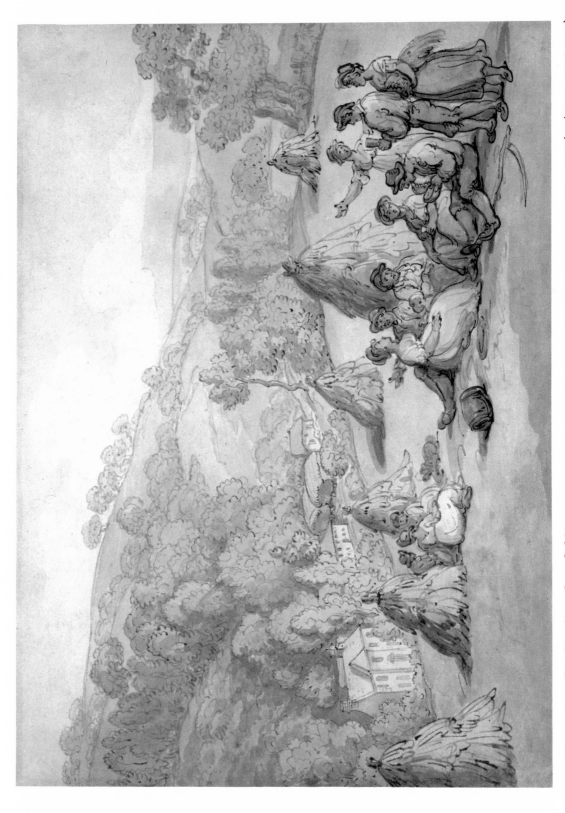

84 Harvesters Resting in a Cornfield

$8\frac{1}{8} \times 11\frac{1}{4}$ in (206 × 285 mm)

86 A Potter Returning from Market $8\frac{3}{4} \times 11\frac{1}{4}$ in $(222 \times 285$ mm$)$

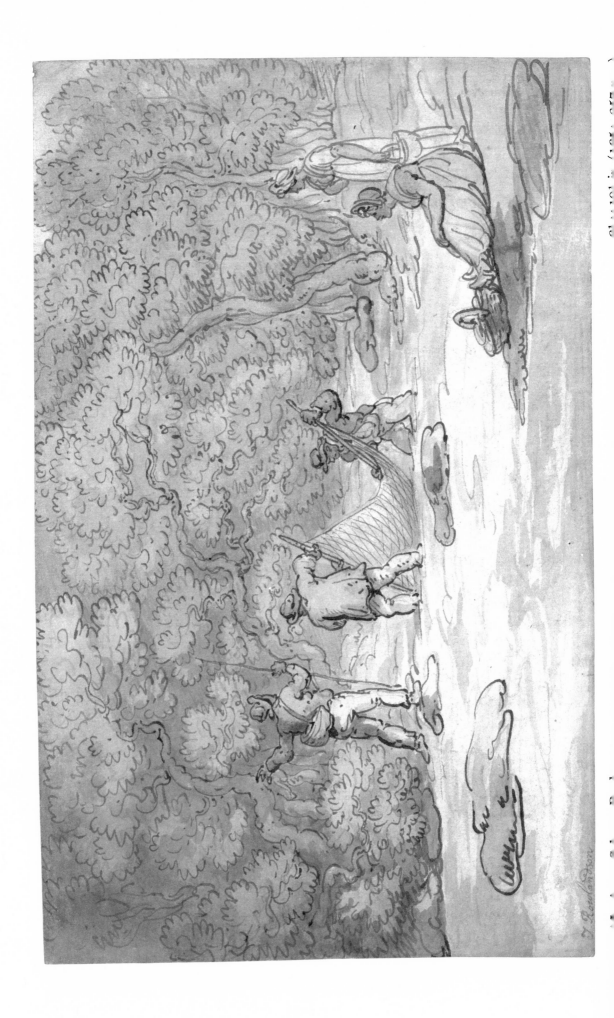

T. Rowlandson

4 Dr Graham's Bathing Establishment

$10\frac{3}{8} \times 16\frac{3}{8}$ in $(267 \times 416 \text{ mm})$

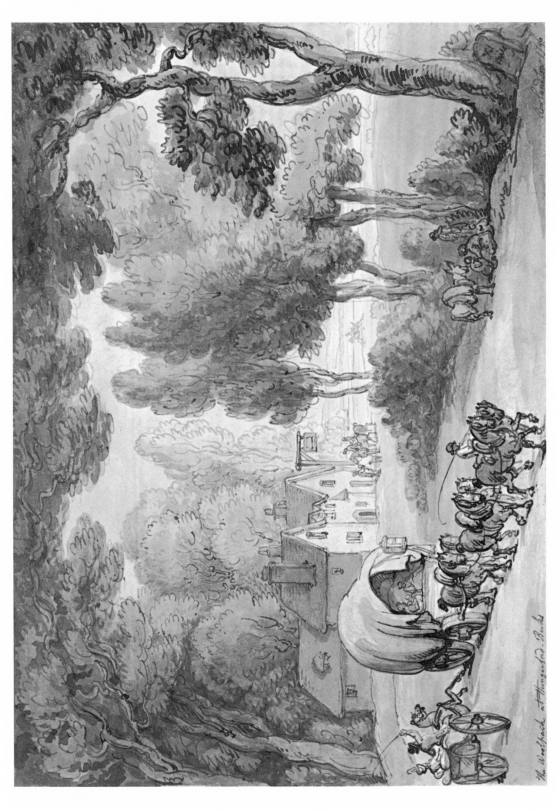

the Woolpack at Hungerford Berks

Rowlandson Jany 1790

$7\frac{7}{8} \times 11$ in $(197 \times 280$ mm$)$

29 'The Woolpack at Hungerford, Berks.'

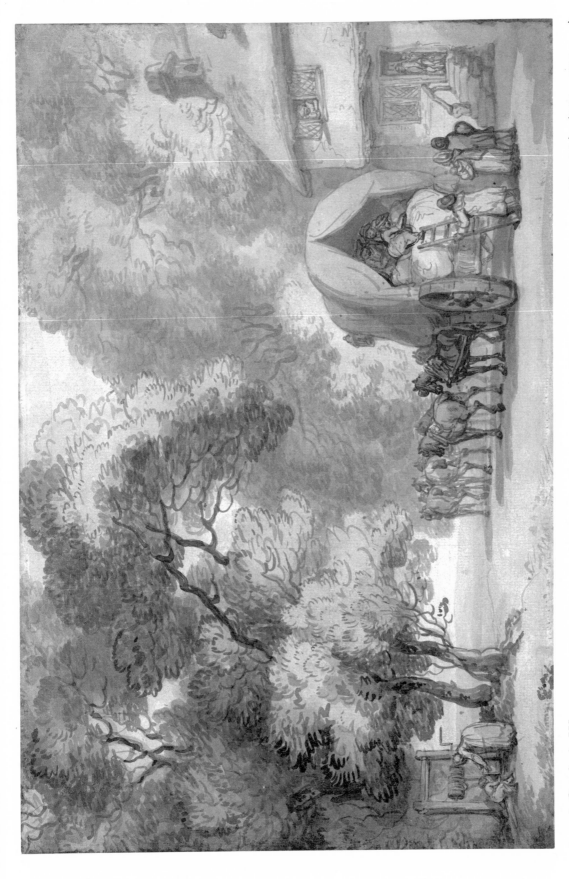

89 A Carrier's Waggon 10 × 15 in (254 × 381 mm)

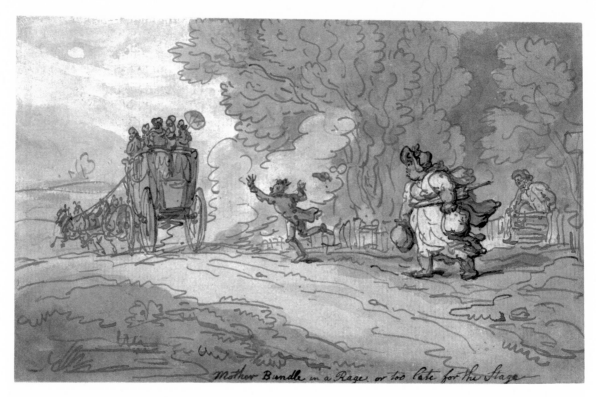

88 'Mother Bundle in a Rage or Too Late for the Stage' $4\frac{1}{2} \times 7$ in (114×178 mm)

90 Loading a Waggon $8\frac{1}{8} \times 12\frac{1}{8}$ in (206×308 mm)

91 The Baggage Waggon $3\frac{1}{2} \times 6\frac{1}{8}$ in (90 × 156 mm)

92 Going to Market $5\frac{1}{2} \times 8\frac{5}{8}$ in (140 × 220 mm)

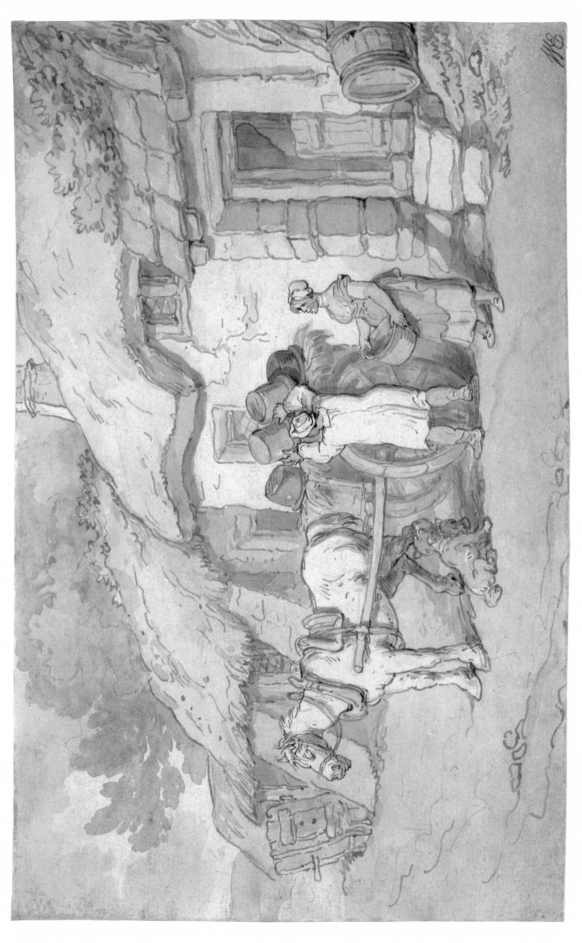

94　A Potter Going Out

$6 \times 9\frac{3}{8}$ in $(152 \times 240$ mm$)$

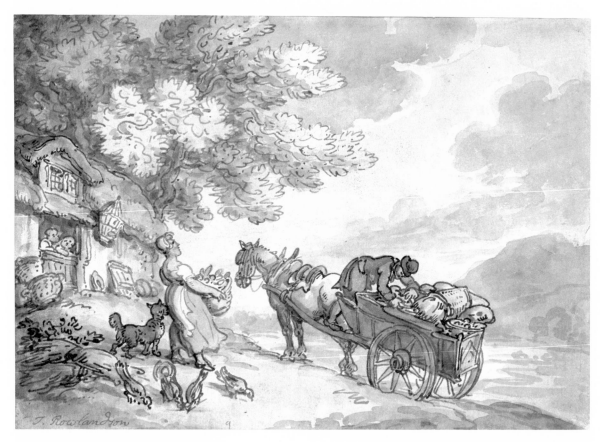

93 Loading a Cart for Market $6\frac{3}{8} \times 9\frac{1}{4}$ in $(162 \times 235$ mm$)$

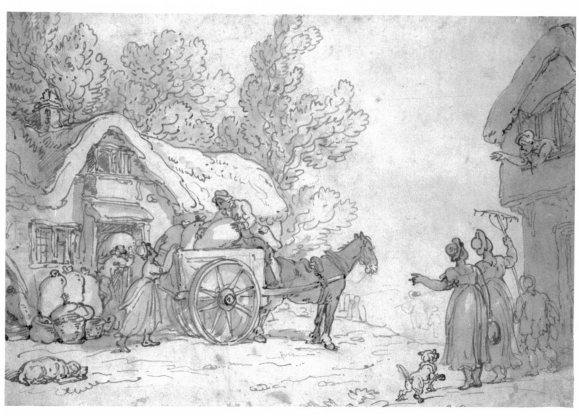

95 Loading Sacks into a Cart $6\frac{5}{8} \times 9\frac{3}{4}$ in $(169 \times 248$ mm$)$

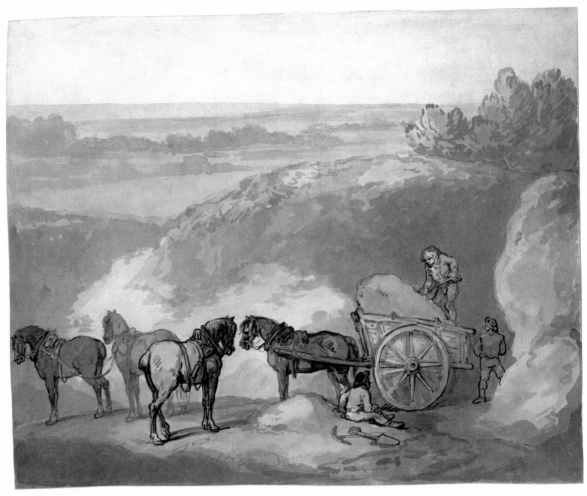

96 Loading Sand $10\frac{3}{4} \times 13\frac{1}{2}$ in $(273 \times 343$ mm$)$

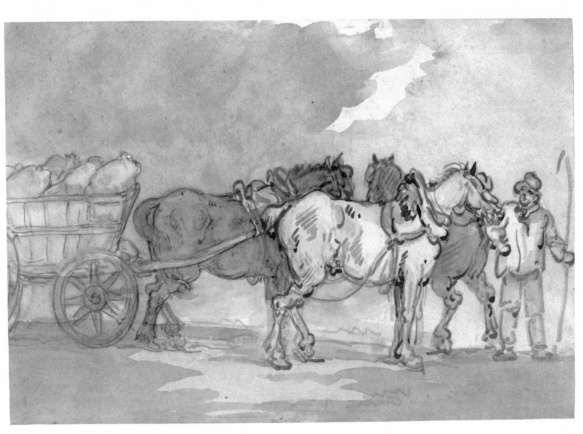

97 A Waggoner $4\frac{3}{4} \times 6\frac{7}{8}$ in $(120 \times 175$ mm$)$

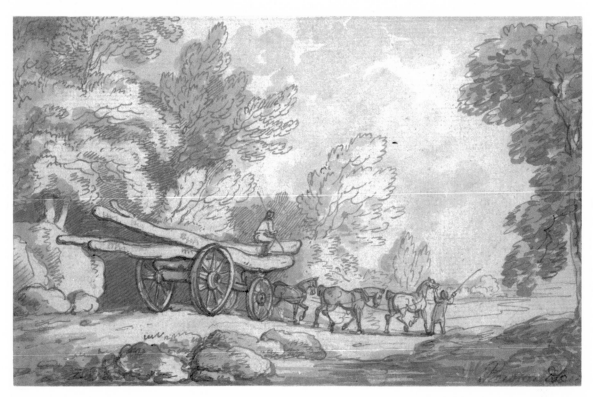

98 A Timber Waggon $4\frac{1}{2} \times 7\frac{1}{4}$ in (115×185 mm)

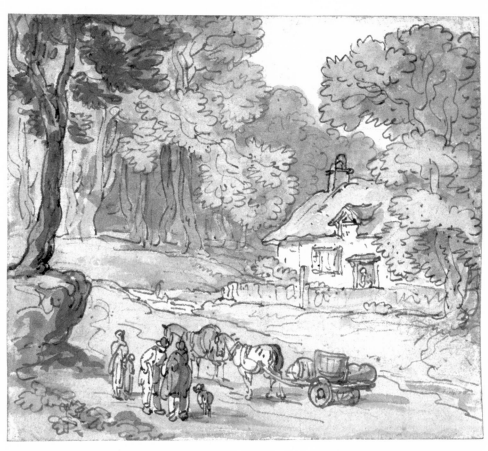

99 Cottage in a Forest Clearing $4\frac{1}{2} \times 5\frac{1}{2}$ in (115×140 mm)

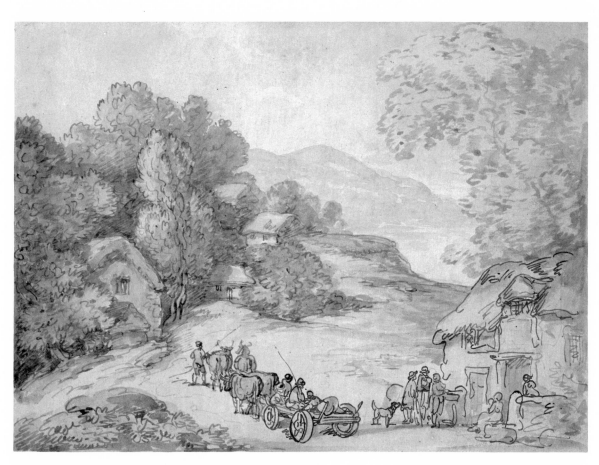

100 A Village in a Hilly Landscape $9\frac{1}{8} \times 12\frac{1}{2}$ in $(232 \times 318$ mm$)$

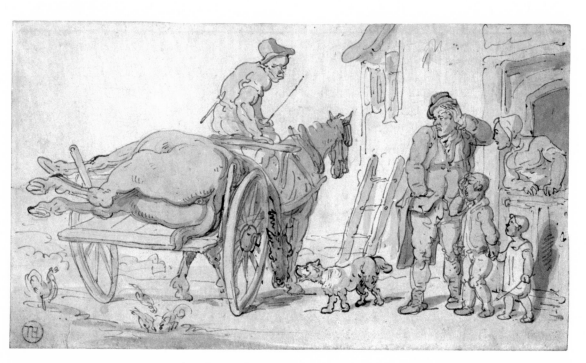

101 A Dead Horse on a Knacker's Cart $3\frac{1}{2} \times 6$ in $(89 \times 152$ mm$)$

102 'Four O'Clock in the Country'

$9\frac{3}{8} \times 12\frac{1}{4}$ in $(238 \times 312$ mm$)$

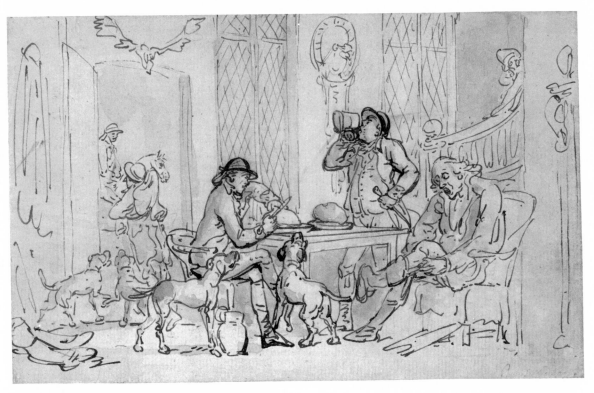

103 Breakfast before the Hunt 5 × 8 in (127 × 202 mm)

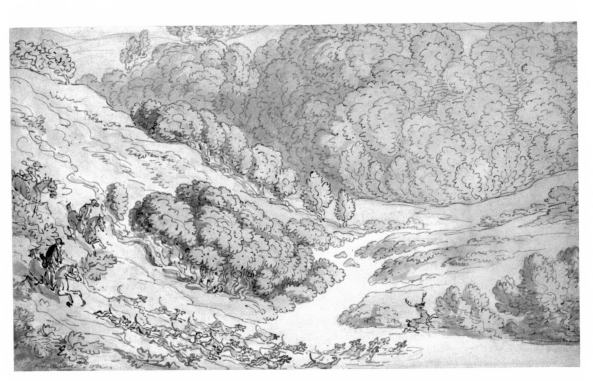

110 A Stag Hunt in the West Country 5¼ × 9 in (134 × 229 mm)

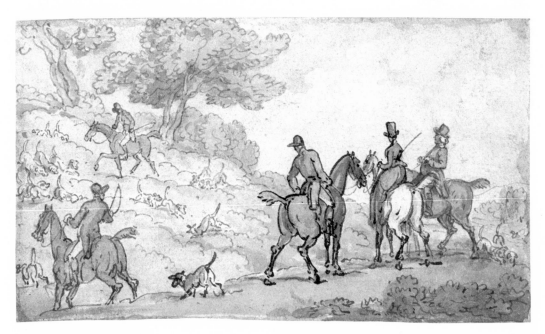

104 Drawing Cover $3\frac{3}{16} \times 5\frac{9}{16}$ in $(81 \times 141$ mm$)$

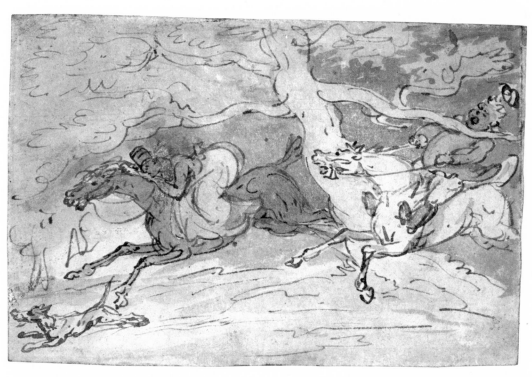

105 'How to Twist your Neck' $3\frac{7}{8} \times 5\frac{13}{16}$ in $(98 \times 147$ mm$)$

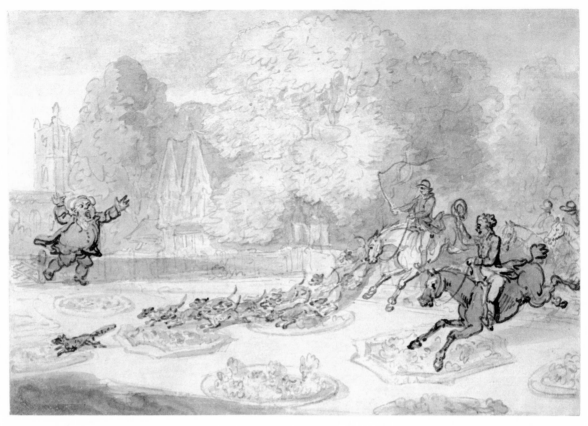

106 The Enraged Vicar

$5\frac{1}{16} \times 7\frac{5}{16}$ in $(128 \times 186$ mm$)$

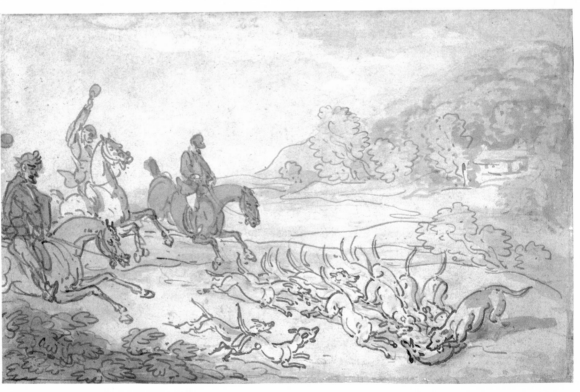

107 The Kill

$4\frac{7}{16} \times 7\frac{1}{16}$ in $(114 \times 180$ mm$)$

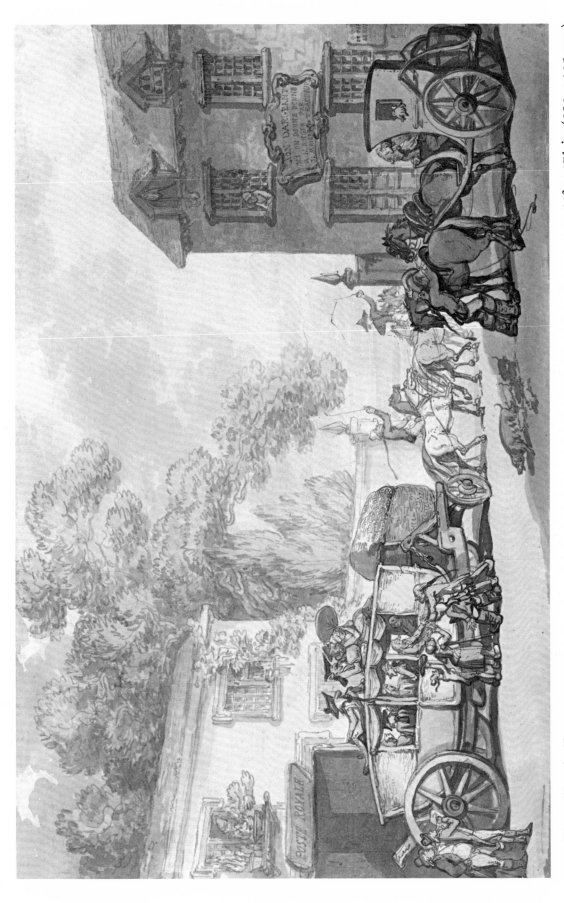

153 Travelling in France

$11\frac{3}{8} \times 17\frac{1}{4}$ in (289 × 445 mm)

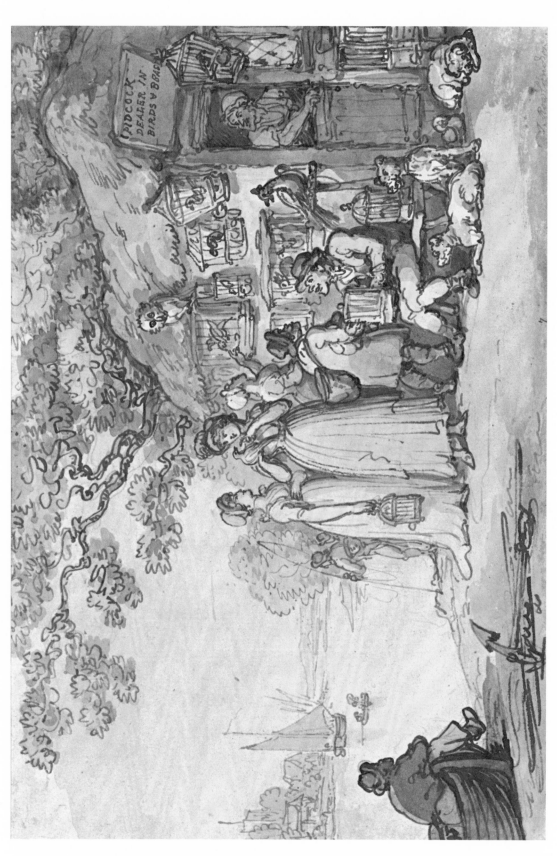

174 'Pidcock, Dealer in Birds and Beasts'

$7 \times 10\frac{3}{8}$ in $(177 \times 262$ mm$)$

108 Full Cry

$10 \times 13\frac{3}{8}$ in $(254 \times 340$ mm$)$

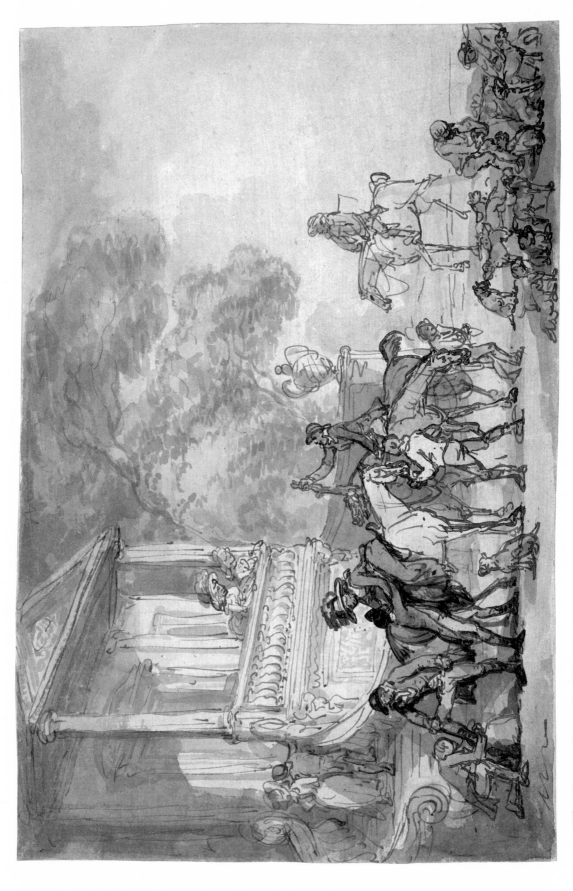

109 The Return from the Hunt

$7\frac{5}{8} \times 11\frac{5}{8}$ in $(194 \times 295$ mm$)$

111 'Stag at Bay – Scene near Taplow, Berks.'

$16\frac{1}{4} \times 20\frac{5}{8}$ (413 × 524 mm)

112 A Stag Hunt in the Park of a Country House $10\frac{7}{8} \times 16\frac{7}{8}$ in (277×428 mm)

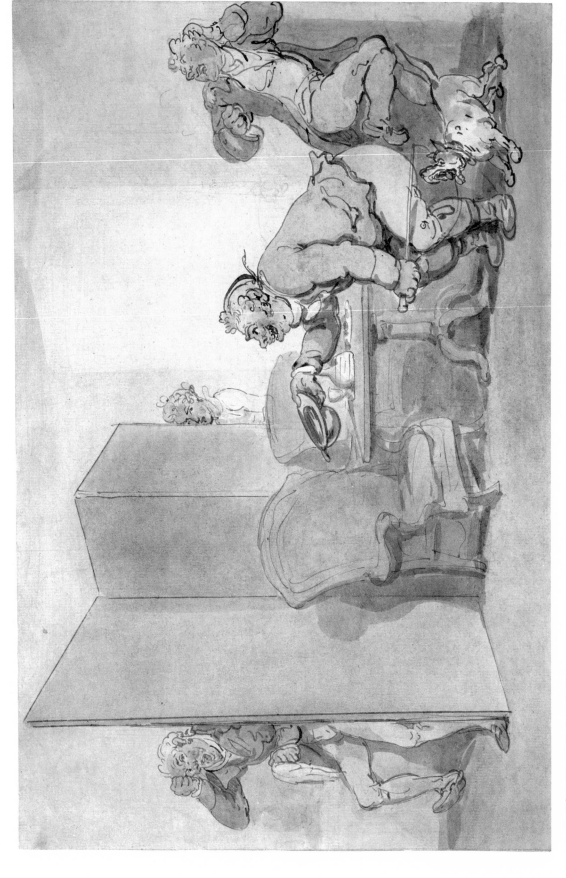

113 The Hunt Subscription

$8\frac{1}{4} \times 12\frac{1}{2}$ in (210×317 mm)

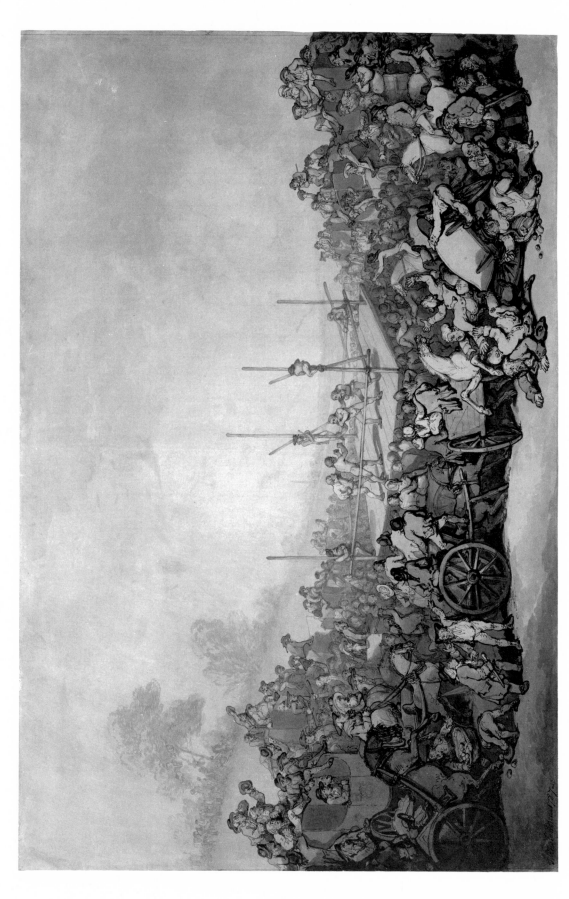

114 The Prize Fight $18\frac{1}{4} \times 27\frac{1}{2}$ in $(463 \times 698$ mm$)$

115 Henry Angelo and Madame Cain Fencing

$6\frac{3}{8} \times 9\frac{7}{8}$ in $(162 \times 250$ mm$)$

116　The Annual Sculling Race for Doggett's Coat and Badge

$5\frac{5}{8} \times 9\frac{3}{16}$ (143 × 233 mm)

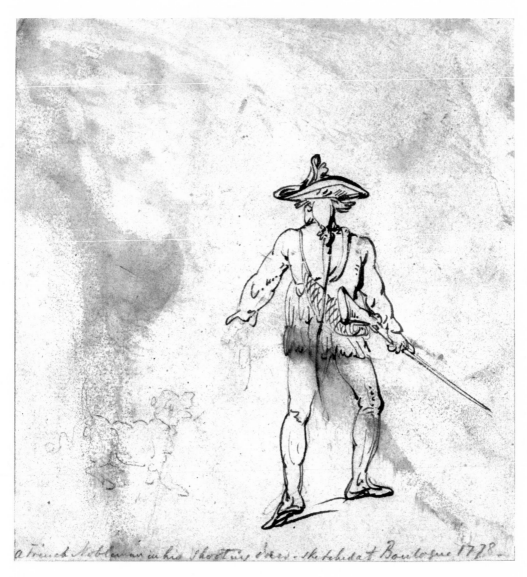

a French Nobleman in his Shooting dress - sketched at Boulogne 1778 -

117 A French Nobleman out Shooting $5\frac{3}{4} \times 5\frac{1}{2}$ in (147 × 140 mm)

118 Skating on the Serpentine

$8\frac{7}{8} \times 14\frac{3}{8}$ in (226×365 mm)

$5\frac{5}{8} \times 9\frac{1}{8}$ in $(142 \times 232$ mm$)$

119 Captain Barclay's Rally Match – the Finish

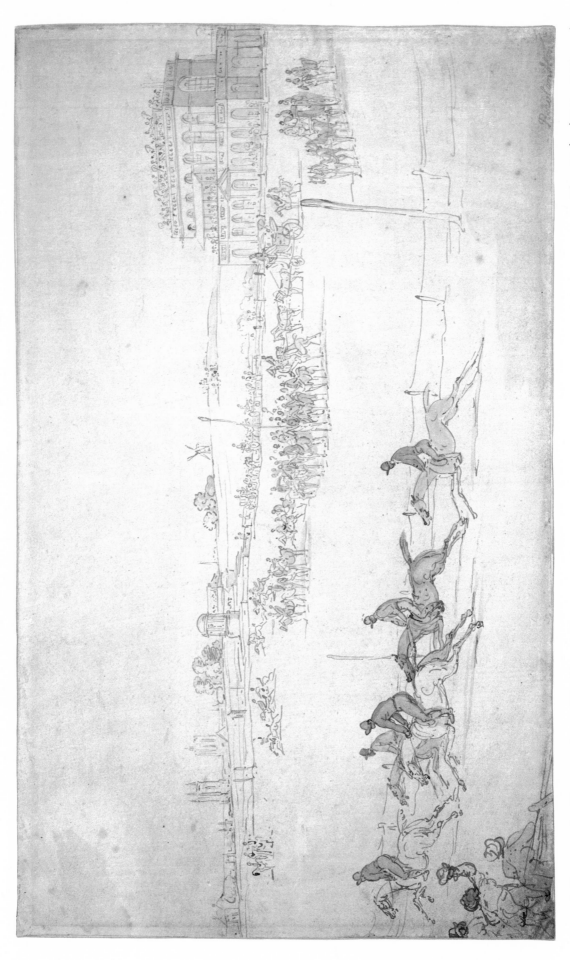

8½ × 14 in (216 × 356 mm)

120 A Race on the Knavesmire at York

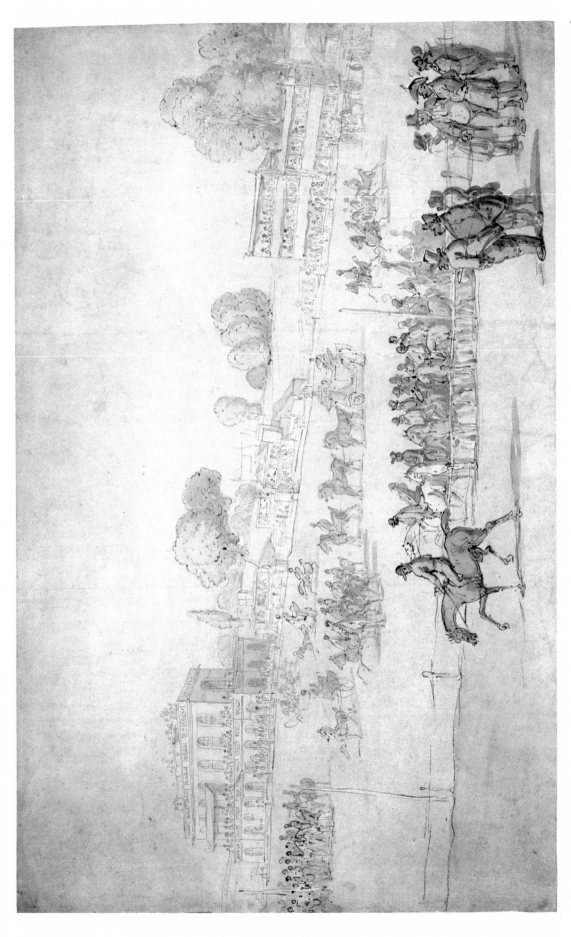

121　Racing at York

$9\frac{1}{8} \times 14\frac{1}{2}$ in (230×367 mm)

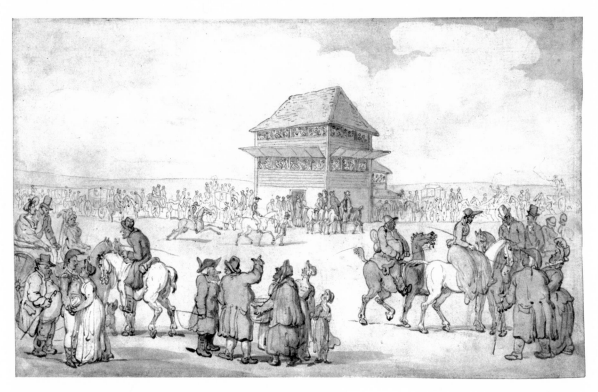

122 A Crowded Race Meeting 5¾ × 9½ in (146 × 242 mm)

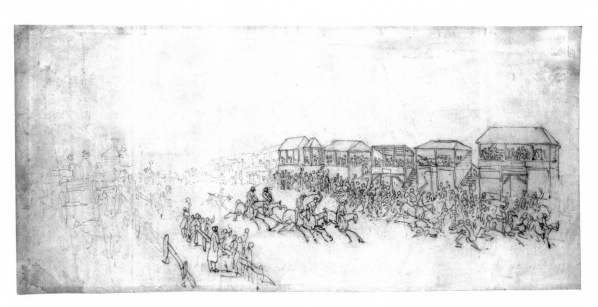

123 A Race Meeting: the Finish of a Race 7⅛ × 15⅝ in (181 × 397 mm)

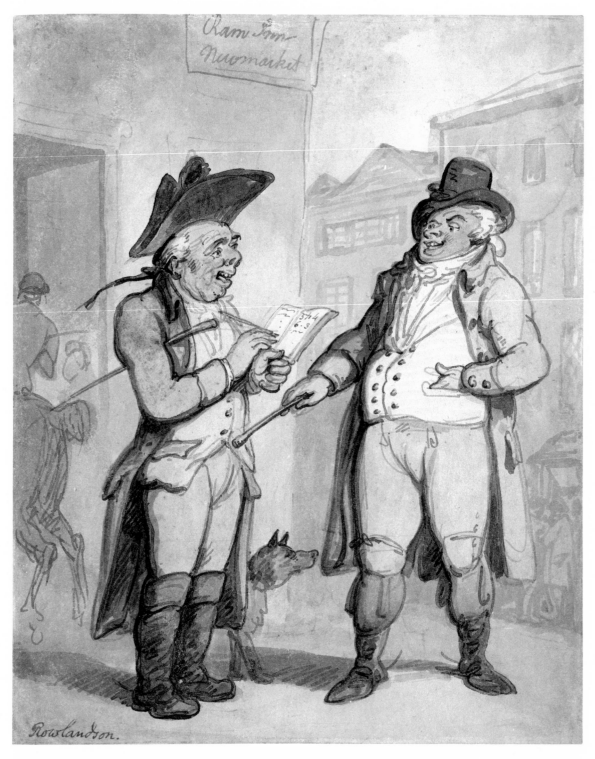

124 The Bookmaker and his Client outside the Ram Inn, Newmarket

$9\frac{7}{16} \times 7\frac{9}{16}$ in $(240 \times 192$ mm$)$

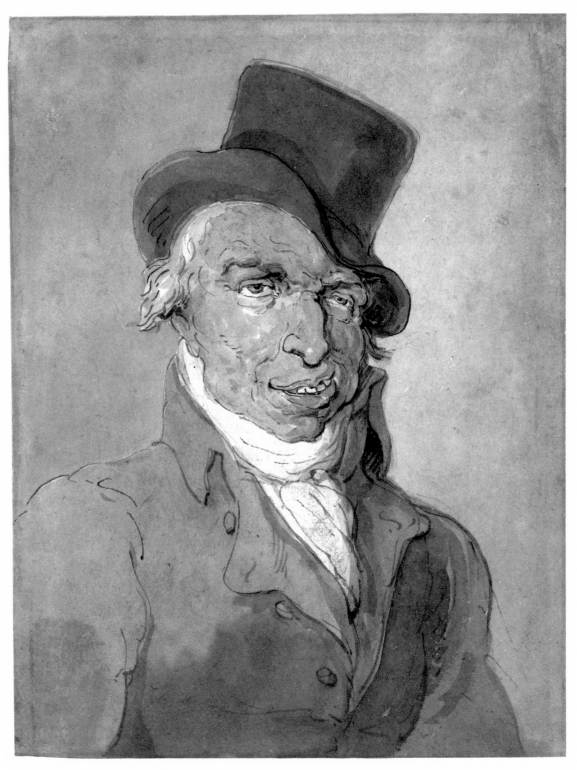

125 A Sporting Cove $7\frac{3}{4} \times 5\frac{15}{16}$ in (197×151 mm)

126 The Riding School

$5\frac{9}{16} \times 8\frac{3}{8}$ in $(141 \times 213$ mm$)$

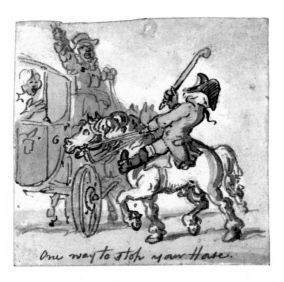

127 (1) 'One Way to Stop your Horse'
$2\frac{3}{4} \times 2\frac{3}{4}$ in (70 × 70 mm)

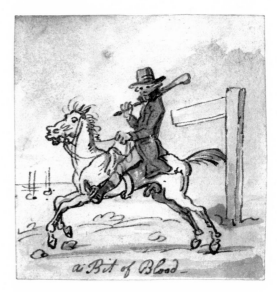

127 (2) 'A Bit of Blood'
$2\frac{3}{4} \times 2\frac{3}{4}$ in (70 × 70 mm)

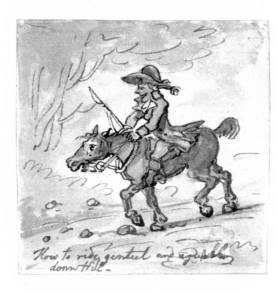

127 (3) 'How to Ride Genteel
and Agreeable Downhill'
$2\frac{3}{4} \times 2\frac{3}{4}$ in (70 × 70 mm)

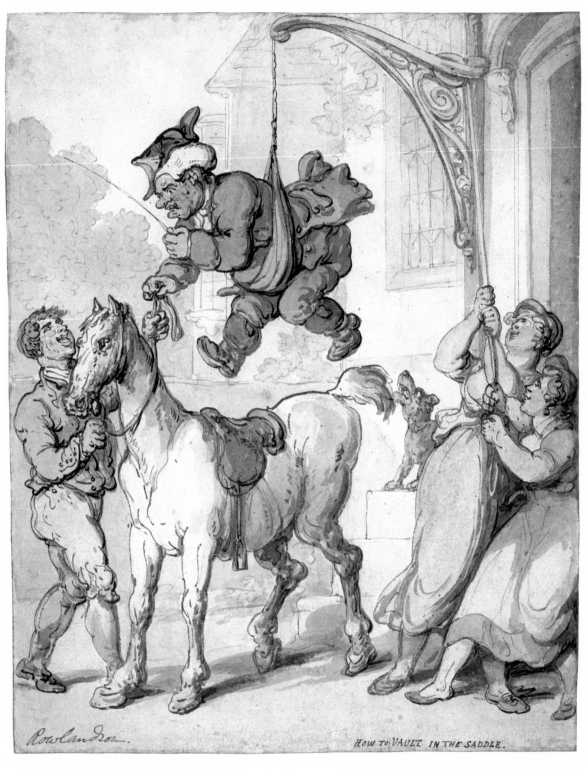

128 'How to Vault in the Saddle' $10\frac{3}{4} \times 8\frac{1}{4}$ in (273 × 210 mm)

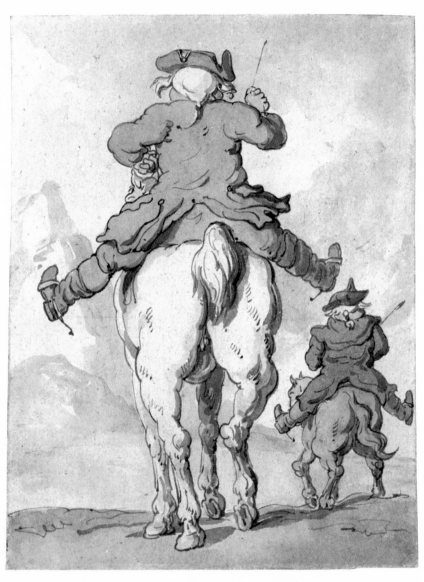

129 Two Men on Horseback seen from Behind
$5\frac{3}{4} \times 4\frac{7}{16}$ in $(146 \times 113$ mm)

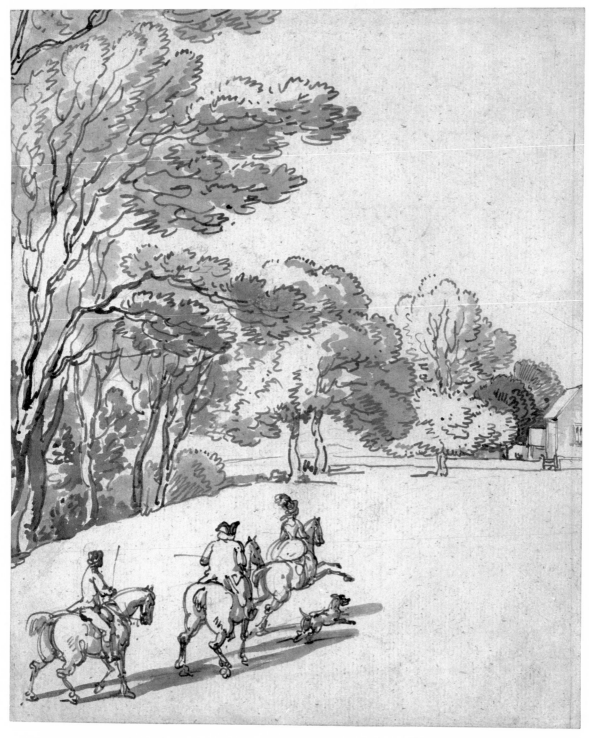

130 The Ride $9 \times 7\frac{3}{8}$ in (228×187 mm)

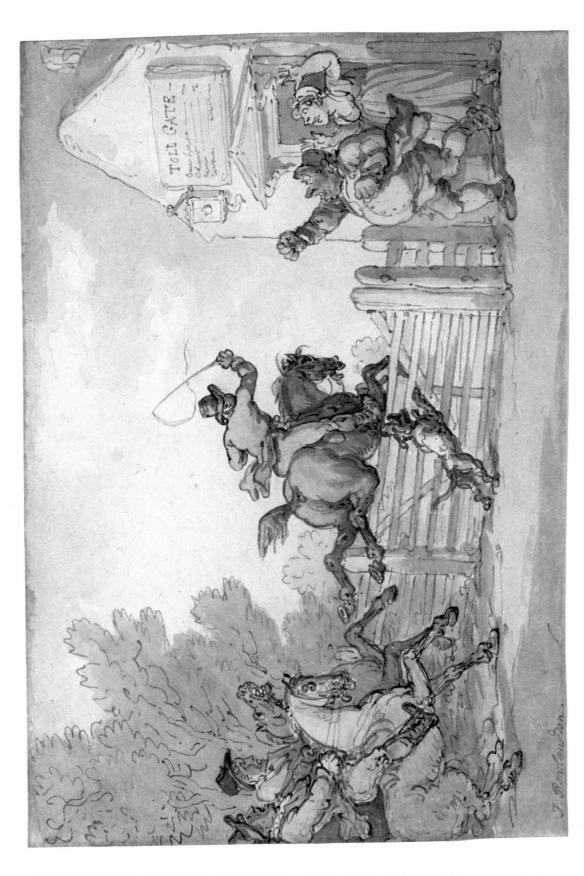

131 Evading the Toll

$6\frac{3}{8} \times 9\frac{1}{8}$ in $(159 \times 231$ mm$)$

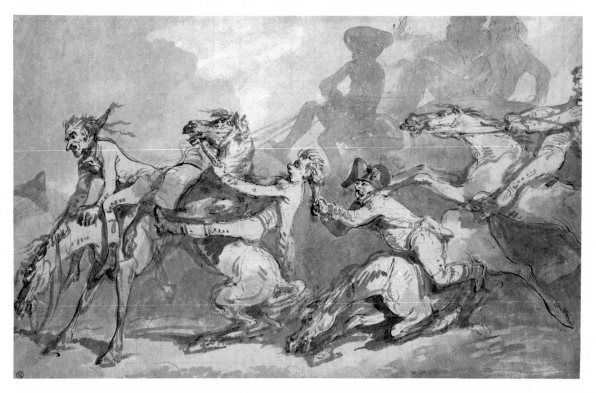

133 Horsemen Colliding $11\frac{3}{4} \times 18\frac{3}{4}$ in $(298 \times 476$ mm$)$

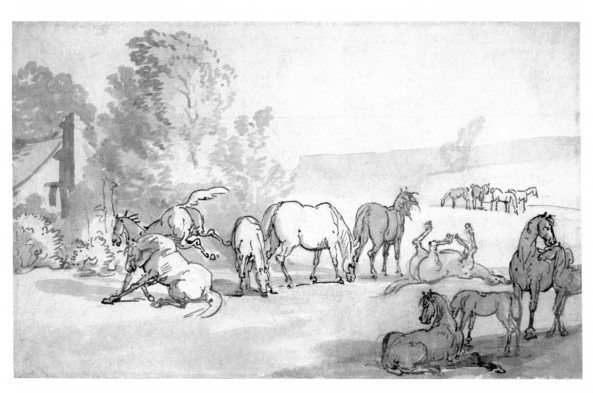

135 Mares and Foals in a Field $5\frac{9}{16} \times 9\frac{1}{8}$ in $(141 \times 232$ mm$)$

134 (1) 'The Foal'
 $2\frac{3}{4} \times 3\frac{7}{8}$ in $(70 \times 98$ mm$)$

134 (2) 'The Colt'
 $2\frac{3}{4} \times 3\frac{7}{8}$ in $(70 \times 98$ mm$)$

134 (3) 'The Racer'
 $2\frac{3}{4} \times 3\frac{7}{8}$ in $(70 \times 98$ mm$)$

134 (4) 'The Hunter'
 $2\frac{3}{4} \times 3\frac{7}{8}$ in (70 × 98 mm)

134 (5) 'The Post-Horse'
 $2\frac{3}{4} \times 3\frac{7}{8}$ in (70 × 98 mm)

134 (6) 'Food for the Hounds'
 $2\frac{3}{4} \times 3\frac{7}{8}$ in (70 × 98 mm)

132 Riding and Driving Mishaps $5\frac{1}{4} \times 15\frac{5}{8}$ in (134×397 mm)

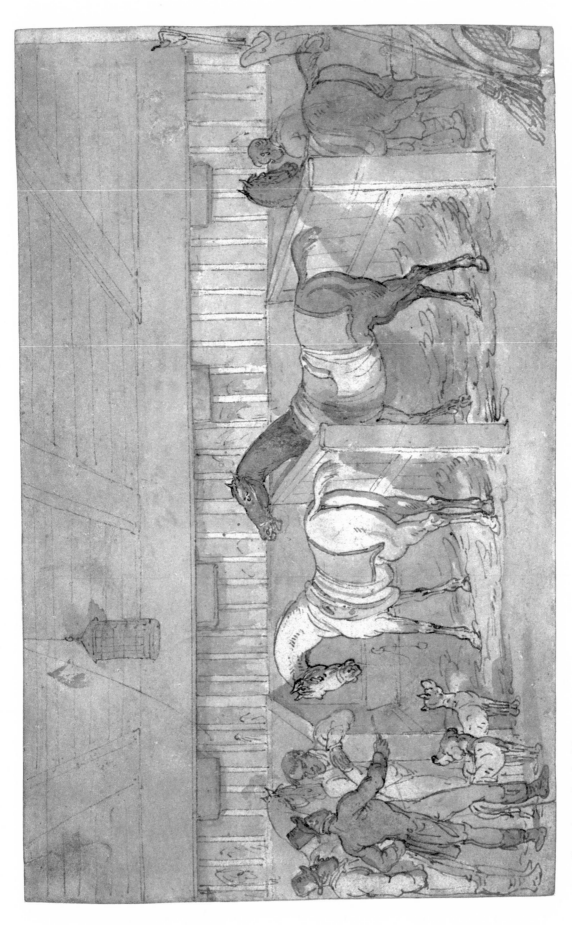

136　Interior of a Stable　　$5\frac{7}{8} \times 9\frac{3}{8}$ in $(150 \times 237$ mm$)$

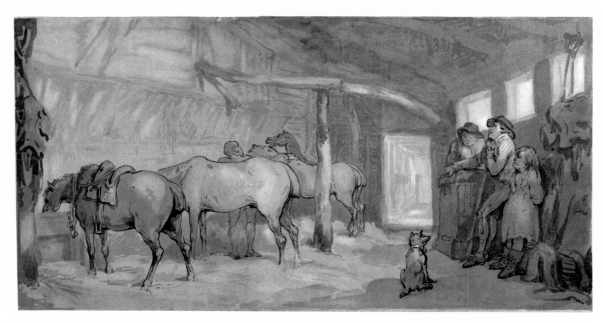

137 The Stable of an Inn $7\frac{7}{8} \times 15\frac{3}{4}$ in (200×400 mm)

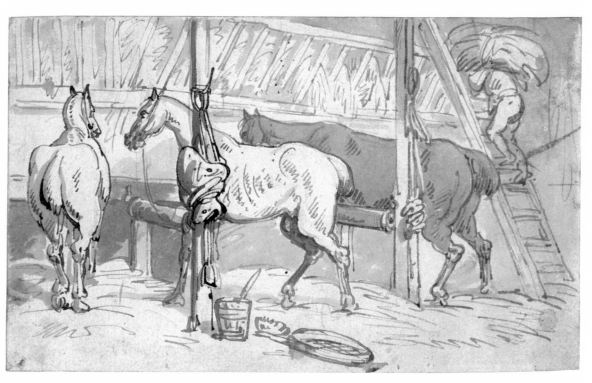

138 Three Horses in Stalls $4\frac{5}{16} \times 7\frac{1}{4}$ in (110×184 mm)

$7 \times 8\frac{1}{2}$ in $(178 \times 216 \text{ mm})$

139 A Saddled Cavalry Horse

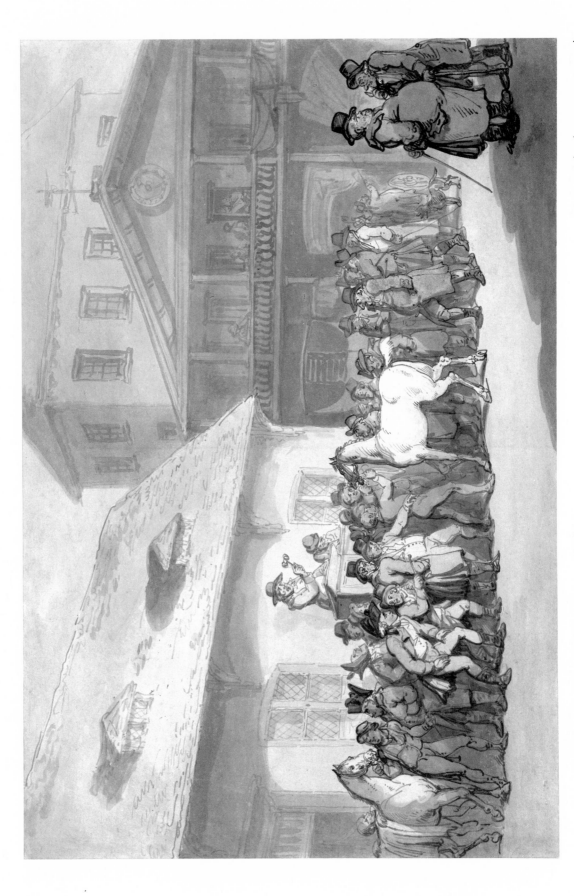

140 A Horse Sale in Hopkins's Repository, Barbican

$10\frac{5}{8} \times 15\frac{3}{4}$ in $(270 \times 400$ mm$)$

141 A Horse Sale at Hopkins's Repository (An outline)

$9\frac{1}{4} \times 15\frac{3}{4}$ in $(236 \times 400$ mm$)$

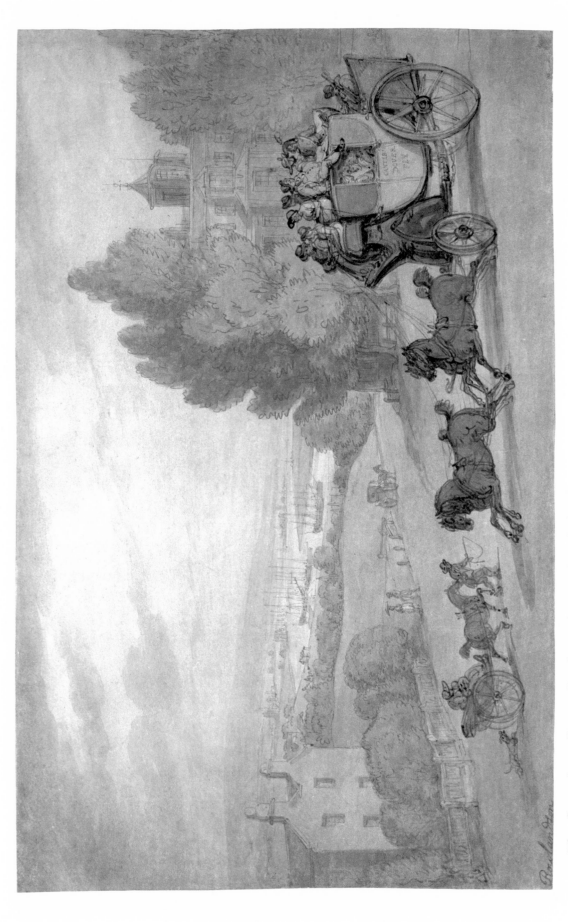

142 The Canterbury–Dover Coach passing Vanbrugh Castle $11\frac{5}{8} \times 18$ in (295 × 457 mm)

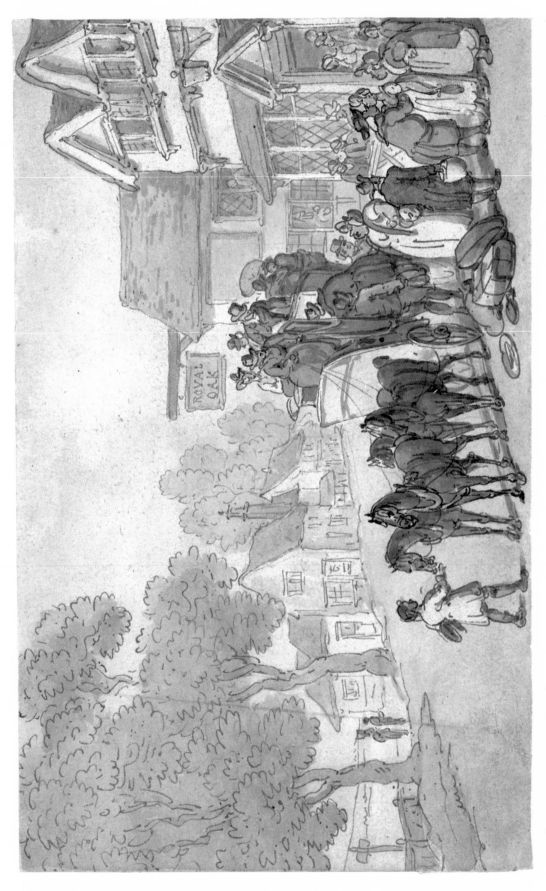

143 Loading a Stage-Coach

$5\frac{1}{2} \times 8\frac{7}{8}$ in $(140 \times 225$ mm$)$

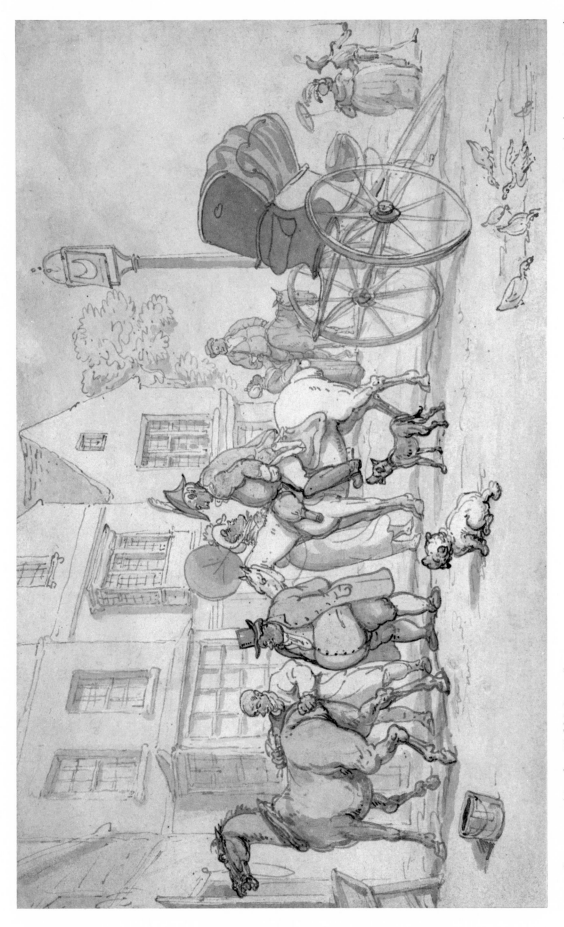

144 Scene outside the Half-Moon Inn

$5\frac{3}{4} \times 9\frac{1}{4}$ in (146 × 235 mm)

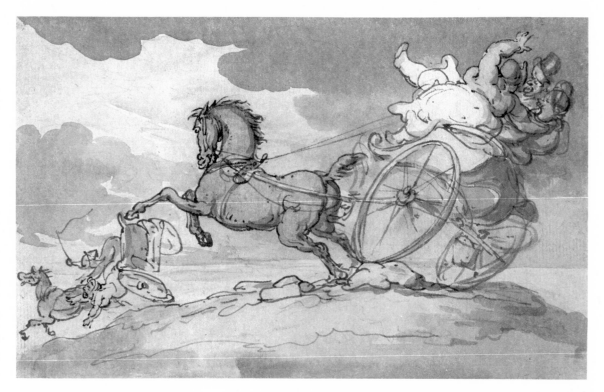

145 Two Gigs in Trouble $4\frac{7}{16} \times 7\frac{3}{16}$ in $(112 \times 182$ mm$)$

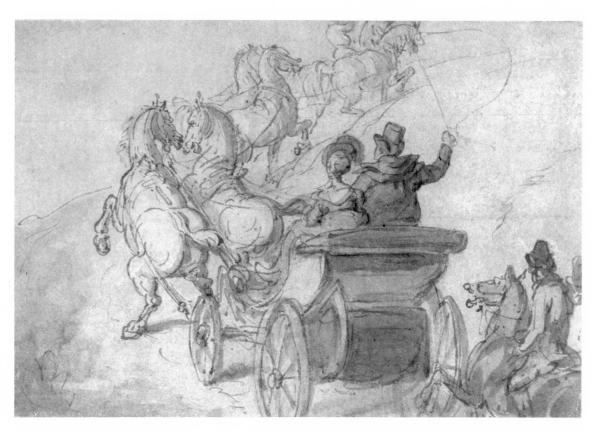

146 A Phaeton and Six $5\frac{1}{4} \times 7\frac{3}{4}$ in $(133 \times 197$ mm$)$

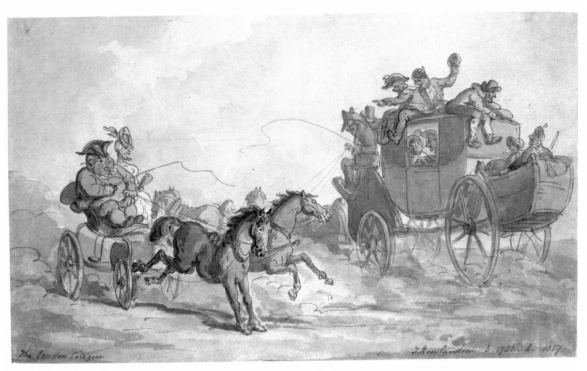

147 'The London Citizen' $5\frac{1}{4} \times 9$ in (134×228 mm)

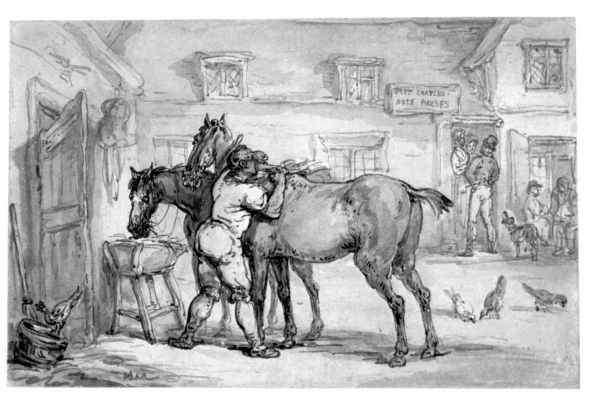

149 A Livery Stable $5\frac{7}{16} \times 8\frac{9}{16}$ in (138×217 mm)

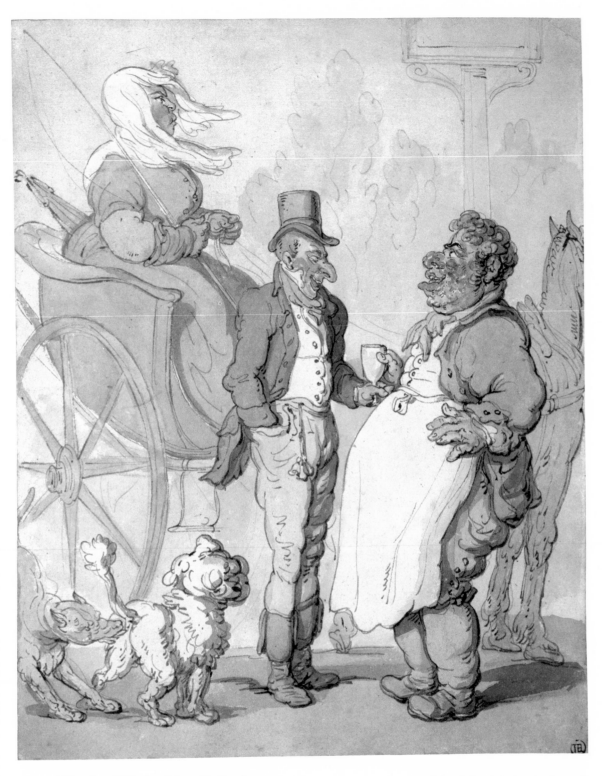

148　'Slender Billy' taking Refreshment　　　　　　　　$10\frac{7}{8} \times 8\frac{1}{2}$ in (276×216 mm)

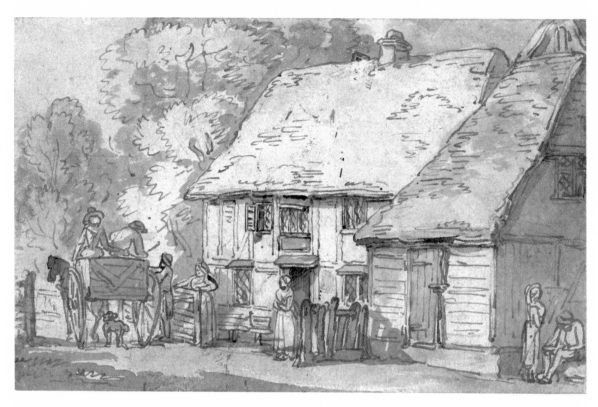

150 The Toll-Gate $4\frac{3}{4} \times 7\frac{1}{4}$ in (121×184 mm)

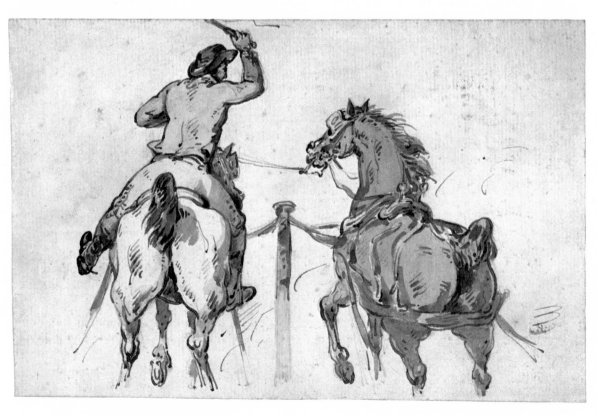

151 An English Postilion $5 \times 7\frac{7}{8}$ in (126×200 mm)

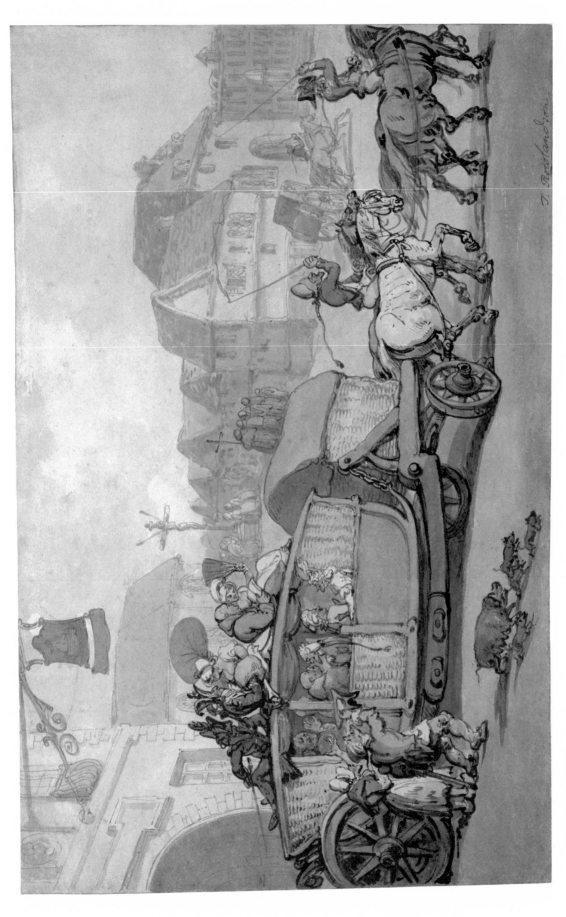

152 The Paris Diligence

T. Rowlandson

$9 \times 14\frac{1}{4}$ in (228×362 mm)

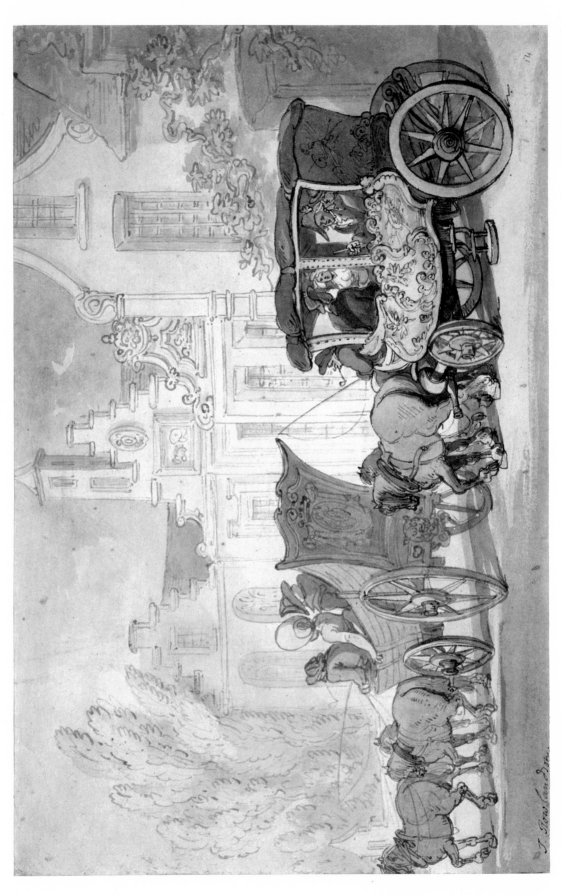

154 Travelling in Holland

$7\frac{3}{4} \times 11\frac{5}{8}$ in $(197 \times 295$ mm$)$

156 A Group of Five Bulls about to Fight

$5\frac{11}{16} \times 8\frac{3}{4}$ in (145×222 mm)

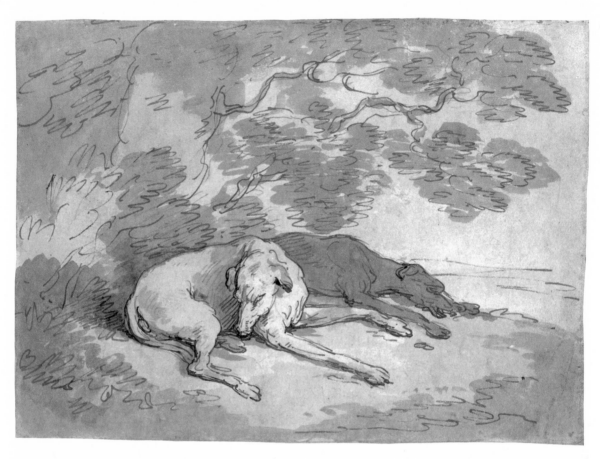

155 Two Greyhounds lying under a Tree $7 \times 9\frac{3}{4}$ in (178×248 mm)

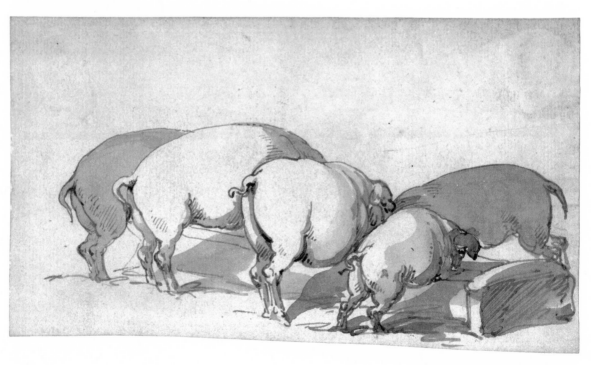

157 Pigs at a Trough $3\frac{1}{8} \times 6\frac{1}{4}$ in (80×157 mm)

158 Study of a Shouting Man $7\frac{3}{4} \times 10$ in (198 × 254 mm)

165 'The Miseries of the Country' $3\frac{7}{8} \times 5\frac{3}{4}$ in (95 × 147 mm)

159 'A Grub Street Poet' 10 × 7 in (250 × 178 mm)

161 An Elderly Buck walking with a Lady 6¾ × 5¾ in (172 × 145 mm)

160 A Gendarme and Another Man 7¼ × 5½ in (184 × 140 mm)

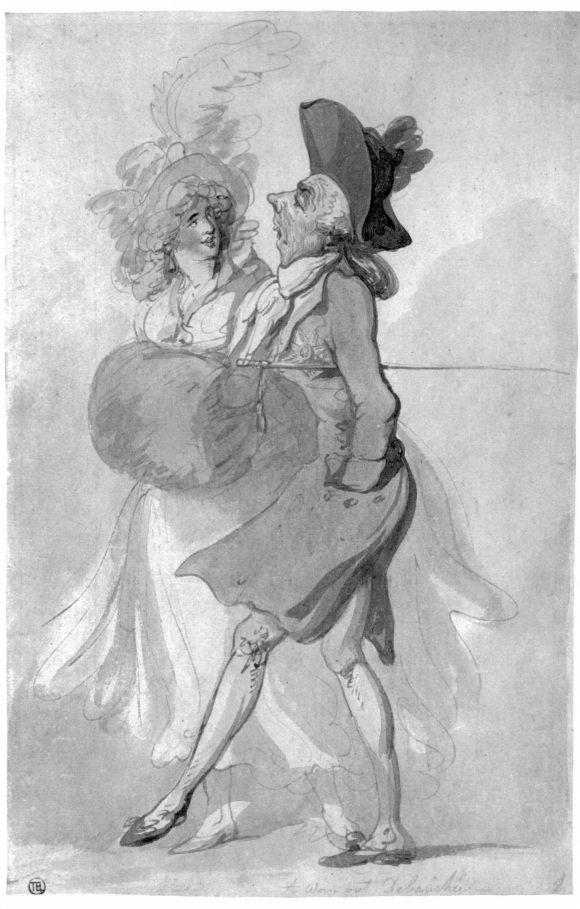

162 'A Worn Out Debaucher' 11¾ × 7¾ in (299 × 197 mm)

$10\frac{7}{8} \times 14\frac{7}{8}$ in (275 × 378 mm)

163 The Gardener's Offering

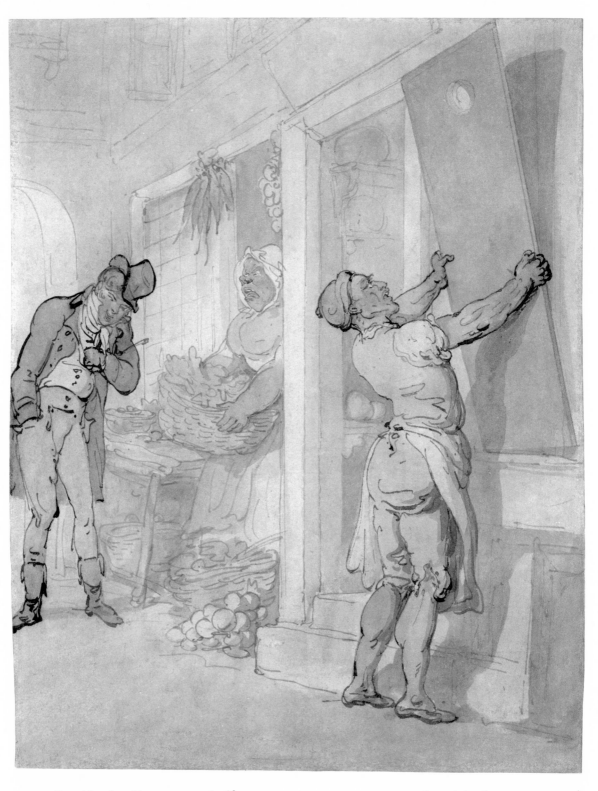

164 Outside the Greengrocer's Shop $10\frac{5}{8} \times 8\frac{1}{4}$ in $(270 \times 210$ mm$)$

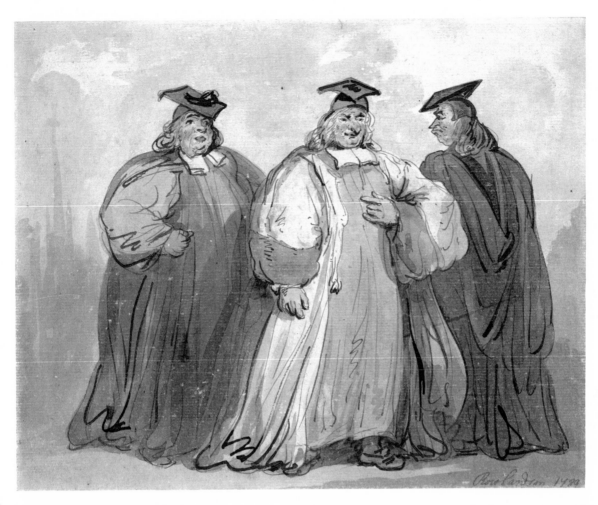

166 Three Clerical Scholars 9 × 11 in (230 × 280 mm)

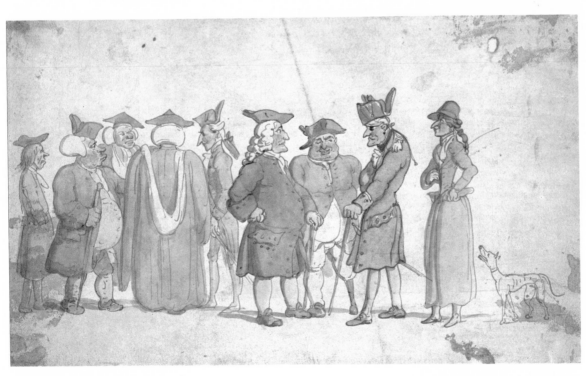

177 A Group of Figures $4\frac{3}{8} \times 7\frac{1}{2}$ in (110 × 190 mm)

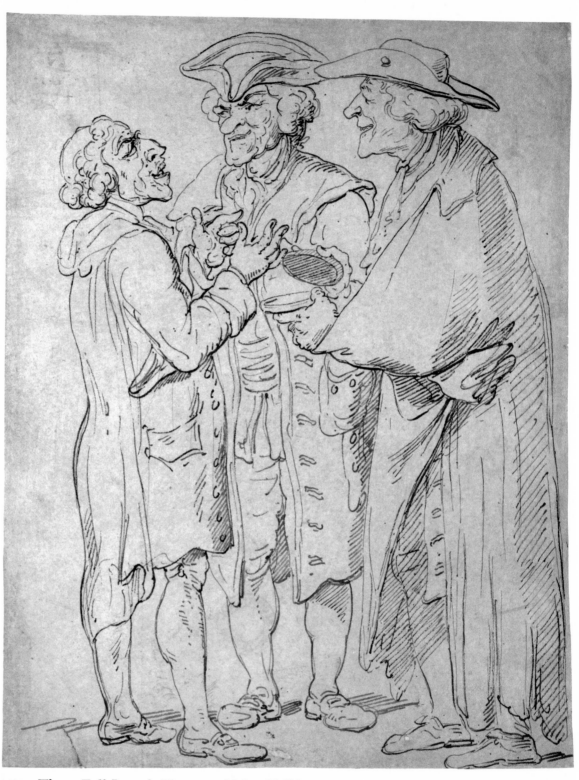

167 Three Full-Length Figures of Men Talking 9½ × 7¼ in (242 × 184 mm)

168 'Bucks of the First Head' $7\frac{1}{8} \times 8\frac{3}{4}$ in (180×222 mm)

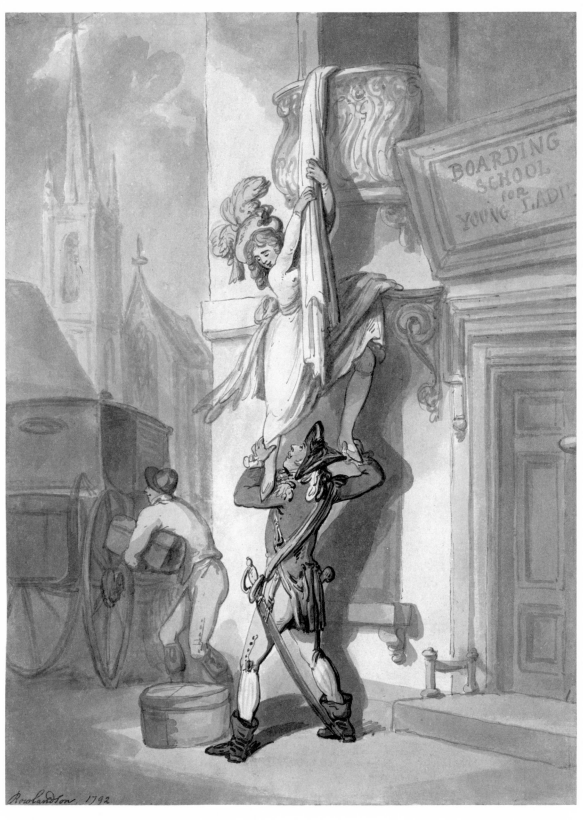

169 The Elopement

$10\frac{7}{8} \times 8$ in (275×203 mm)

Settling a Love Quarrell

170 'Settling a Love Quarrell' $7\frac{3}{4} \times 10\frac{5}{8}$ in (197 × 270 mm)

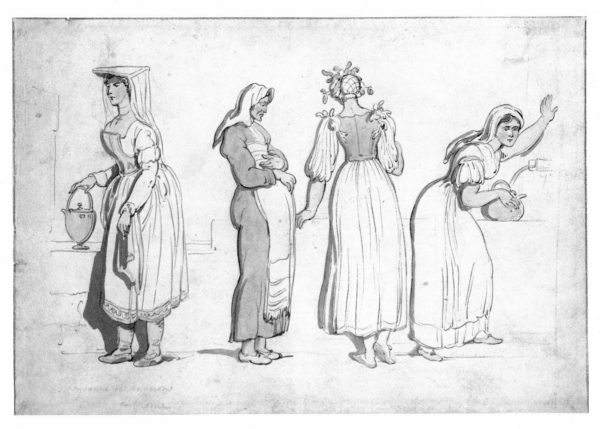

171 Four Women at a Well in Rome 6 × 9 in (152 × 258 mm)

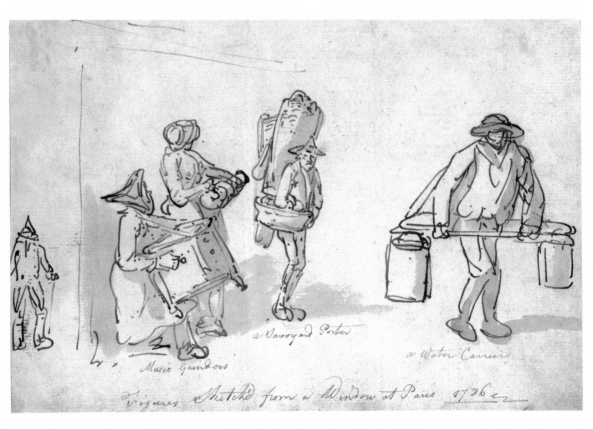

172 Parisian Street Figures 6½ × 9½ in (165 × 242 mm)

173 Feeding the Ducklings

$9 \times 11\frac{5}{8}$ in (230×295 mm)

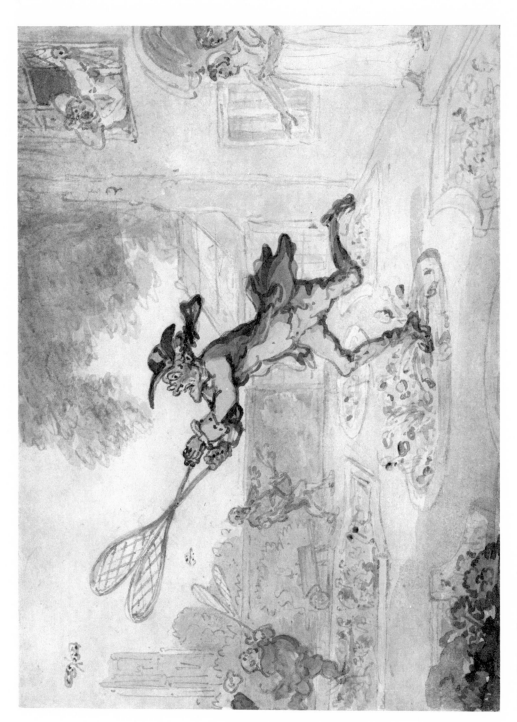

175 Butterfly Hunting

$5\frac{1}{4} \times 7\frac{3}{4}$ in $(134 \times 197$ mm$)$

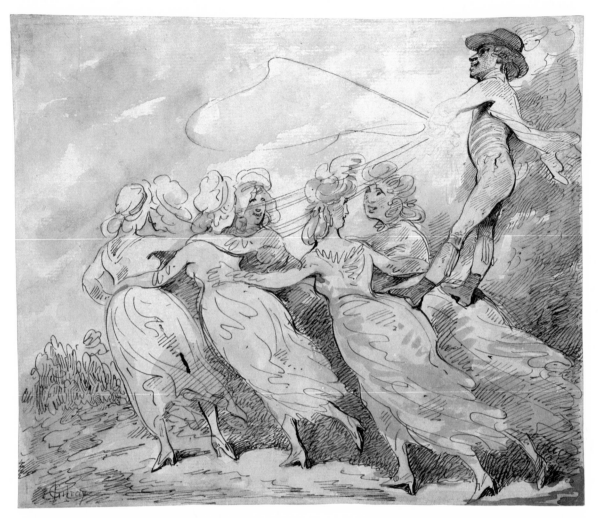

176 A Man Driving a Team of Six Girls 7¾ × 9⅜ in (197 × 239 mm)

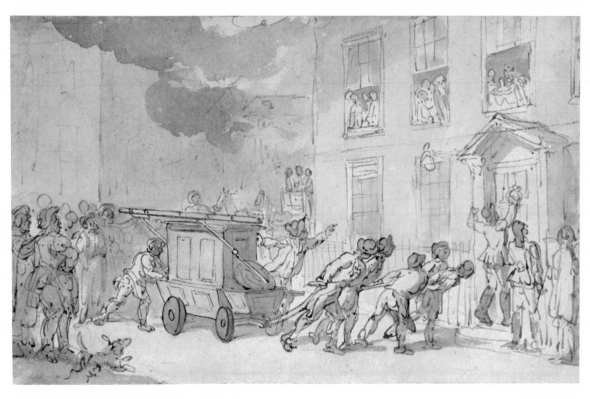

183 The Arrival of the Fire Engine 4½ × 7⅛ in (114 × 180 mm)

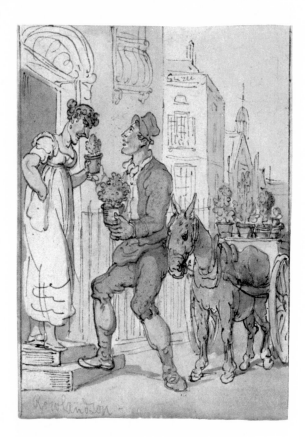

178 A Flower Seller
$4\frac{1}{8} \times 3$ in (105×75 mm)

179 'Knives or Scissers to Grind'
$4\frac{1}{8} \times 2\frac{3}{4}$ in (105×75 mm)

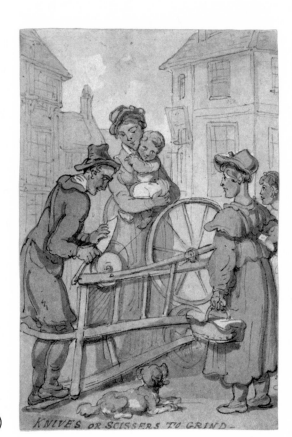

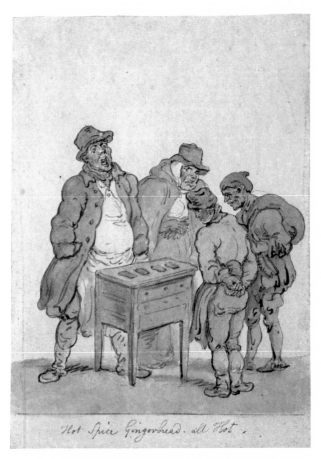

180 'Hot Spice Gingerbread All Hot'
$5\frac{3}{4} \times 4$ in (142×100 mm)

Hot Spice Gingerbread. all Hot.

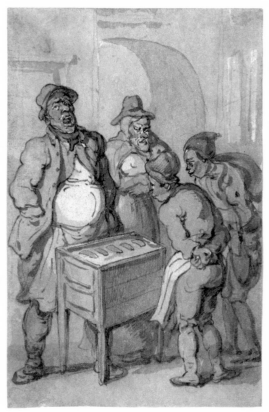

181 'Hot Spice Gingerbread All Hot'
$4\frac{1}{8} \times 2\frac{5}{8}$ in (102×67 mm)

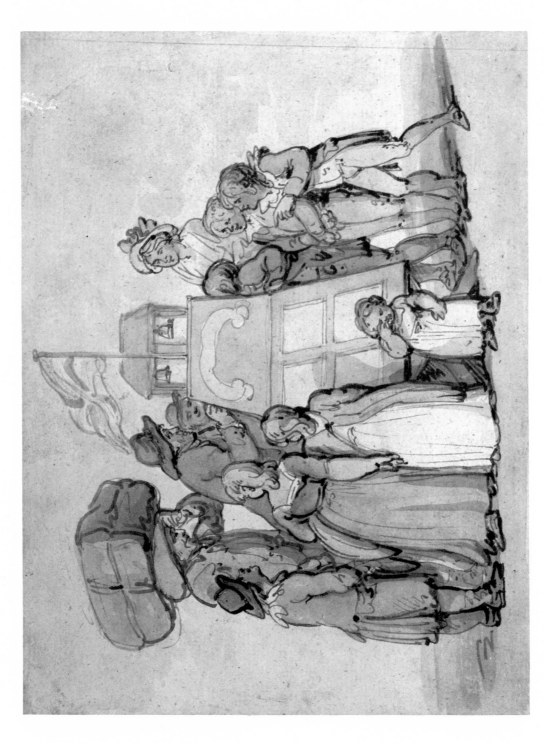

$5\frac{1}{2} \times 7\frac{1}{4}$ in $(140 \times 183$ mm$)$

182 A Peepshow

202 Register Office for the Hiring of Servants

$9\frac{1}{4} \times 12\frac{3}{4}$ in (235×324 mm)

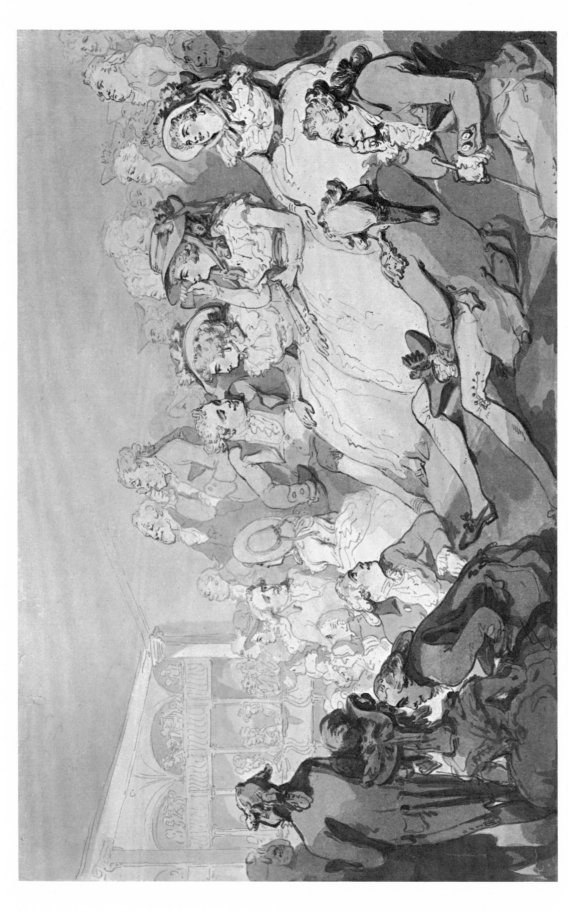

242 An Audience Watching a Play at Drury Lane Theatre

$9\frac{1}{2} \times 14\frac{3}{8}$ in (241 × 365 mm)

184 A Punch and Judy Show

$5\frac{3}{4} \times 9\frac{3}{8}$ in $(146 \times 238$ mm$)$

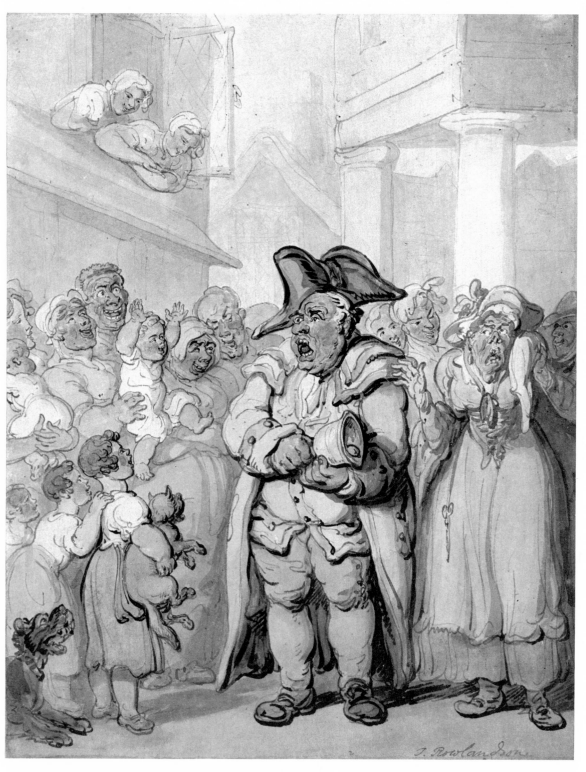

185 The Town Crier $11\frac{3}{4} \times 9\frac{1}{8}$ in (287 × 230 mm)

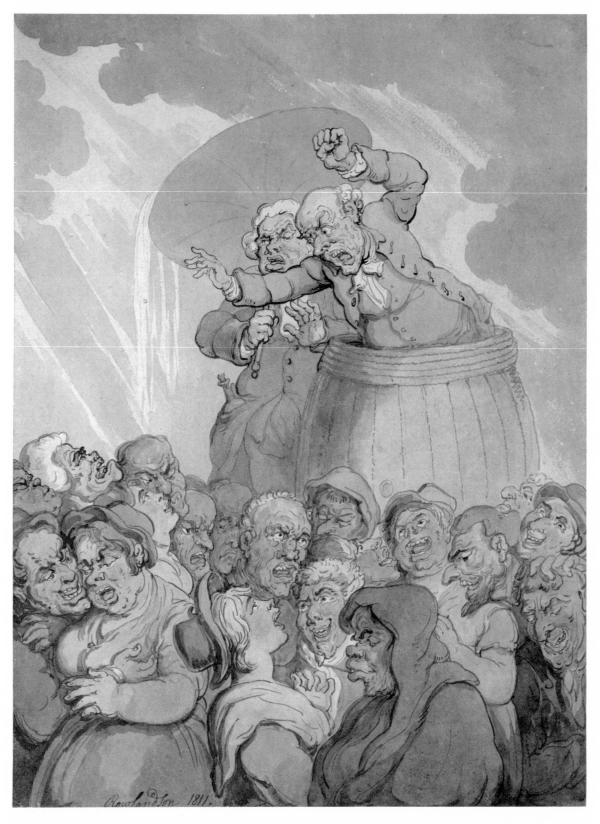

186 A Tub Thumper $12\frac{1}{2} \times 9\frac{1}{4}$ in $(318 \times 235$ mm$)$

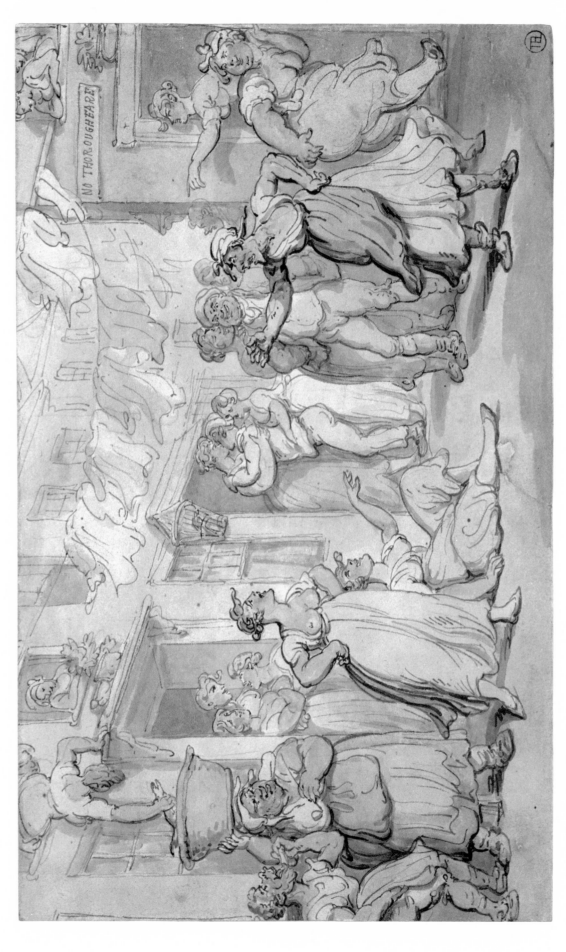

187 Angry Scene in a Street

$5\frac{3}{4} \times 9\frac{1}{4}$ in (145×235 mm)

188　A Gibbet
　　　$14 \times 10\frac{3}{4}$ in $(350 \times 273$ mm$)$

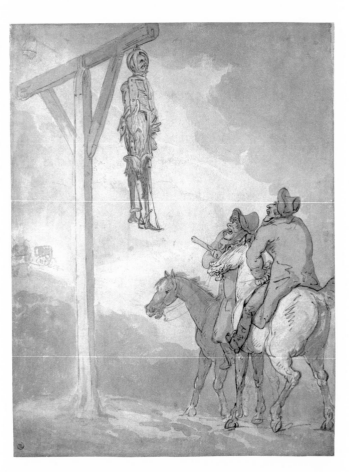

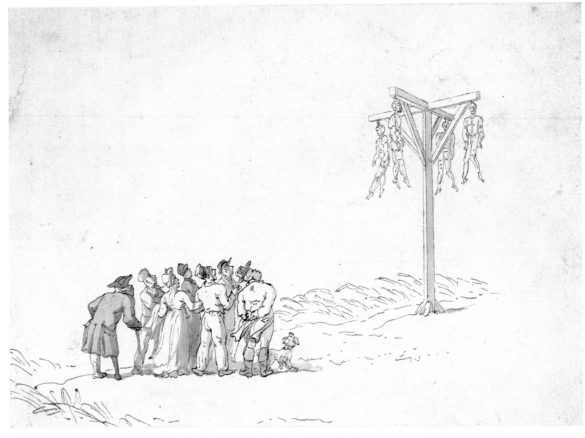

189　Crowd by a Gibbet　　　　　　　　　　　$6\frac{1}{2} \times 8\frac{1}{2}$ in $(165 \times 215$ mm$)$

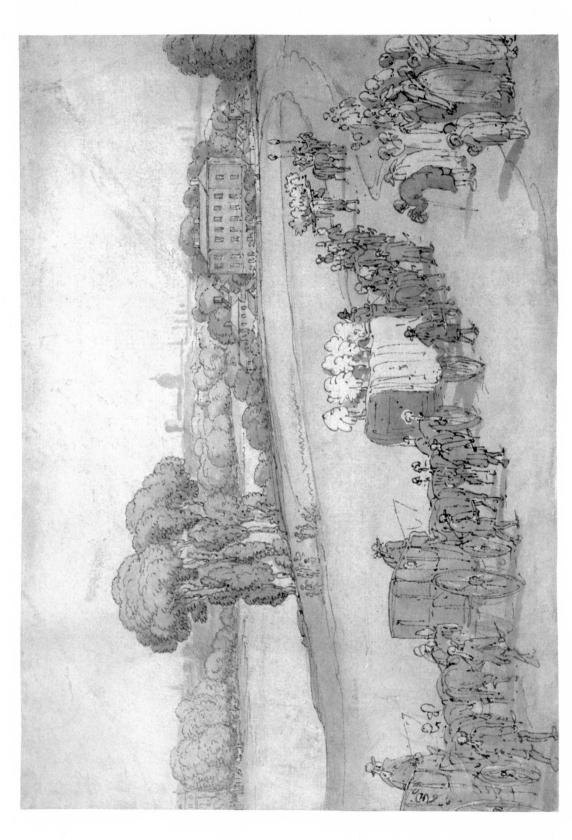

190 A Funeral Procession

$7\frac{7}{8} \times 11$ in (200 × 280 mm)

Rowlandson

191 Monks Carousing outside a Monastery

$6 \times 8\frac{7}{8}$ in $(153 \times 225$ mm)

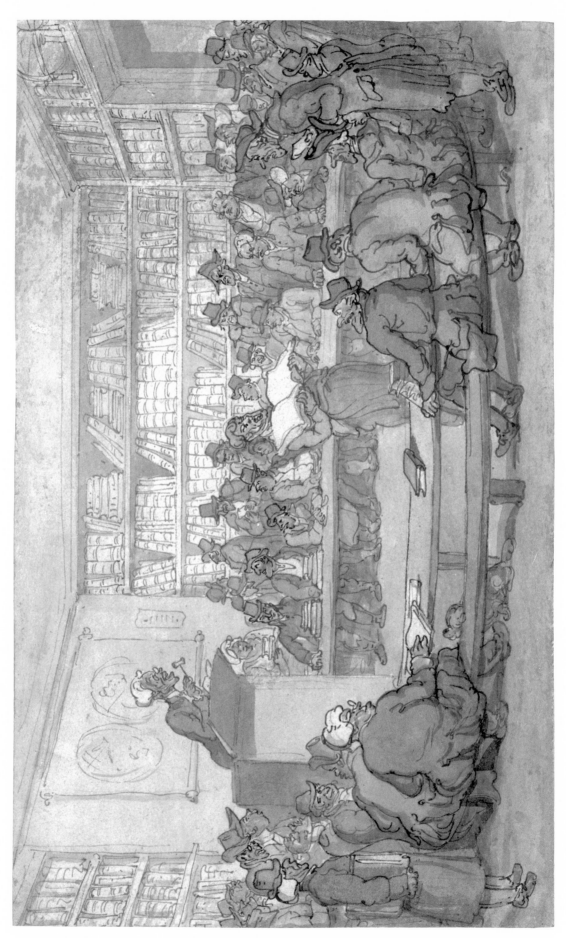

192 A Book Auction

6 × 10 in (152 × 252 mm)

$10\frac{3}{8} \times 12\frac{5}{8}$ in (264×321 mm)

193 'Bookseller and Author'

194 'The Connoisseurs'

$9 \times 11\frac{3}{4}$ in (230×300 mm)

195 'The Historian Animating the Mind of the Young Painter'

$7\frac{3}{8} \times 10\frac{1}{4}$ in $(188 \times 261$ mm$)$

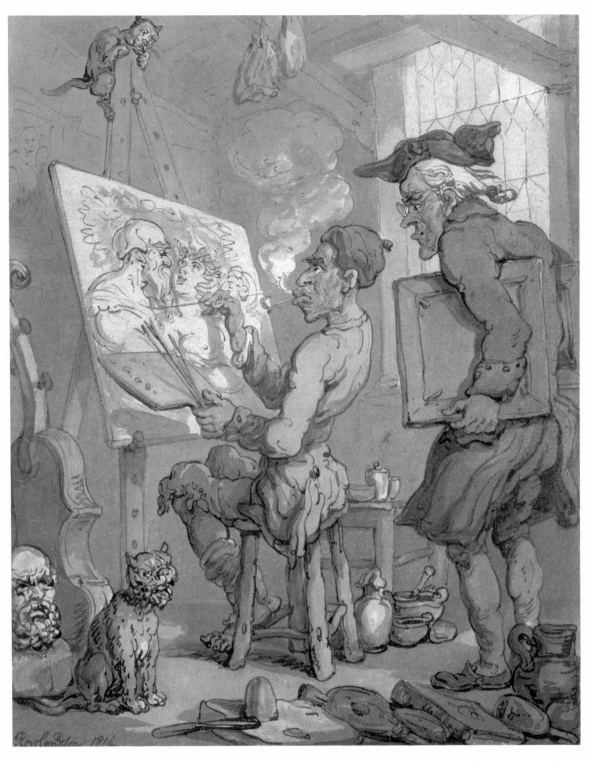

196 An Artist's Studio 10½ × 8½ in (266 × 215 mm)

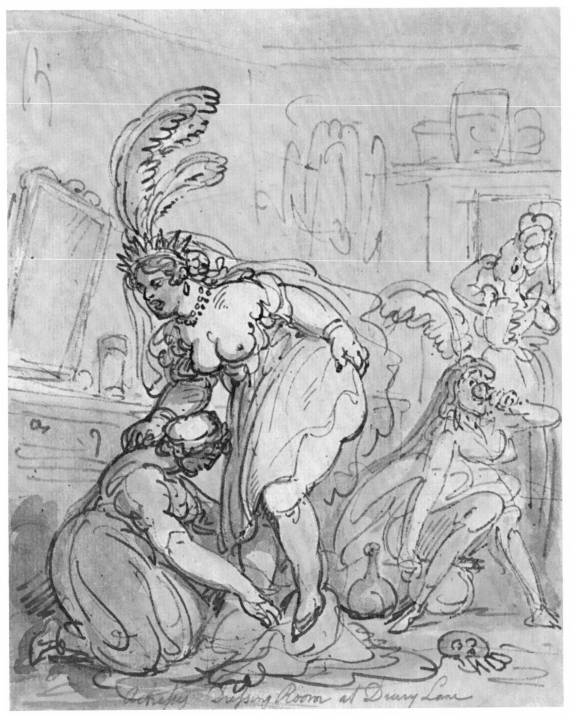

246 'Actresses Dressing Room at Drury Lane' $7\frac{3}{8} \times 6$ in $(187 \times 152$ mm$)$

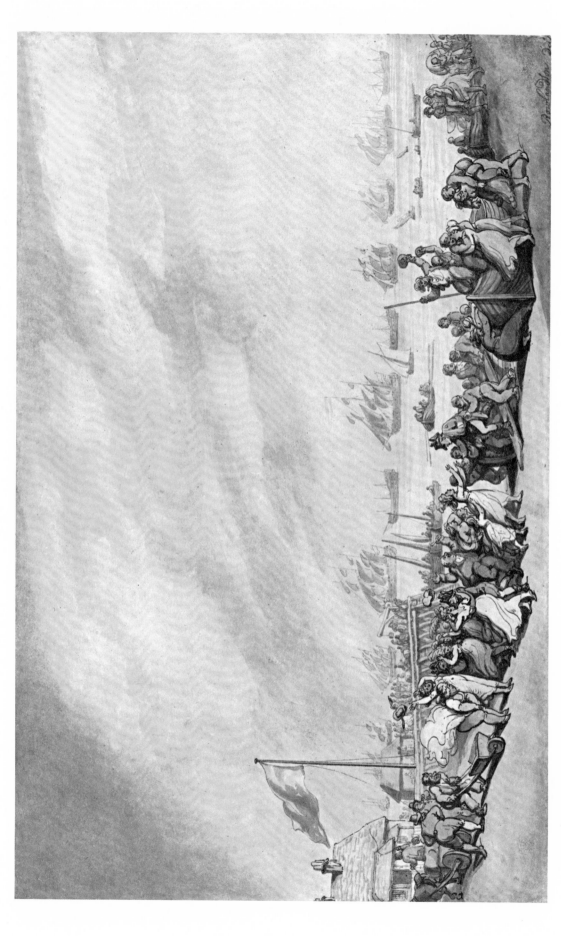

268 The Return of the Fleet to Great Yarmouth in 1797

$10\frac{3}{4} \times 17$ in (273×410 mm)

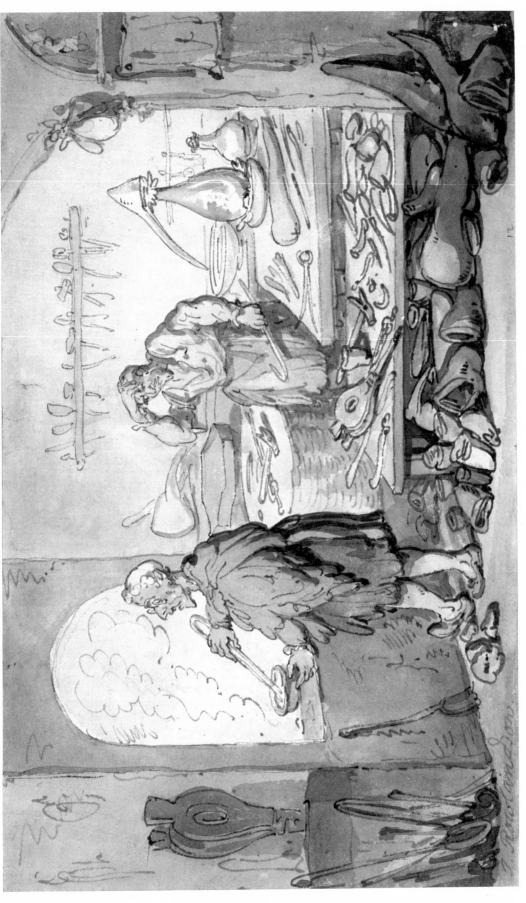

197 The Glass-Maker

$5\frac{1}{2} \times 9\frac{1}{8}$ in $(140 \times 232$ mm$)$

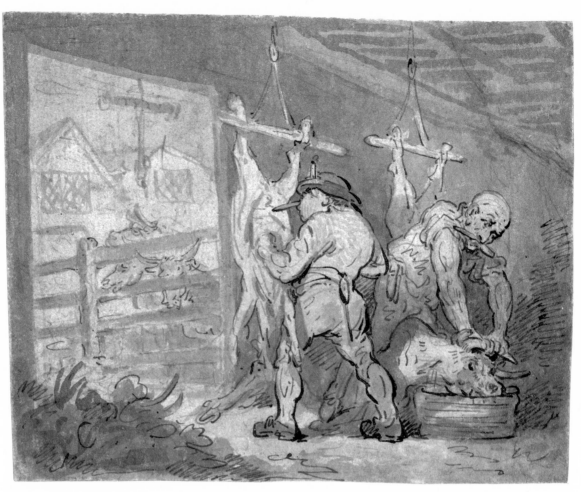

198 The Slaughterhouse $6 \times 7\frac{1}{2}$ in (152×191 mm)

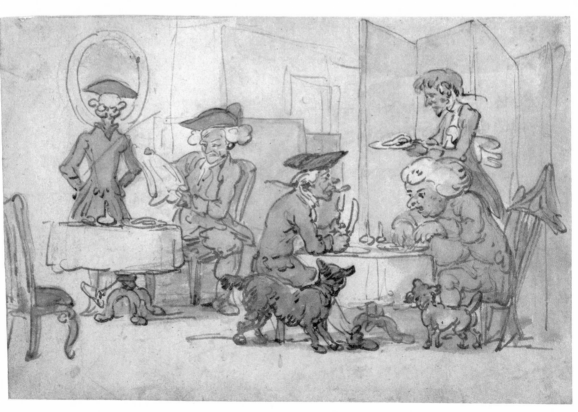

199 Diners in a Chop House $4\frac{3}{8} \times 6\frac{5}{8}$ in (112×168 mm)

200 A Merchant's Office

11×13 in $(280 \times 330$ mm$)$

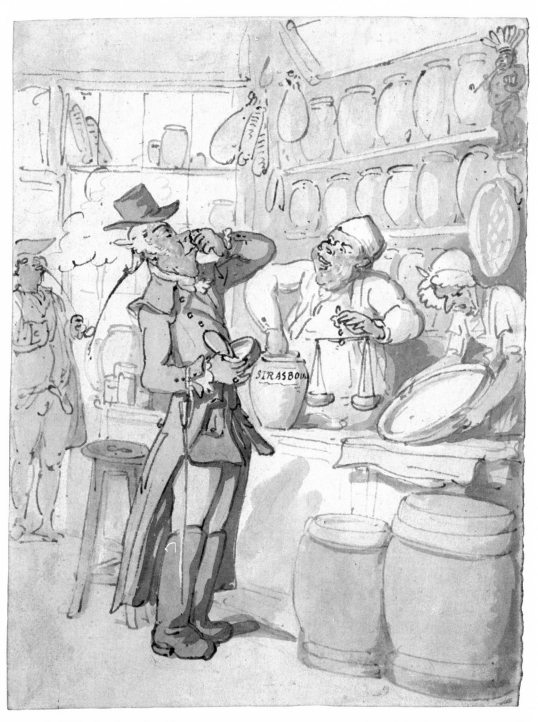

201 A Man buying Snuff $7\frac{3}{8} \times 5\frac{5}{8}$ in $(185 \times 142$ mm$)$

203 Portrait of an old man 7 × 6 in (179 × 152 mm)

204 The Love Letter $11 \times 7\frac{1}{2}$ in $(280 \times 191$ mm$)$

205 A Lady in a White Dress, wearing a Blue Hat $13\frac{3}{8} \times 9\frac{1}{2}$ in (340×240 mm)

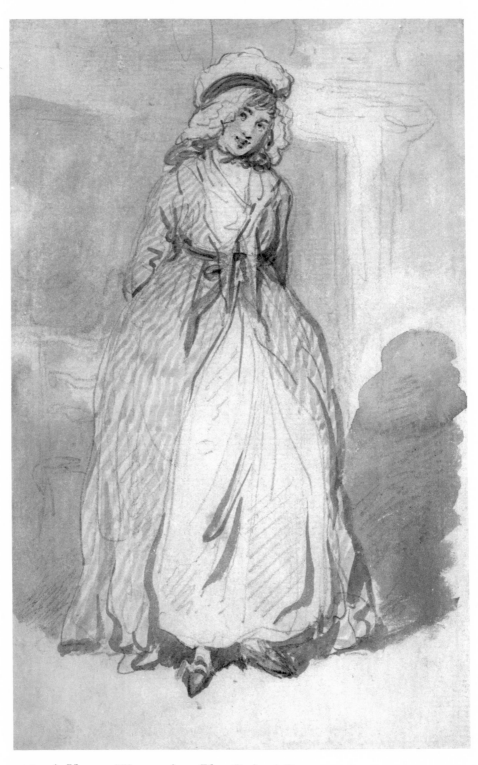

206 A Young Woman in a Blue Striped Dress

$7\frac{5}{8} \times 4\frac{7}{8}$ in (194×124 mm)

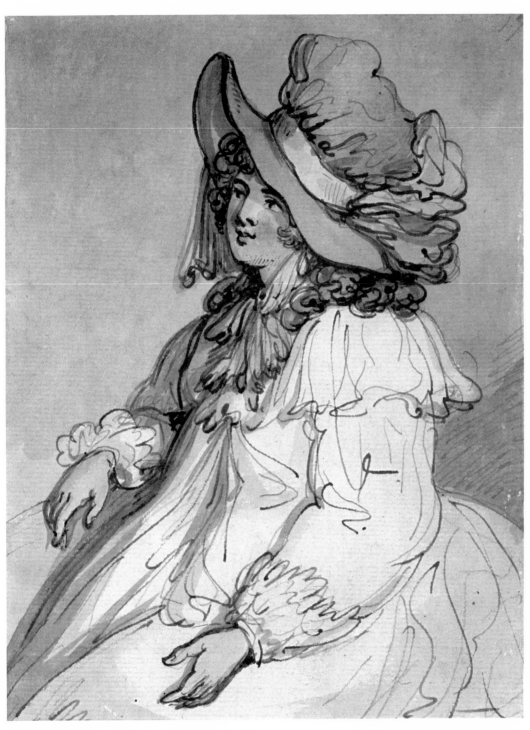

207 'Mad'elle du the de l'Opera' $7\frac{3}{8} \times 5\frac{5}{8}$ in (187 × 143 mm)

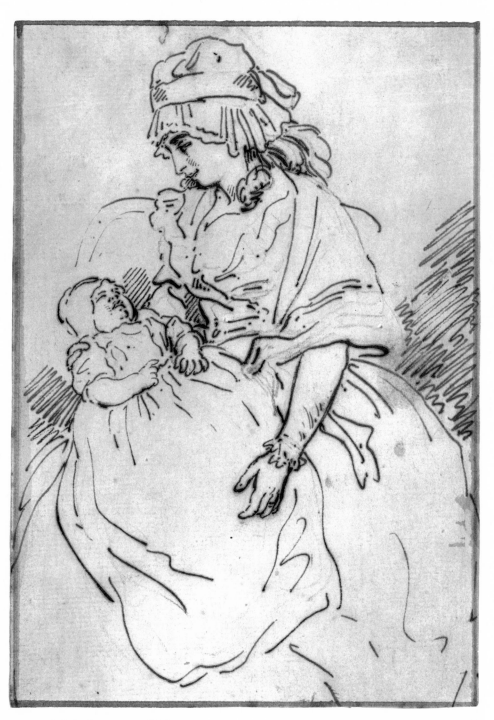

208 A Mother and Child $7\frac{1}{8} \times 5$ in $(180 \times 127$ mm$)$

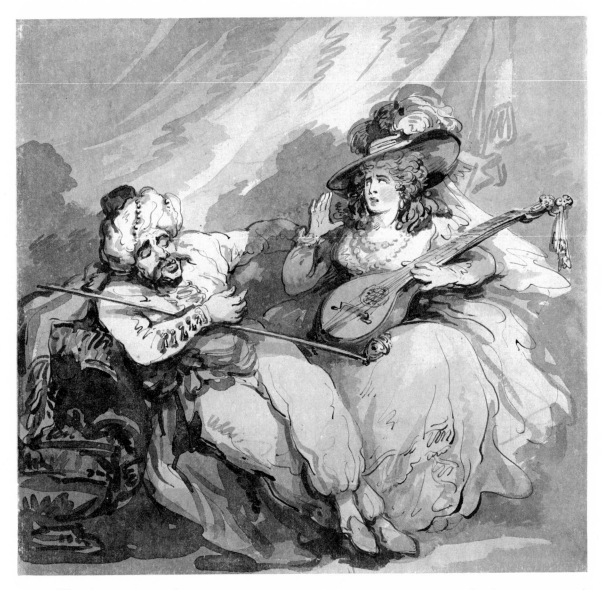

209 The Amorous Turk $11\frac{3}{4} \times 11$ in $(297 \times 280$ mm$)$

210 'Forgiving Lovers'
$9\frac{1}{4} \times 6\frac{1}{2}$ in (235×165 mm)

211 Sleeping Woman watched by a Man
$5\frac{5}{8} \times 7\frac{3}{4}$ in (143×197 mm)

212　Two Sleeping Figures
　　$6\frac{3}{4} \times 8\frac{5}{8}$ in $(172 \times 220$ mm$)$

213　'Cat Like Courtship'
　　$9\frac{5}{8} \times 7\frac{3}{4}$ in $(244 \times 197$ mm$)$

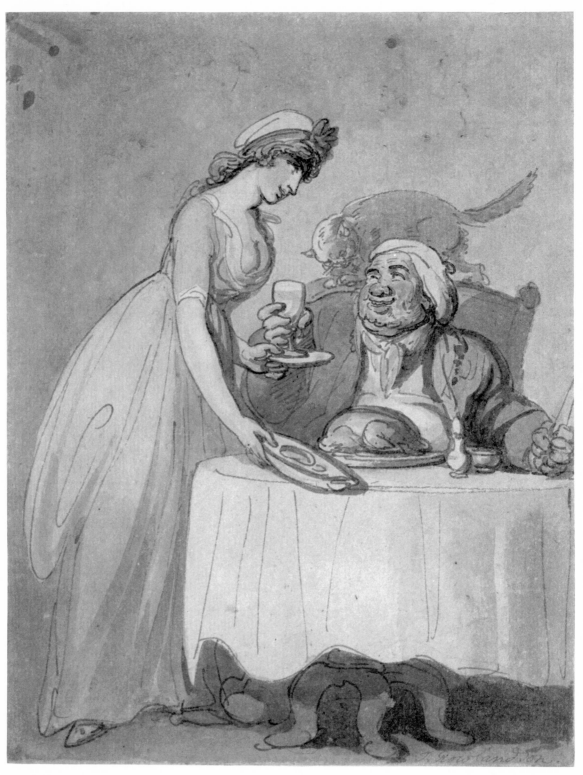

214 The Gourmand $9\frac{1}{2} \times 7\frac{3}{8}$ in $(240 \times 187$ mm$)$

215 The Drunken Nurse $5\frac{5}{8} \times 7\frac{1}{2}$ in (143 × 190 mm)

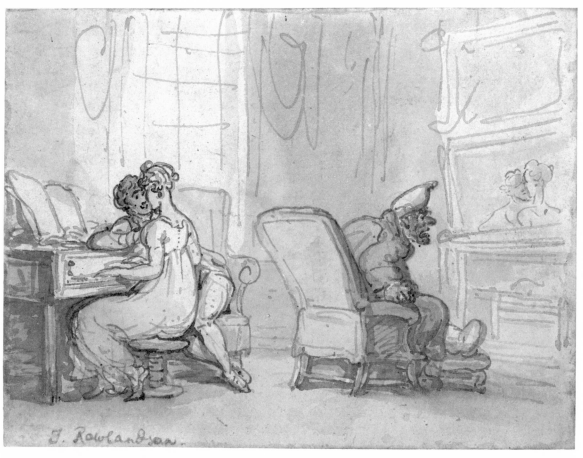

216 Reflections or The Music Lesson $4\frac{1}{8} \times 6\frac{1}{8}$ in $(104 \times 156$ mm$)$

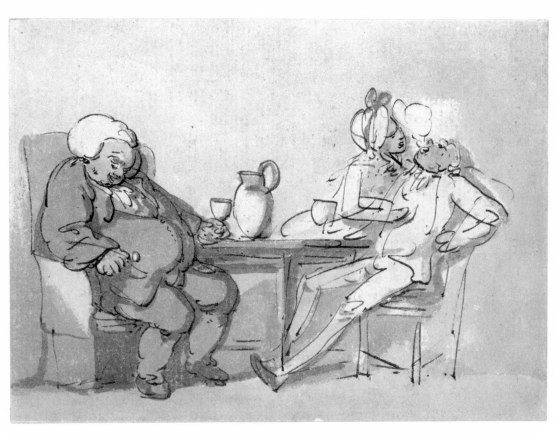

217 The Doctor Overcome $4\frac{1}{4} \times 5\frac{7}{8}$ in $(108 \times 146$ mm$)$

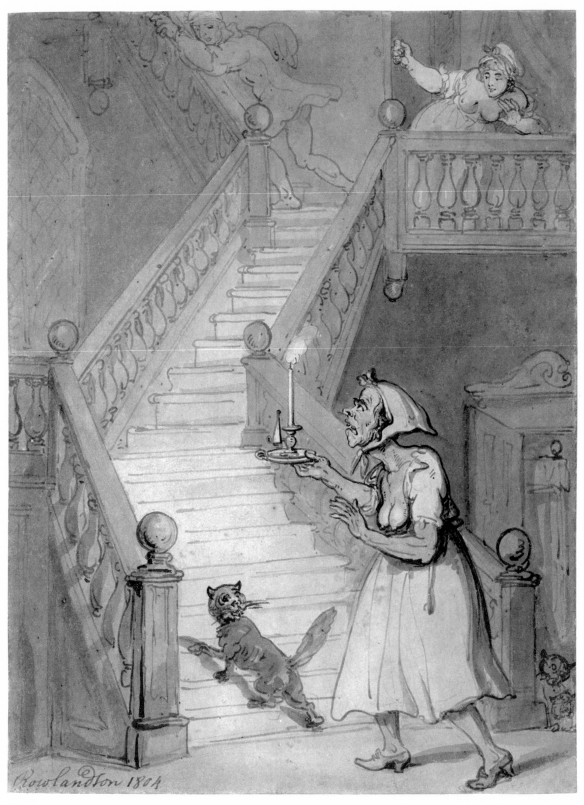

Rowlandson 1804

218 'A Maiden Aunt Smelling Fire' $11\frac{3}{8} \times 8\frac{1}{2}$ in $(288 \times 216$ mm$)$

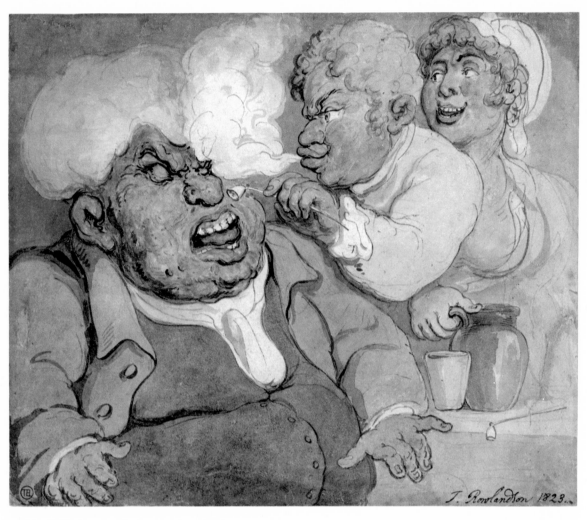

219 Taunting with Smoke from a Pipe 8⅝ × 10¼ in (219 × 261 mm)

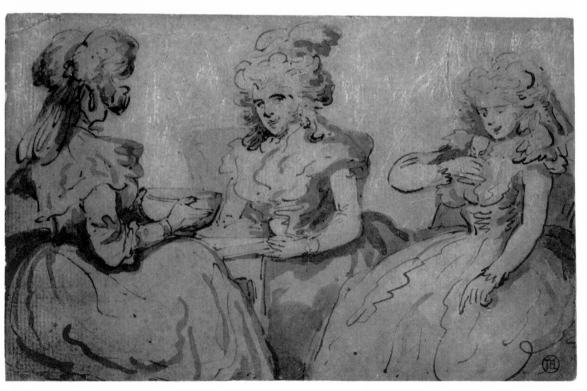

221 Women Drinking Punch 4⅞ × 7¾ in (125 × 197 mm)

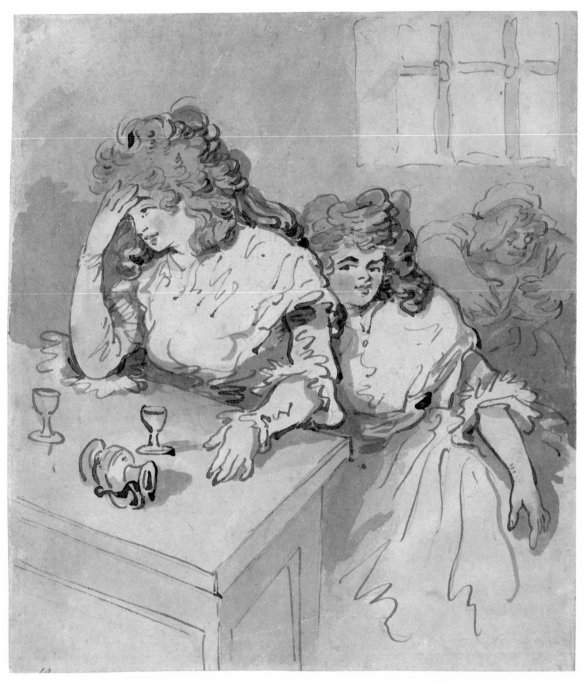

220 Two Girls Tippling $6\frac{7}{8} \times 6\frac{1}{4}$ in (175×155 mm)

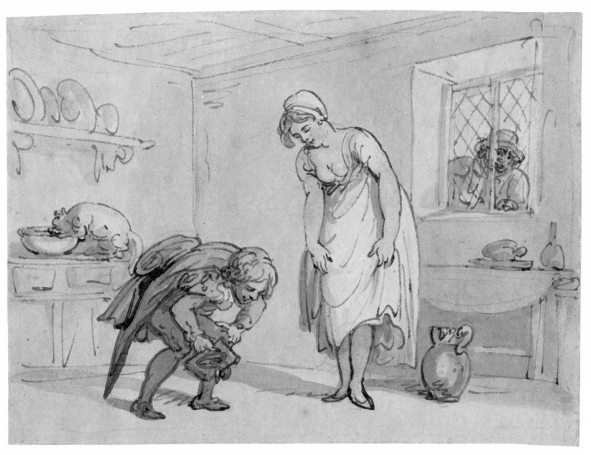

222 'New Shoes' $4\frac{3}{4} \times 6\frac{3}{8}$ in (120×162 mm)

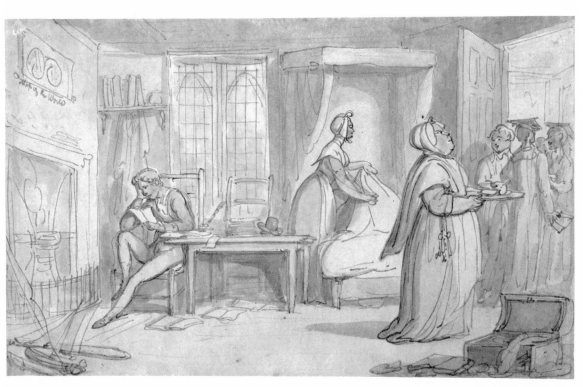

223 The Undergraduate's Room $4\frac{5}{8} \times 7\frac{5}{8}$ in (117×194 mm)

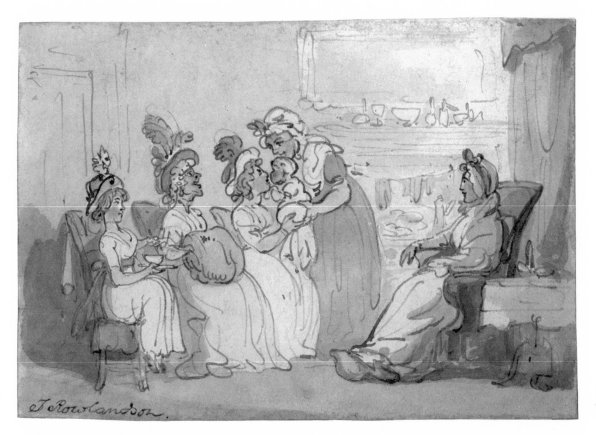

224 The Visitors being shown the Baby 4⅛ × 6 in (105 × 153 mm)

229 'The Duchess of Gordon's Rout' 4¾ × 8⅞ in (120 × 226 mm)

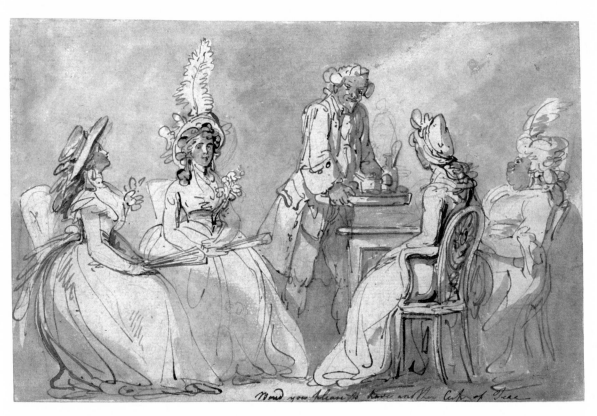

225 (recto) Ladies at Tea $5\frac{7}{8} \times 9\frac{1}{8}$ in $(149 \times 232$ mm$)$

225 (verso) Study of a half-seated Man
$5\frac{7}{8} \times 9\frac{1}{8}$ in $(149 \times 232$ mm$)$

226 'Mr Michell's Picture Gallery, Grove House Enfield 1817'

$5\frac{7}{8} \times 9\frac{3}{8}$ in $(150 \times 237$ mm$)$

227 A Gentleman's Art Gallery $5\frac{3}{4} \times 9$ in $(146 \times 229$ mm$)$

230 Elegant Company Dancing $4\frac{1}{2} \times 7\frac{3}{4}$ in $(115 \times 197$ mm$)$

228 'Jealousy, Rage, Disappointment...'

Rowlandson 1817

$5\frac{3}{4} \times 9\frac{1}{8}$ in (145×231 mm)

231 The Vinery

$7\frac{5}{8} \times 10\frac{7}{8}$ in (195 × 276 mm)

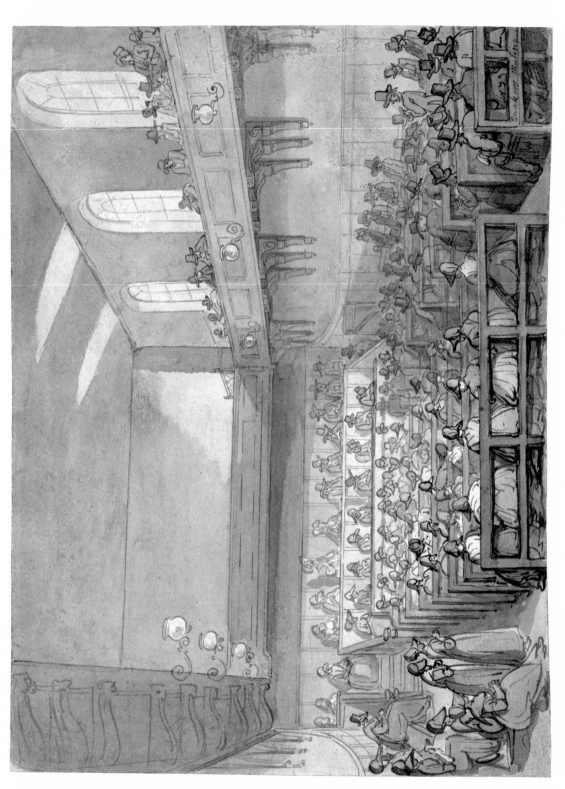

232 'Quakers Meeting' 8½ × 11 in (215 × 280 mm)

233 A Legal Wrangle $6\frac{3}{8} \times 12\frac{1}{8}$ in (162×311 mm)

234 Checkmate

$5\frac{3}{8} \times 7\frac{3}{8}$in $(137 \times 188$ mm$)$

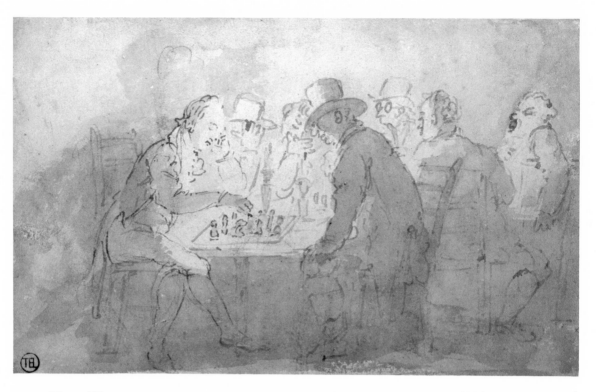

235 Chess Players $4\frac{3}{8} \times 7$ in $(111 \times 178$ mm$)$

236 'A Black Leg Detected Secreting Cards' (a study)

$3\frac{1}{2} \times 5\frac{1}{2}$ in $(89 \times 140$ mm$)$

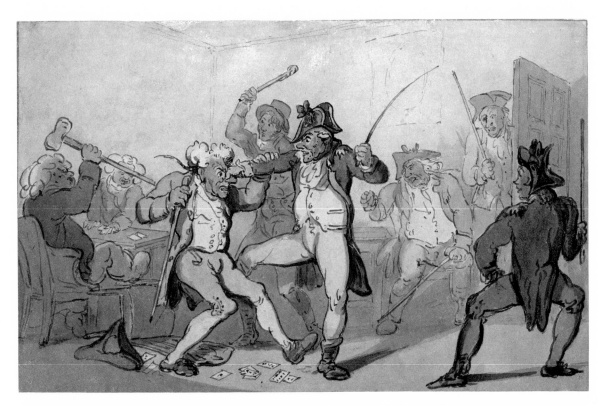

237 'A Black Leg Detected Secreting Cards' 5 × 7⅞ in (127 × 200 mm)

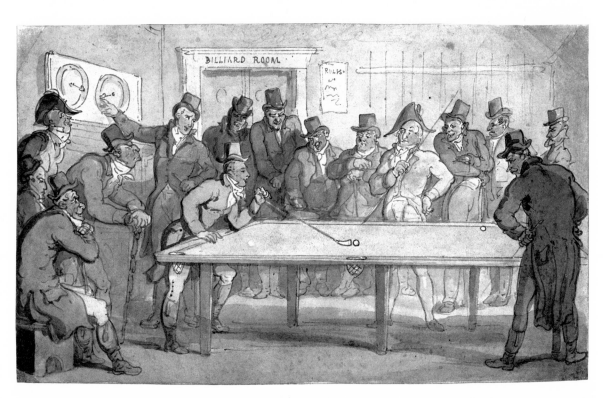

238 'The Billiard Room' 4¾ × 7¾ in (121 × 197 mm)

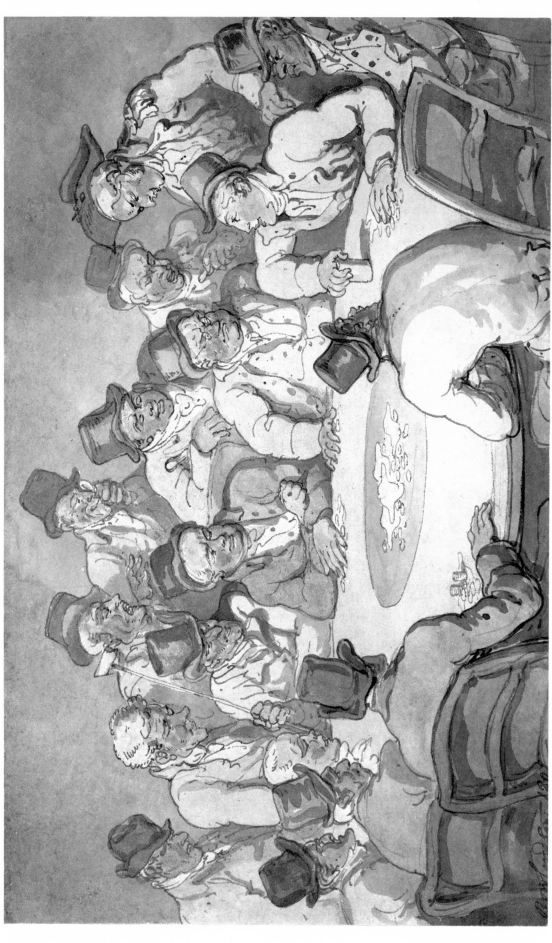

239 The Gaming Table

$5\frac{7}{8} \times 9\frac{1}{2}$ in (150×240 mm)

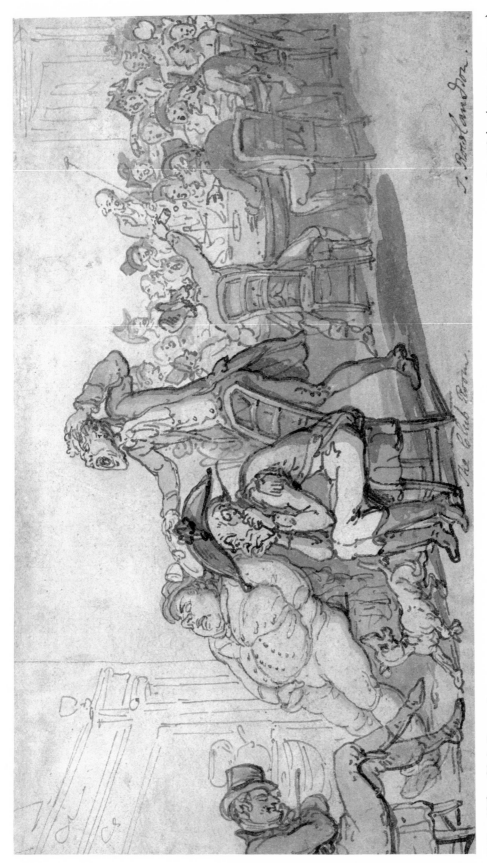

240 'The Club Room'

T. Rowlandson.

The Club Room.

$4\frac{7}{8} \times 8\frac{3}{4}$ in (125×222 mm)

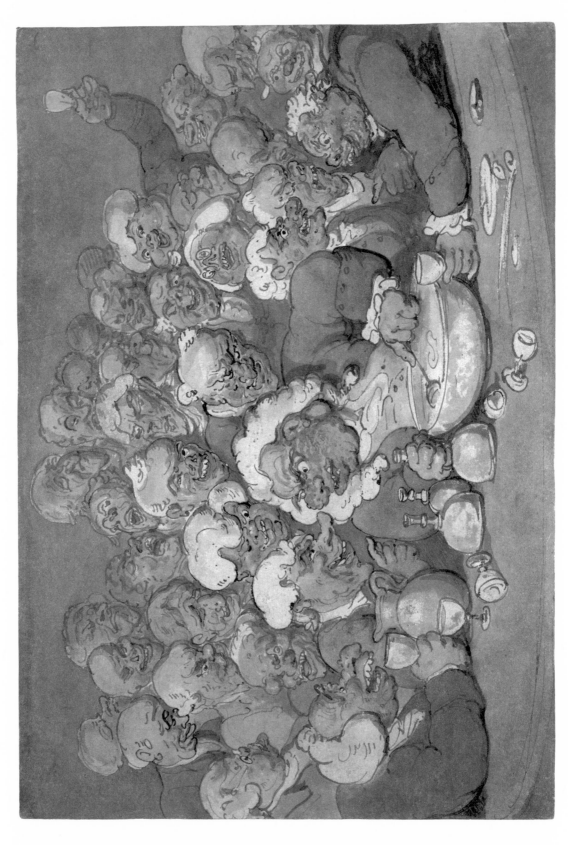

241 Serving Punch $9\frac{1}{2} \times 13\frac{7}{8}$ in (244×352 mm)

243 An Audience at Drury Lane Theatre $8\frac{1}{4} \times 17\frac{1}{2}$ in $(216 \times 460$ mm$)$

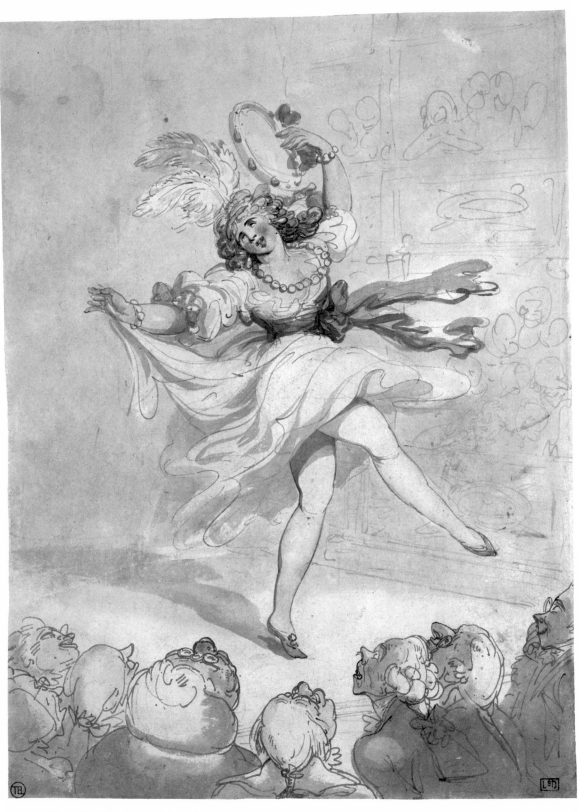

244 Female Dancer with a Tambourin $11\frac{5}{8} \times 8\frac{5}{8}$ in $(295 \times 220$ mm$)$

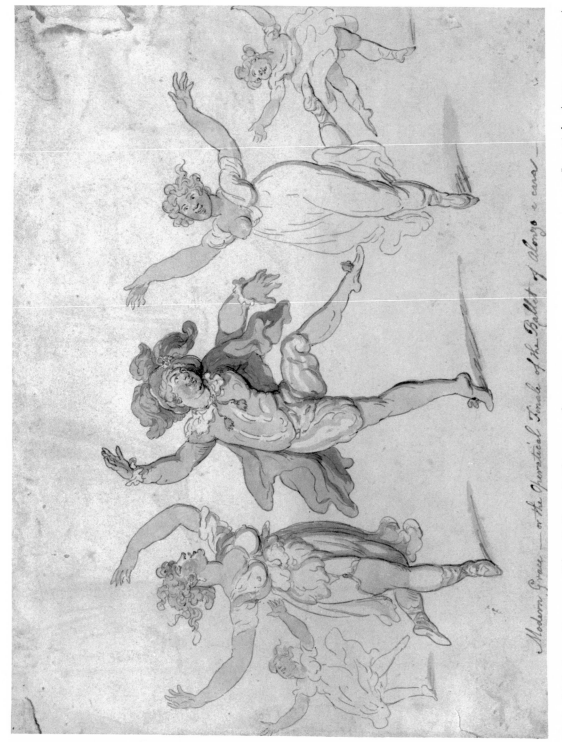

Modern Grace — or the Operatical Finale of the Ballet of Alonzo e cara

$6\frac{7}{8} \times 9\frac{1}{8}$ in $(175 \times 235$ mm$)$

245 'Modern Grace...The Ballet of Alonzo e Cara'

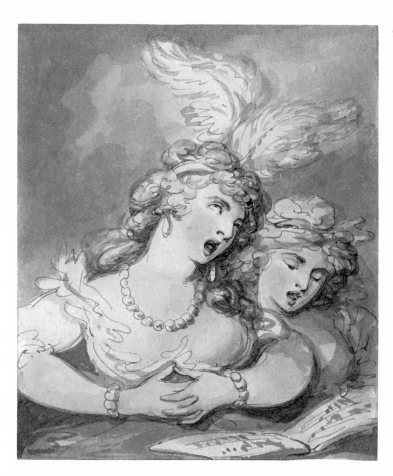

247 The Opera Singers
$5\frac{1}{2} \times 4\frac{3}{4}$ in $(140 \times 120$ mm$)$

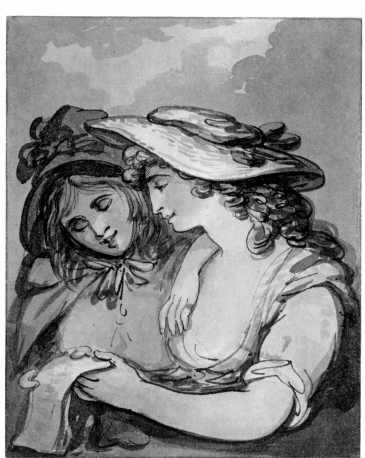

248 The Ballad Singers
$5\frac{3}{8} \times 4\frac{3}{8}$ in $(136 \times 111$ mm$)$

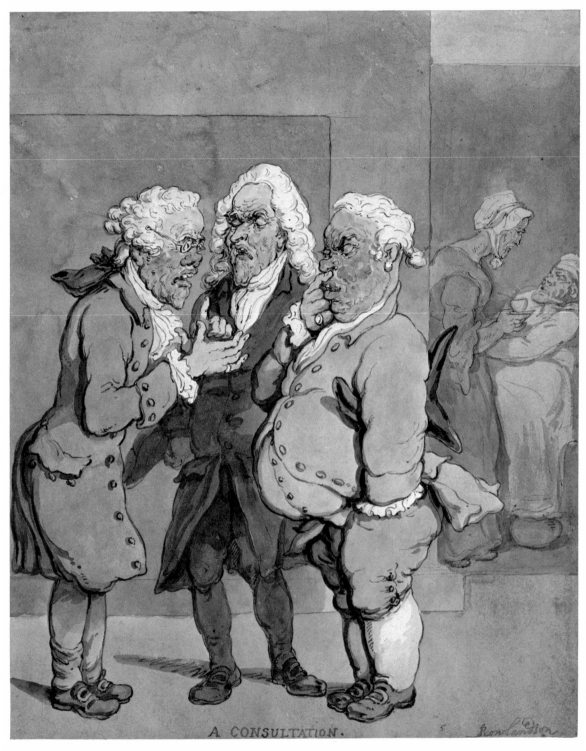

A CONSULTATION. 5. Rowlandson

249 'A Consultation' $10\frac{3}{4} \times 8\frac{3}{4}$ in $(272 \times 222$ mm$)$

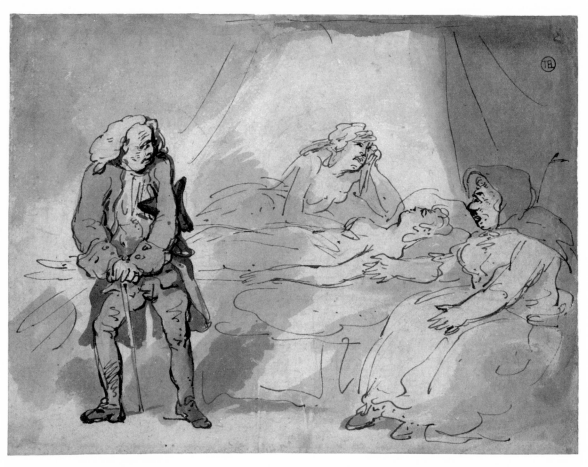

250 A Death-Bed Scene 6¾ × 9 in (171 × 229 mm)

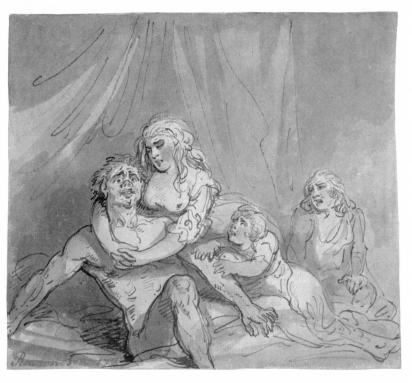

251 The Maniac 6⅞ × 7¾ in (174 × 197 mm)

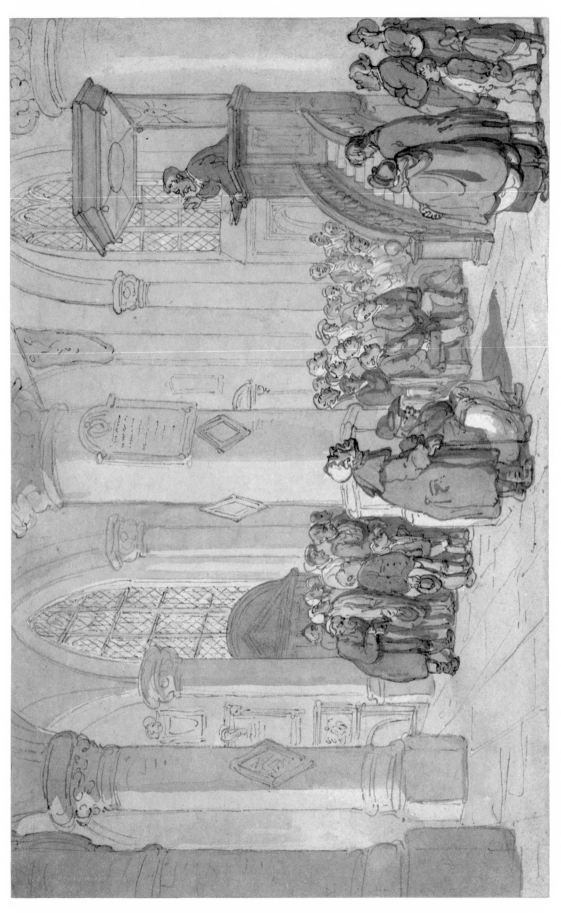

252 The Preacher $5\frac{7}{8} \times 9\frac{1}{4}$ in $(150 \times 184 \text{ mm})$

253　The Cloisters of a Monastery

$4\frac{7}{8} \times 8$ in (123×203 mm)

254　Scene in a Monastery　　　　　　　　　　$5\frac{1}{4} \times 7\frac{1}{2}$ in $(133 \times 191$ mm$)$

255　A Tour in a Cathedral　　　　　　　　　　$4\frac{1}{2} \times 7$ in $(119 \times 178$ mm$)$

256 Mrs Abington $7\frac{3}{4} \times 11\frac{3}{4}$ in (197 × 299 mm)

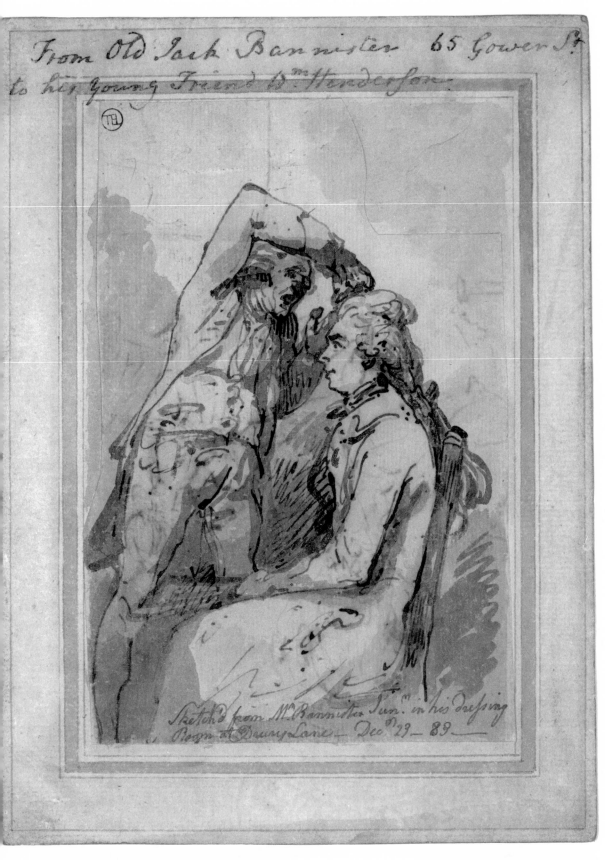

257 Jack Bannister in his Dressing Room $6\frac{3}{4} \times 4\frac{1}{2}$ in (172×115 mm)

258 Interior of a Dressing Room with Jack Bannister $5 \times 8\frac{1}{4}$ in (127×210 mm)

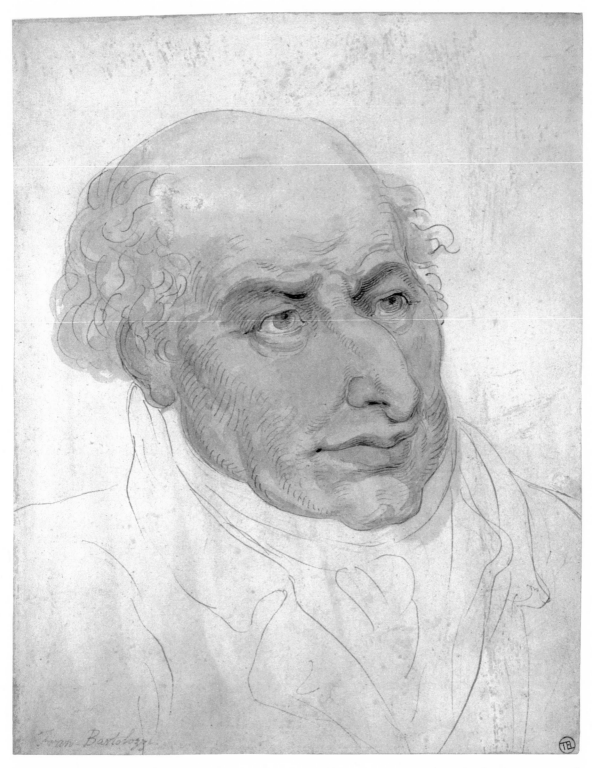

259 Francesco Bartolozzi 10¼ × 8¼ in (260 × 210 mm)

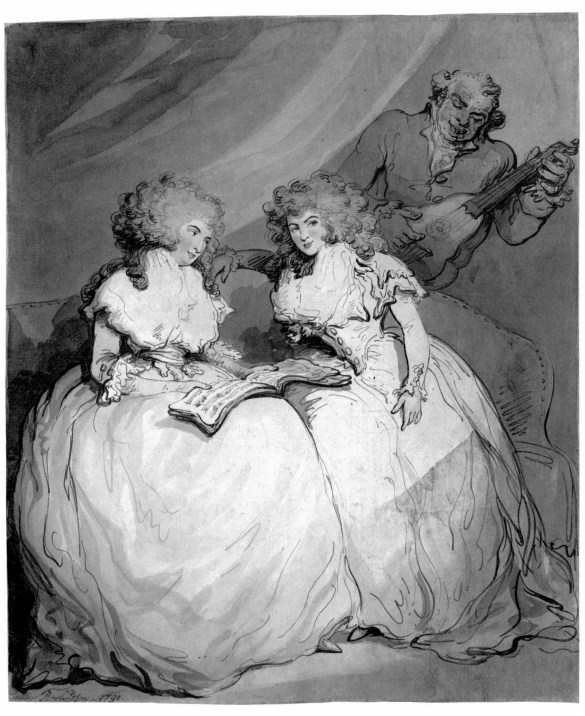

260　The Duchess of Devonshire and the Countess of Bessborough

$19\frac{5}{8} \times 16\frac{7}{8}$ in (499 × 429 mm)

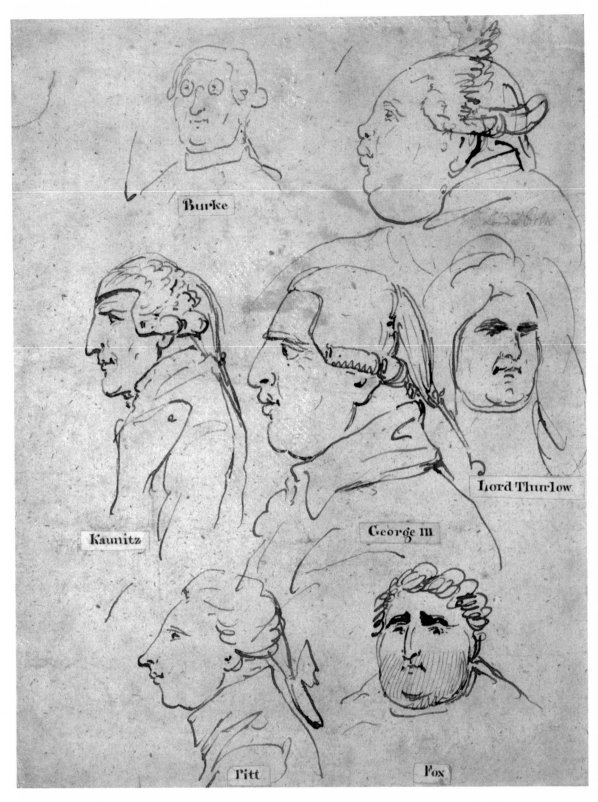

261 Studies of George III and Statesmen 8 × 6⅛ in (202 × 155 mm)

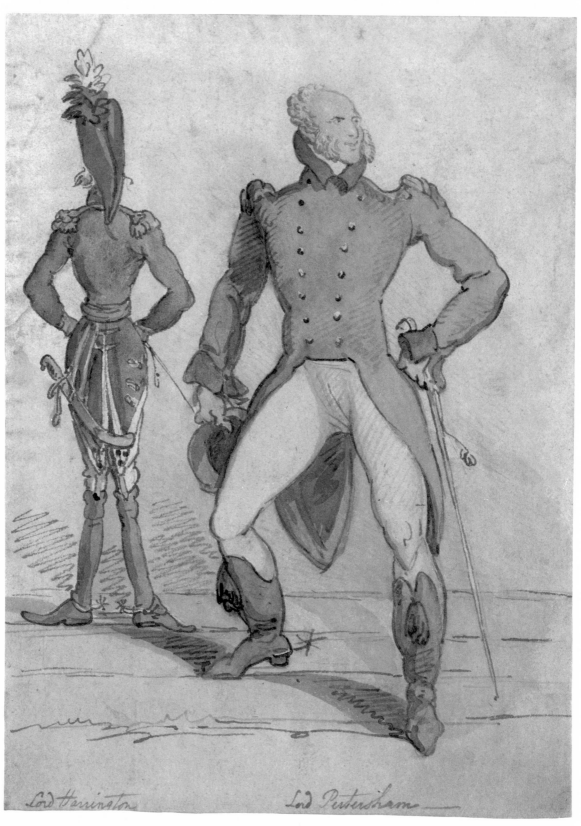

Lord Harrington *Lord Petersham*

262 'Lord Harrington and Lord Petersham' $8\frac{1}{2} \times 6\frac{1}{2}$ in (216×165 mm)

263 'Henderson in the
Character of Falstaff'
12 × 10½ in (305 × 267 mm)

264 George Morland
10 × 6⅛ in (254 × 156 mm)

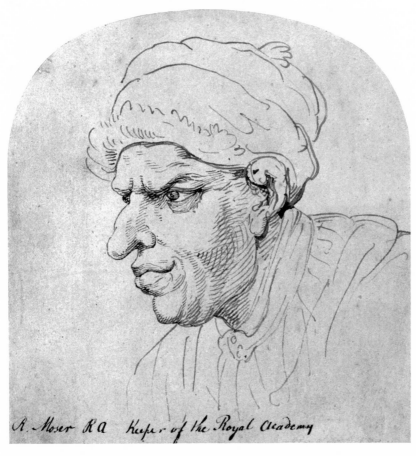

R. Moser RA Keeper of the Royal Academy

265 George Moser 6 × 5¾ in (152 × 147 mm)

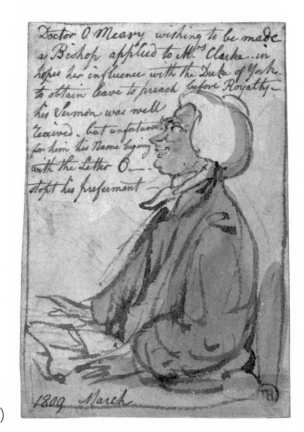

Doctor O'Meary wishing to be made
a Bishop applied to M.rs Clarke in
hopes her influence with the Duke of York
to obtain leave to preach before Royalty.
his Sermon was well
received. but unfortunate
for him his Name begins
with the Letter O.
stopt his preferment

1809 March

266 Dr O'Meara Preaching
4⅛ × 2⅞ in (105 × 73 mm)

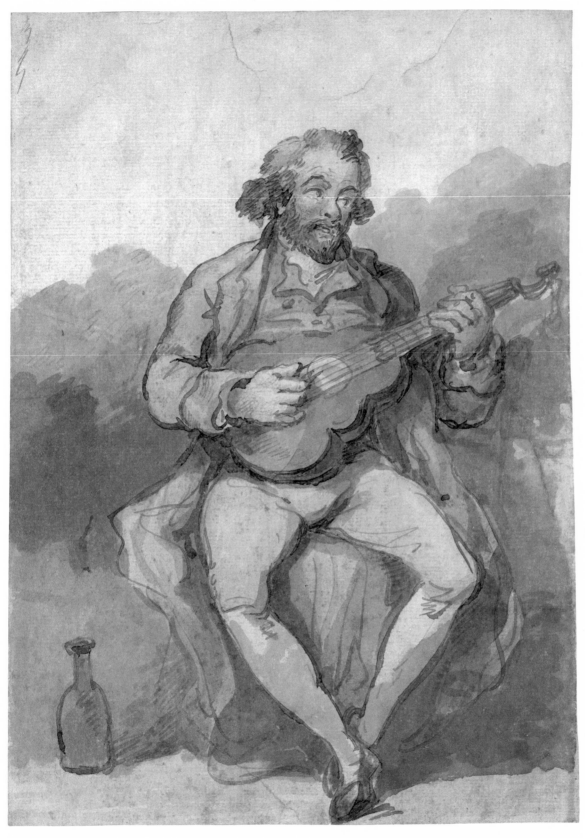

267 'Rogero' $11\frac{1}{4} \times 8$ in (286 × 204 mm)

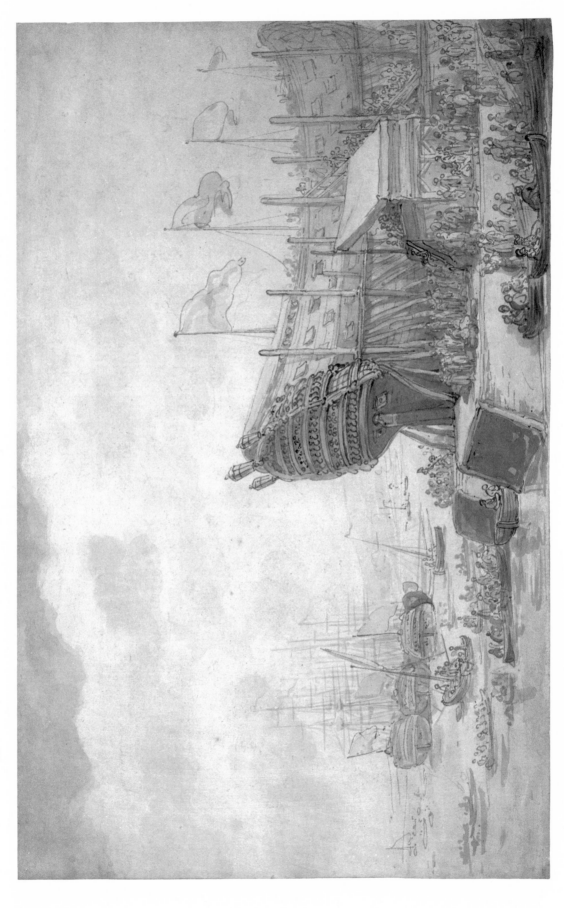

269 The Launching of H.M.S. 'Hibernia' 1804 $9\frac{3}{4} \times 15\frac{1}{4}$ in (248 × 387 mm)

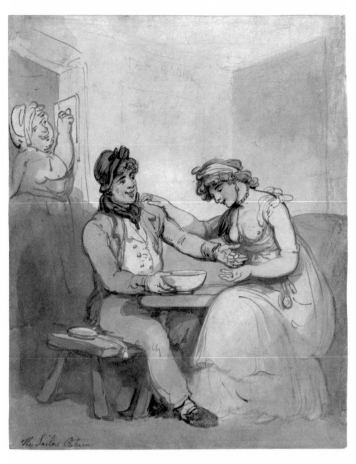

270 'The Sailor's Return'
 $8\frac{5}{8} \times 6\frac{7}{8}$ in (220×175 mm)

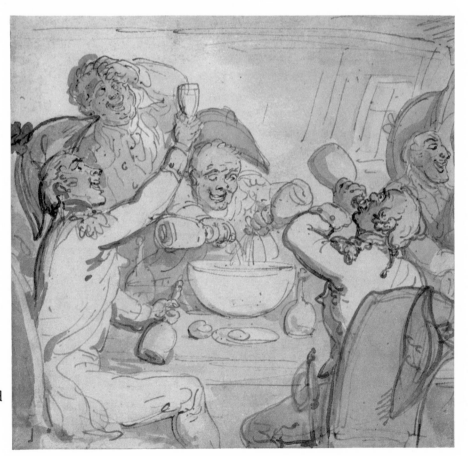

271
Naval Officers and
a Bowl of Punch
$5\frac{3}{4} \times 6$ in
(146×153 mm)

272 A Dutch Packet in a Rising Breeze

$7\frac{3}{4} \times 10\frac{3}{4}$ in (197×273 mm)

275 'Distress' $12\frac{1}{4} \times 17\frac{1}{8}$ in $(311 \times 434$ mm)

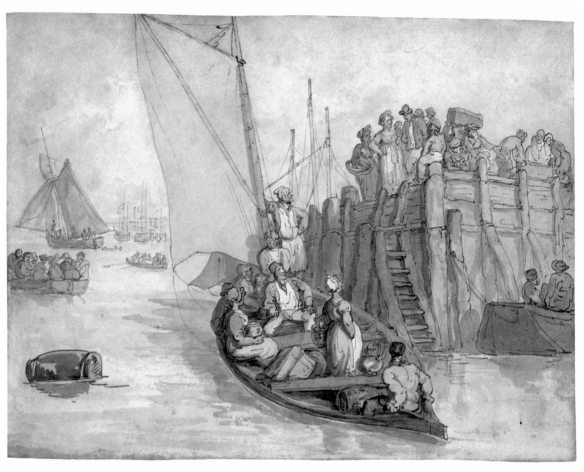

273 A Pier at Amsterdam (Version A) $8\frac{1}{2} \times 11\frac{1}{8}$ in (216×283 mm)

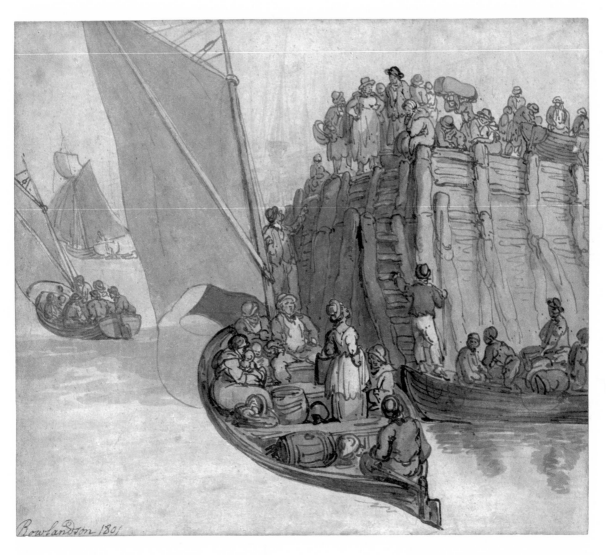

274 A Pier at Amsterdam (Version B) $10 \times 11\frac{1}{2}$ in $(254 \times 292$ mm$)$

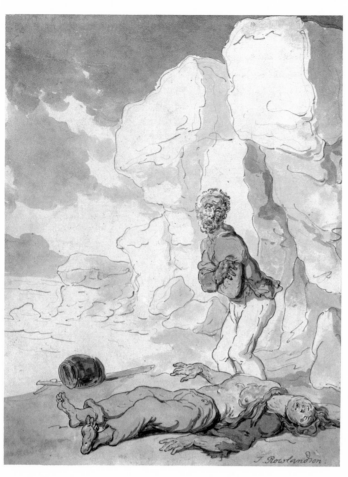

276 Two Shipwrecked Sailors
10¼ × 8 in (261 × 203 mm)

277 Shipwrecked Sailors
6½ × 9⅛ in (165 × 235 mm)

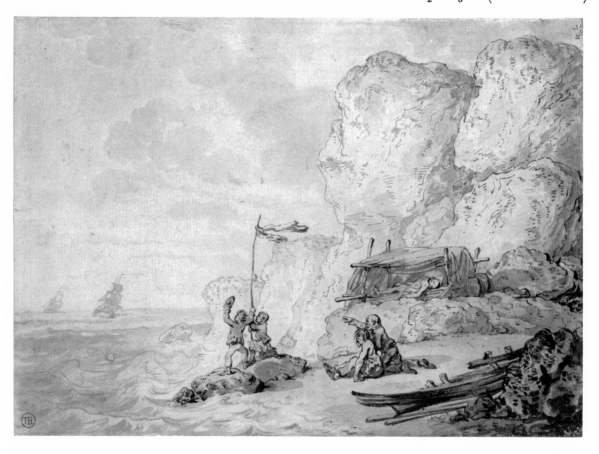

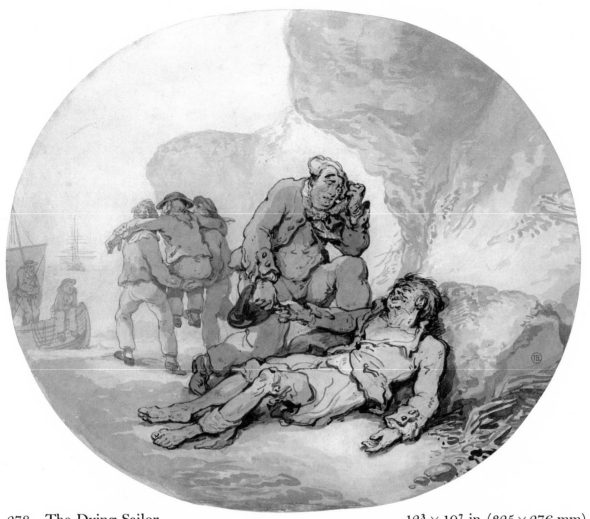

278 The Dying Sailor $12\frac{3}{4} \times 10\frac{7}{8}$ in $(325 \times 276$ mm)

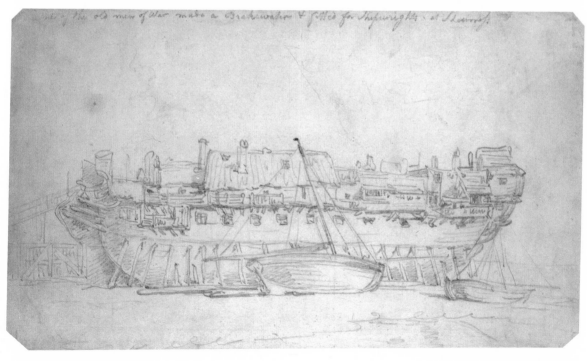

279 Study of a Hulk 8×14 in $(204 \times 351$ mm)

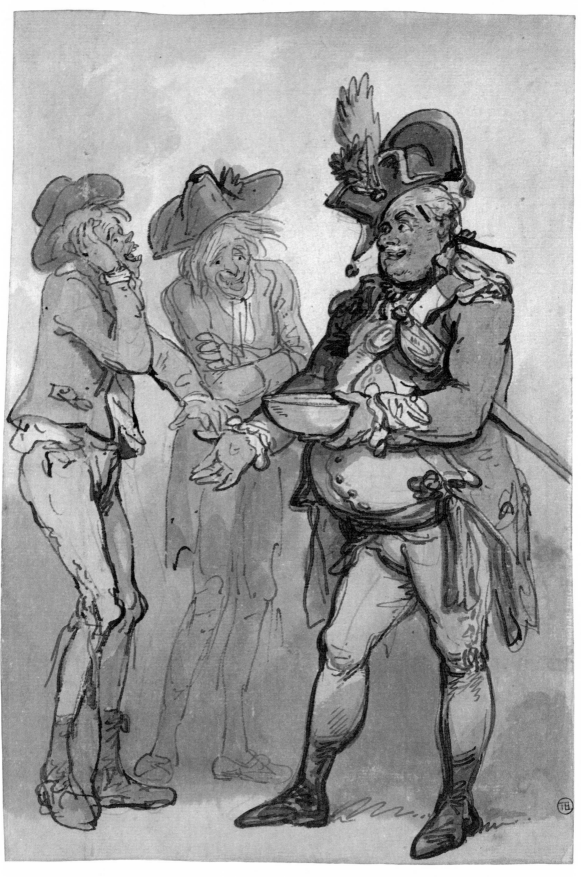

280　The Recruiting Sergeant

$11\frac{7}{8} \times 8\frac{1}{4}$ in (303×210 mm)

281 An Officer and his Servant
$6\frac{1}{8} \times 3\frac{7}{8}$ in (155 × 100 mm)

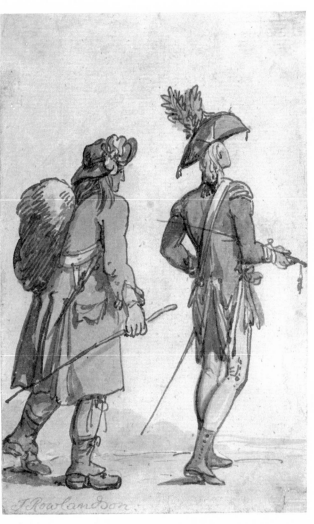

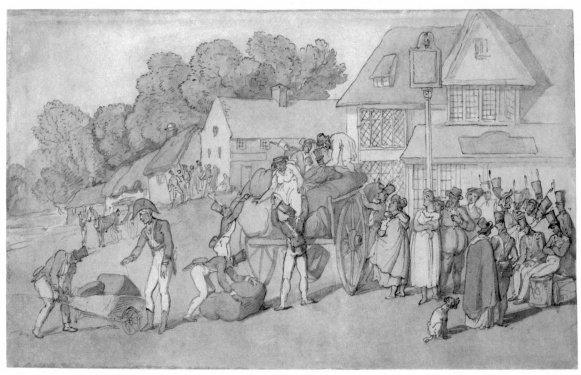

282 The Arrival of a Company of Soldiers at an Inn $5\frac{7}{8} \times 9\frac{5}{8}$ in (150 × 244 mm)

283 'A Review on Blackheath, May 1785' $7\frac{3}{4} \times 13$ in (196 × 330 mm)

284 A Review of the Northampton Militia at Brackley

$7\frac{3}{4} \times 10\frac{1}{4}$ in $(197 \times 260 \text{ mm})$

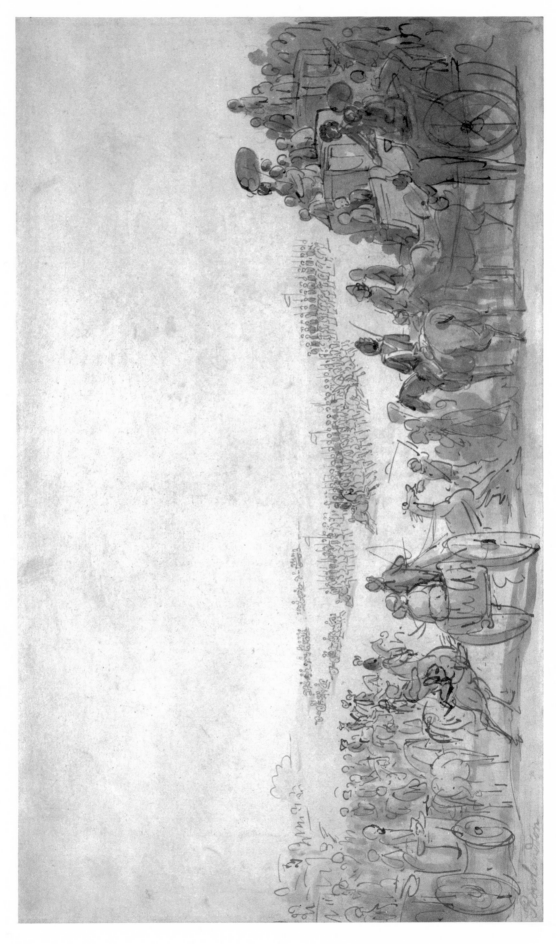

285 Review of Light Horse Volunteers on Wimbledon Common

$9\frac{7}{8} \times 16\frac{1}{2}$ in $(250 \times 420$ mm$)$

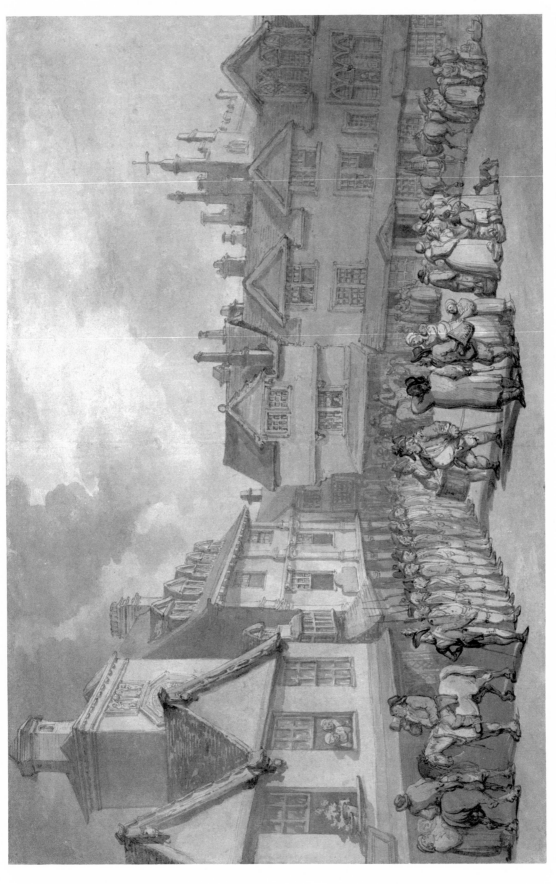

286 A Review in a Market Place $11\frac{3}{8} \times 17\frac{1}{2}$ in $(287 \times 445$ mm$)$

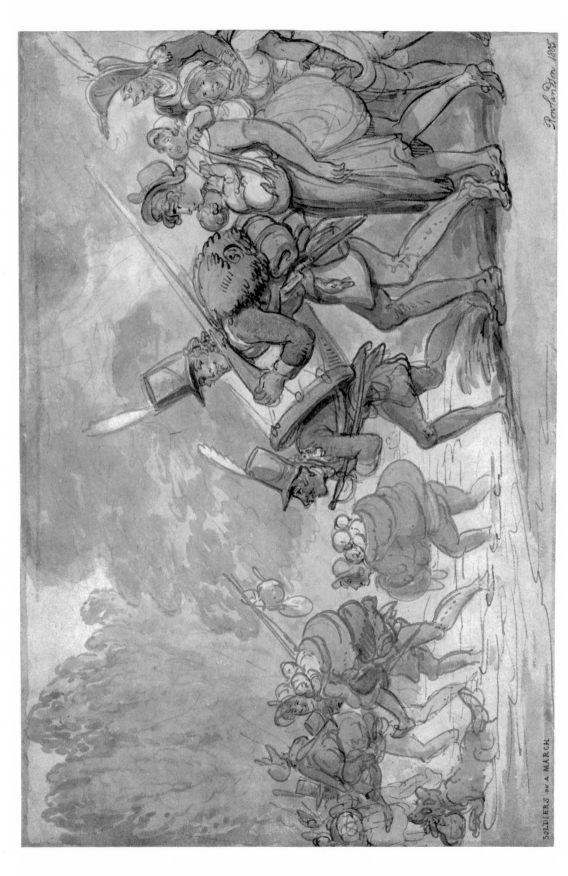

287 'Soldiers on a March'

$9 \times 15\frac{1}{4}$ in $(228 \times 388$ mm$)$

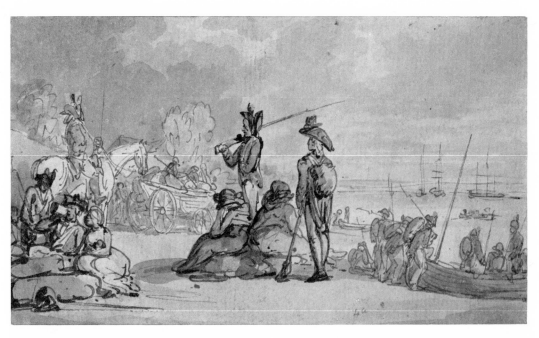

290 Soldiers Embarking $3\frac{1}{4} \times 5\frac{5}{8}$ in (83×142 mm)

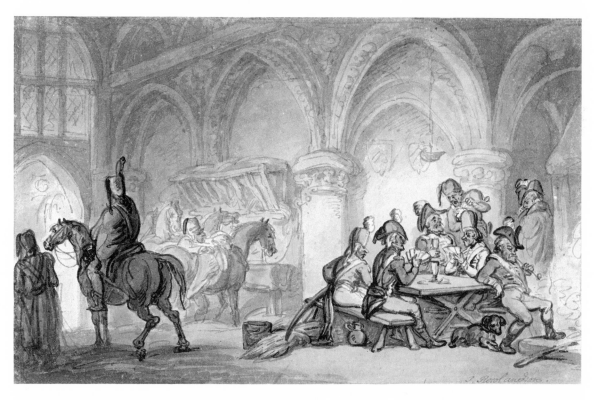

291 Soldiers quartered in a Church $7\frac{1}{4} \times 11\frac{3}{4}$ in (185×287 mm)

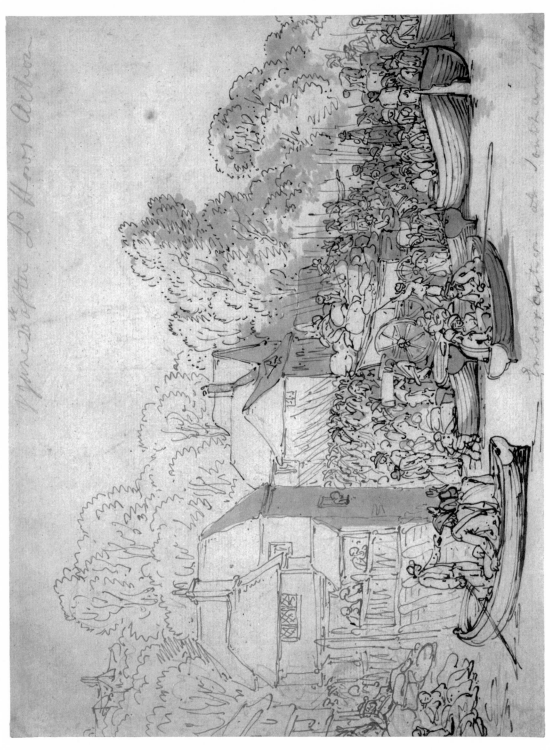

288 Embarkation at Southampton, June 20th 1794 (Version A)

$8\frac{1}{4} \times 11$ in (216×280 mm)

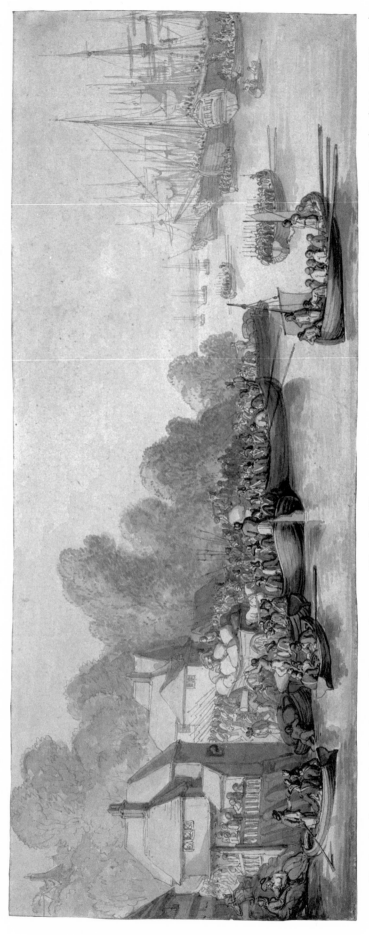

289 Embarkation at Southampton, June 20th 1794 (Version B)

$4\frac{3}{4} \times 11\frac{5}{8}$ in $(120 \times 295$ mm$)$

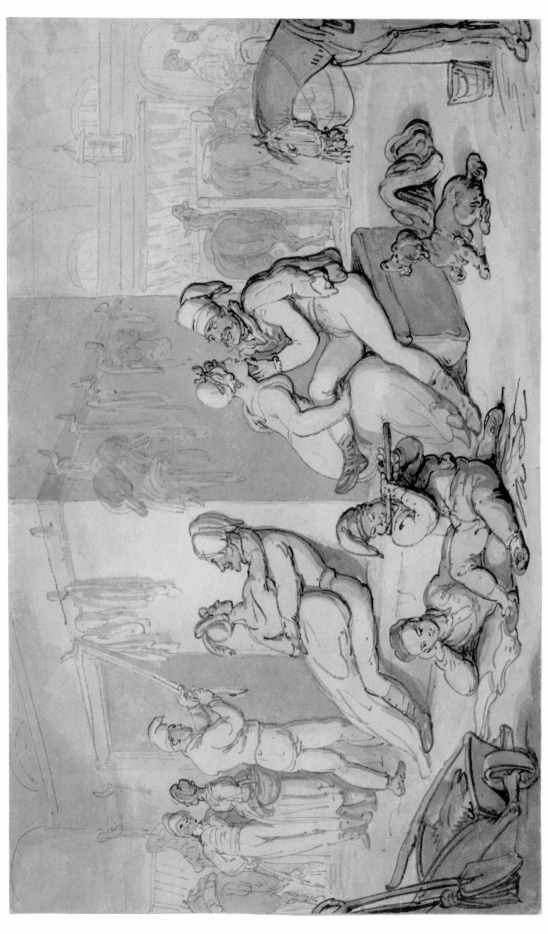

292 A Cavalry Barracks $5\frac{3}{4} \times 9\frac{3}{8}$ in (146 × 238 mm)

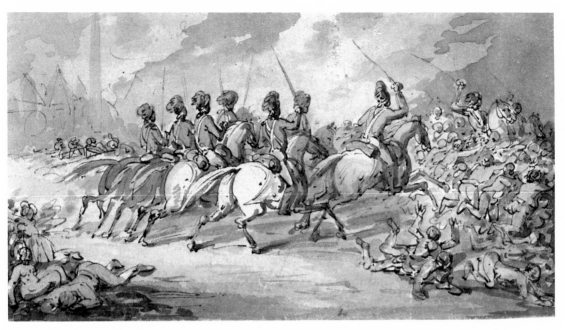

293 Mounted Cavalry Charging a Crowd $3\frac{1}{4} \times 5\frac{7}{8}$ in (82×150 mm)

295 Two Studies of a (?) French Cavalryman $4\frac{1}{4} \times 5\frac{3}{4}$ in (108×146 mm)

296 'Hungarian and Highland Broadsword Exercise'

$8\frac{1}{4} \times 10\frac{3}{4}$ in $(210 \times 272$ mm$)$

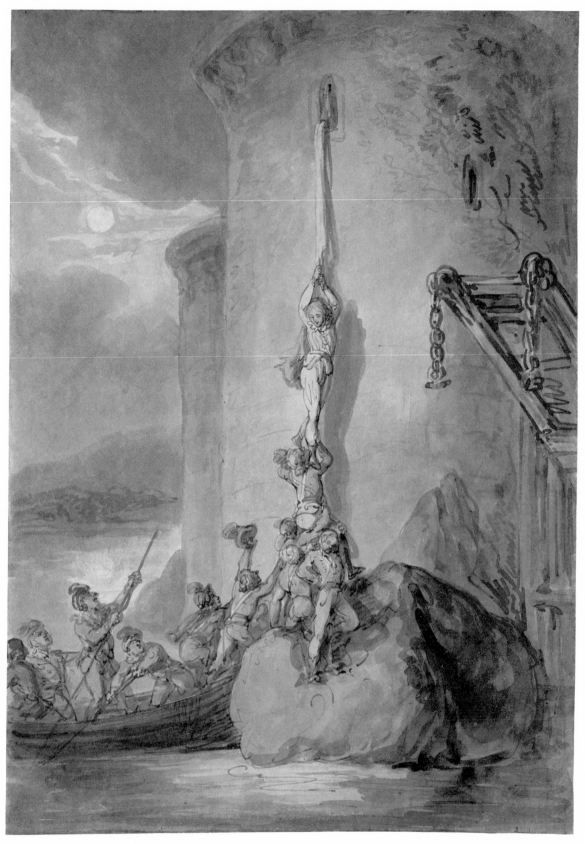

294 A Military Escapade $15\frac{1}{4} \times 10\frac{7}{8}$ in (387×276 mm)

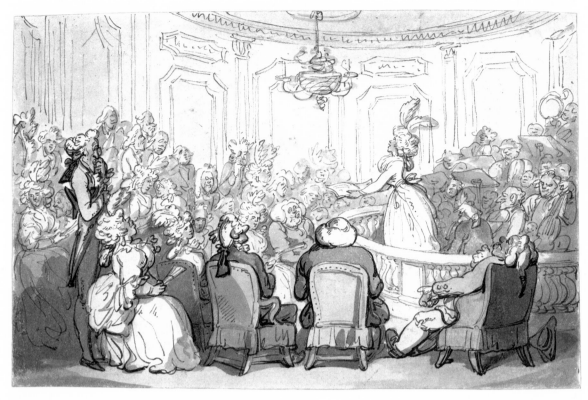

297 Comforts of Bath: 'The Concert' $4\frac{5}{8} \times 7\frac{3}{8}$ in (118×188 mm)

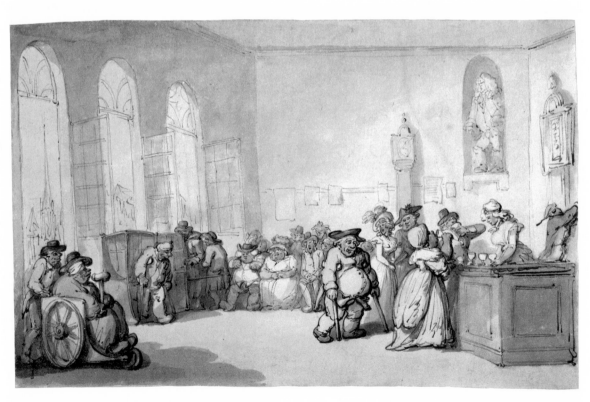

298 Comforts of Bath: 'The Pump Room' $4\frac{5}{8} \times 7\frac{3}{8}$ in (118×188 mm)

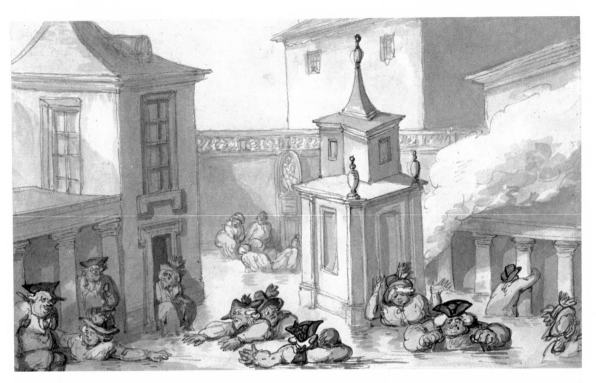

299 Comforts of Bath: 'The Bath' $4\frac{1}{4} \times 7\frac{1}{8}$ in (108×181 mm)

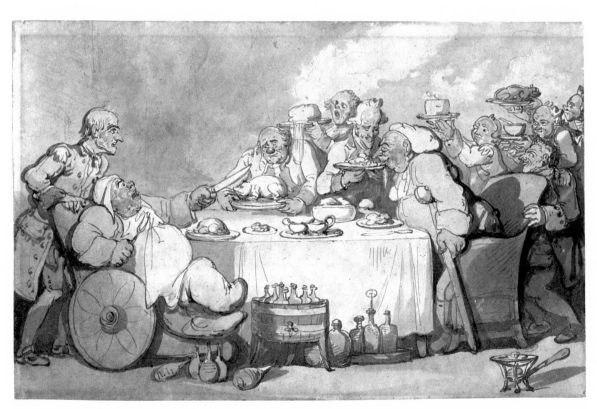

300 Comforts of Bath: 'Gouty Gourmands at Dinner' $5 \times 7\frac{7}{8}$ in (127×200 mm)

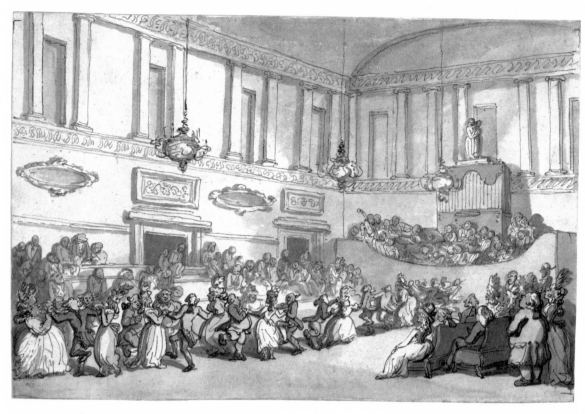

301 Comforts of Bath: 'The Ball' $4\frac{7}{8} \times 7\frac{3}{8}$ in (124×188 mm)

302 Comforts of Bath: 'The Breakfast' $4\frac{3}{4} \times 7\frac{1}{2}$ in (121×191 mm)

303 Comforts of Bath: 'Gouty Persons fall on Steep Hill' $4\frac{7}{8} \times 7\frac{1}{4}$ in (121×185 mm)

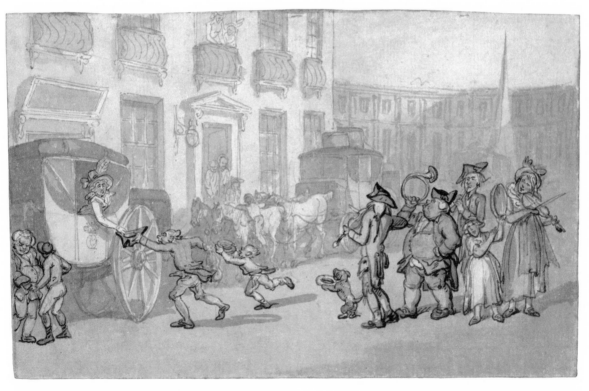

304 Comforts of Bath: Coaches Arriving $4\frac{5}{8} \times 7\frac{1}{4}$ in (118×188 mm)

305 Comforts of Bath: The Music Master $4\frac{3}{4} \times 7\frac{3}{8}$ in $(121 \times 188$ mm$)$

306 Comforts of Bath: Private Practice previous to The Ball $4\frac{7}{8} \times 7\frac{3}{8}$ in $(124 \times 188$ mm$)$

307 'Dr Syntax Bound To a Tree by Highwaymen' 5¼ × 7¼ in (133 × 184 mm)

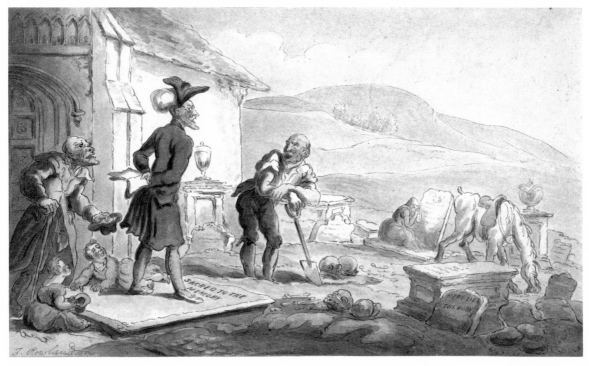

308 'Dr Syntax Meditating on the Tombstones' 4¾ × 7½ in (110 × 190 mm)

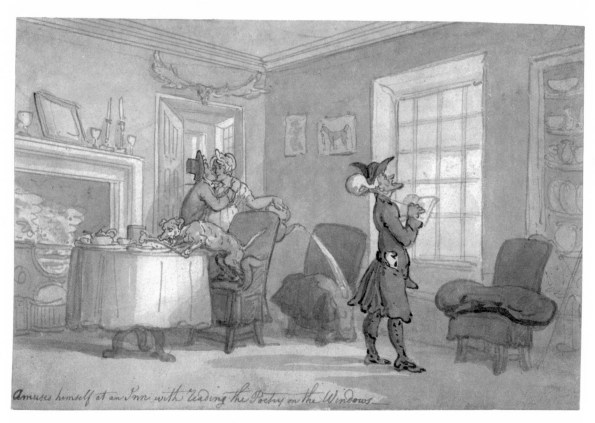

Amuses himself at an Inn with reading the Poetry on the Windows

309 'Dr Syntax Copying the Wit of the Window' $5\frac{3}{8} \times 8\frac{1}{4}$ in (135×210 mm)

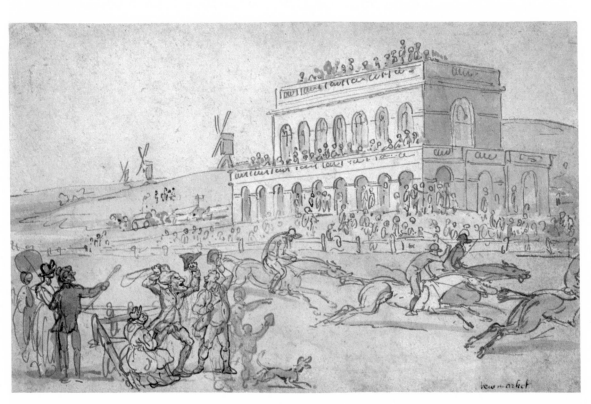

newmarket

310 'Doctor Syntax Loses his Money on the Race Ground at York'
$4\frac{1}{4} \times 6\frac{1}{4}$ in (108×172 mm)

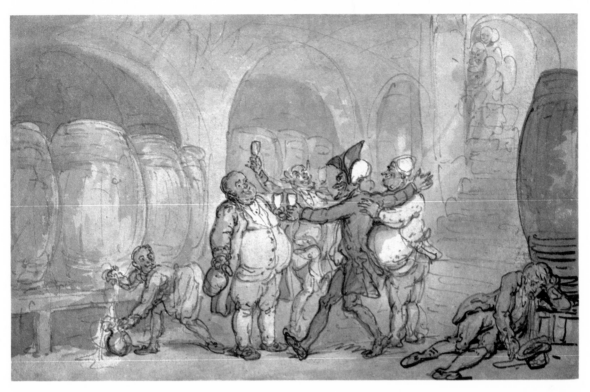

311 'Dr Syntax made Free of the Cellar' $5\frac{1}{4} \times 8\frac{3}{8}$ in (132×212 mm)

312 Preparatory sketch for 'Dr Syntax Sketching the Lake'

$6\frac{1}{2} \times 9\frac{5}{16}$ in (165×239 mm)

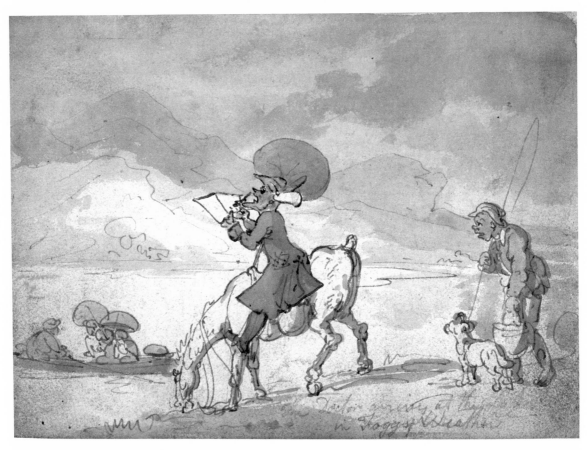

313 'Dr Syntax Sketching The Lake' $5 \times 7\frac{1}{2}$ in $(127 \times 185$ mm$)$

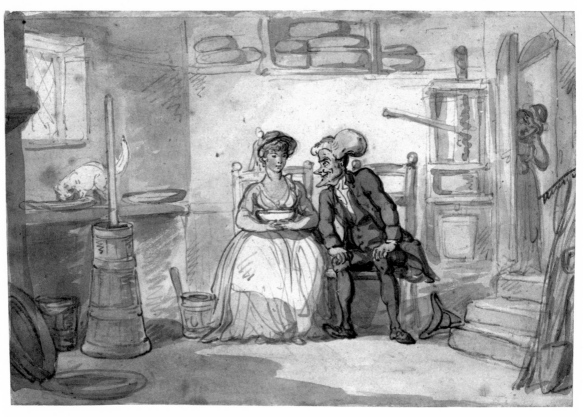

314 'Dr Syntax & Dairymaid' $5\frac{1}{4} \times 7\frac{7}{8}$ in $(133 \times 200$ mm$)$

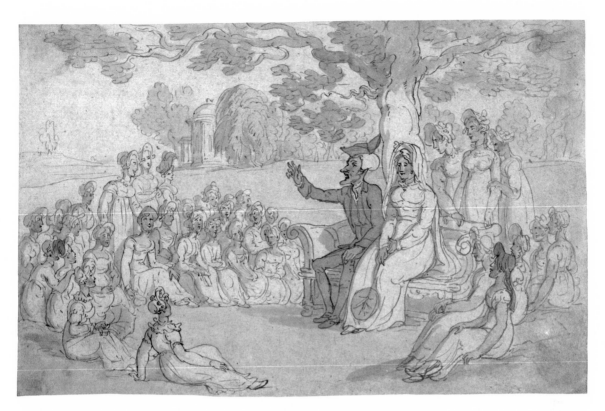

315 'Dr Syntax Visits a Boarding School for Young Ladies'

$5\frac{1}{4} \times 8\frac{1}{8}$ in $(132 \times 207$ mm$)$

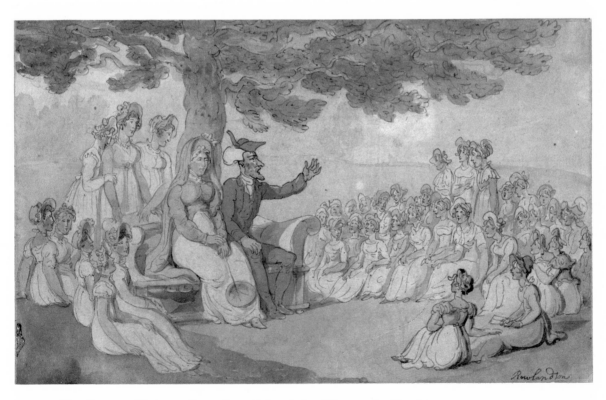

316 'Dr Syntax Visits a Boarding School for Young Ladies'
(Version in reverse of No. 315) $5\frac{1}{8} \times 8\frac{1}{4}$ in $(130 \times 210$ mm$)$

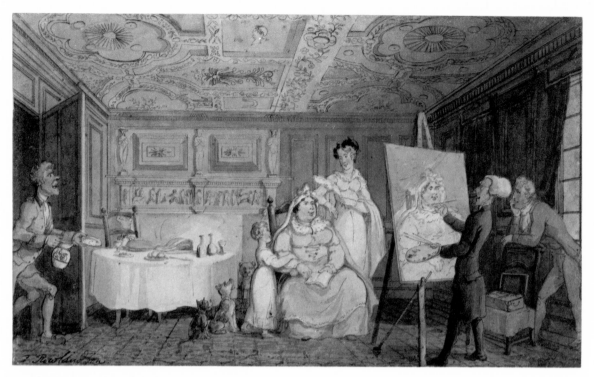

317 'Dr Syntax Painting a Portrait' $4\frac{1}{2} \times 7\frac{1}{2}$ in (115×191 mm)

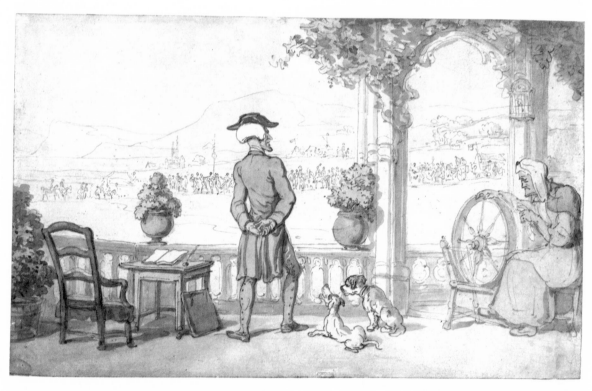

318 'Dr Syntax Soliloquising' $4\frac{3}{4} \times 7\frac{3}{4}$ in (120×197 mm)

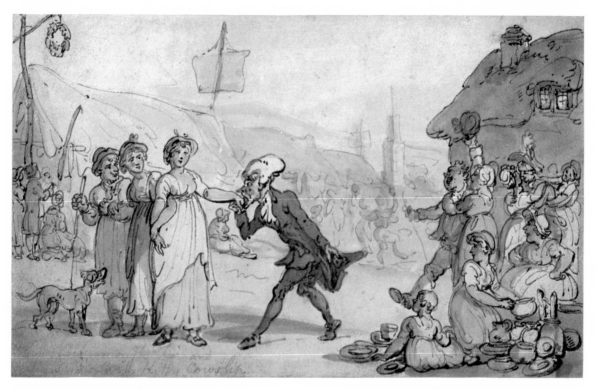

319 Dr Syntax with Kitty Cowslip 5⅛ × 8¾ in (130 × 215 mm)

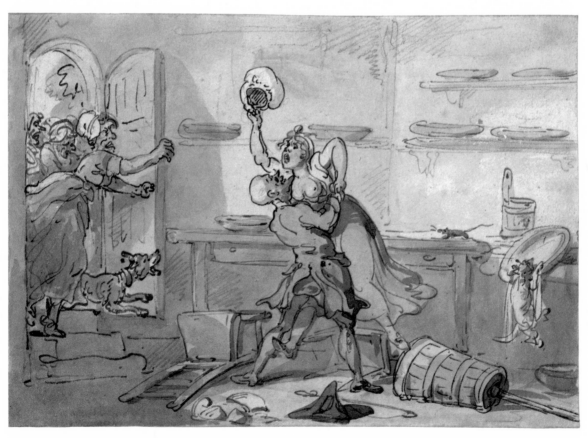

320 Kitty Overcome 5½ × 7⅞ in (140 × 174 mm)

321 Dr Syntax Alarmed by a Whale 5¾ × 9 in (145 × 227 mm)

322 Dr Syntax Attends the Execution 5⅜ × 8½ in (138 × 215 mm)

323 Dr Syntax outside the Halfway House 4⅛ × 6¾ in (105 × 170 mm)

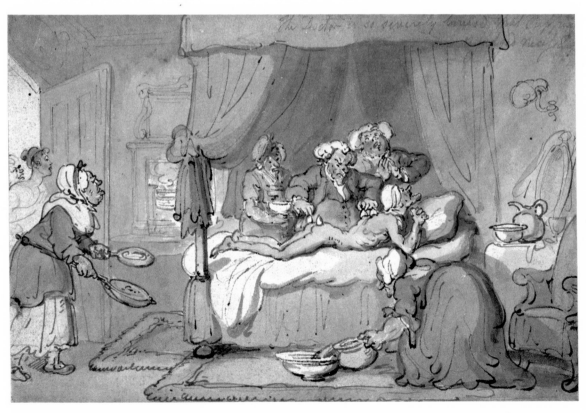

324 'The Doctor is so Severely Bruised that Cupping is Judged Neccessary'
5½ × 8⅜ in (142 × 213 mm)

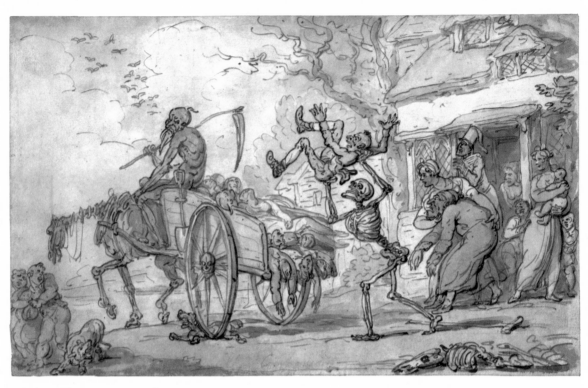

325 'Time and Death and Goody Barton' $5\frac{1}{8} \times 8\frac{3}{8}$ in $(130 \times 212$ mm$)$

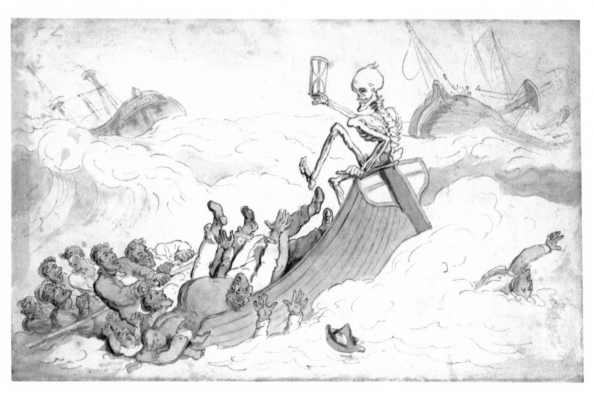

326 'Death turned Pilot' $5\frac{7}{8} \times 9\frac{3}{8}$ in $(150 \times 237$ mm$)$

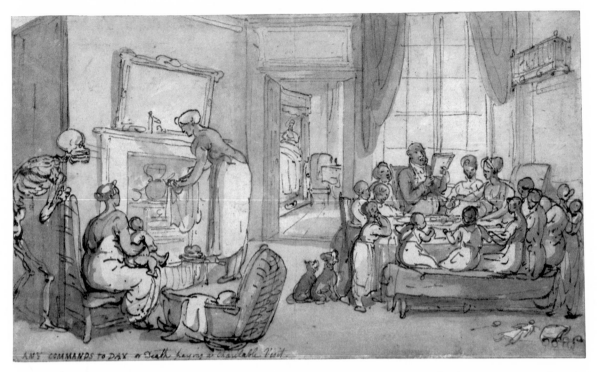

327 'The Family of Children' 4¼ × 7¼ in (107 × 185 mm)

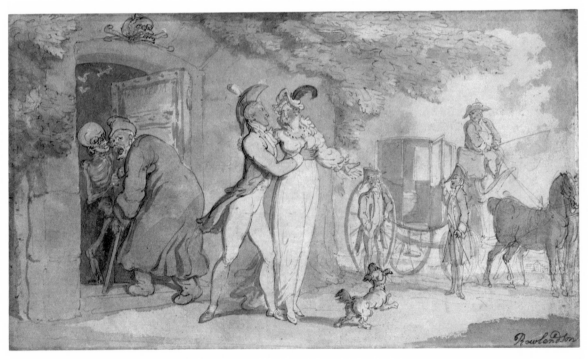

328 'The Mausoleum' 5 × 8¾ in (126 × 222 mm)

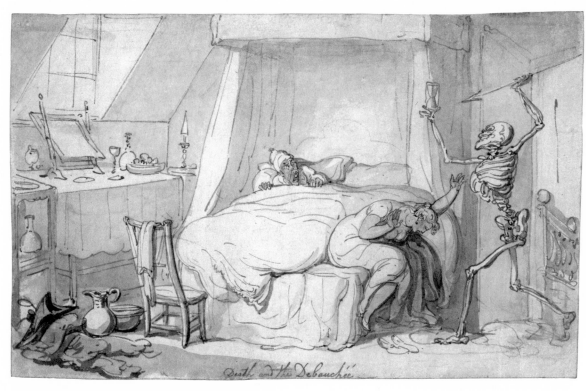

329 Death and the Debauchée $5\frac{3}{8} \times 8\frac{1}{2}$ in $(135 \times 215$ mm$)$

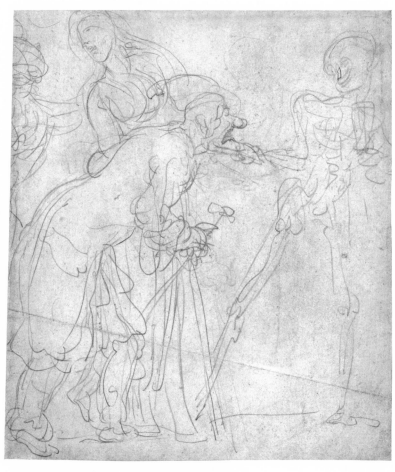

330 An Old Man taunted by Death

$8\frac{5}{8} \times 7\frac{5}{8}$ in $(219 \times 194$ mm$)$

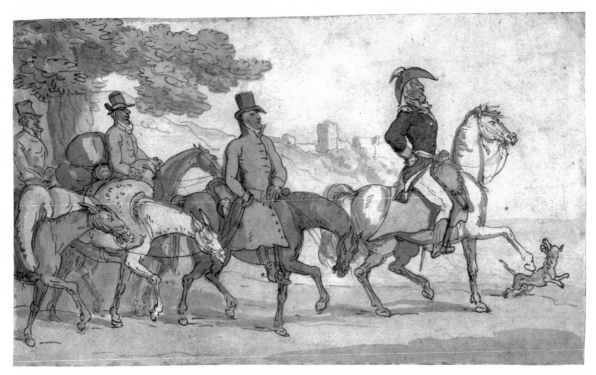

331 'The Military Adventures of Johnny Newcome' 4¼ × 7 in (108 × 178 mm)

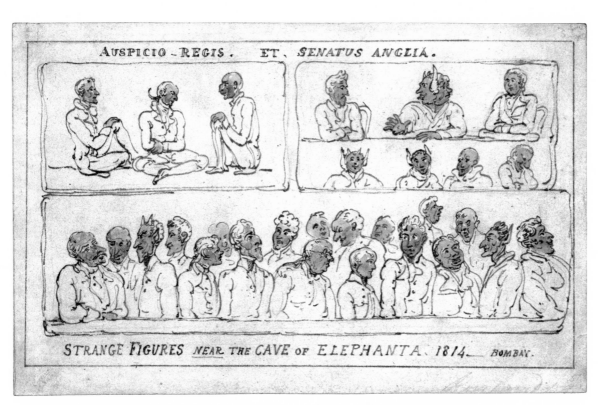

332 'The Grand Master or the Adventures of Qui Hi? in Hindostan'

5 × 8 in (127 × 200 mm)

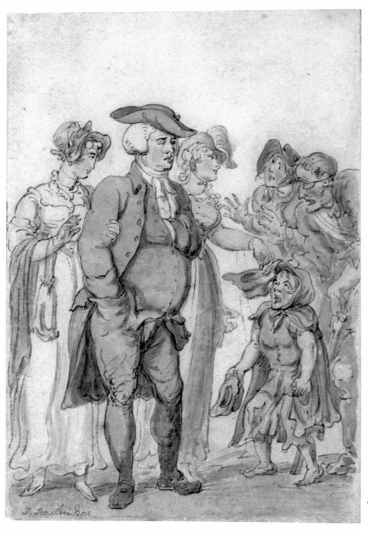

333 The Vicar of Wakefield:
Frontispiece
$6\frac{7}{16} \times 4\frac{9}{16}$ in $(164 \times 116$ mm$)$

333 The Vicar of Wakefield:
'The Departure from
Wakefield' (pl. 3)
$4\frac{1}{2} \times 7\frac{1}{2}$ in $(114 \times 191$ mm$)$

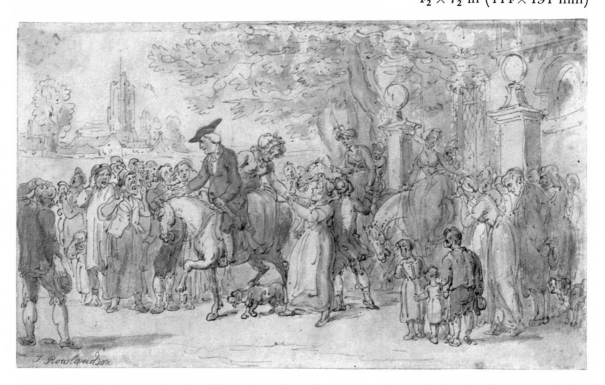

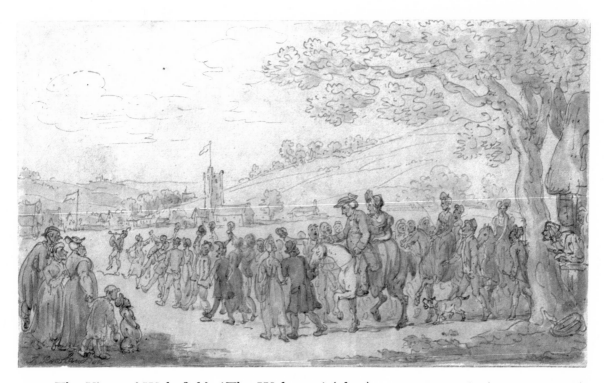

333 The Vicar of Wakefield: 'The Welcome' (pl. 5) $4\frac{7}{16} \times 7\frac{1}{2}$ in (113 × 191 mm)

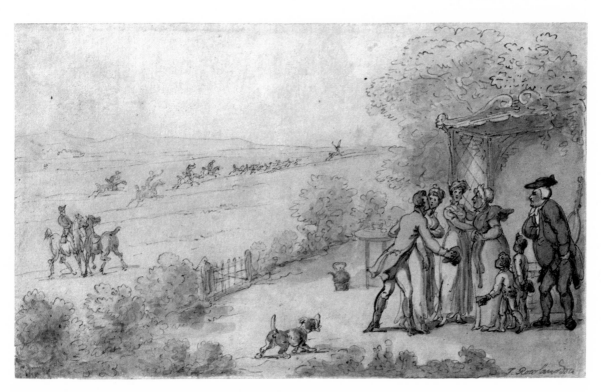

333 The Vicar of Wakefield: 'The Esquire's Intrusion' (pl. 6)

$4\frac{7}{16} \times 7\frac{3}{8}$ in (113 × 188 mm)

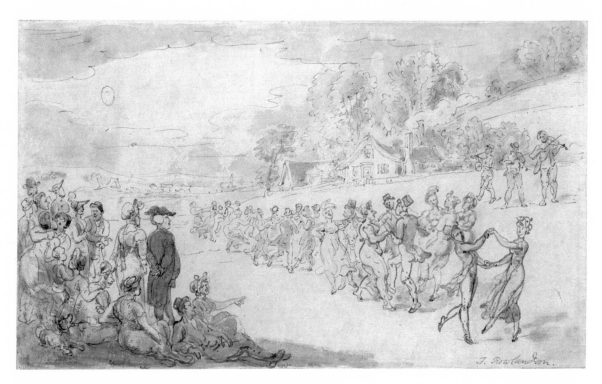

333 The Vicar of Wakefield: 'The Dance' (pl. 8) $4\frac{7}{16} \times 7\frac{7}{16}$ in $(113 \times 189$ mm$)$

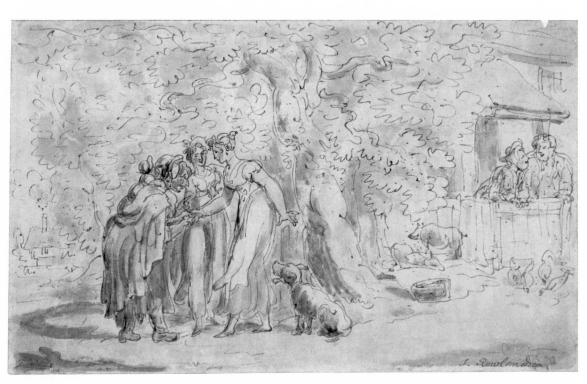

333 The Vicar of Wakefield: 'Fortune-Telling' (pl. 9) $4\frac{1}{2} \times 7\frac{7}{16}$ in $(114 \times 189$ mm$)$

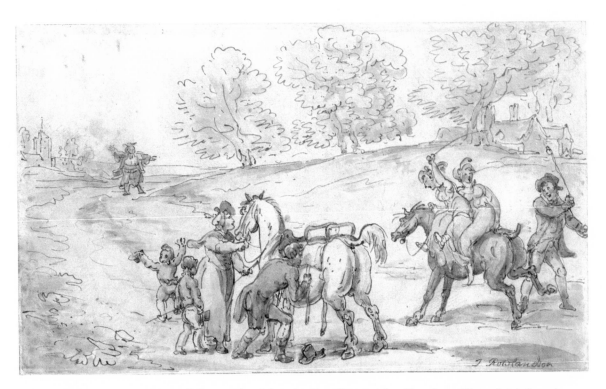

333 The Vicar of Wakefield: 'The Vicar's Family on the Road to Church' (pl. 10)

4½ × 7½ in (114 × 191 mm)

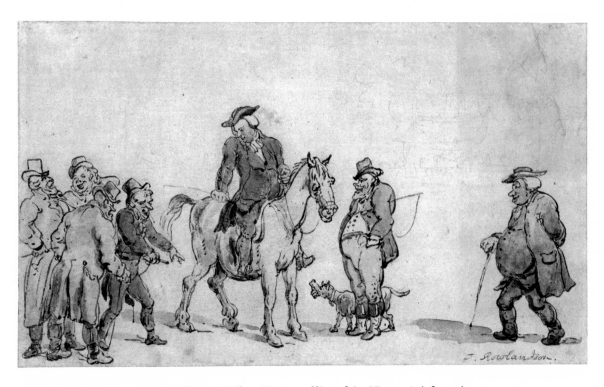

333 The Vicar of Wakefield: 'The Vicar selling his Horse' (pl. 13)

4½ × 7½ in (114 × 191 mm)

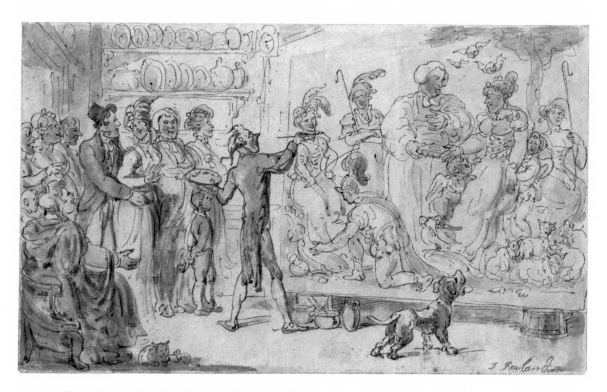

333 The Vicar of Wakefield: 'The Family Picture' (pl. 14)

$4\frac{7}{16} \times 7\frac{7}{16}$ in $(113 \times 189$ mm$)$

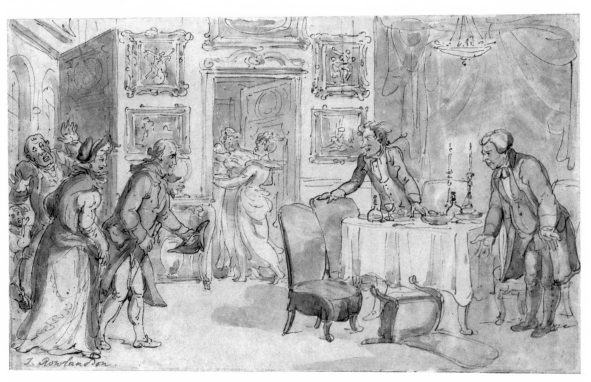

333 The Vicar of Wakefield: 'The Surprise' (pl. 16) $4\frac{1}{2} \times 7\frac{3}{8}$ in $(114 \times 188$ mm$)$

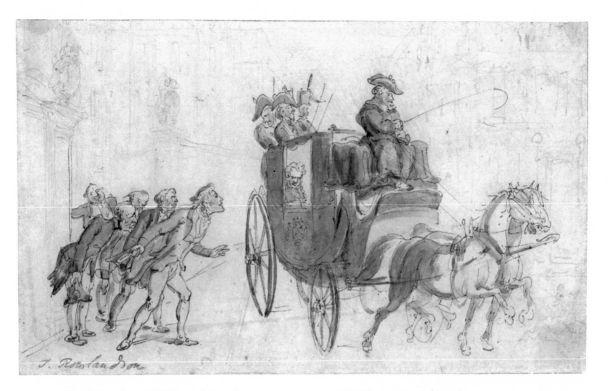

333 The Vicar or Wakefield: 'Attendance on a Nobleman' (pl. 18)

$4\frac{7}{16} \times 7\frac{3}{8}$ in (113×188)

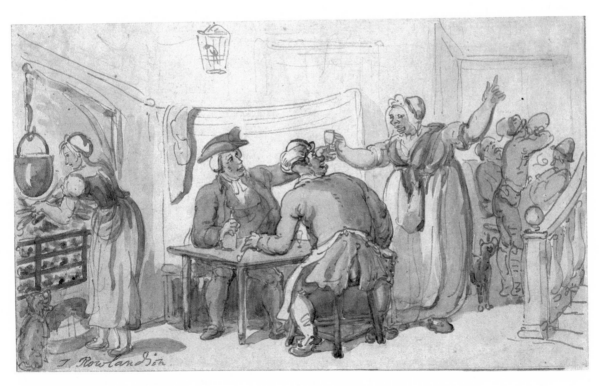

333 The Vicar of Wakefield: 'The Scold, with news of Olivia' (pl. 20)

$4\frac{1}{2} \times 7\frac{1}{2}$ in. $(114 \times 191$ mm$)$

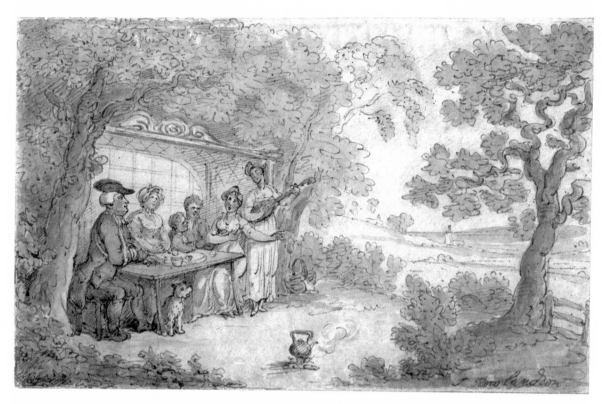

333 The Vicar of Wakefield: 'The Fair Penitent' (pl. 21) $4\frac{1}{2} \times 7\frac{3}{16}$ in (114×183 mm)

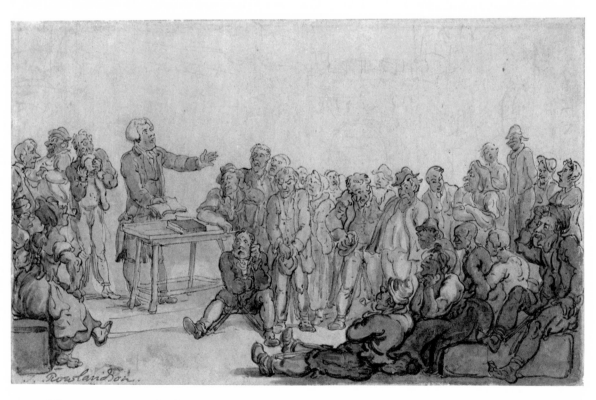

333 The Vicar of Wakefield: 'The Vicar Preaching to the Prisoners' (pl. 23)
$4\frac{1}{2} \times 7\frac{3}{16}$ in (114×183 mm)

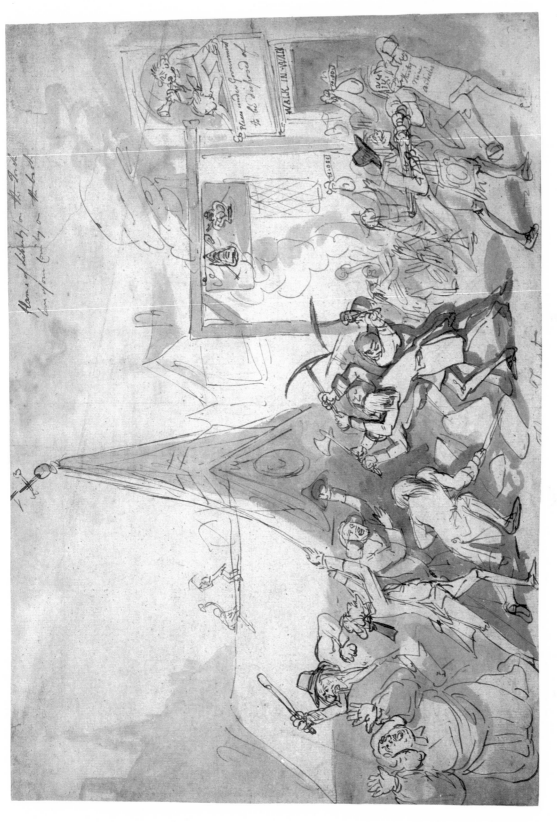

334 'The Test' 11¼ × 16 in (289 × 406 mm)

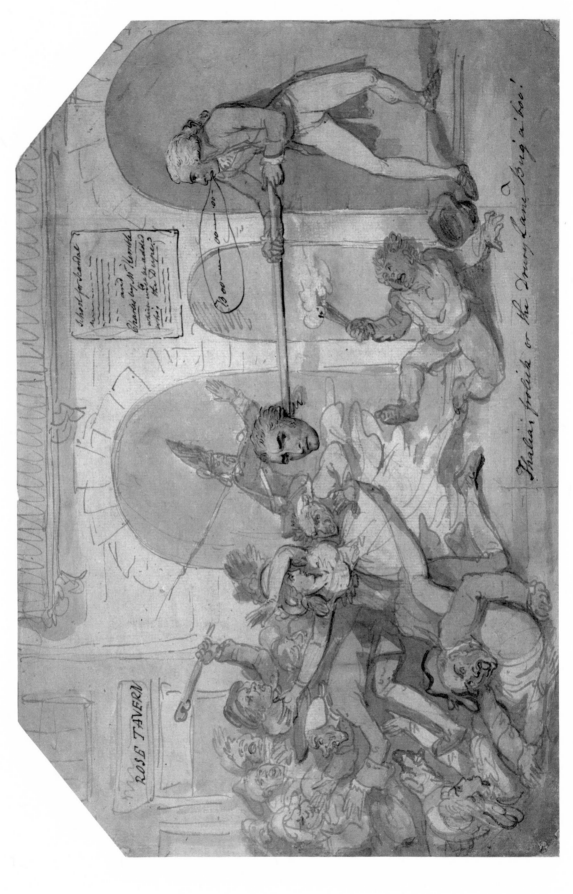

335 Drury Lane. 'The School for Scandal'

$10\frac{1}{2} \times 15$ in (267×381 mm)

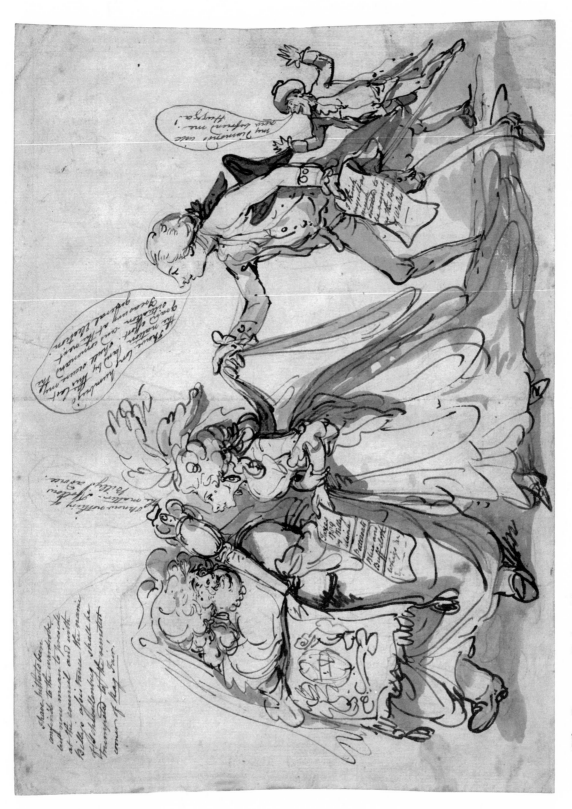

336 'The Prospect Before Us' $8\frac{3}{4} \times 12$ in $(223 \times 305$ mm$)$

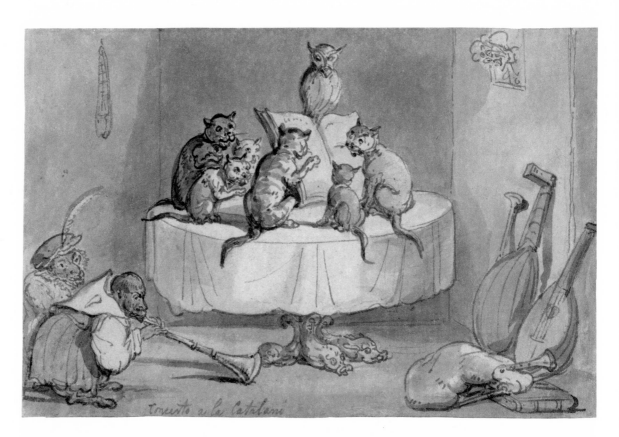

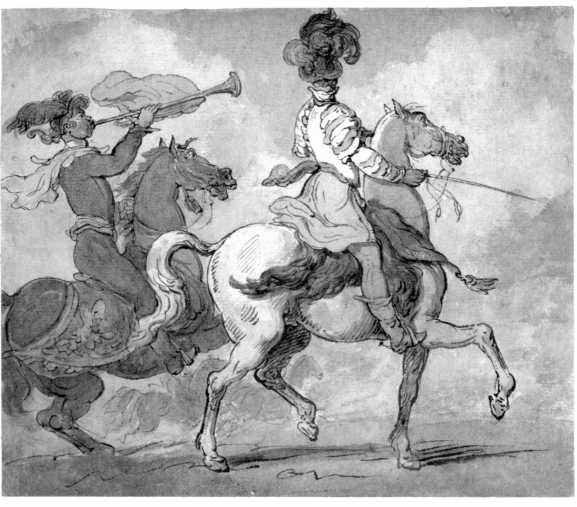

338　The Heralds　　　　　　　　　　　　　$6\frac{1}{4} \times 7\frac{1}{2}$ in (159×191 mm)

337 'Concerto a la Catalani'
 $5\frac{7}{8} \times 8\frac{1}{4}$ in (138×210 mm)

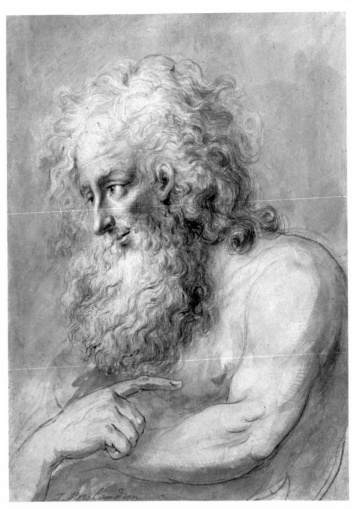

339 A Bearded Man
 $11\frac{1}{4} \times 8\frac{1}{8}$ in (285×205 mm)

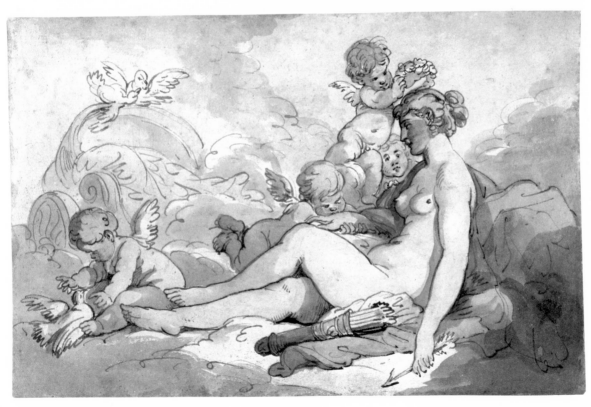

340 Venus Crowned by Cupid $5\frac{5}{8} \times 8\frac{3}{4}$ in (143×222 mm)

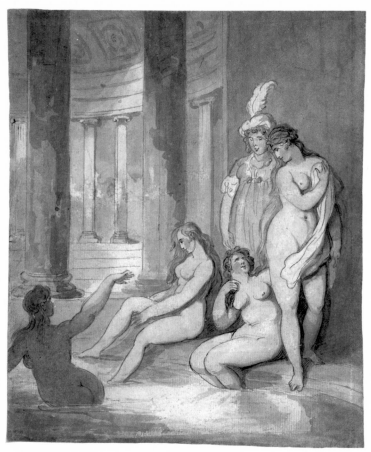

341 Nymphs at a Roman Bath
$8\frac{3}{4} \times 7\frac{3}{8}$ in (222×187 mm)

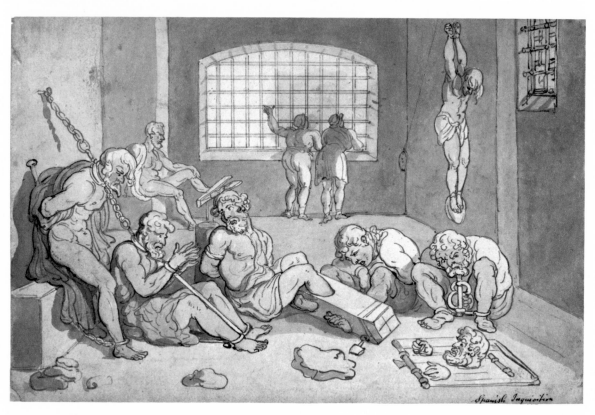

342 Spanish Inquisition

$5\frac{1}{2} \times 8\frac{1}{2}$ in (140×216 mm)

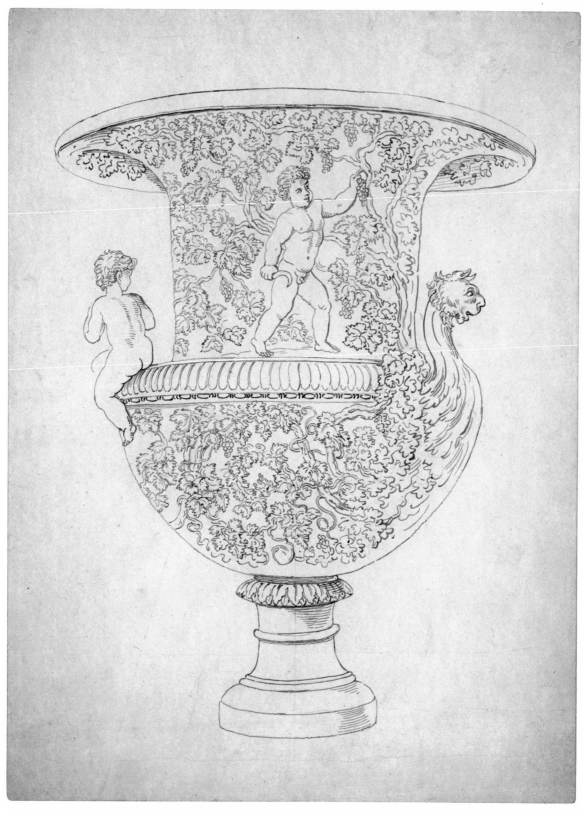

343 Study of a Vase $12\frac{1}{2} \times 9\frac{3}{8}$ in $(319 \times 238$ mm$)$

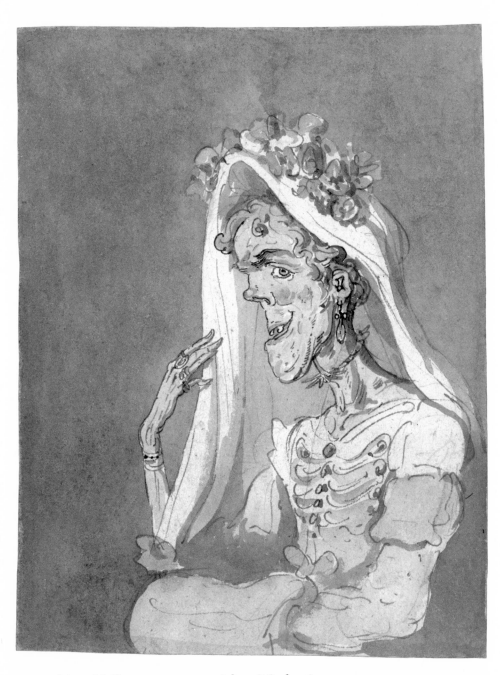

344 'An old Coquette outstood her Market'

$6\frac{11}{16} \times 5\frac{3}{16}$ in $(170 \times 131$ mm$)$

345 Drawings from the Antique. Average size $7\frac{1}{4} \times 4\frac{1}{4}$ in $(184 \times 114$ mm)

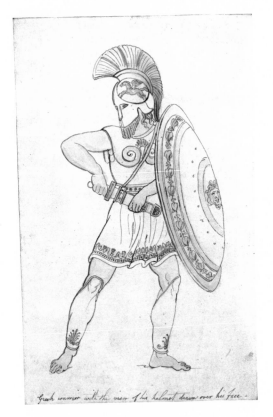

345/1 Greek warrior

345/2 A Greek woman

345/3 Ceres

345/4 Antinous

345/5 Melpomene

345/6 Mars

345/7 Venus

345/8 Antinous

345/9 Antique Seat

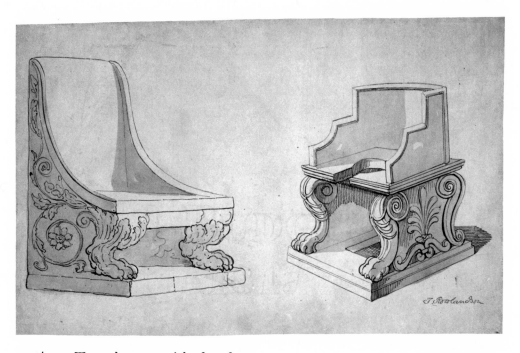

345/10 Two thrones with claw legs

345/11 Candelabre

345/12 Trepied d'Apollon

345/13 Venus

345/14 Libation

345/15 Monument de deux femmes

345/16 Greek philosopher

345/17 A Greek warrior

345/18 A Greek woman

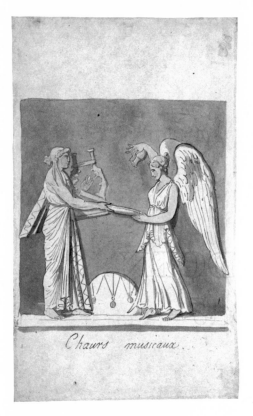

345/19 Chœurs musicaux

345/20 Greek Lady

345/21 Biga/in the Vatican

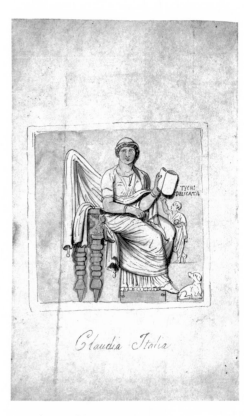

345/22 Claudia Italia

345/23 Siège

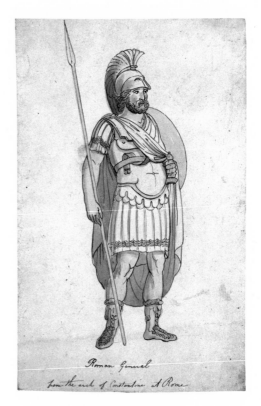

345/24 Roman General

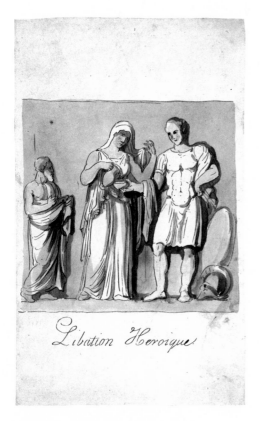

345/25 Libation Héroique

345/26 A mummy,
front and back views

345/27 Three Grecian urns

Jeune fille Romaine

345/28 Jeune fille Romaine

345/29 Grand antique bathing vase

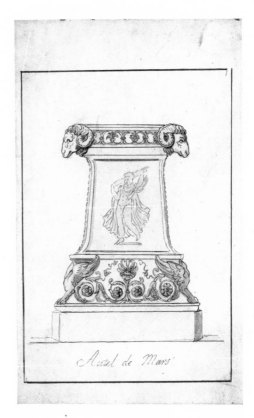

345/30 Autel de Mars

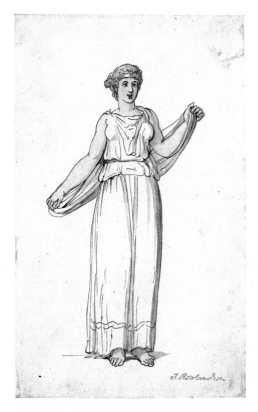

345/31 Greek girl with drapery

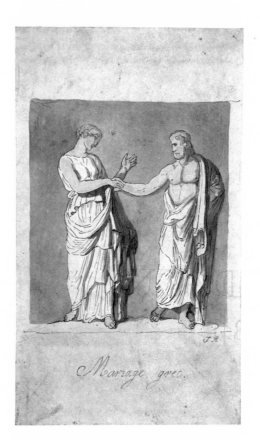

345/32 Mariage grec

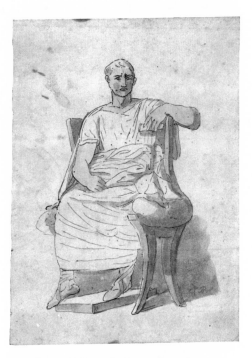

345/33 Man sitting on a throne

345/34 Greek warrior

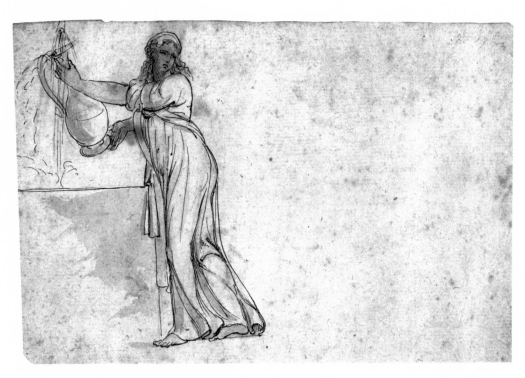

345/35 Woman at a well

BIBLIOGRAPHY

At times the literature about Thomas Rowlandson seems almost as vast as the body of the artist's work. The listing below is intended as a guide to the primary sources and literature on Rowlandson and his work. It attempts to provide a fairly complete bibliography, showing this quintessentially English artist from an international perspective. Specifically excluded from the listing are books illustrated by Rowlandson, a subject covered in the books of J. Lewine (1898), Martin Hardie (1906), R. V. Tooley (1935) and Bernard Falk (1940).

A number of people have generously provided information to help make this bibliography more complete. Philip Pinsof brought attention to the previously-overlooked obituary of the artist in *The London Literary Gazette* of April 1827, in addition to sharing the results of his own bibliographic research. Further kind assistance was lent by R. E. Lewis, Dr Morris Saffron and Robert R. Wark. The Princeton University Library kindly made available the shelf-list of the Dickson Q. Brown collection of literature on Rowlandson and his era.

CATHERINE NICHOLSON

PRIMARY SOURCES

MANUSCRIPTS

Joseph Farington, diary entry, 8 June 1796. TS in British Museum Print Room, p. 656. (Quoted in John Hayes, *Rowlandson Watercolours and Drawings*, p. 23.)

Mr Francis Rimbault's account with Thomas Rowlandson, 29 April 1822, Houghton Library, Harvard University. MS. Typ 100.2. (Reproduced in John Hayes, *Rowlandson Watercolours and Drawings*, p. 10.)

Thomas Rowlandson to Henry Angelo, 18 July 1815. Private collection, ex coll. Francis Harvey.

Thomas Rowlandson to James Heath, 1 March 1804. British Museum Add. MS. 29300 f. 26. (Reproduced in Bernard Falk, *Thomas Rowlandson His Life and Art*, opposite p. 36.)

Thomas Rowlandson, sporting anecdote about Mr Cuthbert Lambert, undated [ca. 1805]. National Gallery of British Sports and Pastimes. (Reproduced in Bernard Falk, *Thomas Rowlandson His Life and Art*, opposite p. 148.)

Thomas Rowlandson to Mrs Landon, 16 November 1820. Henry E. Huntington Library and Art Gallery. (Reproduced in John Hayes, *Rowlandson Watercolours and Drawings*, pp. 24–25.)

Thomas Rowlandson, anecdote of 'the late Capt. Morris' and 'the late Duke of Norfolk,' undated [ca. 1820]. Private collection, ex coll. Gilbert Davis.

Thomas Rowlandson, sporting anecdote about Dick Night, undated [ca. 1790]. Private collection, ex coll. Gilbert Davis.

DOCUMENTS

Records of the artist's residences in the Strand cited in George Gater and E. P. Wheeler, *Survey of London*, London: London County Council, 1937, XVIII, pp. 110, 112.

Royal Academy exhibition listings with the artist's addresses between 1775–1787, published in Algernon Graves, *The Royal Academy of Arts – A complete dictionary of contributors and their work from its foundation in 1769–1904*, London: H. Graves, 1906, VI, p. 384.

Society of Artists exhibition listings, published in Algernon Graves, *The Society of Artists of Great Britain 1760–1791, The Free Society of Artists 1761–1783, A complete dictionary of contributors and their work from the foundation of the societies to 1791*, 1st ed., 1907; rpt. Bath: Kingsmead Reprints (1969, p. 219).

Students' Register of the Royal Academy School, published in Sidney C. Hutchison, *The Royal Academy Schools, 1768–1830*, *Walpole Society* XXXVIII, 1962, pp. 123–191.

Will of Jane Rowlandson (née Chevalier), died 1789. Public Record Office Prob. 10/3112.

Will of Thomas Rowlandson, died 1827. Public Record Office Prob. 10/4946.

PRINTED SOURCES

'Royal Academy, 1784, sixteenth exhibition.' *The European Magazine, and London Review: Containing the Literature, History, Politics, Arts, Manners & Amusements of the Day*, V, April 1784, p. 248.

'The Exhibition. Sculpture and Drawing'. *The Morning Chronicle*, 27 May 1784, p. 3, col. 3.

'The Exhibition'. *The Morning Chronicle*, 1 June 1784, p. 3, col. 3.

St James's Chronicle, 1785.

The Morning Herald, 25 December 1786, p. 2, col. 3.

James Peller Malcolm, *An Historical Sketch of the Art of Caricaturing with Graphic Illustrations*, London: Longman, Hurst, Rees, Orme and Brown, 1813, pp. 114–117, 149.

'Literary Intelligence.... Works nearly ready for Publication.' *The Gentleman's Magazine: and Historical Chronicle* lxxxiv-ii, December 1814, p. 550.

'Literary Intelligence.... Nearly ready for Publication'. *The Gentleman's Magazine: and Historical Chronicle* lxxxv-i, May 1815, p. 446.

'Literary Intelligence.... Nearly ready for publication'. *The Gentleman's Magazine: and Historical Chronicle* lxxxvii-i, March 1817, p. 252.

William Combe, 'Advertisement'. *The Tour of Doctor Syntax, In Search of the Picturesque, a Poem*. 9th ed., London: Ackermann, 1819, pp. i–iii.

William Combe, 'Introduction'. *The Second Tour of Doctor Syntax, In Search of Consolation; a Poem*. 3rd ed., London: Ackermann, 1820, pp. i–ii .

Ephraim Hardcastle (pseud. William Henry Pyne), 'Wine and Walnuts; or, After Dinner Chit-Chat'. *The London Literary Gazette and Journal of Belles Lettres, Arts, Sciences, &c.*, VI, no. 294, 7 September 1822, pp. 570–571; published as a book, 2nd ed., London: Longman, Hurst, Rees, Orme, Brown and Green, 1824, II, pp. 323–327.

Ephraim Hardcastle (pseud. William Henry Pyne), *Somerset House Gazette, and Literary Magazine; or, Weekly Miscellany of Fine Arts, Antiquities, and Literary Chit-Chat*, London: W. Wetton, 1824, I, p. 410; II, pp. 222, 347, 360.

'Biography. Rowlandson.' *The London Literary Gazette and Journal of Belles Lettres, Arts, Sciences, &c.* XI no. 736, 28 April 1827, pp. 267–268.

'Mr Rowlandson.' *The Gentleman's Magazine: and Historical Chronicle* xcvii–i, June 1827, pp. 564–565.

Catalogue of the Valuable Library of the Late Burges Bryan, Esq. . . . To which are added the Books of Prints, &c. of the late Thomas Rowlandson, Esq. London: Sotheby, 18–21 June 1828.

A Catalogue of the Valuable Collection of Prints, Drawings & Pictures of the late distinguished artist, Thomas Rowlandson, Esq., London: Sotheby, 23–26 June 1828.

Henry Angelo, *The Reminiscences of Henry Angelo, with memoirs of his late father and friends, including numerous original anecdotes and curious traits of the most celebrated characters that have flourished during the last eighty years.* London: Henry Colburn and Richard Bentley, 1830, I, pp. 233–240, 254, 262, 389, 410–411, 415–416; II, pp. 1–2, 47, 100–101, 105, 209, 222–223, 253, 292–295, 324–326, 337–338, 403, 439; rpt. London: Kegan Paul, Trench, Trübner; Philadelphia: Lippincott, 1904.

Henry Angelo, *Angelo's Pic Nic; or, Table Talk, including numerous recollections of public characters who have figured in some part or another of the stage of life for the last fifty years; forming an endless variety of talent, amusement, and interest, calculated to please every person fond of biographical sketches and anecdotes* London: John Ebers, 1834, pp. 144–146, 193–194, 368.

John Adolphus, *Memoirs of John Bannister, Comedian* London: Richard Bentley, 1839, I, pp. 287, 290–291.

John Thomas Smith, *A Book for a Rainy Day or Recollections of the Events of the Years 1766–1833*, 2nd ed., 1845; rpt. London: Methuen, 1905, pp, 87, 122.

BOOKS, DISSERTATIONS AND OTHER WORKS

BOOKS

Adrian Bury, *Rowlandson Drawings*, London: Avalon Press, 1949.

Bernard Falk, *Thomas Rowlandson, His Life and Art: A Documentary Record*, London and New York: Hutchinson [1949].

Arthur Hamilton Gibbs, *Rowlandson's Oxford*, London: Kegan Paul, Trench, Trübner & Co., Ltd., 1911.

Joseph Grego, *Rowlandson the Caricaturist* 2 vols. London: Chatto and Windus: New York: J. W. Bouton, 1880; rpt. New York: Collectors' Editions, 1970.

John Hayes, *Rowlandson Watercolours and Drawings*, London: Phaidon Press, 1972.

Arthur William Heintzelman, *The Watercolor Drawings of Thomas Rowlandson in the A. H. Wiggin Collection, Boston Public Library*, New York: Watson-Guptill, 1947.

Selwyn Image, *Some Reflections on the Art of Thomas Rowlandson and George Morland*, London: Print Collector's Club, 1929.

Adolf Paul Oppé, *Thomas Rowlandson, His Drawings and Water-Colours.* London: The Studio Ltd., 1923.

Ronald Paulson, *Rowlandson: A New Interpretation*, London: Studio Vista, New York: Oxford University Press, 1972.

Frederic Gordon Roe, *Rowlandson: The Life and Art of a British Genius*, Leigh-on-Sea, England: F. Lewis; New York: Studio, 1947.

Gert Schiff, *The Amorous Illustrations of Thomas Rowlandson*, Cythera Press, 1969.

Osbert Sitwell, *Famous Water-Colour Painters IV: Thomas Rowlandson*, London: The Studio Ltd., 1929.

John Newneham Summerson, *The Microcosm of London by T. Rowlandson and A. C. Pugin*, London: King Penguin Books, 1943; rev. ed. London and New York, 1947.

Kurt von Meier, *The Forbidden Erotica of Thomas Rowlandson*, Los Angeles: Hogarth Guild, 1970.

Robert Rodger Wark, *Drawings by Thomas Rowlandson in the Huntington Collection*, San Marino, California: The Huntington Library, 1975.

Robert Rodger Wark, *Rowlandson's Drawings for* THE ENGLISH DANCE OF DEATH, San Marino, California: The Huntington Library, 1966.

Robert Rodger Wark, *Rowlandson's Drawings for a Tour in a Post Chaise*, San Marino, California: The Huntington Library, 1963.

Edward Carl Johannes Wolf, *Rowlandson and his Illustration of Eighteenth-Century English Literature*, Copenhagen: E. Munksgaard, 1945.

Arthur Henry Young, *Thomas Rowlandson*, New York: Willey Book Company, 1938.

DISSERTATIONS

Anthony Lacy Gully, 'Thomas Rowlandson's *Doctor Syntax*.' Diss. Stanford 1972.

Idis Birgit Hartmann, *Thomas Rowlandson–Stilphasen in seinen Landschaftsdarstellungen*, Diss. Tübingen 1971, (Tübinger privately printed, 1971).

OTHER WORKS

John Hawkesworth, *Rowlandson's England* [film], British Film Institute, 1955.

William Turner Walton, *Dr Syntax: a pedagogic overture for orchestra*, 1921.

William Turner Walton, *Portsmouth Point: an overture*, Oxford: Oxford University Press, 1929.

ARTICLES AND PASSAGES IN BOOKS

V. Adarioukov, 'Rousskié Kazaki v Parijé [prints and drawings of the Cossacks in Paris]', *Rousskii Bibliophil*, fasc. 3, March 1911, pp. 5–13.

Violet and Seymour Altman, *The Book of the Buffalo Pottery*, New York: Crown, 1969, pp. 111–117, et passim.

John Ashton, *English Caricature and Satire on Napoleon I*, London: Chatto and Windus, 1888, pp. 60, 132, et passim.

Henry A[ustin] D[obson], 'Rowlandson, Thomas', *Dictionary of National Biography*, London: Oxford University Press, 1897, XVII, pp. 357–359.

Henry Austin Dobson, 'The "Vicar of Wakefield" and its Illustrators', *English Illustrated Magazine*, October 1890; rpt as preface to *The Vicar of Wakefield*, London and New York: Macmillan, 1890; rpt. as an essay in *Side-Walk Studies*, London: Chatto and Windus, 1902, pp. 132, 139–140, 147.

Jean Avalon, 'Malades, médecins et charlatans dans la caricature anglaise au temps d'Hogarth et de Rowlandson', *Aesculape*, XL, February 1957, pp. 3–62.

J. D. Aylward. 'Some XVIII-century Fencing Books', *Connoisseur*, CXXI, March 1948, pp. 33–37.

William Bates, 'Thomas Rowlandson, Artist', *Notes and Queries*, 4th series, IV, October 2, 1869, pp. 278–279.

Richard M. Baum, 'A Rowlandson Chronology', *Art Bulletin*, XX, September 1938, pp. 237–250.

Cuthbert Bede, 'Rowlandson's "Hunting Breakfast"', *Notes and Queries*, 6th series, X, November 15, 1884, pp. 383–384.

Cuthbert Bede, 'Rowlandson's "Hunting Breakfast"', *Notes and Queries*, 6th series, XI, February 7, 1885, pp. 113–114.

Emmanuel Bénézit, *Dictionnaire critique et documentaire des peintres, sculpteurs, dessinateurs et graveurs de tous les temps et de tous les pays*, Paris: Gründ, 1954, VII, pp. 400–401.

Robert Laurence Binyon, 'Figure Painters: Rowlandson', *English Water-Colours*, 1933, 2nd ed, London: Black, 1944, pp. 61–70.

Martin Birnbaum, 'The Drawings of Thomas Rowlandson', *International Studio*, LXXXVII, July 1927, pp. 72–74.

Martin Birnbaum, 'Thomas Rowlandson', *Jacovleff and Other Artists*, New York: Struck, 1946, pp. 97–108.

J. A. Blaikie, 'A Forgotten Satirist', *The Magazine of Art*, VI, 1883, pp. 394–395.

Jeff Blanchard, 'Rowlandson's "None but the Brave Deserve the Fair"', *The Stanford Museum*, II, 1973, pp. 17–20.

John Gilbert Bohun Lynch, *A History of Caricature*, London: Faber and Gwyer, 1926, pp. 55–59.

Benjamin Bord and Jean Avalon, 'L'Oeuvre de Thomas Rowlandson: Son intérêt psychologique et medical', *Aesculape*, XXI, August and October 1931, pp. 201–224, 257–264.

A. Brett Waller and James L. Connelly, 'Thomas Rowlandson and the London Theatre', *Apollo*, LXXXVI, August 1967, pp. 130–134.

Alexander Meyrick Broadley, *Napoleon in Caricature 1795–1821*, 2 vols., London: Bodley Head, 1911, I, pp. 23–24, 30–32, et passim.

L. Burroughs, 'High Life and Low Life in the Eighteenth Century: Rowlandson's "Squire's Kitchen" and "A Gaming Table at Devonshire House"', *Bulletin of the Metropolitan Museum of Art*, XXXVI, October 1941, pp. 209–211.

Adrian Bury, 'An Oil by Rowlandson', *Connoisseur*, CLI, October 1962, p. 116.

Adrian Bury, 'Thomas Rowlandson, Historian of English Social Life', *History Today*, VI, July 1956, pp. 466–476.

Robert, William Buss, 'Thomas Rowlandson', *English Graphic Satire and its Relation to Different Styles of Painting, Sculpture, and Engraving*, London: privately printed, 1874, pp. 133–137.

William C. Butterfield, 'The Medical Caricatures of Thomas Rowlandson', *Journal of the American Medical Association*, CCXXIV, April 2, 1973, pp. 113–117.

Walter Butterworth, Thomas Rowlandson, Caricaturist and Satirist', *Manchester Quarterly*, XXXIX, July 1920, pp. 179–192.

Ada Walker Camehl, 'The Porcelain Tours of Doctor Syntax', *Antiquarian*, XVII, October 1931, pp. 24–28, 58

Ada Walker Camehl, 'The Second Porcelain Tour of Doctor Syntax', *Antiquarian*, XVII, November 1931, pp. 31–33, 62.

Ada Walker Camehl, 'The Third Porcelain Tour of Doctor Syntax', *Fine Arts*, XVIII, January 1932, pp. 33–35.

Charles Richard Cammell, 'Early Books of the Sword: III. English and Scottish', *Connoisseur*, XCVII, June 1936, pp. 326–330.

Charles Carter, 'Aberdeen Art Gallery: The Collection of Water-Colours', *Scottish Art Review* V no. 2 (1955), pp. 26–27.

D. N. Casey, 'Art of Rowlandson, Smirke, and Wilkie, Reproduced by the Clews Brothers', *Bulletin of the Rhode Island School of Design*, XXIV, October 1936, pp. 51–53.

Champfleury (pseud. Jules François Felix Husson Fleury), 'La révolution jugée par Gillray et Rowlandson', *Histoire de la Caricature sous la république, l'empire et la restauration*, Paris: Dentu, [1874], pp. 231–254.

Ernest Alfred Chesneau, *La Peinture anglaise*, 1882; published in English as *The English School of Painting*, London: Cassell, 1885, pp. 321–326.

Norman Chevers, 'Rowlandson's "Hunting Breakfast"', *Notes and Queries*, 6th series, X, December 20, 1884, p. 505.

Desmond Coke, *Confessions of an Incurable Collector*, London: Chapman and Hall, 1928, pp. 96–146, 153–160, et passim.

Frederic Taper Cooper and Arthur Bartlett Maurice, 'History of the Nineteenth Century in Caricature', *The Bookman*, XVII (March 1903), pp. 61, 64–65; published as a book, New York: 1904.

Selwyn John Curwyn Brinton, *Bartolozzi and his pupils in England*, New York: Scribner, 1904, pp. 45–47.

Herbert Minton Cundall, 'Drawings at Windsor Castle', *Connoisseur*, XCII, July 1933, pp. 8–11.

Selwyn John Curwyn Brinton, 'The Comedy of Life', *The Eighteenth Century in English Caricature*, New York: Scribner, 1904, pp. 74–96.

Selwyn John Curwyn Brinton, 'The Davenham Collection: English Eighteenth-Century Caricaturists – Thomas Rowlandson', *Connoisseur*, XLII, July 1915, pp. 131–138.

Randall Davies and Cecil Arthur Hunt, 'Thomas Rowlandson', *Stories of the English Artists from Vandyck to Turner 1600–1851* London: Chatto, and Windus; New York: Duffield, 1908, pp. 168–175.

Randall Robert Henry Davies, *Chats on Old English Drawings*, London: Fisher Unwin, 1923, pp. 89–93, 164–167.

Frank Davis, '"This England" – As seen by Thomas Rowlandson', *Illustrated London News*, CLXXXV, 21 July 1934, p. 118.

Frank Davis, 'Rowlandson Jottings', *Illustrated London News*, CLXXXVIII, 11 April 1936, p. 646.

Frank Davis, 'Wigstead–Thomas Rowlandson's Artist Friend', *Illustrated London News*, CLXXXIX, 12 September 1936, p. 452.

Frank Davis, 'Three Aspects of the British Temper', *Illustrated London News*, CXCI, 17 July 1937, p. 132.

Frank Davis, 'Rowlandson the Poet', *Illustrated London News*, CXCI, 27 November 1937, p. 960.

Frank Davis, 'A Rowlandson Sketch-Book', *Illustrated London News*, CXCIII, 20 August 1938, p. 338.

Frank Davis, 'A Rowlandson Exhibition.' *Illustrated London News*, CXCIV, 3 June 1939, p. 998.

Frank Davis, 'Rowlandson Again', *Illustrated London News*, CXCV, 6 April 1940, pp. 460–461.

Frank Davis, 'Rowlandson at Birmingham', *Illustrated London News*, CCXV, 26 November 1949, p. 830.

Frank Davis, 'Quirks and Oddities of Human Behaviour', *Illustrated London News*, CCXIX, 6 October 1951, p. 524.

Frank Davis, 'Rowly at Reading', *Illustrated London News*, CCXL, 21 April 1962, p. 626.

Arman Dayot, 'Deux grands humoristes anglais – J. Gillray et Th. Rowlandson', *L'Art et les artistes*, XI, July 1910, pp. 147–157.

Armand Dayot, *La Peinture anglaise de ses origines à nos jours*, Paris: Laveur, 1908, pp. 323–326, et passim.

Magdeleine A. Dayot, 'Caricatures et Moeurs anglaises (1750–1850)', *L'Art et les artistes*, XXXV, March 1938, pp. 187–192.

Edmond and Jules de Goncourt, *L'Art du dix-huitième siècle*, 2nd ed., Paris: Rapilly, 1873, II, p. 255.

Loÿs Delteil, *Manuel de l'amateur d'estampes des XIXe et XXe siècles*, Paris: Dorban-ainé, 1925, II, pp. 453–454.

André Dennery, 'L'Exposition d'Art et Tourisme', *L'Amour de l'art*, XIX, March 1938, pp. 91–93.

Otto Demus, 'Eine Rembrandt-Travestie von Thomas Rowlandson', *Phoebus*, II, 1949, pp. 80–81.

Jeanne Doin, 'Thomas Rowlandson', *Gazette des Beaux Arts*, 4e periode, I March–April 1909, pp. 287–296, 376–384.

Thomas Wade Earp, 'Rowlandson', *Drawing and Design*, n.s. I, November 1926, pp. 167–173.

H. Edwards, 'Distinguished Collaboration: *Microcosm of London*', *Antiques*, XLIX, March 1946, pp. 167–169.

Graham Everitt (pseud. William Rodgers Richardson), *English Caricaturists and Graphic Humorists of the Nineteenth Century*, London: Swan, Sonneschein, Le Bas & Lowney, 1886, pp. 3, 4, 84, 118.

H. G. Fell, 'Rowlandson Resurrection: "Vauxhall Gardens"', *Connoisseur*, CVXI, September 1945, pp. 56–57.

Alexander Joseph Finberg, 'Rowlandson & Blake', *The English Water Colour Painters*, London: Duckworth, 1905, pp. 114–121.

Augustin Filon, 'Thomas Rowlandson', *La Caricature en Angleterre*, Paris: Hachette, 1902, pp. 115–133.

Stanley W. Fisher, 'Dr Syntax on Porcelain', *Apollo*, LIII, February 1951, pp. 43–46.

Peter Floud, 'Grants in aid [Rowlandson drawing acquired for Plymouth]', *Museums Journal*, LVIII, 1958–1959, pp. 208–212.

Alfred M. Frankfurter, 'Thomas Rowlandson, Poet of Caricature', *Antiquarian*, XIV, June 1930, pp. 51–53, 70.

Pisanus Fraxi (pseud. H. Spencer Ashbee), *Bibliography of Prohibited Books*, London: 1877; rpt. New York: Jack Brussel, 1962, II, xlix–li, pp. 346–398.

Eduard Fuchs, *Die Karikatur der europäischen Völker vom Altertum bis zur Neuzeit*, Berlin: Hofmann, 1902, pp. 289–292.

Herbert Furst, 'A Note on Rowlandson', *Apollo*, XXIII, June 1936, pp. 310–313.

G. A. Gannon, 'Early English Watercolours in the National Gallery of Victoria, Melbourne', *Connoisseur Yearbook*, 1960, pp. 89–93.

William Gaunt, *A Concise History of English Painting*, New York: Praeger, 1964, pp. 118–119.

Mary Dorothy George, *English Political Caricature to 1792: A Study of Opinion and Propaganda*, Oxford: Clarendon Press, 1959, pp. 170–175, 179–186, et passim.

Mary Dorothy George, *English Political Caricature 1793–1832: A Study of Opinion and Propaganda*, Oxford, Clarendon Press, 1959, pp. 119–126, et passim.

Mary Dorothy George, *Hogarth to Cruikshank: Social Change in Graphic Satire*, New York: Walker, 1967, pp. 13, 17, 28, et passim.

Frank Gibson, 'The landscape Element in Thomas Rowlandson's Art', *International Studio*, LXV, October 1918, pp. 111–117.

Curt Glaser, *Die Graphik der Neuzeit vom Anfang des XIX. Jahrhunderts bis zur Gegenwart*, Berlin: Cassirer, 1922, pp. 66–67.

Ernst Hans Josef Gombrich, *Art and Illusion: A Study in the Psychology of Pictorial Representation*, 1960; 2nd ed. Princeton, New Jersey: Princeton University Press, 1961, p. 352.

Maurice Harold Grant, *A Dictionary of British Landscape Painters from the 16th Century to the Early 20th Century*, Leigh-on-Sea, England: Lewis, 1952, p. 166.

Algernon Graves, *Art Sales from Early in the Eighteenth Century to Early in the Twentieth Century*, London: Algernon Graves, 1921, III, pp. 107–108.

Algernon Graves, *A Century of Loan Exhibitions 1813–1912*, London: Algernon Graves, 1914, III, p. 1158; IV, p. 2161.

Algernon Graves, *A Dictionary of Artists who Have Exhibited Works in the Principal London exhibitions from 1760–1893*, London: H. Graves & Co., 1901, p. 241.

Basil Gray, *The English Print*, London: Black, 1937, pp. 34–35, 39.

Joseph Grego, 'Our Graphic Humorists: Thomas Rowlandson', 2 parts. *The Magazine of Art*, XXVI, February, March 1902, pp. 166–169, 210–214.

J[oseph] G[rego], 'Rowlandson's Tour in a Post Chaise 1782', *The Graphic Summer Number*, (1891); rpt. in R. R. Wark, *Rowlandson's Drawings for a Tour in a Post Chaise*, San Marino: The Huntington Library, 1963.

Joseph Grego, 'Thomas Rowlandson, The Caricaturist', *Notes and Queries*, 5th series, X, 20 July 1878, pp. 43–44.

Harlan W. Hamilton, *Doctor Syntax: A Silhouette of William Combe*, Kent, Ohio: Kent State University Press, 1969, pp. 243–260, et passim.

M[artin] H[ardie], 'Rowlandson, Thomas', *Bryan's Dictionary of Painters and Engravers*, New York: Macmillan, 1904, IV, p. 291.

Martin Hardie, 'Thomas Rowlandson, *English Coloured Books*, New York: Putnam, 1906, pp. 159–176, 315–318.

Martin Hardie, 'The Tours of Dr Syntax: Rowlandson's Unpublished Illustrations', *Connoisseur*, XVIII, August 1907, pp. 214–219.

Martin Hardie, 'Thomas Rowlandson and other Figure and Animal Painters', *Water-Colour Painting in Britain: I. The Eighteenth Century*, New York: Barnes & Noble, 1966, pp. 205–219.

John Robert Harvey, *Victorian Novelists and their Illustrators*, London: Sidgwick & Jackson, 1970; New York: New York University Press, 1971, pp. 28–29, 62–65.

Arthur William Heintzelman, 'Exhibitions from the Wiggin Gallery: Thomas Rowlandson', *Boston Public Library More Books*, XVIII, September 1943, pp. 334–335.

Arthur William Heintzelman, 'The Watercolor Drawings of Rowlandson', *Boston Public Library More Books*, XXII, December 1947, pp. 367–375.

Arthur Mayger Hind, *A History of Engraving & Etching from the 15th Century to the year 1914*, 3rd rev. ed. Boston: Houghton Mifflin, 1923, pp. 233, 235–236, 381.

Arthur Mayger Hind, Notes on the History of Soft-Ground Etching', *Print Collector's Quarterly*, VIII, December 1921, pp. 377–397.

Henry Russel Hitchcock, 'English Art acquisitions', *Smith College Museum of Art Bulletin*, no. 29–32, 1951, pp. 22–23.

Sinclair Hamilton Hitchings and Catherine Bryson Nicholson, 'Rowlandson's Roundels', 'A Rowlandson Bibliography: Progress Report', 'Census of Rowlandson Drawings', 'Rowlandson Drawings and Questions of Authenticity', *A Rowlandson Letter* II, June 1975, an offset report distributed by the Print Department of the Boston Public Library.

Sinclair Hamilton Hitchings and Catherine Bryson Nicholson, 'Rowlandson Drawings in Public Collections in the United States and Canada', 'Bibliographic Notes', 'A Selected Rowlandson Bibliography', *A Rowlandson Letter*, I, April 1974, an offset report distributed by the Print Department of the Boston Public Library.

G. Bernard Hughes, 'Thomas Rowlandson', *Apollo*, XXXVII, January 1943, pp. 1–3.

Joris Karl Huysmans, *Certains: G. Moreau, Degas, Cheret, Whistler, Rops, Le Monstre, Le Fer, etc.*, 1889; 5th ed., Paris: Plon, 1908, pp. 84–87.

Joris Karl Huysmans, 'Le Salon officiel de 1881', *L'Art moderne*, Paris: Charpentier, 1883, pp. 203–206.

Selwyn Image, 'The Serious Art of Thomas Rowlandson' *Burlington Magazine*, LXVII, October 1908, pp. 5–16.

G. Jean-Aubry, 'Caricature Anglaise', *Arts et metiers graphiques*, no. 31, 15 September 1932, pp. 21–22.

E. Dudley H. Johnson, 'Special Collections at Princeton: The Works of Thomas Rowlandson', *Princeton University Library Chronicle*, II, November 1940, pp. 7–20.

Alfred Forbes Johnson, 'Rudolf Ackermann and Thomas Rowlandson', *Penrose's Annual*, XXXVII, 1935, pp. 41–43.

Gunnar Jungmarker, 'Handtecknings- och Gravyrsamlingen Äldre Konstnärer' *Stockholm Nationalmusei Årsbok*, n.s., V, 1935, pp. 128–130.

Willem Rudolf Juynboll, *Het komische Genre in De Italiannische Schilderkunst*, Leiden: N. V. Leidsche Uitgeversmaatschaapij, 1934, pp. 189, 218.

David Keppel, 'Rowlandson', *Art Quarterly*, XII, 1949, pp. 74–80.

Francis Donald Klingender, *Hogarth and English Caricature*, London and New York: Transatlantic Arts, [1945], p. xi, et passim.

Phyllis and Eberhard Kronhausen, *Erotic Art 2*, New York: Bell, 1970, plates 2, 3, 4.

J. Lewine, *Bibliography of Eighteenth Century Art and Illustrated Books: Being a Guide to Collectors of Illustrated Works in English and French of the Period*, London: Sampson Low, Marston & Co., 1898, pp. x–xi, 479–485.

Basil Somerset Long, 'English Drawings in the Collection of Mr Archibald G. B. Russell, Lancaster Herald', *Connoisseur* XLIX, July 1924, pp. 137–145.

Basil Somerset Long, 'Rowlandson Drawings in the Desmond Coke Collection', *Connoisseur* LXXIX, December 1927, pp. 204–213.

Basil Somerset Long, 'More Drawings by Rowlandson in the Desmond Coke Collection', *Connoisseur*, LXXX, February 1928, pp. 67–73.

Edward Lucie-Smith, *Eroticism in Western Art*, New York: Praeger, 1972, pp. 103–4, 141.

Frank Jewett Mather, 'Some Drawings by Thomas Rowlandson', *Print Collector's Quarterly*, II, December 1912, pp. 389–437.

Antonio Maraini, 'Alcuni acquarelli inediti di Thomas Rowlandson', *Dedalo*, I, December 1920, pp. 476–485.

Jonathan Mayne, 'Rowlandson at Vauxhall', *Victoria & Albert Museum Bulletin*, IV, July 1968, pp. 77–81.

Alpheus Hyatt Mayor, 'Hawkers and Walkers', 'Rowlandson and Debucourt', *Prints & People: A Social History of Printed Pictures*, New York: Metropolitan Museum of Art, 1971, plates 204, 602–605.

Alpheus Hyatt Mayor, 'Rowlandson's England', *Metropolitan Museum of Art Bulletin*, n.s., XX, February 1962, pp. 185–201.

J. J. Mayoux, 'Thomas Rowlandson', *Études Anglaises*, II, January-March 1938, pp. 1–15.

Robert Melville, *Erotic Art of the West*, New York: Putnam, 1973, pp. 24, 65–66, 67, 69, 206.

André Paul Charles Michel, *Histoire de l'art*, Paris: Armand Colin, 1924, VII/2, pp. 698–701.

Hippolyte Mireur, *Dictionnaire des Ventes d'Art Faites en France et à l'Étranger pendant les XVIIIe & XIXe siècles*, Paris: Maison d'Éditions d'oeuvres artistiques, 1912, VI, pp. 344–346.

Richard Muther, *Geschichte der Malerei im XIX. Jahrhundert*, Munich: G. Hirth, 1893–1894, II, pp. 20–23; published in English as *The History of Modern Painting*, London: Dent, 1907.

Georg Kasper Nagler, 'Rowlandson, Thomas', *Neues Allgemeines Künstler-Lexikon*, Munich: Fleischmann, 1843, XIII, pp. 503–505.

Ralph Henry Nevill, 'Rowlandson and his Work', *Printseller*, I, 1903, pp. 63–64.

Ralph Henry Nevill, 'Thomas Rowlandson', *Connoisseur*, II, January 1902, pp. 42–48.

Freeman O'Donoghue and Henry M. Hake, *Catalogue of Engraved British Portraits, preserved in the Department of Prints and Drawings in the British Museum*, London: Trustees of the British Museum, 1908/1925, III, p. 621; VI, pp. 544, 676.

Adolf Paul Oppé, 'Rowlandson the Surprising', *Studio*, CXXIV, November 1942, pp. 147–158.

W[yatt] P[apworth], 'Thomas Rowlandson', *Notes and Queries*, 4th series, IV, 4 December 1869, p. 490

W[yatt] P[apworth], 'Thomas Rowlandson, Artist', *Notes and Queries*, 4th series, IV, 31 July 1869, pp. 89–91.

George Paston (pseud. Emily Morse Symonds), *Social Caricature in the Eighteenth Century*, London: Methuen, 1905, pp. 131–137.

Ronald Paulson, 'The Spectres of Blake and Rowlandson', *The Listener*, 2 August 1973, pp. 140–142.

Ronald Paulson, 'The Tradition of Comic Illustration from Hogarth to Cruikshank', *Princeton University Library Chronicle*, XXXV, Autumn-Winter 1973, pp. 35–60.

Mildred J. Prentiss, 'Exhibition of color plate books and original drawings [by Cruikshank and Rowlandson]', *Bulletin of the Art Institute of Chicago*, XXVI, March 1932, pp. 32–34.

Sarah Treverbian Prideaux, 'List of books containing illustrations by T. Rowlandson, based on "Rowlandson, the caricaturist", by J. Grego', *Aquatint Engravers*, London: Duckworth, 1909, pp. 379–387.

Victor Sawdon Pritchett, *The Living Novel*, London: 1946; rev. ed. New York: Random House, 1964, pp. 20–22.

A. Radcliffe, 'New Treasures at the Victoria & Albert Museum', *Apollo*, LXXXVII, June 1968, p. 406.

George Redford, *Art Sales: A History of Sales of Pictures and other Works of Art*, London: privately published, 1888, II, p. 172.

Gilbert Richard Redgrave, *A History of Water-Colour Painting in England*, London: Sampson Low, Marston & Co., 1892, pp. 151, 243, 246.

Samuel Redgrave, *A Dictionary of Artists of the English School: Painters, Sculptors, Architects, Engravers and Ornamentists*, London: Longmans, Green & Co., 1874, pp. 353–354.

Henry Reitlinger, *From Hogarth to Keene*, London: Methuen, 1938, pp. 75–78.

Daniel Catton Rich, 'An exhibition of water color drawings by Rowlandson', *Bulletin of the Art Institute of Chicago*, XXX, February 1936, pp. 20–21.

A. E. Richardson, 'Betsy's Marriage or What the Village Said. An original and unpublished scandal both written and depicted by Thomas Rowlandson', *Country Life*, LXXIV, 2 December 1933, pp. 583–585.

John C. Riely, 'Horace Walpole and "the Second Hogarth"', *Eighteenth-Century Studies*, IX, Autumn 1975, pp. 42–43.

Victor Rienacker, 'Rowlandson Prints', *Print Collector's Quarterly*, XIX, January 1932, pp. 11–30.

Frederic Gordon Roe, 'Drawings by Rowlandson: Captain Bruce S. Ingram's Collection', *Connoisseur*, CXVIII, December 1946, pp. 85–91.

Frederic Gordon Roe, 'Rowlandson and Landscape', *Old Water-Colour Society Club Annual*, XXV, 1947, pp. 21–30.

John Lewis Roget, *A History of the 'Old Water-Colour' Society, Now the Royal Society of Painters in Water Colours*, London: Longmans, Green & Co., 1891, I, pp. 204, 205, 362–363, 474–475.

Henry Preston Rossiter, 'Rowlandson: Georgian Humor, Idyllic Caricature in his Drawings Shown at Boston', *Art News*, XXXVI, 2 April 1938, pp. 9–10.

O. Joseph Rothrock, 'Rowlandson Drawings at Princeton: Introduction and Checklist', *Princeton University Library Chronicle*, XXXVI, Winter 1974–1975, pp. 87–110.

L. E. Rowse, '"Hayfield near Enfield" by Thomas Rowlandson', *Bulletin of the Rhode Island School of Design*, XVIII, July 1930, pp. 30–32.

Morris Harold Saffron, 'The Doctor Dissected; Twelve Medical Caricatures by Thomas Rowlandson', foreword to *Thomas Rowlandson: Medical Caricatures*, New York: Editions Medicina Rara, [1971].

Malcolm Charles Salaman, 'A Group of Rowlandson Drawings', *Apollo*, X, July 1929, pp. 17–24; rpt. as a brochure by Frank T. Sabin Gallery.

Malcolm Charles Salaman, *Londoners Then and Now as Pictured by their Contemporaries*, London: The Studio Ltd., 1920, pp. 24–25, 28–29, 30–32.

Harry Salpeter, 'Thomas Rowlandson', *American Artist*, September 1947, pp. 30–33.

S. James A. Salter, 'Rowlandson's "Hunting Breakfast"', *Notes and Queries*, 6th series, X, 20 December 1884, pp. 504–505.

Allen M. Samuels, 'Rudolf Ackermann and *The English Dance of Death*', *The Book Collector*, XXIII, Autumn 1974, pp. 371–380.

Carl O. Schniewind, 'A Unique Copy of *The Microcosm of London* Acquired for the Charles Deering Collection', *Bulletin of the Art Institute of Chicago*, XXXIV, September–October 1940, pp. 77–78.

R. R. M. Sée, 'Rowlandson', *L'Art vivant*, III, 1 December 1927, pp. 955–958.

Jean A. Seligmann, 'Le livre anglais illustré en couleurs dans la première moitié due XIXe siècle', *La Renaissance de l'art*, IV, June 1921, pp. 302–309.

Frank Siltzer, *The Story of British Sporting Prints*, New York: Scribners, 1925, pp. 237–238.

Osbert Sitwell, 'Thomas Rowlandson', *Sing High! Sing Low! A Book of Essays*. London: Macmillan, 1944, pp. 117–135.

Osbert Sitwell, 'Thomas Rowlandson', *Le Fortique*, IV, November 1946, pp. 108–128.

Sacheverell Sitwell, *Narrative Pictures: A Survey of English Genre and its Painters*, 1936; rpt. New York: Schocken, 1969, pp. 13–17.

Walter Shaw Sparrow, 'Morland, Rowlandson and Ibbetson', *British Sporting Artists from Barlow to Herring*, London: Lane; New York: Scribner, 1922, pp. 145–163.

Walter Shaw Sparrow, 'Rowlandson and Howitt – Painters of Sport', *International Studio*, XCVII, December 1930, pp. 61–64, 108.

Mabel Woods Smith, 'A Check List of Doctor Syntax Designs', *Antiques*, XII, December 1927, pp. 487–491.

Harrison Ross Steeves, *Before Jane Austen: The Shaping of the English Novel in the Eighteenth Century*, New York: Holt, Rinehart and Winston, 1965, pp. 133, 387, 390–391.

John Stenson, 'Thomas Rowlandson', *Notes and Queries*, 4th series, IV, 18 December 1869, p. 541.

Frederick George Stephens, 'Thomas Rowlandson, the Humorist', *The Portfolio*, XXII, 1891, pp. 141–148.

Denys Sutton, 'Thomas Rowlandson: Mirror of the Georgian World', *Country Life*, CVIII, November 1950, p. 1415.

Harry Thornber, 'Thomas Rowlandson and his Works', *Manchester Quarterly*, V, April 1886, pp. 97–117; rpt London: J. Heywood, 1886.

George Walter Thornbury, *British Artists from Hogarth to Turner, being a series of biographical sketches*, London: Hurst & Blackett, 1861, II, pp. 50–52.

Ronald Vere Tooley, *English Books with Coloured Plates: A Bibliographical Account, 1790–1860* 1935; 2nd ed. London: Batsford; Boston: Boston Book & Art, 1954, pp. 20–25, 328–354.

P. Troutman, 'Evocation of Atmosphere in the English Watercolour', *Apollo*, LXXXVIII, July 1968, pp. 51–57.

Andrew W. Tuer, 'Rowlandson', *Notes and Queries*, 7th series, VI, 7 July 1888, p. 10.

Cornelius Veth, 'The Art of Thomas Rowlandson', *Comic Art in England*, Amsterdam: Menno Hertzberger, 1930, pp. 51–59.

Jan Pieter Veth, 'Thomas Rowlandson (Austellung bei Amsler & Ruthard, Berlin)', *Kunst und Künstler*, VII, 1908/1909, pp. 39–41.

Jan Pieter Veth, 'Thomas Rowlandson', *Im Schatten alter Kunst*, Berlin: Cassirer, 1911, pp. 141–146.

H[ans] V[ollmer], 'Rowlandson, Thomas', *Allgemeines Lexikon der Bildenden Künstler*, ed. by Ulrich Thieme and Felix Becker, Leipzig: Seeman, 1935, XXIX, pp. 127–128.

C. E. Vulliamy, 'Gillray and Rowlandson', *Printseller*, I, 1903, pp. 347–349.

Robert Rodger Wark, 'Rowlandson's "Mrs Siddons Rehearsing"', *Ten British Pictures 1740–1840*, San Marino, California: The Huntington Library, 1971, pp. 66–77.

A. Weber, *Tableau de la caricature médicale depuis les origines jusqu'à nos jours*, Paris: Editions Hippocrate, 1936, pp. 60–73, 89.

William Thomas Whitley, *Artists and their Friends in England (1700–1799)*, London: Medici Society, 1928, II, pp. 396–397.

Margaret Whittemore, 'A Doctor Syntax Quilt: Great Grandfather's Comic Strip', *Antiques*, LV, March 1949, pp. 182–183.

Reginald Howard Wilenski, *English Painting*, London: Faber & Faber, 1933, pp. 171–176.

Reginald Howard Wilenski, *An Outline of English Painting*, London: Faber and Faber, 1946, pp. 44–45.

Iolo Aneurin Williams, *Early English Water-Colours and Some Cognate Drawings by Artists Born not Later than 1785*, London: Connoisseur, 1952, pp. 137–142.

Thomas Wright, *England under the House of Hanover*, 1st ed., 1848; 2nd ed. published as *Caricature History of the Georges, or, Annals of the House of Hanover, compiled from the squibs, broadsides, window pictures, lampoons, and pictorial caricature of the time*, London: J. C. Hotton, [1868], pp. 381–383, 528–529, 631, 634.

Thomas Wright, *A History of Caricature & Grotesque in Literature and Art*. London: Virtue Brothers, 1865, pp. 461, 480–488.

Helma Wolf-Catz, 'Thomas Rowlandson en James Gillray', *Kroniek van Kunst en Kultuur*, XVII, 1957, pp. 185–189.

Willi Wolfradt, 'Rowlandson: Zum 100. Todestag des grossen englishen Karikaturisten', *Uhu, das neue Ullstein-Magazin*, III, April 1927, pp. 17–24.

Carl Zigrosser, 'The Microcosm of London', *Print Collector's Quarterly*, XXIV, April 1937, pp. 144–172.

ANONYMOUS ARTICLES

'Rowlandson the Caricaturist', *The Antiquary*, II, September 1880, pp. 111–115.

'National art collections' fund; illustrated acquisitions of 1940', *Apollo*, XXXIII, June 1941, p. 158.

'Ausstellung Thomas Rowlandson im Buchgewerbemuseum Leipzig', *Archiv für Buchgewerbe*, March 1912, pp. 88–90.

'Rowlandson the Caricaturist', *Bookworm*, II, January 1889, pp. 49–53.

J. C. 'England's Three Greatest Artist-Humorists Since Hogarth', *Brush and Pencil*, XIV, July 1904, pp. 243–252.

'Grenville Lindall Winthrop [Bequest]', *Bulletin of the Fogg Museum of Art*, X, November 1943, pp. 53, 71.

R. E. F. 'Recent Acquisitions of Drawings', *Bulletin of the Metropolitan Museum of Art*, IV, February 1909, pp. 24–25.

B. B. 'Drawings by Rowlandson', *Bulletin of the Metropolitan Museum of Art*, XIX, February 1924, p. 50.

F. 'Vom englischen Kunsthandel', *Der Cicerone*, I, 1909, pp. 249–254.

'One of the great Romances of Auction: A long-lost Rowlandson, bought for £1, sold for 2,600 Guineas', *Illustrated London News*, CVII, 4 August 1945, pp. 126–127.

'Rowlandson's Record of London Life: Society, Theatre, Commerce and Officialdom', *Illustrated London News*, CCXII, 15 May 1948, p. 558.

'Thomas Rowlandson, "The Pictorial Diarist", Displayed in a Touring Loan Exhibition', *Illustrated London News*, CCXVII, 25 November 1950, p. 877.

'Handzeichnungen und Aquarelle [at F. A. Prestel's Frankfurt]', *Internationale Sammler-Zeitung*, 15 February 1912, p. 55.

'Samuel Collings' Designs for Rowlandson's *Picturesque Beauties of Boswell*', an illustrated keepsake privately printed for the Johnsonians, 1975.

'The Lupton Bequest', *Leeds Art Calendar*, VII, no. 23, 1953, pp. 3–10.

M. C. 'Thomas Rowlandson and some contemporary comic draughtsmen', *Leeds Art Calendar*, IX, no. 30, 1955, pp. 5–17.

'Thomas Rowlandson, the Caricaturist', *Leisure Hour*, XXIX, 10 April 1880, pp. 233–238.

'Bequests, gifts and purchases', *Metropolitan Museum of Art Bulletin*, n.s., XVIII, October 1959, p. 38.

S. R. 'Thomas Rowlandson, Artist', *Notes and Queries*, 4th series, IV, 11 September 1869, pp. 224–225.

'Rowlandson', *Notes and Queries*, 7th series, V, 23 June 1888, p. 487.

'Grego's Rowlandson and his Work', *Pears' Pictorial*, March 1895.

'Unpublished Works and Recent Acquisitions', *Smith College Museum of Art Bulletin*, no. 40, 1960, p. 43.

'Rowlandson's Old London', *Springfield Museum of Fine Arts Bulletin*, V, October–November 1938, pp. 1–2.

'Thomas Rowlandson and his Works (Written in 1895): Rowlandson, Artist and Caricaturist', *Walker's Monthly*, no. 58–63, October 1932–March 1933.

'Purchases [Rowlandson drawing, 'Execution Day at York']', *York Art Gallery Preview*, no. 3, 1946, p. 4.

'Acquisitions', *York Art Gallery Preview* no. 4, 1948, p. 4.

'Recent acquisitions', *York Art Gallery Preview*, no. 27, 1954, pp. 279–283.

CATALOGUES OF EXHIBITIONS AND CATALOGUES OF COLLECTIONS INCLUDING DRAWINGS BY THOMAS ROWLANDSON

'Catalogue of a collection of Drawings by Thomas Rowlandson, now in the Drawing Room of the Club, chiefly in illustration of the "Dance of Death"; lent by Joseph Parker, Esq.', *Burlington Fine Arts Club, London*, December 1882.

'English Humorists in Art', *Royal Institute of Painters in Water-Colour*, London, June 1889.

Laurence Binyon, *Catalogue of Drawings by British Artists and artists of foreign origin working in Great Britain, preserved in the Department of Prints and Drawings in the British Museum*, London: Trustees of the British Museum, 1902. III, pp. 247–266.

Catalogue of Water Colour Paintings by British Artists and Foreigners Working in Great Britain. South Kensington Museum, London [Victoria and Albert Museum], London: His Majesty's Stationery Office, 1908, pp, 311–313; rev. ed. 1927 by Basil S. Long and F. W. Stokes.

Harry Elkins Widener, *A Catalogue of Some of the More Important Books, Manuscripts and Drawings in the Library of Harry Elkins Widener*, Philadelphia: privately printed, 1910, pp. 167–170.

A Catalogue of Books Illustrated by Thomas Rowlandson, Grolier Club, New York, November 1916. (The catalogue lists a number of drawings lent from private collections.)

C. B. Stevenson, *Illustrated Catalogue of the Permanent Collection of Water-Colour Drawings in the Laing Art Gallery and Museum*, Newcastle-on-Tyne, 1937.

C. Reginald Grundy and Frederic Gordon Roe, *A Catalogue of the Pictures and Drawings in the Collection of Frederick John Nettlefold*, Vol. III, 1937.

Arthur Ewart Popham, *A Handbook to the Drawings and Water-Colours in the Department of Prints and Drawings, British Museum*, London: Trustees of the British Museum, 1939, p. 110.

'[Twenty-six] Water Color Drawings by Thomas Rowlandson', *Art Institute of Chicago, Exhibition no. 15*, July–October 1939.

John Richard Craft, introduction, 'Washington County Museum of Fine Arts Tenth Anniversary Exhibition', Hagerstown, Maryland, October 1941. (Twenty Rowlandson drawings lent by Arthur Newton Gallery, New York.)

David Bell, introduction, 'Tro Trwy Gymru....: A Tour through Wales, [28] drawings by Thomas Rowlandson from the Sir John Williams Collection in the National Library of Wales, Aberystwyth', *Arts Council of Great Britain travelling exhibition*, 1947.

Denys Sutton, 'Some British Drawings from the collection of Sir Robert Witt, C. B. E., D. Litt', *Arts Council of Great Britain*, 1948.

Gilbert Davis, introduction, 'Exhibition of [80] Works by Thomas Rowlandson from the collection of Gilbert Davis, Esq', *City Art Gallery, Bristol*, March–April 1949.

Gilbert Davis, introduction, 'Exhibition of [100] Works by Thomas Rowlandson from the collection of Gilbert Davis, Esq', *City of Birmingham Museum and Art Gallery*, December 1949–January 1950.

Gilbert Davis, introduction, '[150]Watercolours & Drawings by Thomas Rowlandson,' *Arts Council of Great Britain travelling exhibition*, 1950 and 1951.

Adolf Paul Oppé, *English Drawings, Stuart & Georgian Periods, in the collection of His Majesty the King at Windsor Castle*, London: Phaidon, 1950, pp. 85–89.

Michael Strang Robinson, *A Pageant of the Sea: The MacPherson Collection of Maritime Prints & Drawings in the National Maritime Museum, Greenwich*, London and New York: Halton, 1950, pp. 182–184, 208.

'Watercolours and drawings by Thomas Rowlandson; Coloured Engravings by James Gillray', *Whitechapel Art Gallery*, London, 1953 (exhibition included 41 Rowlandson drawings lent from the Gilbert Davis collection).

Lajos Vayer, *Master Drawings from the Collection of the Budapest Museum of Fine Arts, 14th–18th Centuries*, New York: Abrams, 1957, pl. 108.

Gerald Dickens, 'The Dress of the British Sailor: National Maritime Museum, Greenwich', London: Her Majesty's Stationery Office, 1957, pls. 9, 10, 11.

Peter A. Tomory, introduction. 'A Collection of Drawings by Thomas Rowlandson 1757–1827', *Auckland City Art Gallery*, [1958].

Horst Vey, *A Catalogue of the Drawings by European Masters in the Worcester Art Museum*, Worcester, Massachusetts: Worcester Art Museum, 1958, pp. 11–12.

Iolo Aneurin Williams, introduction, 'Watercolours and Drawings from the City Art Gallery, Leeds', *Thomas Agnew & Sons*, London, October–November 1960.

John Hayes, *A Catalogue of the Watercolour Drawings by Thomas Rowlandson in the London Museum*', London: Her Majesty's Stationery Office, 1960.

Robert Rodger Wark, 'Drawings by Thomas Rowlandson', *Huntington Library and Art Gallery*, San Marino, California April–June 1960.

'Thomas Rowlandson: Drawings from Town & Country', *Reading Museum and Art Gallery*, 1962, a loan exhibition from the L. M. E. Dent collection.

'Thomas Rowlandson 1757–1827: A Selection of Books and Drawings from the Collection of Dr. Morris H. Saffron', *Grolier Club*, New York, December 1963–February 1964.

'An Exhibit of Books and Manuscripts from the Johnsonian Collection Formed by Mr and Mrs Donald F. Hyde at Four Oaks Farm', *Houghton Library, Harvard University*, Cambridge, Massachusetts, 1966, (frontispiece illustrates an early Rowlandson drawing in the collection).

James L. Connelly and A. Brett Waller, 'The School for Scandal: Thomas Rowlandson's London', *Museum of Art, University of Kansas*, Lawrence, Kansas, 1967, pp. 59–61.

Thomas McCormick, *Vassar College Art Gallery: Selections from the Permanent Collection*, Poughkeepsie, New York: 1967, p. 29.

Frederick Cummings, *Romantic Art in Britain: Paintings and Drawings 1760–1860*, Philadelphia: Philadelphia Museum of Art, 1968, pp. 110, 155–156.

Egbert Haverkamp-Begemann and Ann-Marie S. Logan, *European Drawings and Watercolors in the Yale University Art Gallery 1500–1900*, New Haven: Yale University Press, 1970, I, pp. 125–126.

Johanna Gill, 'Thomas Rowlandson', *British Watercolors and Drawings from the Museum's Collection*, published as *Bulletin of the Rhode Island School of Design Museum*, LVIII, April 1972, pls. 29–32.

John Baskett and Dudley Snelgrove, *English Drawings and Watercolors, 1550–1850, in the collection of Mr and Mrs Paul Mellon*, New York: Pierpont Morgan Library, 1972, pls. 68–73.

John C. Riely, 'The Age of Horace Walpole in Caricature: An Exhibition of Satirical Prints and Drawings from the Collection of W. S. Lewis.' New Haven: Yale University Press, 1973, items 2 and 44.

Anne Kirker, introduction, 'Supplement to the Exhibition Catalogue: "Rowlandson (A Collection of Drawings by Thomas Rowlandson 1757–1827)"', *Auckland City Art Gallery*, March–April 1975.

Denys Oppé, introduction, 'English Watercolours and Drawings of the 18th & 19th Centuries', *Guildhall Picture Gallery, Winchester*, July–August 1975, loan exhibition from the Oppé collection.

Robert Rodger Wark, *Drawings by Thomas Rowlandson in the Huntington Coollection*. San Marino, California: Huntington Library, 1975.

AUCTION CATALOGUES AND DEALERS' CATALOGUES LISTING DRAWINGS BY THOMAS ROWLANDSON

The number of lots containing Rowlandson drawings or the number of Rowlandson drawings listed in the catalogue appears at the end of most entries. In entries for auction catalogues, the names of owners are given chiefly to identify the sale. These names do not necessarily indicate the collections from which Rowlandson drawings were sold.

American Art Association, New York, 4 February 1919
 The notable and extensive collection of illustrated books and caricatures from the private library of J. Barton Townshend, Esq., of Philadelphia. (5 lots).

American Art Association, Anderson Galleries, New York, sale no. 3839, 16–17 April 1930
 Etchings and English sporting prints...Rowlandson drawings...from the estate of Mrs H. O. Havemeyer... (29 lots).

American Art Association, Anderson Galleries, New York, sale no. 4130, 21 November 1934
 Eli B. Springs collection. (24 lots, all ex coll. Sidney L. Phipson).

American Art Association, New York, sale no. 4272, 4 November 1936
 Collection of Mrs Samuel Insull.

American Art Association, Anderson Galleries, New York, sale no. 4286, 6 January 1937
 Sporting and colored plate books, original drawings – the renowned collection of Fitz Eugene Dixon, Philadelphia, Pennsylvania. (1 lot of 14 drawings).

Anderson Galleries, New York, 23–24 November 1916
 The Frederic R. Halsey Collection of Prints, Part II: Sporting Prints. (4 lots).

Anderson Galleries, New York, sale no. 1646, 3 April 1922
 Gilbey collection. The sporting library of a well-known collector...together with original drawings by Alken, George Cruikshank and Rowlandson.

Anderson Galleries, New York, sale no. 1717, 5–6 March 1923
 Books, autographs and manuscripts of extreme rarity from the library of Mrs Luther S. Livingston of Cambridge, Massachusetts...(1 lot, describing a quarto album of 50 drawings).

Anderson Galleries, New York, sale no. 1773, 15 November 1923
 Sixty-three very fine Rowlandson drawings and water colors...the collection of Mr Sidney Lovell Phipson....

Amory Hall, Boston, Massachusetts, May 1835
 Exhibition of a selected collection of modern and ancient original drawings and paintings, engraving-books, &c....(2 lots).

Amsler & Ruthardt, Berlin, 5–7 June 1912
 Collection of Oscar von Zur Mühlen of Saint Petersburg.

Appleby Brothers Ltd, London, 22 April–10 May 1969
 Exhibition of 18th and 19th century English Watercolours. (5 drawings).

John Baskett Ltd, London, November–December 1969
 Exhibition of drawings and prints by Thomas Rowlandson (1756–1827). (27 items).

Charles S. Boesen, New York, [ca. 1943]
 Illustrated books, press books, original watercolors from the library of the late Dr. S. W. Bandler, Part III. (40 lots).

Fitzroy Carrington Gallery, New York, October–November 1923
 Catalogue of an exhibition of drawings by Sir Peter Lely, Sir Godfrey Kneller, Richard Cosway, John Hoppner, Thomas Rowlandson.

Caxton Head, J. and M. L. Tregaskis, London, 1898
 Catalogue of watercolour drawings by Thomas Rowlandson....

Caxton Head Catalogue 1009, James Tregaskis & Son, London, [1934]
 (20 items).
Christie's, London, 13 October 1802
 Earl Grosvenor sale.
Christie's, London, 13 December 1837
 S. F. Rimbault sale. (392 lots).
Christie's, London, 20 January 1888
 Thomas Capron sale.
Christie's, London, 15 March 1889
 Thomas Capron sale.
Christie's, London, 17 April 1893
 Catalogue...a collection of 20 drawings by T. Rowlandson....
Christie's, London, 18 May 1893
 Catalogue of a valuable collection of water-colour drawings by T. Rowlandson, the property of Charles
 Moseley....
Christie's, London, 21 May 1895
 Catalogue of a collection of water-colour drawings...also drawings by T. Rowlandson, the property of a
 lady of rank....
Christie's, London, 30 January 1896
 (80 lots)
Christie's, London, 21 February 1898
 Catalogue of pictures & drawings of Hastings Wright, Esq. deceased: a collection of watercolour drawings by
 T. Rowlandson...(31 lots).
Christie's, London, 15 May 1899
 Catalogue of a choice collection of water-colour drawings by Thomas Rowlandson, the property of William
 Wright....(117 lots).
Christie's, London, 3 April 1905
 Catalogue of a collection of water colour drawings by T. Rowlandson the property of a lady...(59 lots).
Christie's, London, 20 May 1905
 Louis Huth sale.
Christie's, London, 10 June 1907
 Catalogue of a collection of drawings by T. Rowlandson and engravings, the property of a nobleman,...(27
 lots).
Christie's London, 11 May 1908
 A collection of drawings by T. Rowlandson, the property of Richard Smith, Esq., deceased...(49 lots).
Christie's, London, 28 April 1908
 Joseph Grego sale.
Christie's, London, 4 June 1908
 Joseph Grego sale.
Christie's, London, 11 February 1911
 H. Lee Warner sale.
Christie's, London, 10 April 1911
 Sir Charles Wentworth Dilke sale.
Christie's, London, 12 February 1912
 Catalogue of a collection of water colour drawings by Thomas Rowlandson the property of a gentleman...
 (more than 100 items).
Christie's, London, 16 April 1923
 Catalogue of drawings by Thomas Rowlandson, from the collection of the late Sir John Crampton...(94 lots).
Christie's, London, 12 December 1924
 Brewerton sale.
Christie's, London, 22 November 1929
 Catalogue of drawings by Thomas Rowlandson, the property of Captain Desmond Coke...(60 lots).
Christie's, London, 13 June 1930
 Catalogue of old pictures, the property of Sir Hastings Hadley D'Oyly, Bart...also drawings by Thomas
 Rowlandson...(26 lots).
Christie's, London, 25 April 1940
 Arthur N. Gilbey sale.
Christie's, London, 27 July 1945
 (sale of rediscovered Rowlandson masterpiece, *Vauxhall Gardens*).
Christie's, London, 29 April 1960
 Pictures and Drawings of the Nineteenth Century from various sources. (2 lots).
Christie's, London, 13 March 1961
 Catalogue of English drawings of the 18th and 19th centuries, the property of Canon Francis H. D. Smythe.
 (3 lots).
Christie's, London, 28 June 1963
 English pictures and drawings c. 1650–c. 1850, the properties of the Rt. Hon. Lord Astor of Hever...(21
 drawings).
Christie's, London, 22 November 1963
 Catalogue of English pictures, prints and drawings c. 1650–c. 1950 the properties of Mrs J. A. Baker
 (6 drawings).
Christie's, London, 21 July 1964
 Catalogue of Prints and Drawings by Old Masters, English Watercolours and English Prints the Properties
 of the late Albert Herbert, F.S.A....(5 drawings).

Christie's, London, 27 April 1965
>English drawings and watercolours and a few prints.

Christie's, London, 22 March 1966
>Catalogue of English drawings and watercolours, the properties of Sir William Henry Dyke Acland, Bart....
>(3 drawings).

Christie's, London, 5 July 1966
>Catalogue of English drawings and watercolours, the properties of Her Late Royal Highness, the Princess
>Royal,...(4 drawings).

Christie's, London, 24 October 1967
>Catalogue of English drawings and watercolours, the property of Mrs Alexander Russell and others.
>(2 drawings).

Christie's, London, 12 December 1967
>Catalogue of English prints, drawings and watercolours, the property of Mrs N. Danby,...(2 lots).

Christie's, London, 2 March 1971
>Fine English drawings & watercolours, the properties of David M. Beardsell, Esq.,...(6 lots).

Christie's, London, 15 June 1971
>Important English drawings and watercolours, the properties of the Rt. Hon. The Earl of Antrim...(5 lots).

Colnaghi and Obach's Galleries, London, 1912
>Selected Drawings by Thomas Rowlandson.

Colnaghi & Company, London, May–June 1972
>Exhibition of English Drawings and Watercolours. (1 drawing).

Cotswold Gallery, London, March–April 1924
>Catalogue of the second annual exhibition of water colours by J. M. W. Turner, R. A. & other masters of
>the English school.

Cotswold Gallery, London, 1929
>Seventh annual exhibition of water-colours by J. M. W. Turner, R.A., Girtin, Rowlandson, Samuel Palmer,
>and other masters of the English school.

Davis Galleries, New York, September–October 1967
>Thomas Rowlandson (1757–1827). (36 drawings).

Davis Galleries, New York, December 1968
>Nineteenth Century English Watercolors and Drawings. (2 drawings).

Francis Edwards, London, July 1912
>Catalogue of an interesting collection of books illustrated by George, Isaac, and Isaac Robert Cruikshank,
>Thomas Rowlandson,...also...Original Drawings. (9 drawings).

Ellis & Smith, London, [ca. 1930]
>Early English Prints. (7 drawings).

Ellis & Smith, London, May 1949
>A loan exhibition of important drawings by Thomas Rowlandson (1756–1827). And an appreciation by Pierre
>Jeannerat.

Ellis & Smith, London, 1948
>Catalogue of early English drawings.

Fine Arts Society, London, January 1895
>Catalogue of a collection of water-colour drawings by Thomas Rowlandson and John Downman, with a pre-
>fatory note by Joseph Grego. (279 items).

E. Foster, London, 21–24 April 1828
>A catalogue of the collection of pictures of the late John Jackson, Esq...also the Collection of Drawings,
>including specimens of Wilson, Girtin, Cipriani, Rowlandson, Morland, &c. (9 lots).

Gropper Art Gallery, Cambridge, Massachusetts, December 1970
>Recent acquisitions. (3 drawings).

Gropper Art Gallery, Cambridge, Massachusetts, August 1973
>Rowlandson etchings and a few related items. (3 drawings).

Gutekunst's Gallery, London, catalogue 30, 1907
>Drawings and prints by T. Rowlandson.

Gutekunst's Gallery, London, 1909
>Drawings by Thomas Rowlandson; also etchings by D. S. MacLaughlin and H. Mulready Stone.

M. Knoedler & Co., New York, 1–15 February 1913
>Catalogue of original drawings by Thomas Rowlandson.

M. Knoedler & Co., New York, 1–15 March 1915
>Catalogue of an exhibition of water colors by Thomas Rowlandson.

Emile Laffon, Zurich, 7–8 April 1938
>(21 entries).

Leger Galleries, London, February 1962
>Early English watercolours including a group by Thomas Rowlandson and sketches by James Holland, R.W.S.

Leicester Galleries, London, catalogue 10, 1903
>Water-colour drawings by Thomas Rowlandson.

R. E. Lewis, Inc., Nicasio, California, list no. 195, May 1974
>Twenty-five prints and drawings by Thomas Rowlandson. (2 drawings).

R. E. Lewis, Inc., San Francisco, January–February 1963
>Thomas Rowlandson: Watercolors & Etchings.

R. E. Lewis, Inc., San Francisco, June–July 1969
>Thomas Rowlandson: Prints and Drawings (8 Drawings).

Maggs Brothers, London, catalogue no. 438, 1923 Engravings and drawings. (22 drawings).

Maggs Brothers, London, catalogue no. 458, 1925. (10 drawings).
Alister Mathews, Bournemouth, England, catalogue 75, spring 1970
 Books and drawings. (4 drawings).
Alister Mathews, Bournemouth, England, catalogue 76, autumn 1970
 Drawings. (4 drawings).
Alister Mathews, Bournemouth, England, catalogue 77, spring 1971
 Drawings & watercolours. (1 drawing).
Alister Mathews, Bournemouth, England, catalogue 81, spring 1973
 Drawings & watercolours. (1 drawing).
F. R. Meatyard, London, catalogue 21 n.s., winter 1939
 An illustrated catalogue of war time bargains in original etchings and drawings by leading artists, old and
 modern. (10 drawings).
Frederick Muller & Co., Amsterdam, 22–23 June 1910
 Henri Duval de Liège sale. (1 drawing).
Parke-Bernet Galleries, New York, catalogue 11, 25 February 1938 Standard Sets, Drawings, Manuscripts, Americana,
 including property collected by the late Matthew M. Looram, New York...(19 drawings).
Parke-Bernet Galleries, New York, catalogue 54, 25 October 1938
 Van Sweringen sale. (6 drawings).
Parke-Bernet Galleries, New York, catalogue 177, 28 February 1940
 Joseph McInerney, Robert Cluett III, Dickson Q. Brown sale.
Parke-Bernet Galleries, New York, catalogue 321, 2 December 1941
 First editions, original drawings, paintings, caricatures...collected by William H. Woodin, New York....
 Part I. (6 lots containing 67 drawings).
Parke-Bernet Galleries, New York, catalogue 331, 6 January 1942
 William H. Woodin sale, part II. (10 lots containing 71 drawings).
Parke-Bernet Galleries, New York, catalogue 352, 26 February 1942
 William H. Woodin sale, part III. (8 lots containing 10 drawings).
Parke-Bernet Galleries, New York, catalogue 755, 28 March 1946
 Property of Scott & Fowles, New York.
E. Parsons & Sons, London, catalogue no. 4
 Old Master Drawings.
Phillips, London, 23 April 1872
 William W. Pearce sale.
Paul Prouté et ses fils, Paris, catalogue 'Cochin', 1962
 (1 drawing).
Paul Prouté et ses fils, Paris, catalogue 'Colmar', 1964
 (7 drawings).
Paul Prouté et ses fils, Paris, catalogue 46, autumn 1967
 (1 drawing).
Puttick & Simpson, London, 20 April 1908
 The library of the late Joseph Grego, Esq. and another property. (1 lot attributed to Rowlandson).
Puttick & Simpson, London, 25 June 1908
 Catalogue of the collection of engravings formed by the late Joseph Grego, Esq.... a few choice drawings by
 Rowlandson, H. Alken, etc.
Puttick & Simpson, London, 17 December 1912
 Catalogue of the valuable library of the late Ralph Clutton, Esq....also the unique Rowlandson and Gillray
 collections [formed by Francis Harvey]. (1 lot containing 113 drawings).
Nicolas Rauch, S. A., Geneva, June 1960
 Dessins de maîtres anciens et modernes. (1 drawing).
Henry Reinhardt Galleries, Chicago, 1913
 Original drawings by Rowlandson. (89 drawings).
Frank T. Sabin, London, [ca. 1930]
 A group of Rowlandson drawings, essay by Malcolm C. Salaman (rpt. of an article appearing in *Apollo*, July
 1929).
Frank T. Sabin, London, 1933
 A catalogue of watercolour drawings by Thomas Rowlandson (1756–1827), by V. P. Sabin. (112 drawings).
Frank T. Sabin, London, spring 1934
 Catalogue of an exhibition of water-colours by Thomas Rowlandson.
Frank T. Sabin, London, 1938
 Selection of drawings by T. Rowlandson 1756–1827.
Frank T. Sabin, London, 1939
 Drawings of Thomas Rowlandson 1756–1827.
Frank T. Sabin, London, 1948
 A catalogue of watercolour drawings by Thomas Rowlandson 1756–1827, by Philip Sabin. (50 drawings).
Frank T. Sabin, London, March 1952
 Thomas Rowlandson 1756–1827: Catalogue of an exhibition of watercolour drawings. (60 drawings).
Frank T. Sabin, London, 1954
 Thomas Rowlandson: Catalogue of an exhibition of watercolour drawings, II. (41 drawings).
Frank T. Sabin, London, 1956
 The Bicentenary of the birth of Thomas Rowlandson (1756–1827): A selection of a few of his watercolour
 drawings. (24 drawings).

Charles J. Sawyer, London, Serendipity catalogue 290, 1973
 (5 drawings).
Hellmut Schumann, A. G., Zurich, catalogue 492, [ca. 1973]
 English illustrated books from a distinguished private collection. (1 drawing).
Sotheby's, London, 29 June 1818
 Matthew Michell sale.
Sotheby's, London, 14 April 1819
 Matthew Michell sale.
Sotheby's, London, 18–21 June 1828
 Catalogue of the valuable library of the late Burges Bryan, Esq.... to which are added the books of prints, &c.
 of the late Thomas Rowlandson, Esq.
Sotheby's, London, 23–26 June 1828
 A catalogue of the valuable collection of prints, drawings, & pictures of the late distinguished artist, Thomas
 Rowlandson, Esq.
Sotheby's, London, 27–29 June 1853
 Catalogue of the valuable and important historical, topographical, antiquarian, and ecclesiastical library of the
 late eminent architect A. W. Pugin, Esq.,... (1 lot containing *The Microcosm of London* in 3 volumes with the
 original drawings).
Sotheby's, London, 9 December 1912
Sotheby's, London, 24 February 1914
 Catalogue...the property of the late Sir Charles Robinson...also a collection of drawings by Thomas
 Rowlandson.
Sotheby's, London, 12 March 1919
 (14 volumes of prints and some drawings ex coll. Francis Harvey).
Sotheby's, London, 9–10 June 1921
 William Henry Bruton sale. (1 lot of 68 drawings for 'A Tour in a Post Chaise').
Sotheby's, London, 25 June 1925
 Catalogue of drawings...including an extensive collection of water-colour drawings by T. Rowlandson....
Sotheby's, London, 20 November 1928
 Catalogue of old engravings, the property of the late Dame Charlotte de Bathe and drawings in water-colour
 by Thomas Rowlandson. (113 lots).
Sotheby's, London, 21 July 1931
 The Desmond Coke Collections. Catalogue of choice drawings in water-colour by Thomas Rowlandson...
 (125 lots).
Sotheby's, London, 11 May 1938
 Catalogue of the...collection of watercolour drawings...by Thomas Rowlandson, the property of the late
 M. Louis Deglatigny of Rouen, France... (112 lots).
Sotheby's, London, 12 June 1940
 The Eumorfopoulous & Harcourt Johnstone collections. (39 drawings).
Sotheby's, London, 21 October 1942
 Catalogue of drawings...including...a collection of water-colour drawings by T. Rowlandson....
Sotheby's, London, 29 January 1947
 Catalogue of modern paintings, drawings, and sculpture. (2 lots).
Sotheby's, London, 10–12 February 1947
 Catalogue of the well-known collection of drawings of the English school...the property of Randall Davies,
 Esq. .S.A. (41 lots).
Sotheby's, London, 18 June 1947
 Catalogue of fine modern & old pictures...a collection of Rowlandson drawings, the property of Henry Harris,
 Esq.... (28 lots).
Sotheby's, London, 27 January 1954
 H. S. Reitlinger Collection, part II: Catalogue of paintings and drawings of the English school, 1st section.
 (40 lots).
Sotheby's, London, 26 May 1954
 H. S. Reitlinger Collection, part IV: Catalogue of drawings by artists of the English school, 2nd section.
 (38 lots).
Sotheby's, London, 20 March 1957
 Catalogue of eighteenth century and modern drawings and paintings including the property of Mrs M. M.
 Richardson,...and drawings by...Rowlandson, the property of R. P. Morris... (18 lots).
Sotheby's, London, 12 November 1958
 Catalogue of modern English drawings, paintings, and sculpture...also drawings by...Rowlandson...
 property of the Most Hon. the Marquess of Carisbrooke... (2 lots).
Sotheby's, London, 12 January 1959
 Catalogue of old master and eighteenth to nineteenth century engravings including...the Dyson Perrins
 collection of Rowlandson engravings... (1 lot of 23 volumes of prints, including 36 drawings, all ex coll.
 Francis Harvey).
Sotheby's, London, 11 February 1959
 Catalogue of eighteenth and nineteenth century drawings and paintings including drawings by...Rowlandson
 ...the property of Mrs Vera Ashton... (2 drawings).
Sotheby's, London, 24 February 1960
 Catalogue of fine eighteenth and nineteenth century drawings and paintings including the property of Miss
 Margaret S. Davies, LL.D.,...of Mrs C. W. Dyson Perrins,...of the late Sir Eldred Hitchcock, C.B.E....
 (57 lots).

Sotheby's, London, 30 November 1960
>Catalogue of fine paintings and drawings of the English School...the property of the late Charles Russell, Esq., also drawings by Thomas Rowlandson...the property of Mr Edward Pugliese of New York,...(9 lots).

Sotheby's, London, 19 April 1961
>Catalogue of fine paintings and drawings of the English school, including the property of Mrs Frances Brandon, ...(22 lots).

Sotheby's, London, 18 October 1961
>Catalogue of British Drawings of the 17th to 19th centuries, the property of H. C. Green, Esq. (8 lots).

Sotheby's, London, 14 March 1962
>Catalogue of fine English paintings and drawings of the 18th and 19th century, including the property of Sir Ian Horobin, Madame J. Laboureur,...the late Professor E. Davison Telford...(19 lots).

Sotheby's, London, 23 January 1963
>Catalogue...including the property of the Rt. Hon. the Earl of Kimberley,...(2 drawings).

Sotheby's, London, 30 January 1963
>Catalogue...including the property of Mrs B. E. Todhunter...(3 drawings).

Sotheby's, London, 13 February 1963
>Catalogue...including the property of Douglas Fraser, Esq.,...(5 drawings).

Sotheby's, London, 20 February 1963
>Catalogue...including the property of Mrs R. L. M. Head,...(1 drawing).

Sotheby's, London, 6 March 1963
>Catalogue...including the property of the late Robert Horner,...(4 drawings).

Sotheby's, London, 20 March 1963
>Catalogue...including the property of Lady Drownlow,...(7 drawings).

Sotheby's, London, 10 April 1963
>Catalogue...including the property of A. L. Fawkes, Esq....(5 drawings).

Sotheby's, London, 15 May 1963
>Catalogue...including the property of the late Mrs M. V. Cunliffe...(2 drawings).

Sotheby's, London, 24 July 1963
>Property of various owners. (9 drawings).

Sotheby's, London, 13 November 1963
>Catalogue...including the property of the late Lady Hudson,...(2 drawings).

Sotheby's, London, 21 October 1964
>Catalogue of the collection of English drawings formed by the late Sir Bruce Ingram. Part I. (15 lots).

Sotheby's, London, 9 December 1964
>Catalogue of the collection of English drawings formed by the late Sir Bruce Ingram. Part II. (13 lots).

Sotheby's, London, 20 January 1965
>Catalogue of the collection of English drawings formed by the late Sir Bruce Ingram. Part III. (6 lots).

Sotheby's, London, 7 April 1965
>Catalogue...including the property of the Hon. Matthew Beaumont,...(7 drawings).

Sotheby's, London, 22 April 1965
>Property of various owners. (2 drawings).

Sotheby's, London, 12 May 1965.
>Catalogue...including the property of Mrs A. M. Riesco,...(1 drawing).

Sotheby's, London, 2 June 1965
>Catalogue...including the property of the late the Hon. Mrs D. Fellowes,...(4 drawings).

Sotheby's, London, 27 October 1965
>Catalogue...including the property of Mrs Margaret Withers...(25 drawings).

Sotheby's, London, 24 November 1965
>Catalogue...including the property of Mrs F. J. O'Meara,...(12 lots of drawings ex coll. Achenbach Foundation, San Francisco).

Sotheby's, London, 14 June 1967
>Property of various owners. (1 drawing).

Sotheby's, London, 22 October 1970
>L. G. Duke sale, part IV. (1 drawing).

Sotheby's, London, 20 July 1972
>Catalogue...the property of Sir John Dilke, Bt.,...(18 lots).

Sotheby's, London, 5 April 1973
>Catalogue of fine eighteenth and nineteenth century English drawings and watercolours...(6 lots).

Sotheby Parke Bernet, New York, sale 3667, 19 September 1974
>Old Master Paintings. (1 drawing).

Sotheby Parke Bernet, New York, sale 3768, 4 June 1975
>Nineteenth Century European Paintings. (2 drawings).

Henry Sotheran & Co., London, catalogue 40, [ca. 1913]
>Catalogue of original drawings by Thomas Rowlandson, also engraving & caricatures and books illustrated by him...(63 drawings).

Henry Spencer & Sons, Retford, Nottinghamshire, 18 October 1974
>Fine drawings & caricatures by Rowlandson, Beardsley, Phil May, Leech and others by order of Sir George Stedman; and from other sources. (43 lots).

Squire Gallery, London, 1932
>Early English watercolours & drawings, from 1700 to 1850.

Squire Gallery, London, 1938
>Watercolours & drawings....

Victoria Gallery, London, 1889–1890
 The Humorous & Grotesque Art Exhibition.
Walker's Gallery, London, catalogue 256, 1923
 Nineteenth annual exhibition of early English water-colours and...drawings by Thomas Rowlandson.
Zeitlin & Ver Brugge Booksellers, Los Angeles, catalogue 215, 1966 Old master drawings. (1 drawing).
Zeitlin & Ver Brugge Booksellers, Los Angeles, catalogue 228, fall-winter 1971–1972
 Eighteenth & Nineteenth century English master drawings and prints. (5 drawings).
Zeitlin & Ver Brugge Booksellers, Los Angeles, offset listing, [1974] Thomas Rowlandson. (5 drawings).

INDEX OF TITLES

SUBJECT INDEX

References are to Catalogue numbers